Rudi Sebastian

WATER

A Journey through the Element

Prologue

Axel Weiß

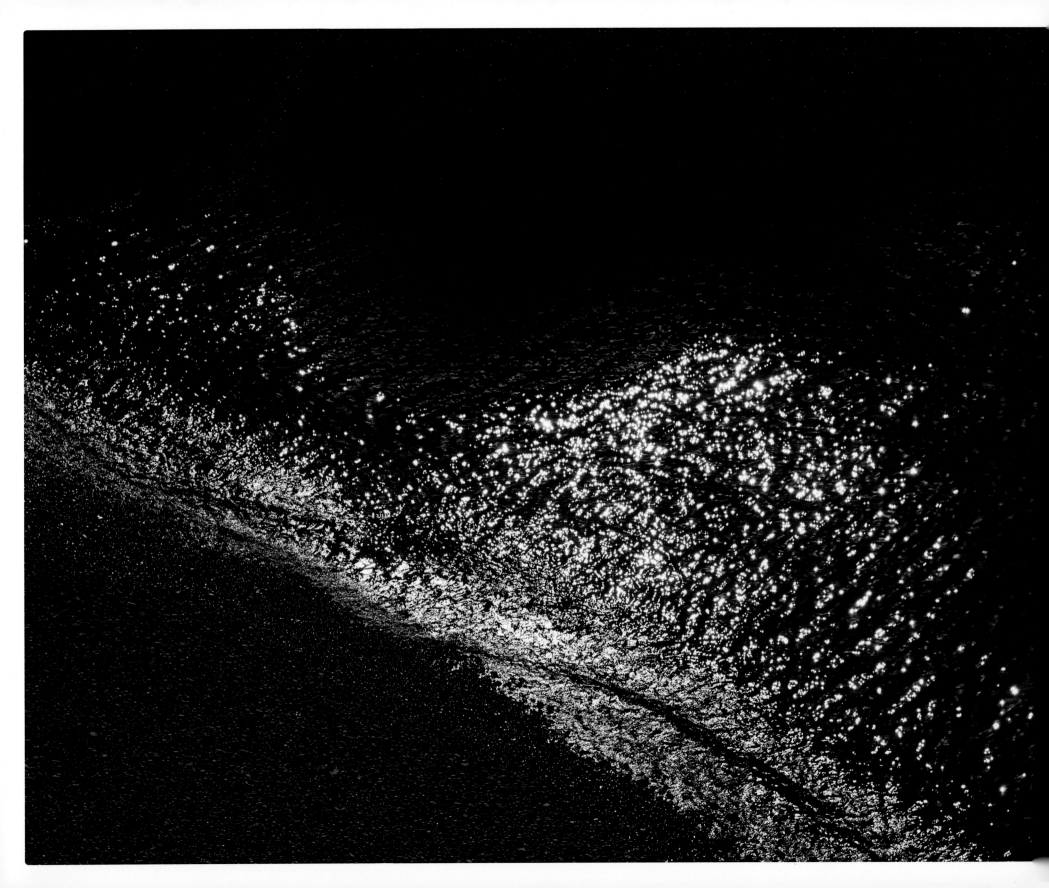

Rudi Sebastian

WASSER
Eine Entdeckungsreise

Prolog

Axel Weiß

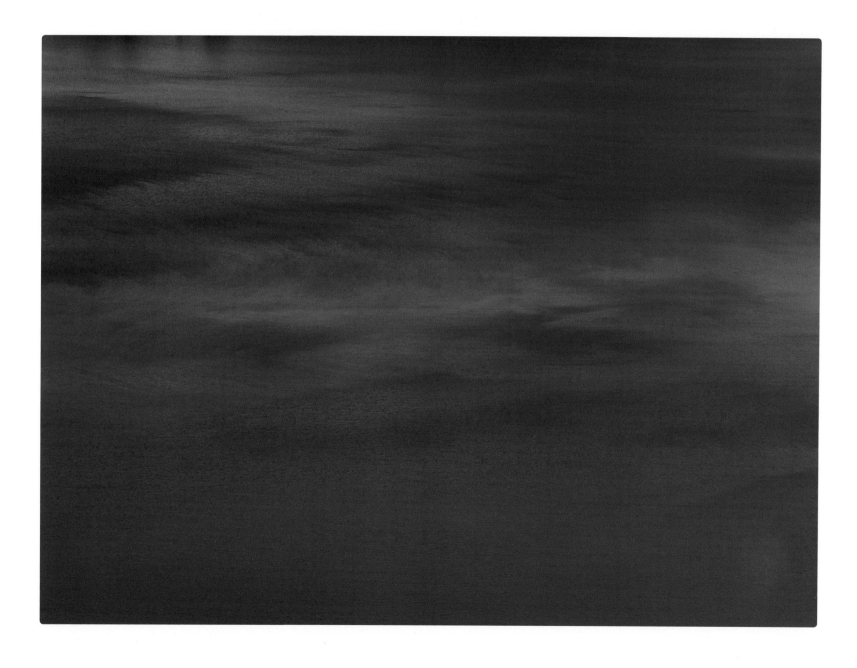

How it began ...

In the winter of 2002, I was standing at the edge of the crater of Mount Mazama, a volcano in Oregon, the surface of Crater Lake stretching out below me, and I could scarcely believe my eyes. Of course, all of the landscape surrounding this lake was overwhelming in its beauty. The volcanic cones along the Ring of Fire were towering in the far distance, the crater's edge lay right in front of me—yet nothing captured me the way the water's surface did: it was a pure International Klein Blue that had left the canvas and entered the natural world. Of course, there is a simple physical explanation for this phenomenon, but what is a rational argument compared to a sensual experience? When I saw these patterns, this untainted blue, the rest of the landscape became irrelevant.

It felt like photography reconciled with painting. Years later I realised just how much influence this experience and the resulting photograph had on my subsequent photographic practice. Ever since that day, water as a topic came to dominate my work. Yet it would take years for me devote myself fully to photography and the topic of water. At first, I was still looking for something that would hold the images together, but through the course of my work, the theme seemed to intensify and accelerate on its own.

Water, the happy coincidence of cosmic happenstance, the chameleon; the molecule that made all the difference. Life on Earth started with it. It can be described in scientific terms and yet that which makes it special is difficult to put into words. It resists objective visualization; it appears in countless forms and shapes. Our experience of water is almost always mediated. Soluble salts, discolorations, and reflections dictate the way in which we experience it—almost never as water "in itself". Water is pure. Water is pure magic. My aim is to capture this magic. I am less interested in the location and the landscape that surrounds it. I want to explore this universal concept; the fundament of water and what it does to us; the creative powers it releases on earth and within us; its ceaseless interactions with its surroundings, its oscillating colours, its kinetic energy, and its ever-changing shape.

It is of course impossible to present a comprehensive likeness of this miraculous substance. The more you learn about it, the more you understand that its manifestations on this earth are countless. Some readers may find this book lacking in one aspect or another. I would ask you therefore to consider this a work in progress that may never come to a natural or decisive close. Some images I excluded on purpose since I wanted to avoid well-known subjects and popular "classics".

Over the course of my work I realised that the greater the scale of a given scene—when shooting a river, for example—the more detail and specificity is lost, which renders images far less useful for my purposes. I spent a long time trying to come up with meaningful divisions and chapters for my images; in the end, I opted for the easiest option. The resulting overlaps were inevitable and, to my mind, do not seem grave enough to warrant finding a different system altogether.

We live in times of accelerating climate change, with millions of tonnes of plastic polluting the waters, bringing death for many species and eventually for humans, too. There is little to indicate that things are going to change any time soon. Coral bleaching is destroying reefs, overfishing is threatening to extinguish many species of fish which are already suffering from ecological stress; this book does not want to look away from any of those issues. On the contrary, I am keenly aware of and concerned about these ongoing problems. I do not believe that photographs can save the world, yet I have the utmost respect for anyone who tries to do just that and is not just looking for an alibi to justify their individual fulfilment. Beauty is like a salve for reality. The point of no return, the moment in which we can no longer undo what we have done to our planet, is approaching ever faster. They say that we protect only that which we know and love. I so wish I could believe it.

Wie alles begann …

Als ich im Winter 2002 am Kraterrand des Vulkans Mount Mazama in Oregon stand und hinunter auf die Oberfläche des Crater Lake blickte, traute ich meinen Augen kaum. Natürlich war die ganze Landschaft dieses Kratersees überwältigend. Die Vulkankegel des Pazifischen Feuerrings im fernen Hintergrund, der Kraterrand vor mir – aber nichts schlug mich so in seinen Bann wie die Wasseroberfläche des Sees: aus der Leinwand gesprungenes Yves-Klein-Blau von einer unglaublichen Reinheit. Natürlich lässt sich dieses Phänomen physikalisch leicht erklären. Aber was ist eine rationale Erklärung gegen das Sehen und Erleben? Die Landschaft drumherum wurde unwichtig angesichts dieser Strukturen in reinem Blau.

Erst Jahre später wurde mir klar, welchen gewaltigen Einfluss dieses Erlebnis und das daraus entstandene Foto auf meine weitere fotografische Arbeit hatten. Seit diesem Moment hat mich Wasser als fotografisches Thema nicht mehr losgelassen. Es sollte allerdings noch ein paar Jahre dauern, bis ich mich ganz der Fotografie widmen und Wasser zu meinem Hauptthema werden würde. Zunächst noch suchend nach der großen Linie, hat diese sich dann im Laufe der Zeit immer mehr herausgebildet und sich die Arbeit daran intensiviert und beschleunigt.

Wasser, der Glücksfall kosmischer Zufälle, das Chamäleon, das Molekül, das den Unterschied macht. Das Leben auf der Erde hat darin begonnen. Es ist wissenschaftlich beschreibbar und doch unfassbar in seinen besonderen Eigenschaften. Es entzieht sich einer objektiven Visualisierung; unendlich sind seine Erscheinungsformen. Es formt unsere Umwelt und spiegelt sie, es ist unsichtbar und sichtbar gleichzeitig. Unsere Wahrnehmung des Wassers basiert fast immer auf indirekten Erfahrungen. Gelöste Salze, Verunreinigungen, Reflexionen bestimmen, wie wir es erleben – fast nie als Wasser „an sich". Wasser ist pur. Wasser ist pure Magie. Diese Magie einzufangen, ist mein Anliegen. Nicht der konkrete Ort, nicht die klassische Landschaft ist es, was mich dabei interessiert. Mir geht es um das Universelle, das, was Wasser im Kern aus- und mit uns macht. Die kreative Kraft, die es auf der Erde, um uns und mit uns entfaltet. Die permanente Interaktion mit der Umgebung, changierende Farben, kinetische Energie, sich permanent verändernde Formen.

Natürlich ist es nicht möglich, ein allumfassendes Porträt dieses Wunderstoffes abzubilden. Je mehr man sich damit beschäftigt, desto klarer wird, wie vielgestaltig seine Erscheinungsformen sind, die auf unserer Erde vorkommen. Der ein oder andere Betrachter wird dies oder das vermissen. Betrachten Sie deshalb das vorliegende Buch als „Work in Progress", als Prozess, der wohl nie sein natürliches Ende finden wird. Vieles ist ganz bewusst nicht in diesem Buch enthalten, da ich allzu Bekanntes und oft gezeigte „Klassiker" vermeiden wollte. Ich habe im Lauf der Arbeiten erkannt, dass mit zunehmender Größe zum Beispiel eines Flusses die Dinge häufig unspezifischer und ungeeigneter für mein Anliegen werden. Lange habe ich nach einer sinnvollen Aufteilung für das Buch gesucht und bin letztendlich bei der einfachsten aller Möglichkeiten gelandet. Die Überschneidungen, die sich zwangsläufig ergeben, erschienen mir kaum so sortierbar, dass eine andere Aufteilung Sinn ergeben hätte.

In Zeiten des sich beschleunigenden Klimawandels, in denen Millionen Tonnen Plastik in den Gewässern einen schleichenden Tod für viele Arten und letztlich für uns Menschen bedeuten, lässt weniges hoffen, dass sich daran in absehbarer Zeit etwas ändern wird. Jetzt, wo Korallenriffe ausbleichen und die Überfischung vielen Arten, die ohnehin schon unter großem ökologischen Druck stehen, den Rest gibt, ist dieses Buch durchaus nicht als Ignoranz gegenüber diesen Problemen zu sehen. Ganz im Gegenteil. Mir sind sie sehr bewusst und sie belasten mich. Ich glaube nicht daran, die Welt mit Fotos retten zu können. Doch ich habe größte Hochachtung vor denen, die es ernsthaft wollen und nicht nur ein Alibi für ihre Selbstverwirklichung suchen. Schönheit ist wie ein Balsam gegen die Realitäten. Der „Point of no Return", an dem keine Rettung mehr möglich ist, nähert sich beängstigend schnell. Es heißt immer, nur das, was wir kennen und lieben, schützen wir auch. Wie gerne würde ich das glauben.

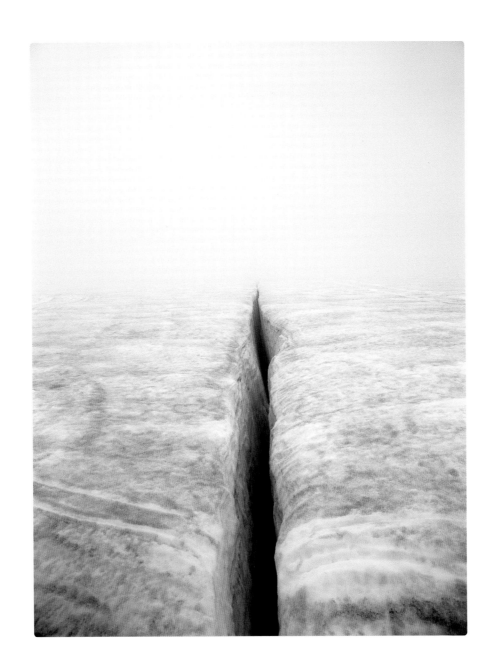

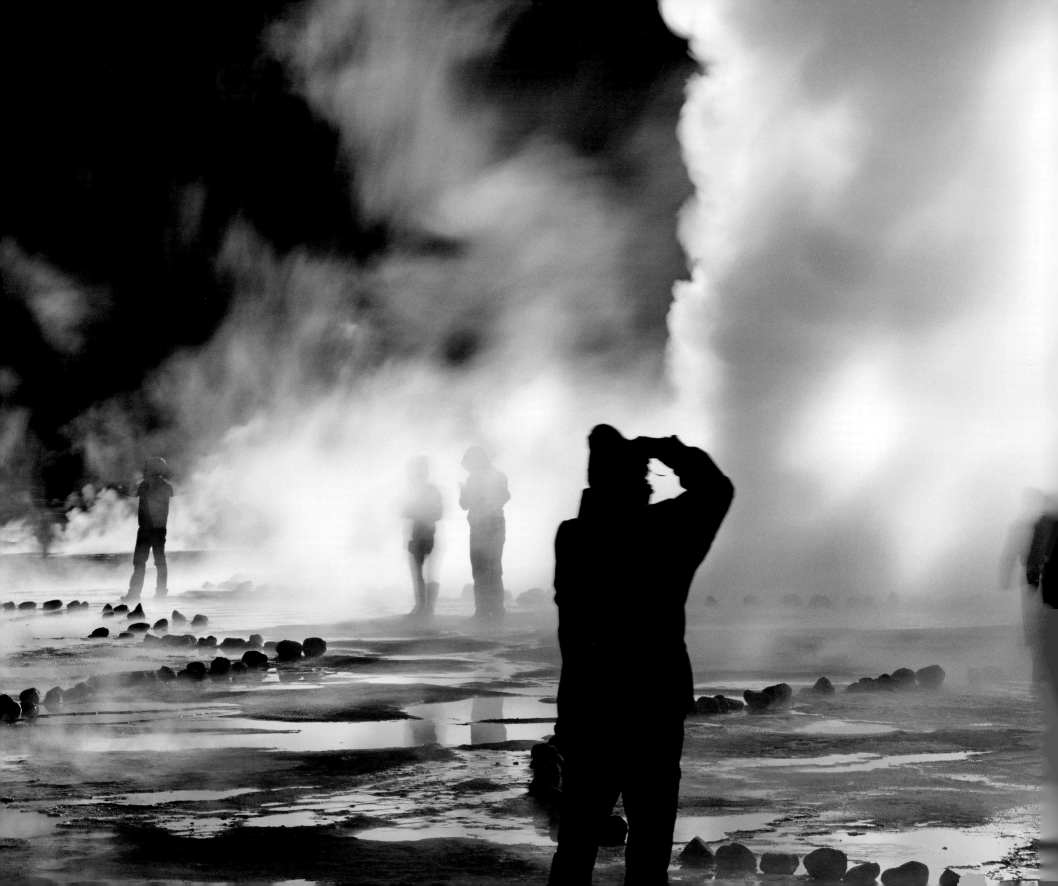

CONTENTS

INHALT

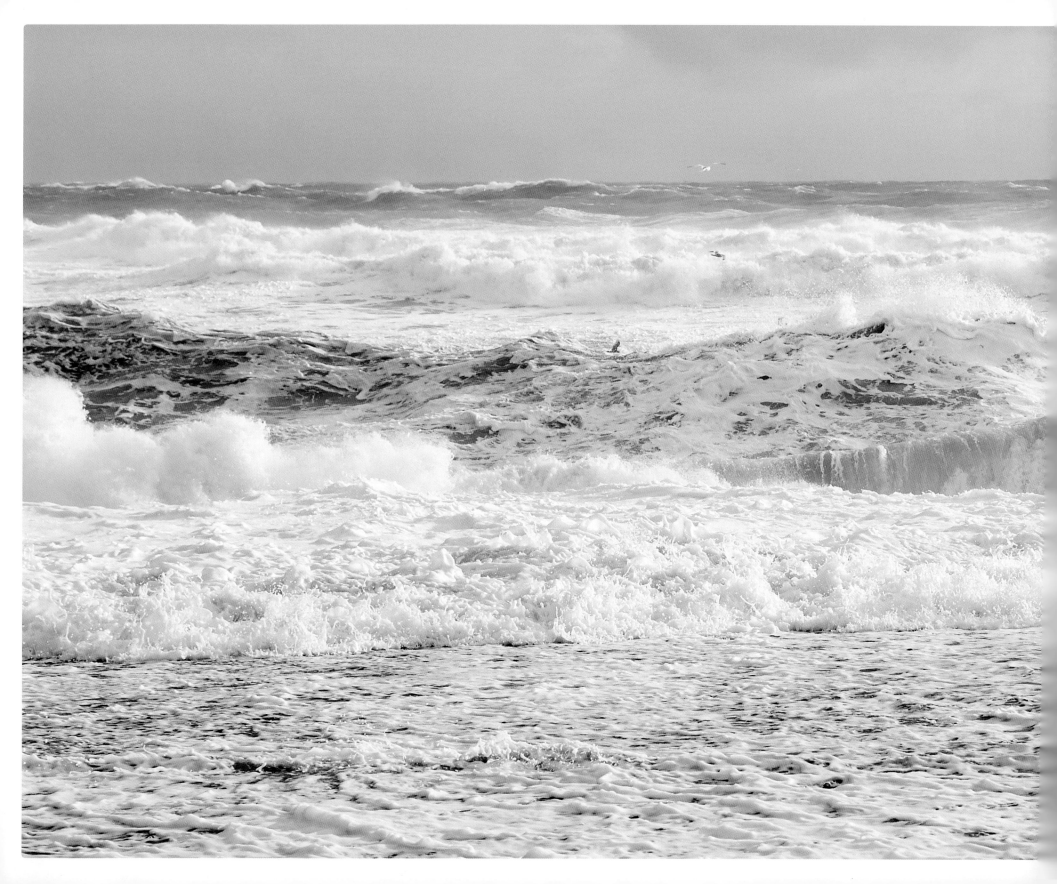

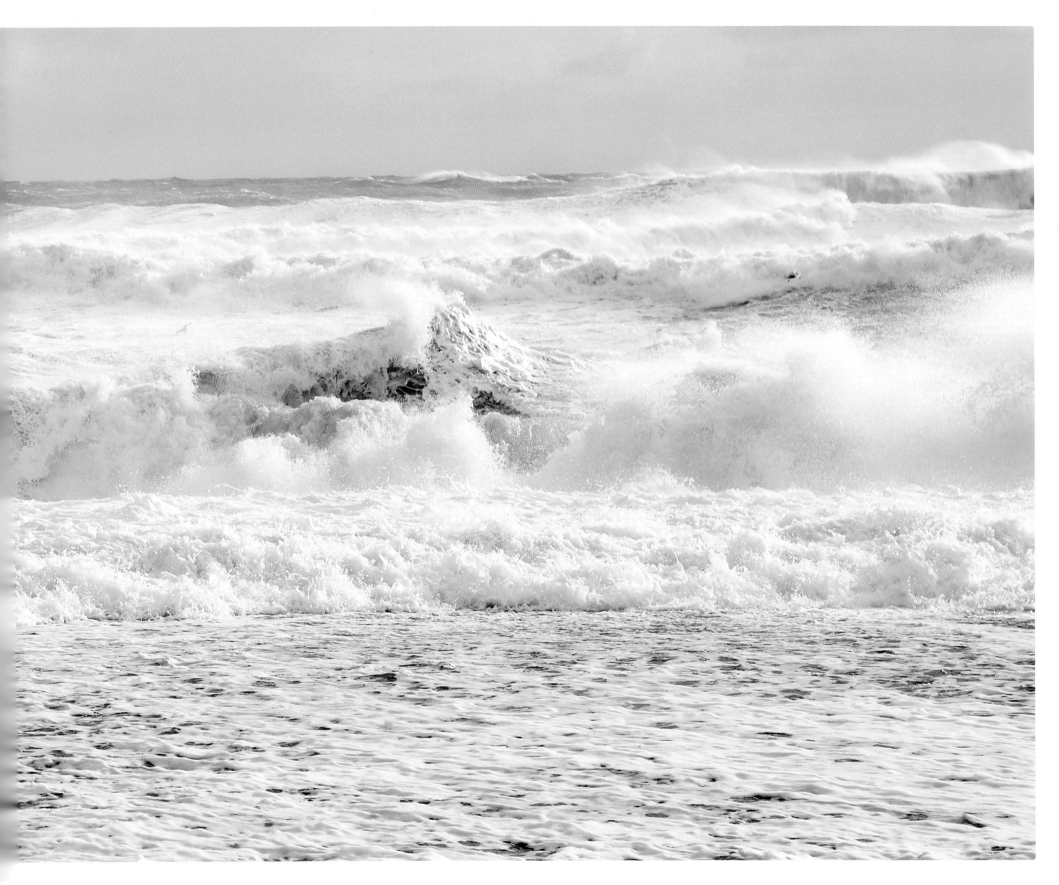

WHAT IS WATER AND WHERE DOES IT COME FROM?

The Greek philosopher Aristotle thought water was one of four elements which constitute the world. This theory was not too far from the truth: after all, back in Aristotle's days, water was covering more than two thirds of the planet's surface. Water is one of the most fascinating and versatile yet simple chemical compounds. One oxygen atom plus two hydrogen atoms, and there we have it: our water molecule.

Water is the only matter on earth that occurs naturally in three different states of aggregation: solid, liquid, and gas. The seas and other saltwater sources make up roughly 97 percent of our planet's water reserves. Only about three percent are freshwater, of which more than half appear in its solid state: Earth is covered in 5.7 million cubic miles of ice, snow, and glaciers. One tenth of a percent of all water on earth exists as gas; it is invisible vapor in the atmosphere.

Water is a versatile carrier and an almost irresistible solvent. In fact, pure water almost never occurs naturally; it is far too prone to mixing with other matter. It even attracts substances which do not appear to be soluble —it is all just a matter of time and quantity. Water is a large-scale landscape artist. It shapes whole continents over geological time scales, acts as a lubricant between tectonic plates, eats away relentlessly at even the hardest of stones, can flood and carry off whole mountain ranges, and brings sediment which in turn can form a vast new mountain.

Yet water is important on a smaller scale, too: life needs water. Not only does water act as a carrier for soluble minerals and other matter within organisms, it also helps stabilize the crucial three-dimensional structure of larger molecules such as enzymes—without this structure, they would not function. Furthermore, water contributes to forming double helix in DNA. Without water's special attractive force (more on that later), life as we know it would not exist. All this is not even to mention water's role in the so-called "primordial soup", the original ocean in which millions of years ago chemical reactions created life on earth.

But where did water come from? For a long time, the hypothesis held that water had first been brought to earth by comets which were colliding with the Earth's freshly formed surface for 4.5 billion years. In the early days of the solar system, a vast number of lumps of various size were orbiting around the sun. Among them there were numerous comets, the composition of which can in many cases be compared to dirty chunks of ice—which contain a high percentage of water. Recently, though, research found that there are obvious differences between water found on a comet and water found on Earth; consequently, comets had to be dismissed as potential original carriers of water to Earth.

Scientists are now debating whether Earth may have been formed from several smaller celestial bodies with their enveloping solar dust- and gaseous clouds. This would account for about four fifths of the Earth's mass. On this young Earth, the only water present was bound in rock and mineral structures. Other celestial bodies collided with the Earth, making the new planet even larger, and bringing more water. About 30 percent of water may have been added in this way. Current research suggests that one or two percent of water molecules may be directly traced back to the gaseous cloud surrounding the sun in the early phases of the solar system. This much we know: liquid water can only have occurred in larger quantities on the Earth's surface after the young planet had reached a certain stable size and mass, and after it had cooled down sufficiently. When temperatures fell below the boiling point of water, 212 degrees Fahrenheit, it rained on earth for the first time.

Since the very beginning of life on Earth more than four billion years ago, the amount of water on the planet has remained constant at more than 300 million cubic miles. Bound water from the Earth's core is steadily being released and reaches the Earth's surface, yet at the same time, the splitting of water molecules in the atmosphere by sunlight causes a loss: water undergoes a photochemical reaction and becomes hydrogen gas; it vanishes into the universe. Overall, there is a balance between loss and gain, and for about 600 million years, the chemical composition of the world's oceans has probably been very similar to what we find today.

WAS IST WASSER UND WO KOMMT ES HER?

Der griechische Philosoph Aristoteles hielt Wasser für eines der vier Elemente, die für ihn die Grundlage der Welt bildeten. Ganz verkehrt war das aus damaliger Sicht nicht: Wasser bedeckt immerhin weit mehr als zwei Drittel der Oberfläche unseres blauen Planeten. Und Wasser ist sicherlich eine der erstaunlichsten, erfolgreichsten und auch der einfachsten chemischen Verbindungen überhaupt. Ein Atom Sauerstoff plus zwei Atome Wasserstoff, fertig ist das Wassermolekül.

Wasser kommt als einziger Stoff auf der Erdoberfläche in drei Aggregatzuständen vor: fest, flüssig, gasförmig. Rund 97 Prozent der Wasservorräte lagern in den Weltmeeren als Salzwasser. Nur gut drei Prozent sind Süßwasser, davon mehr als die Hälfte gebunden in fester Form: 24 Millionen Kubikkilometer Eis, Schnee und Gletscher bedecken die Erde. Ein Promille des Wassers existiert daneben gasförmig als unsichtbarer Wasserdampf in der Atmosphäre.

Wasser ist ein vielseitiger Transporteur und ein fast unwiderstehliches Lösungsmittel. Faktisch gibt es in der Natur gar kein reines Wasser, so gern vermischt es sich mit anderen Stoffen. Selbst scheinbar unlösbare Substanzen nimmt es auf – alles nur eine Frage der Zeit und der Menge. Wasser wirkt als Landschaftsgestalter im großen Stil, formt in geologischen Zeiträumen ganze Kontinente, wirkt als Schmiermittel zwischen tektonischen Platten, es löst unerbittlich härteste Gesteine, schwemmt ganze Gebirge weg und lagert Sande ab, die später wieder neue, gewaltige Gebirge bilden können.

Wasser wirkt aber auch im Kleinen: Leben braucht Wasser. Denn Wasser ermöglicht nicht nur den Transport gelöster Salze und anderer Stoffe in den Organismen, sondern hilft etwa auch, die dreidimensionale Struktur großer Moleküle wie Enzyme zu stabilisieren, ohne die diese nicht wirksam wären. Auch gestaltet es die Doppelhelix der Erbsubstanz DNS mit. Ohne die speziellen Bindungskräfte des Wassers (dazu später mehr) gäbe es kein Leben in der uns bekannten Form. Da reden wir noch gar nicht von der „Ursuppe", jenem Urmeer, in dem vor Milliarden Jahren das Leben auf der Erde mit der chemischen Evolution seinen Anfang nahm.

Woher aber kam dieses Wasser? Lange wurde vermutet, dass ein Großteil des Wassers auf der Erde von Kometen eingebracht wurde, die seit 4,5 Milliarden Jahren auf der frisch gebildeten Erde einschlugen. Gerade in der Anfangszeit des Sonnensystems kreisten ja Unmengen kleinerer und größerer Brocken um die Sonne, viel mehr als heute. Unter ihnen befanden sich auch zahlreiche Kometen, deren Zusammensetzung oft schmutzigen Eisbällen mit hohem Wasseranteil gleicht. Inzwischen ergaben aber Untersuchungen deutliche Unterschiede zwischen dem Wasser in Kometen und irdischem Wasser, Kometen scheiden für die Erde als alleinige Wasserträger daher aus.

Diskutiert wird derzeit, ob sich die Erde aus mehreren kleinen, Wasser enthaltenden Himmelskörpern samt den sie umgebenden solaren Staub- und Gaswolkenresten gebildet haben könnte. So könnten etwa vier Fünftel der Erdmasse zusammengekommen sein. Wasser lag in dieser jungen Erde zunächst in Mineralien gebunden in den Gesteinen vor. Weitere Himmelskörper schlugen ein und vergrößerten den frisch gebackenen Planeten, brachten weiteres Wasser mit. Bis zu 30 Prozent des Wassers könnten so noch dazugekommen sein. Ein bis zwei Prozent der Wassermoleküle mögen direkt auf Reste der um die Sonne befindlichen Gaswolke aus der Frühphase des Planetensystems zurückgehen, lassen aktuelle Forschungen vermuten. Fakt ist: Flüssiges Wasser kann es an der Erdoberfläche erst in größeren Mengen gegeben haben, nachdem die junge Erde eine gewisse stabile Größe und Masse erreicht hatte und auch ausreichend abgekühlt war. Der erste Regen fiel wohl, als die Temperaturen den Siedepunkt des Wassers bei rund 100 Grad Celsius unterschritten hatten.

Seit den Anfängen vor mehr als vier Milliarden Jahren ist die Wassermenge von über einer Milliarde Kubikkilometern auf der Erde ungefähr gleich geblieben. Zwar wird aus dem Erdinneren ständig gebundenes Wasser freigesetzt und an die Oberfläche nachgeliefert. Die Zerlegung von Wasser in der Atmosphäre durch Sonnenlicht sorgt aber andererseits für Verluste: Das aus Wasser fotochemisch entstandene Wasserstoffgas kann ins All entschwinden. Alles in allem hat sich ein Gleichgewicht entwickelt und seit ungefähr 600 Millionen Jahren haben die Weltmeere wohl eine ähnliche Zusammensetzung wie heute.

ANOMALIES IN THE SYSTEM

Unlike other molecules, water often defies expectations and sometimes appears to violate the laws of physics. We currently know of roughly 70 such "anomalies of water"—and for us, they are a stroke of luck. It is only through these anomalies that life on earth in all its various shapes and forms can develop and thrive. Life as we know it strongly depends on temperatures between freezing and boiling point (between 32 and 212 degrees Fahrenheit) and this is where the first anomaly of water comes in.

Due to its small molecular size, water should freeze at much lower temperatures than 32 degrees Fahrenheit. In theory, water should reach its boiling point (the temperature at which it turns to gas) at negative temperatures - not once it reaches 212 degrees. This anomaly only occurs because liquid water displays a surprising degree of order. It is by no means a wild clutter of single water molecules; it has a fixed internal structure. Molecules within this liquid continually attach and detach from each other. In water, they move in a sort of dynamic network within which individual elements are linked by so-called hydrogen bridges. The reason for this phenomenon is because electric charge is not spread out across the water molecule in a uniform manner; in some areas, electric charge is stronger than in others. Thus, for a fraction of a second, neighboring water molecules will either attract or repulse each other due to their electric dipole moment. They accelerate and decelerate—a dynamic system of dancing water molecules, connected by hydrogen bridges. This also explains water's high surface tension, which is strong enough to support some insects as they move across it.

Breaking this network requires a lot of energy. Thus, it is only at temperatures of over 212 degrees Fahrenheit that individual molecules move so fast within the liquid that their attractive forces are no longer sufficient to keep them attached; the liquid turns to gas.

Water has another important property. It can absorb large amounts of heat and store it for a comparatively long time. Again, this is made possible by hydrogen bridges between molecules: the added energy breaks the bridges, and as they cool down, they release heat. The oceans' temperature, for instance, has a very narrow fluctuation range. This is what enables them to be a stable ecological biosphere.

Another exceptional aspect of water may sound harmless at first, but it has far-reaching consequences. When the temperatures fall, matter usually contracts and becomes denser. Water does not follow this rule: it does not reach maximum density at freezing point, which is 32 degrees, but rather at 39 degrees Fahrenheit. In practice, this "density anomaly of water" means that at 39 degrees, water is at its heaviest. Both warmer and colder water will be lighter and will therefore settle above it.

During cold weather, bodies of water freeze from the top downwards. Yet due to enclosed air pockets, amongst other factors, the ice that forms does not conduct heat as well as liquid water does; it therefore insulates downwards. This is the reason why even in the coldest of winters, large bodies of water will always have areas which are not covered by ice at their deepest points. Due to the density anomaly of water, fish and other organisms can survive even at 39 degrees Fahrenheit.

ANOMALIEN IM SYSTEM

Im Vergleich mit anderen Molekülen benimmt sich Wasser immer wieder anders, als zu erwarten wäre, und hält sich vermeintlich nicht an physikalische Regelmäßigkeiten. Diese „Anomalien des Wassers" – rund 70 kennen wir inzwischen – sind unser großes Glück. Nur durch sie konnte sich das Leben auf der Erde in der uns bekannten Form und Vielfalt überhaupt entfalten. Leben, wie wir es kennen, ist stark angewiesen auf Temperaturen zwischen null und 100 Grad Celsius – und da kommt die erste Abweichung des Wassers von der Norm ins Spiel.

Eigentlich sollte Wasser angesichts seiner geringen Molekülgröße bei weitaus niedrigeren Temperaturen gefrieren als null Grad Celsius. Und sieden, also verdampfen, sollte Wasser theoretisch schon bei deutlichen Minusgraden und nicht erst bei plus 100 Grad. Möglich wird die Abweichung, weil flüssiges Wasser eine erstaunliche Ordnung aufweist. Flüssiges Wasser ist nämlich mitnichten ein wildes Nebeneinander der einzelnen Wassermoleküle, sondern es hat eine innere Struktur: Ständig verbinden und lösen sich in dieser Flüssigkeit die Moleküle. Sie bewegen sich in flüssigem Wasser in einer Art variablem Netzwerk, dessen einzelne Mitglieder durch sogenannte Wasserstoffbrücken miteinander verbunden sind. Die Ursache dafür liegt darin, dass die elektrische Ladung nicht gleichmäßig über das Wassermolekül verteilt vorliegt, sondern Schwerpunkte bildet. Deshalb stoßen sich benachbarte Wassermoleküle wegen ihrer elektrischen Dipolkräfte jeweils für einen Moment ab oder ziehen sich an. Sie bremsen und beschleunigen – ein dynamisches System miteinander über die Wasserstoffbrücken verbundener, tanzender Wasserteilchen. Das ist auch für die hohe Oberflächenspannung des Wassers verantwortlich, die sogar Insekten wie Wasserläufer trägt.

Es braucht Energie, um dieses Netzwerk aufzubrechen. Erst bei rund 100 Grad Celsius bewegen sich deshalb die einzelnen Moleküle in der Flüssigkeit so schnell, dass die Anziehungskraft zwischen ihnen nicht mehr ausreicht und die Flüssigkeit zu Gas wird.

Wasser hat eine weitere wichtige Eigenschaft. Es kann große Wärmemengen aufnehmen und gut und vergleichsweise lange speichern. Es sind wieder die Wasserstoffbrücken zwischen den Molekülen, die das ermöglichen: Energiezufuhr bricht die Bindungen auf, abkühlend geben sie Wärme wieder frei. Die Temperatur etwa der Meere weist so nur eine recht geringe Schwankungsbreite auf, was einen stabilen ökologischen Lebensraum liefert.

Und es gibt noch etwas Besonderes. Auf den ersten Blick klingt es ganz harmlos, doch die Konsequenzen sind heftig. Wenn die Temperaturen sinken, werden Stoffe üblicherweise dichter, weil sie sich zusammenziehen. Nicht aber Wasser: Seine größte Dichte erreicht es eben nicht am Gefrierpunkt bei null Grad Celsius, sondern bei vier Grad. Diese „Dichteanomalie des Wassers" bedeutet in der Praxis: Mit vier Grad Celsius ist Wasser am schwersten. Sowohl wärmeres wie auch kälteres Wasser lagert sich deshalb immer darüber ab, weil es leichter ist.

Wetterbedingt gefrieren Gewässer von oben her. Das sich bildende Eis leitet aber, unter anderem wegen der eingelagerten Luft, Wärme sehr viel schlechter als flüssiges Wasser und isoliert nach unten hin. Selbst in den knackigsten Wintern bleiben deshalb in größeren Gewässern tiefe Zonen eisfrei. Dank der Dichteanomalie des Wassers können also Fische und andere Organismen bei vier Grad Celsius überleben.

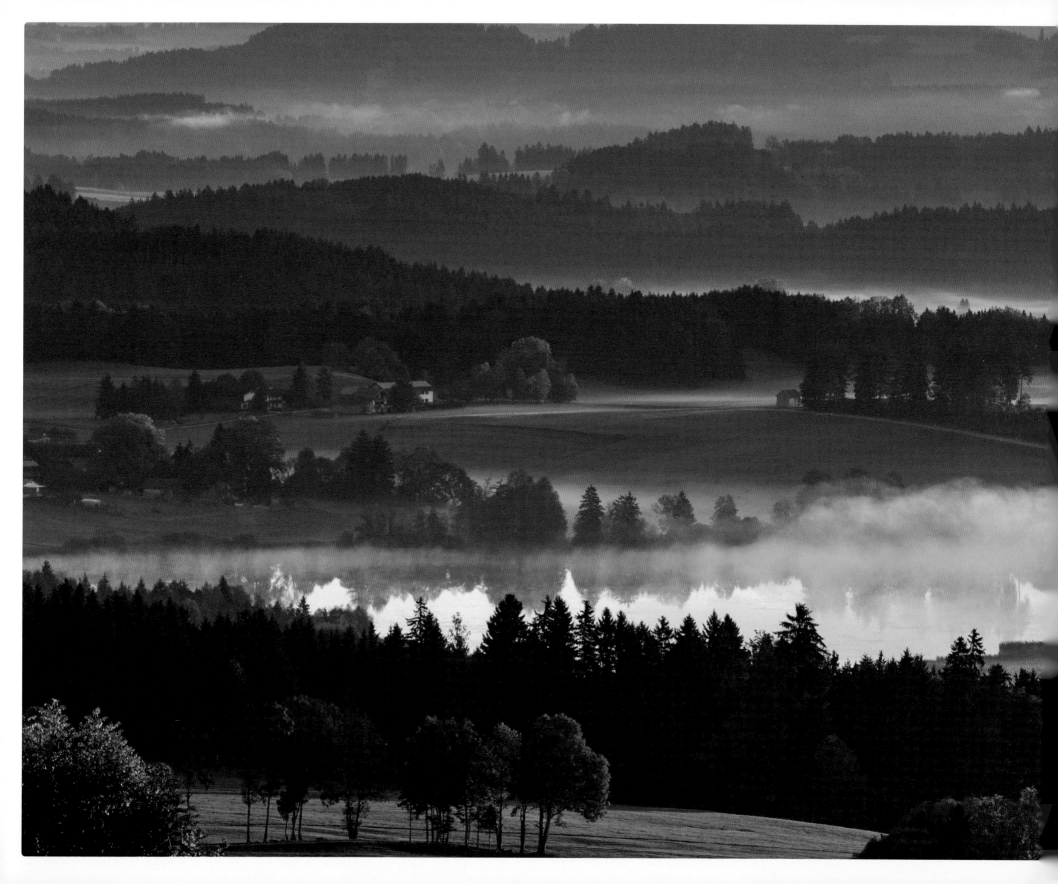

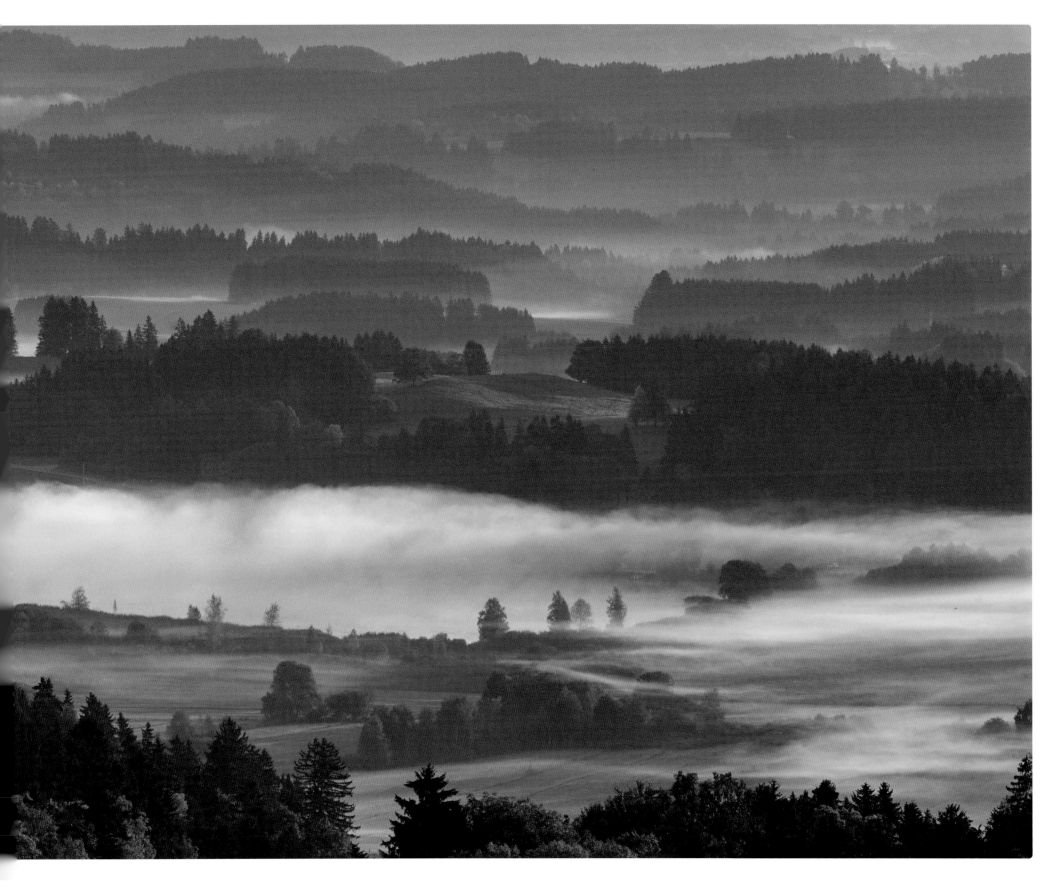

WEATHER NEEDS WATER

Two forms of water, liquid water and gas—that is to say, vapor in the atmosphere—are in constant exchange. This is known as the hydrological cycle, the cycle of evaporation and rainfall. Of the overall amount of 300 million cubic miles of water on earth, about 15,600 cubic miles evaporate into the atmosphere each year—most of it from the oceans. That is almost as much water as there is in the Caspian Sea. After about eight and a half weeks on average, this water will return as rainfall, often occurring far from the place where it had evaporated. About a quarter of this rain falls on land. Rivers, streams, bogs, swamps, and lakes, as well as glaciers and snow fields will store this water for a certain amount of time before it is returned once more to the oceans.

The sun provides the energy for the Earth's weather cycle—it is the motor in the Earth's weather machine, as it were. Depending on the time of year, the area in which the sun's radiation is at its strongest moves between just south and just north of the equator. This means that the areas that get the hottest and where therefore the most evaporation occurs moves, too. This results in extraordinary weather phenomena such as high- and low-pressure systems. Water plays an important role in the dynamics of climate and weather. For one, it is an important energy carrier which shifts heat away from areas with extremely high solar radiation levels around the equator to colder areas, as far as the polar regions. This happens due to oceanic currents such as the Gulf stream as well as evaporation and the hydrological cycle.

For water to evaporate, a significant amount of energy is needed. This energy is stored within the resultant vapor. In humid tropical regions, clouds during thunder-

storms can grow up to 10 miles high. The warm, humid air enters the upper atmosphere and is transported from the equator northwards and southwards. In the temperate zones, the energy is released when the vapour in the air cools down, condensates, and manifests once again as rainfall. This global "steam engine" is also responsible for high- and low-pressure systems. The basic procedure, greatly simplified, is as follows: when very humid air rises, it leaves a space behind. In this area, a low-pressure system forms. From the temperate zone, more air pours into this tropical trough. This new air soon also heats up and rises until it is redirected north- or southwards. Thermal radiation into space creates heat loss which causes the air to sink again. In areas where this now very dry air reaches the ground, high pressure systems are formed. These so-called sub-tropical high-pressure belts are rather stable zones, often characterized by large stretches of desert.

Two areas with a difference in pressure will always want to equalize. Thus, air will stream from the high- to the low-pressure system; this manifests as wind and storms. Of course, if we really want to understand weather, we have to consider other factors such as the role of the Earth's rotation, landform configuration and many more. It can be said, however, that the way in which regular weather-related processes unfold depend strongly on the air's humidity and the properties of water.

In the global cycle of water, clouds play an important role as the link between evaporation and rainfall. Clouds are formed when the air is saturated with humidity and as long as there are enough cloud condensation nuclei such as pollen, dust, or other small particles to which condensation can attach. They are crucial

for the Earth's energy cycles, too. During daytime, they provide shade and cooler temperatures; at night, they bring warmth by absorbing and returning heat radiating from the ground. Small oscillations in cloud coverage—just a little bit more or a little bit less—can often have a huge impact on temperatures on the ground.

Clouds and water are therefore two of the most important elements that influence the climate, and with it, climate change. Clouds are made up of miniscule water droplets, often as small as ten to several hundred micrometers. At very high altitudes, tiny floating ice crystals may form. Drops of water can remain liquid even at temperatures of -4 degrees Fahrenheit or lower, and so it may happen that a cloud is made up of liquid drops in its lower levels, ice crystals on top, and in between a layer in which liquid drops mingle with frozen ice particles. We still know little about these mixed-phase layers, yet the processes that occur within them are crucial for making accurate weather predictions and forecasts.

This much we know: through condensation, water droplets moving in the atmosphere attract more water molecules as well as gathering other foreign particles in the air. As they are assimilated, chemical reactions occur within the water droplets. Water's behaviour determines how clouds form and dissipate; it therefore also dictates how much sunlight does or does not reach the ground to create warmth. Weather needs water.

KEIN WETTER OHNE WASSER

Das flüssige Wasser und der gasförmige Wasserdampf in der Atmosphäre stehen in einem regen Austausch, dem sogenannten hydrologischen Zyklus, einem großen Kreislauf aus Verdunstung und Niederschlägen. Von der Gesamtmenge an 1,4 Milliarden Kubikkilometern Wasser auf der Erde verdunsten jährlich etwa 65.000 Kubikkilometer in die Atmosphäre, zumeist über den Ozeanen. Das ist immerhin fast die Wassermenge im Kaspischen Meer. Nach durchschnittlich anderthalb Wochen fällt dieses Wasser oft weit entfernt vom Ort der Verdunstung als Niederschlag wieder herab. Ein gutes Viertel davon trifft auf Land. Flüsse, Bäche, Moore, Sümpfe und Seen, aber auch Gletscher und Schneeflächen speichern das Wasser eine gewisse Zeit, bevor es wieder abfließt und erneut im Ozean landet.

Energetischer Motor der großen Wettermaschine auf unserem Planeten ist die Sonne. Deren maximale Einstrahlkraft wandert je nach Jahreszeit vom Äquator ein Stück nördlich und südlich. Damit wandern auch die Zonen größter Erwärmung und Verdunstung mit – diese bilden die zentralen Wetterküchen für die Großwetterlagen aus Hoch- und Tiefdruckgebieten. Das Wasser spielt in der Dynamik des Klima- und Wettergeschehens eine wichtige Rolle. Es dient einerseits als wichtiger Energietransporter, der Wärme aus den Zonen maximaler Sonneneinstrahlung rund um den Äquator bis in die Polarregionen bringt. Das geschieht zum einen durch riesige Meeresströme wie etwa den Golfstrom, aber auch durch Verdunstung im hydrologischen Kreislauf.

Zum Verdampfen des Wassers wird anfangs sehr viel Energie verbraucht und im Wasserdampf gespeichert. Bis zu 16 Kilometer hoch türmen sich in den feuchten Tropen die täglichen Gewitterwolken in den Himmel.

Die warme, wasserhaltige Luft wird vom Äquator aus in der oberen Atmosphäre nach Norden und Süden transportiert. In den gemäßigten Breiten wird die Energie schließlich wieder freigesetzt, wenn der in der Luft enthaltene Wasserdampf beim Abkühlen kondensiert und als Niederschlag zu Boden sinkt. Diese globale Dampfmaschine ist andererseits auch für Hoch- und Tiefdruckgebiete und damit das Wettergeschehen verantwortlich. Grob vereinfacht passiert Folgendes: Wenn die wasserdampfgesättigte Luft aufsteigt, fehlt sie unten am Boden. Dort entsteht eine Zone mit tiefem Luftdruck. In diese tropische Tiefdruckrinne strömt aus mittleren Breiten neue Luft nach. Diese steigt bald ebenfalls erhitzt nach oben, wird in der Höhe wiederum nach Norden oder Süden abgelenkt. Durch Abgabe von Wärmestrahlung ins All kühlt sie ab und sinkt nach unten. Wo diese dann eher trockene Luft auf den Boden stößt, bilden sich Hochdruckgebiete. Diese subtropischen Hochdruckgürtel sind recht stabile Zonen – erkennbar an den dort oftmals vorhandenen trockenen Wüsten.

Weil Druckunterschiede sich freilich immer ausgleichen wollen, strömt Luft vom Hochdruckgebiet zum Tief – erkennbar in Form von Winden und Stürmen. Um Wetter zu erklären, kommen natürlich noch der Einfluss der Erddrehung, des Reliefs der Erdoberfläche und einiges andere dazu. Aber wie diese Wetterprozesse ablaufen, ist maßgeblich vom jeweiligen Wassergehalt der Luft und den Eigenschaften des Wassers abhängig.

Im globalen Wasserkreislauf spielen Wolken als Bindeglied zwischen Verdunstung und Niederschlag eine wichtige Rolle. Wenn die Luft mit Wasserdampf gesättigt ist und genügend Kondensationskeime wie

Pollen oder Staub vorhanden sind, an denen sich die Wassermoleküle sammeln können, entstehen Wolken. Auch für den Energiehaushalt der Erde sind sie wichtig. Wolken kühlen tagsüber durch Abschattung und heizen nachts, in dem sie vom Boden kommende Wärmestrahlung aufnehmen und – unter anderem – wieder nach unten abgeben. Ein paar Prozent mehr oder weniger an Wolkenbedeckung macht bei den Temperaturen in Bodennähe daher oft eine Menge aus.

Wolken und Wasser gehören somit zu den wichtigsten Elementen, die Klima – und Klimawandel – bestimmen. Wolken bestehen aus winzigen, oft nur zehn bis mehrere Hundert Mikrometer großen Wassertröpfchen. In großen Höhen können sich auch kleine schwebende Eiskristalle bilden. Weil Wassertropfen auch bei Temperaturen von zwanzig Grad unter null oder weniger flüssig bleiben können, kann es passieren, dass eine Wolke in Bodennähe flüssige Tröpfchen enthält, im obersten Bereich Eiskristalle, dazwischen aber eine Zone, in der (noch) flüssige Tropfen mit (schon) gefrorenen Eisteilchen gemeinsam vorkommen. Letztlich wissen wir über solche gemischtphasigen Wolkenbereiche noch recht wenig, obwohl die dort ablaufenden Mechanismen für die Niederschlagsberechnung und Wettervorhersage wichtig sind.

Klar ist: Bewegte Wassertropfen in der Atmosphäre nehmen durch Kondensation neue Wassermoleküle und andere Stoffe aus der Luft auf, lösen diese und ermöglichen in ihrem Inneren chemische Reaktionen der aufgenommenen Stoffe. Das Verhalten des Wassers regelt letztlich die Wolkenbildung und -auflösung mit und bestimmt damit ganz wesentlich, wie viel Sonnenlicht am Boden ankommt und dort wärmt – oder eben nicht. Ohne Wasser kein Wetter.

La Réunion, France

Sevilla, Spain

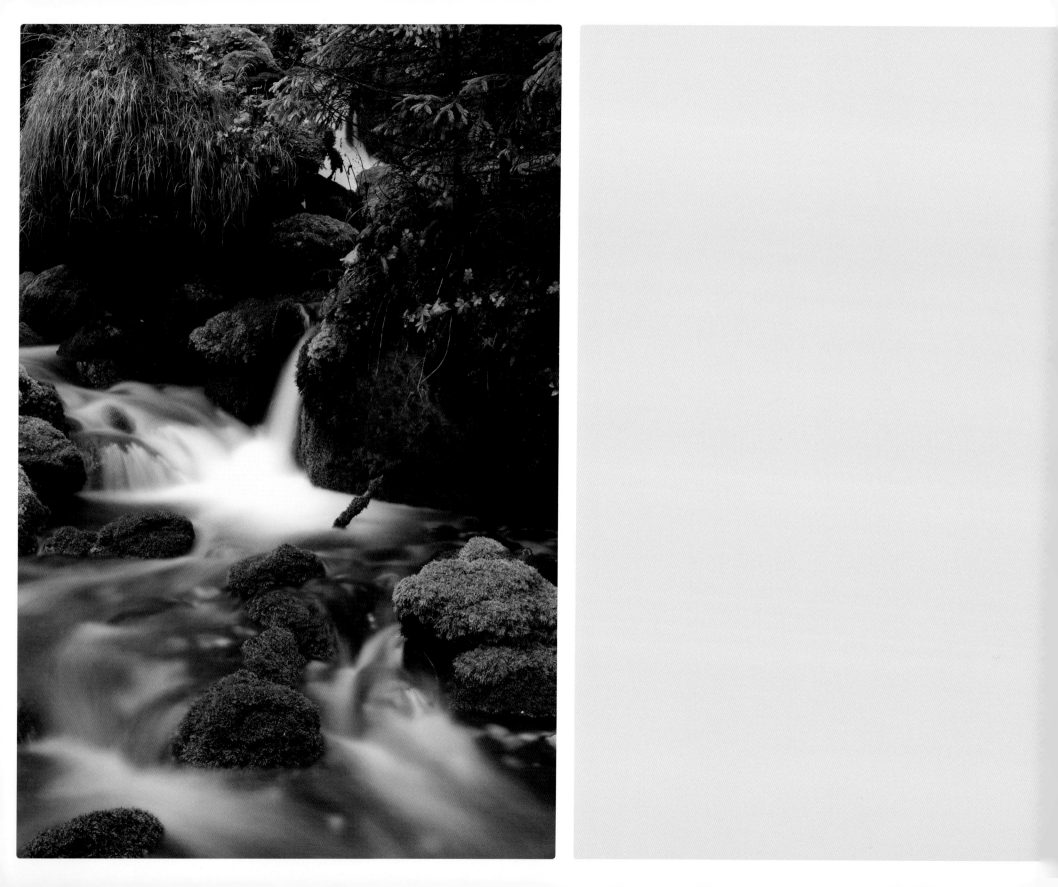

TAKING THE PLUNGE RIVERS
IMMER ABWÄRTS FLÜSSE

It's all downhill from here. Once a river enters this world, so to speak, it must move downwards. At first it is wild and impatient, yet the larger it grows, the slower it moves. Once it reaches the end, it almost comes to a standstill; as if to pause just before entering the great vastness and its traces—small rivulets often scattered across the delta—become one with the seemingly infinite ocean. One day, some of these molecules may return to the source and enter the cycle again. If you were to replace the word river with the word life—all of the above would still retain its universal truth. Panta rhei. Everything flows.

Von nun an geht's bergab. Hat ein Fluss erst einmal das Licht der Welt erblickt, führt sein Weg bergab. Zu Beginn oft schnell und ungestüm, im weiteren Verlauf und mit zunehmender Größe wird er langsamer. Geht es dem Ende zu, kommt er fast zum Stehen – als ob er noch einmal innehalten wollte, bevor er in das große Ganze Eingang findet und sich seine, oft in einem Delta zerfransten Spuren in den schier endlosen Weiten der Ozeane verlieren. Irgendwann in ferner Zukunft kehrt das eine oder andere Molekül zur Quelle zurück und der Kreislauf beginnt von Neuem. Ersetzte man das Wort Fluss durch das Wort Leben – das Geschriebene würde genauso seine universelle Gültigkeit behalten. Panta rhei. Alles fließt.

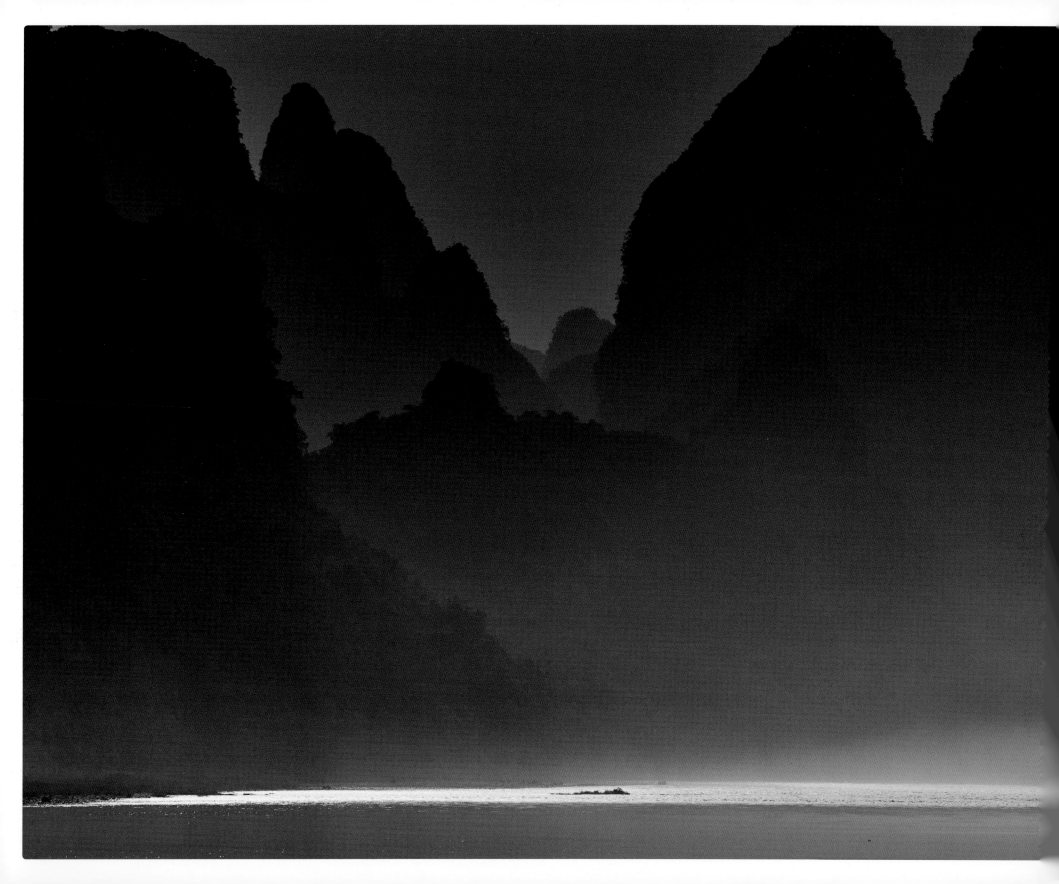

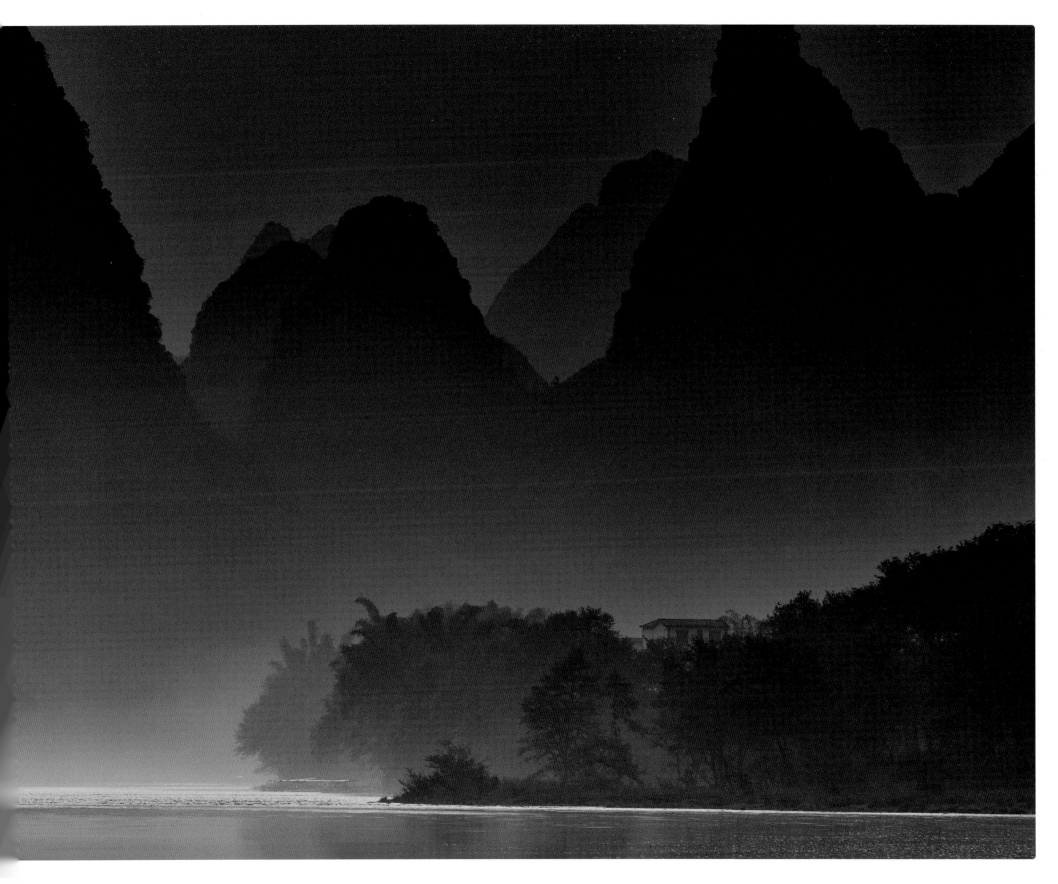

FROM RIVULET TO STREAM

Though no two are the same, all rivers have one thing in common: they have a beginning and an end. They flow, and they must flow downwards. Their source is always located at a higher point than their terminus, and a smaller river always enters a larger one. A river's point of origin, its source, is often difficult to determine. Most rivers end in another, larger river, until at the very end, they enter the sea. Some of them run dry, and some evaporate, sometimes naturally, sometimes because too much water has been taken from them. A few rivers enter a so-called closed basin, a lake that allows no outflow. Depending on the season and rainfall, small creeks can turn into streams, and streams into rivers. Often, a precise classification is difficult. All of these rivers and smaller streams above ground only constitute about two percent of all fresh water on earth. They gather liquid, or more precisely, non-gaseous precipitation on land and with it they make their way towards the oceans. No river on this earth, no matter how large it is, crosses two continents.

Yet there are more differences than similarities between rivers. Just a few years ago for instance, a stream joining the Amazon River in Peru was found to reach near boiling temperatures of up to 187 degrees Fahrenheit and above. Any text on water courses must touch on the Amazon River. Depending on the method of measurement, either the Amazon or the Nile is the world's longest river. It carries an incredible amount of water: the Amazon contains more water than the next seven largest rivers combined. This constitutes about 20 percent of the Earth's liquid fresh water. For now, though, we will look at another river which cannot be omitted in a book on water.

THE PLANET'S GARBAGE COLLECTOR

The Yangtze River is a sad, cautionary tale. China's biggest river sets a tragic record in carrying more plastic into the oceans than any other river in the world. Together, the Yangtze River and India's Ganges River carry more plastic into the oceans than all of the other river systems in the world combined. All across our planet, rivers are being mistreated as nature's garbage collectors for feces, industrial waste, and domestic waste. What does not settle into the sediments enters the sea. Just a handful of rivers are still allowed to flow naturally, without human interference. Many of them have been straightened, forced into a rigid new river bed and are barely more than artificial channels. Hydroelectric power plants and reservoirs block the water's natural flow.

THE VEIN OF LIFE

Rivers are the cradle of human civilization. The first settlements and cities formed on their banks. They served as a means of transport, communication, and delivering resources. Along their path, they connect; across it, they divide. It may seem a bit childish, but the metaphor of rivers as the Earth's veins can help illustrate the current situation. Too many pollutants, blocked arteries—a cardiac arrest seems inevitable. Just like with humans, the problem may go unnoticed for a long time as things continue as they were. Suddenly, out of nowhere, the system collapses. At that point, saving the patient is difficult, maybe impossible.

THE FLOW OF TIME

All thy pleasant fields are ever
Changing with each gush of rain:
Ah! And in the self-same river
Dost thou never swim again.

Johann Wolfgang von Goethe writes in his poem *Stability in Change*, as translated by John S. Dwight. Here, Goethe refers directly to Heraclitus' famous phrase "Panta rhei". Everything flows. The present is but an abstract moment between the past and the future. Just as a river flows from its source to the delta, so time flows towards the future; a quantum physicist may disagree, of course. Yet our own personal experience of everyday life tells us that there is no turning back time. What has been will never be again. Water cannot flow uphill, and a stream will never be the same at two different points in time. This holds true even for Leonardo da Vinci, whose Landscape Drawing for Santa Maria Della Nave featuring a river is considered the first pure landscape drawing in the history of occidental art. The Mona Lisa's background also shows a landscape with a river running through it—not a coincidence, surely?

VOM RINNSAL ZUM STROM

Bei aller Unterschiedlichkeit haben alle Flüsse einiges gemein. Sie haben einen Anfang und ein Ende. Sie fließen und sie fließen immer bergab. Ihr Ursprung liegt immer höher als ihr Ende und der kleinere Fluss mündet in den größeren. Der Ursprung eines Flusses, die Quelle, ist oft nicht eindeutig zuzuordnen. Die meisten Flüsse enden in einem anderen, größeren, bis am Ende der Kette der größte im Meer endet. Einige versickern oder verdunsten, ob auf natürliche Weise oder weil man vorher zu viel Wasser entnommen hat, bevor sie das Meer erreichen. Einige münden in sogenannte Endseen. Bäche können im jahreszeitlichen Wandel oder durch starke Niederschläge zu Flüssen und Flüsse zu Strömen werden. Eine eindeutige Zuordnung ist schwierig. Alle überirdischen Wasseradern zusammen machen nur etwa zwei Prozent des globalen Süßwassers aus. Sie bilden den nicht verdunsteten Teil der Überlandniederschläge, der den Ozeanen zuströmt. Kein einziger Fluss auf der Erde überquert kontinentale Grenzen, sei er noch so groß.

Eindeutig aber überwiegen die Unterschiede gegenüber den Gemeinsamkeiten: Erst vor wenigen Jahren beispielsweise wurde ein Zufluss zum Amazonas in Peru entdeckt, dessen Wasser mit 86 Grad und mehr kochend heiß ist. Apropos Amazonas – in einem Text über Fließgewässer darf er natürlich nicht fehlen. Es ist – je nach Messmethode – übrigens gar nicht so eindeutig, ob er oder der Nil der längste Fluss der Erde

ist. Unstrittig ist die unvorstellbare Wassermenge, die der Amazonas enthält. Sie ist größer als die der sieben nächstgrößeren Flüsse zusammen. Es handelt sich dabei um rund 20 Prozent des gesamten, nicht gefrorenen Süßwassers der Erde. Doch zunächst zu einem anderen Fluss, der in solch einer Aufzählung ebenso nicht fehlen darf.

DIE MÜLLABFUHR DES PLANETEN

Der Jangtse-Fluss steht hier als trauriges Beispiel. Kein anderer Fluss der Erde trägt auch nur annähernd so viel Plastik in die Ozeane wie der größte Strom Chinas. Zusammen mit dem Ganges in Indien transportiert er mehr Plastik in die Ozeane als alle anderen großen Flusssysteme zusammen. Flüsse werden weltweit als natürliche Müllabfuhr für Fäkalien, Industriegifte und Hausmüll missbraucht. Was sich nicht in den Flusssedimenten ablagert, landet früher oder später im Meer. Nur noch wenige Flüsse dürfen gänzlich naturbelassen ihren ursprünglichen Lauf nehmen. Viele sind begradigt, in ein festes Bett gezwängt und von einem Kanal kaum noch zu unterscheiden. Wasserkraftwerke und Stauseen blockieren oder behindern den freien Lauf des Wassers.

LEBENSADER FLUSS

Flüsse sind Keimzellen menschlicher Zivilisation. An ihnen entstanden die ersten festen Siedlungen und die ersten Städte. Flüsse sind Transport- und Kommunikationswege und Nahrungslieferanten. Sie verbinden in der Länge und trennen in der Breite. Vielleicht ist es naiv:

Aber das sich aufdrängende Bild der Flüsse als Adern des Organismus Erde passt sehr gut zur Beschreibung der aktuellen Situation. Zu viele Schadstoffe, verstopfte Arterien – und der Infarkt ist vorprogrammiert. Es ist wie beim Menschen: Lange bleibt das Problem unbemerkt und alles geht wie immer. Und dann, ganz plötzlich, bricht das System zusammen. Rettung ist dann entweder aufwendig oder nicht mehr möglich.

DER FLUSS UND DIE ZEIT

Gleich, mit jedem Regengusse,
Ändert sich dein holdes Tal,
Ach! und in demselben Flusse
Schwimmst du nicht zum zweiten Mal.

Diese Strophe aus dem Gedicht *Dauer im Wechsel* von Johann Wolfgang von Goethe bezieht sich direkt auf den von Heraklit überlieferten Ausspruch „Panta rhei". Alles fließt. Die Gegenwart ist nur ein theoretischer Moment zwischen Vergangenheit und Zukunft. So wie ein Fluss von der Quelle zur Mündung fließt, fließt die Zeit in Richtung Zukunft, auch wenn Quantenphysiker etwas anderes behaupten. Unsere tägliche Erfahrung ist eindeutig. Es gibt kein Zurück. Was war, kommt nicht wieder. Wasser fließt nicht bergauf und ist nie zu einem anderen Punkt in der Zeit identisch. Auch nicht bei Leonardo da Vinci, dessen Landschaft mit Fluss als die erste reine Landschaftsdarstellung der abendländischen Kunst gilt. Auch der Hintergrund der Mona Lisa zeigt eine Flusslandschaft. Sicher kein Zufall?

Waterways. A street has been reclaimed by the Rhine during flooding in winter. This street used to be part of the Rhine's river bed.

Wasserstraße. Was eigentlich eine Straße ist, wurde bei diesem Winterhochwasser vom Rhein zurückerobert, war sie doch einmal Teil seines natürlichen Flussbettes.

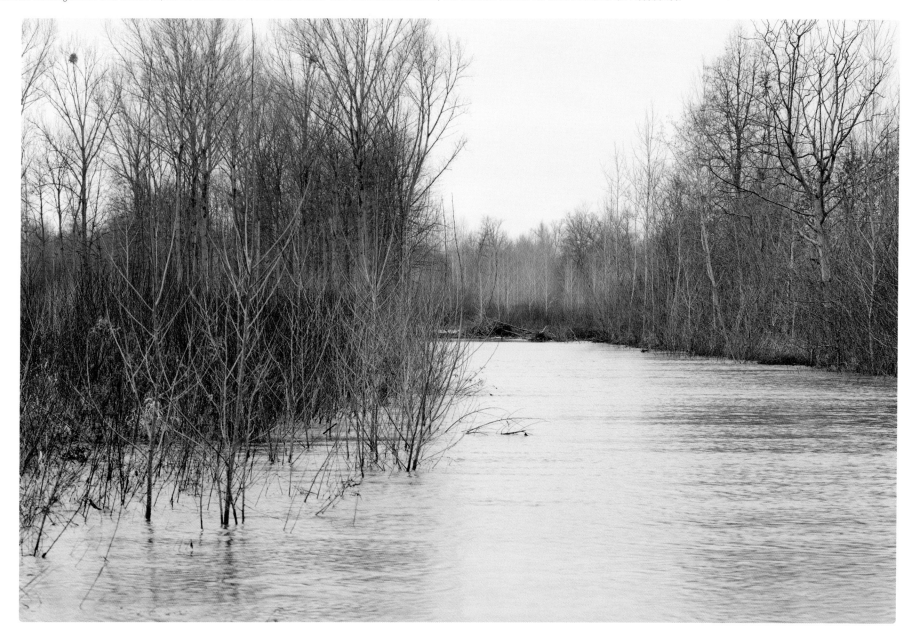

Flooding, Rhine near Rastatt, Germany

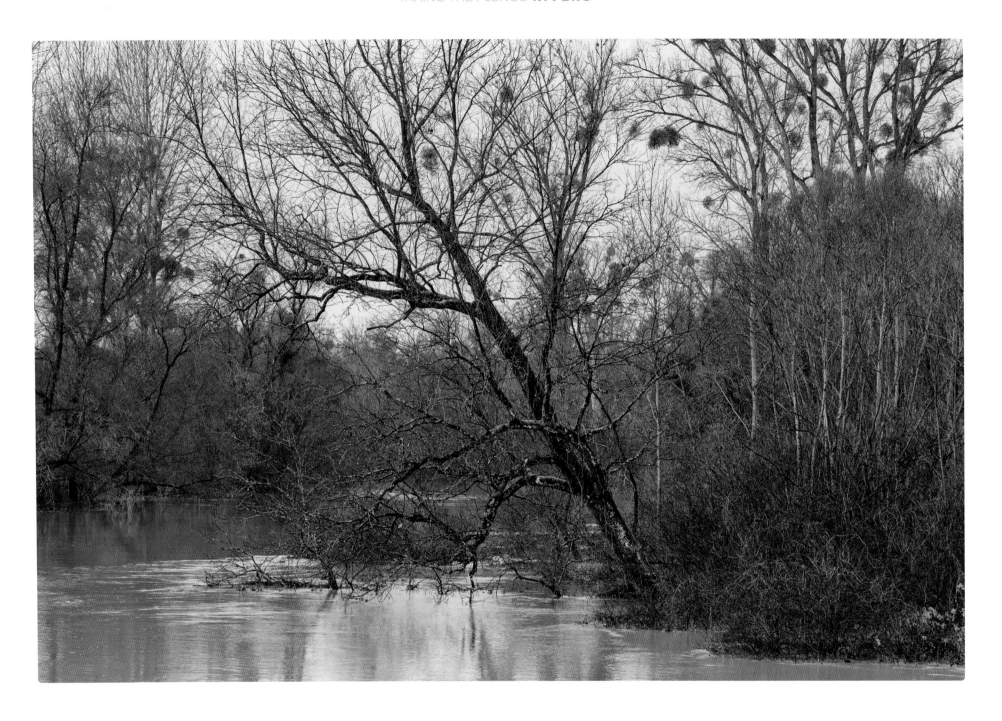

Flooding, Rhine near Rastatt, Germany

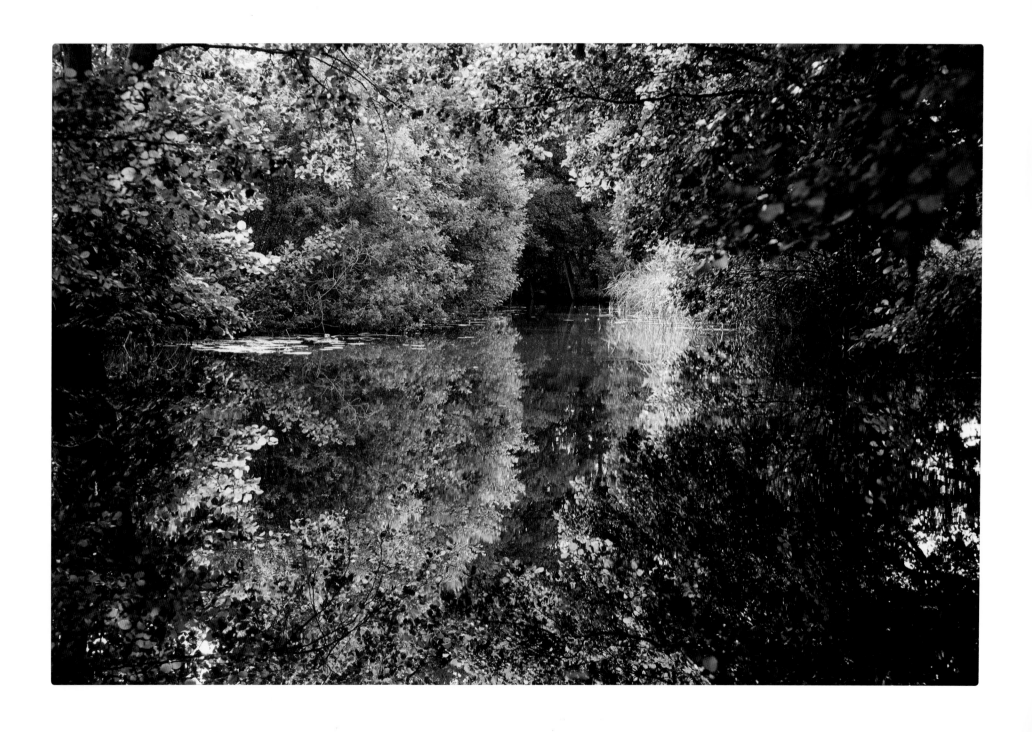

The Havel River, Germany

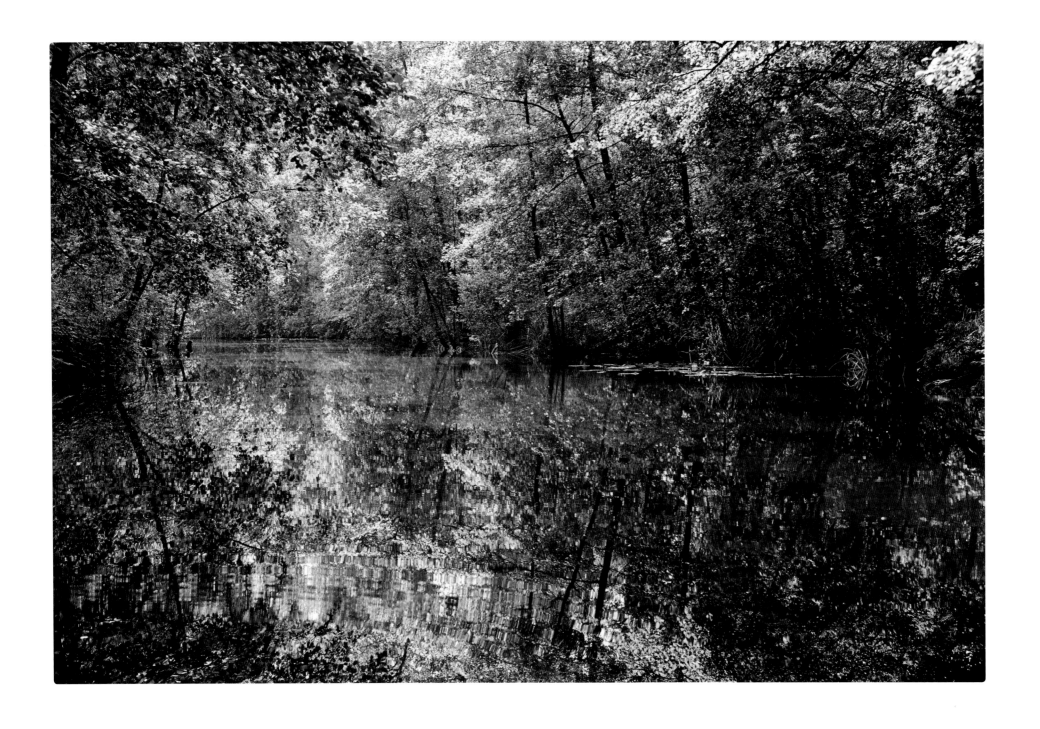

The Havel River, Germany

The Amazon of the North. That is what locals call this part of the Havel River in Brandenburg. Here, the water has come to an almost complete standstill, creating a very still surface which reflects the river bank's wild vegetation.

Amazonas des Nordens. So nennen Einheimische diesen Teil der Havel in Brandenburg. Das fast stehende Teilstück ermöglicht nahezu perfekte Spiegelungen der dschungelartigen Ufervegetation.

The Havel River, Germany

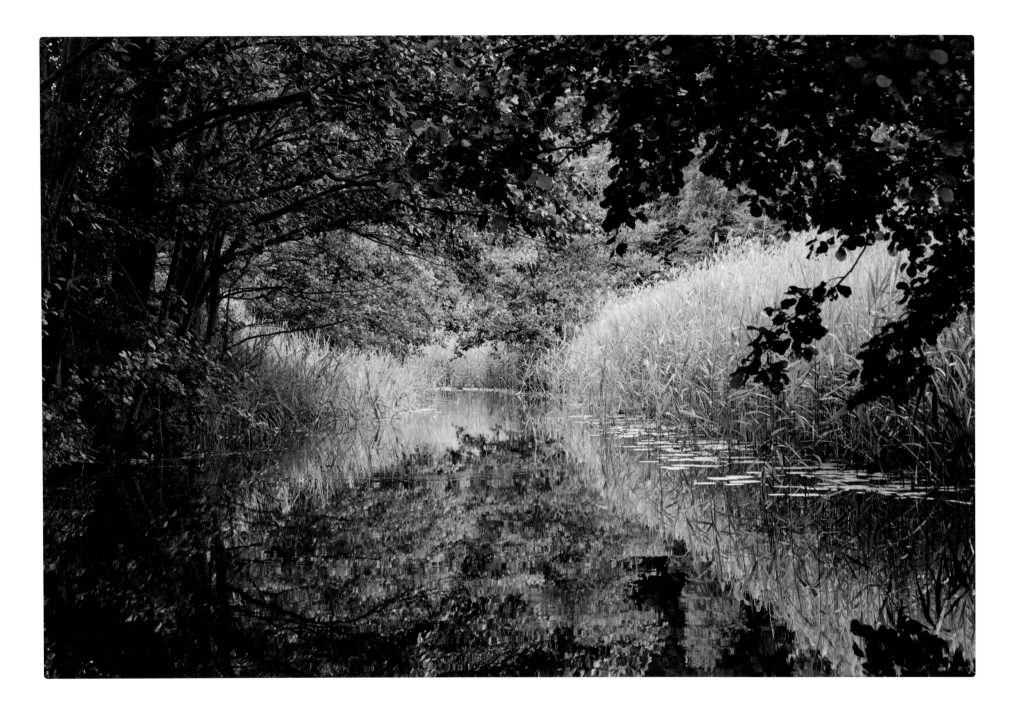

The Havel River, Germany

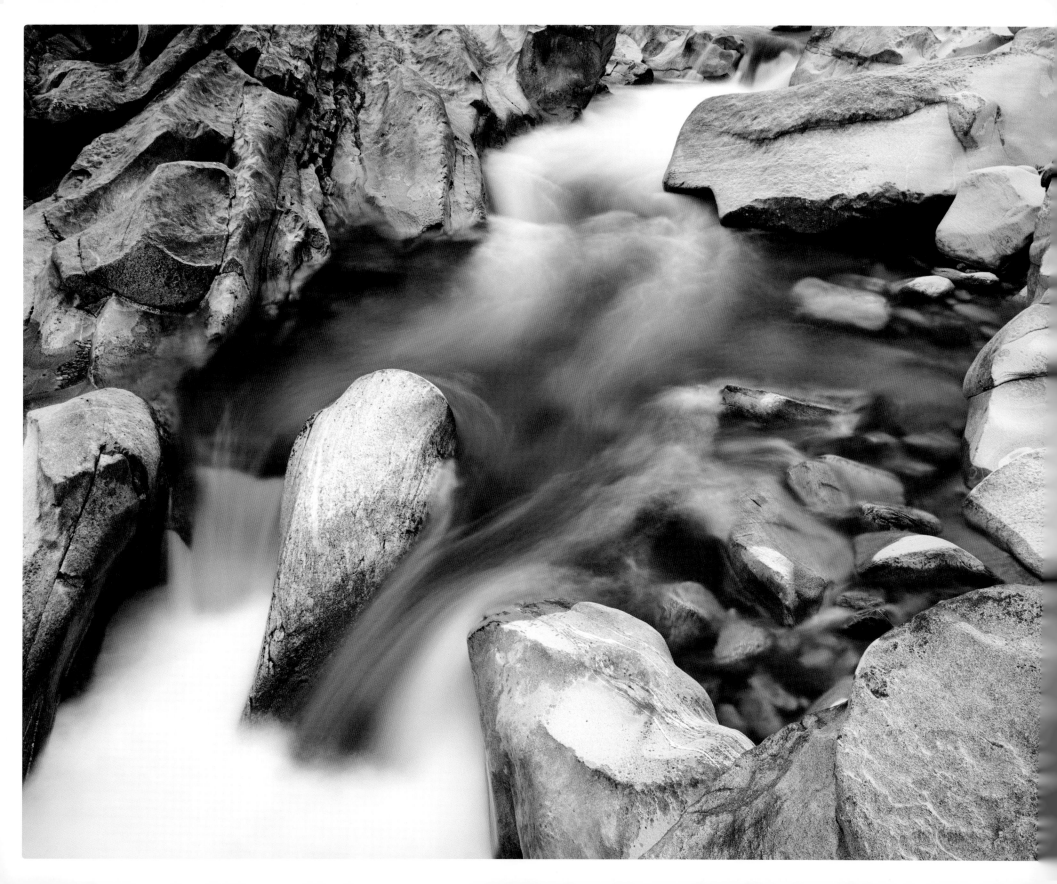

THE YOUNG AND WILD

DIE JUNGEN WILDEN

The Soča in Slovenia and the Verzasca in Switzerland run through the Alps, which, geologically speaking, are very young. They are both wild and untamed rivers, and each of them has a rightful claim to the title of world's most beautiful natural Alpine river. They seem like non-identical twins. They have the same parents; they both look alike; and yet they are very different.

The Soča works its way through a riverbed of limestone in the south-eastern Julian Alps, slowly yet permanently altering the bedrock. The Verzasca's force, however, hits older, much harder gneiss and granite. The Soča ends in Italy, where it is called Isonzo, and flows into the Mediterranean. The Verzasca enters Lago Maggiore in Switzerland. Both of them run through wild, narrow ravines and wide, even plains. Both of them start in an alpine landscape and end in a mild Mediterranean area. Both are visually stunning, colorful rivers.

Of course, water can take on almost any color depending on levels of light, the sun's angle, the sky's color, the time of day, or the time of the year. Yet each river has its own characteristic color based on solutes and emulsified matter as well as the colour of the ground; it is the sum total of all the various factors. I visited both rivers at different times of the year and different times of day, and I found that both of them are green. The Soča, which is often referred to as the Emerald River, tends towards blue and often has a turquoise hue. The name Verzasca comes from the Italian words "verde" and "aqua"—green water. It has a yellow tone in it and often shines a bright bottle green.

Die Flüsse Soča in Slowenien und Verzasca in der Schweiz fließen in den – erdgeschichtlich gesehen – jungen Alpen wild und ungezähmt und erheben beide mit Recht Anspruch auf den Titel des schönsten und natürlichsten Flusses der Alpen. Sie sind wie zweieiige Zwillinge. Sie haben die gleichen Eltern, sehen sich sogar ähnlich und sind doch ganz und gar unterschiedlich.

Während sich die Soča in den südöstlichen Julischen Alpen durch ein Bett aus Kalkstein arbeitet und permanent verändert, trifft die Kraft der Verzasca auf wesentlich älteren und härteren Gneis und Granit. Die Soča mündet in Italien – dort umbenannt in Isonzo – ins Mittelmeer, die Verzasca noch in der Schweiz in den Lago Maggiore. Beide durchlaufen wilde, enge Schluchten und weite, flache Ebenen. Beide beginnen in einer alpinen Gebirgslandschaft und enden in milder mediterraner Umgebung; beide sind farblich herausragende Juwelen unter den Flüssen.

Klar, Wasser kann je nach Licht, Sonnenstand, Farbe des Himmels und Tages- und Jahreszeit praktisch jede Farbe annehmen. Aber gelöste und emulgierte Stoffe und insbesondere die Farbe des Untergrunds geben doch jedem Wasserkörper eine charakteristische Eigenfarbe. Im Grunde eine Art Quersumme aller Faktoren. Da ich beide Flüsse zu allen Jahreszeiten besucht und in jeder Art von Tageslicht gesehen habe, kann ich feststellen: Beide Flüsse sind grün. Allerdings tendiert die Soča, die man treffenderweise den Smaragdfluss nennt, zum Blau und sieht deswegen türkis aus. Die Farbe der Verzasca – der Name leitet sich von „verde aqua" ab – ist deutlich gelber und bezaubert mit einem satten Flaschengrün.

Soča, Slovenia

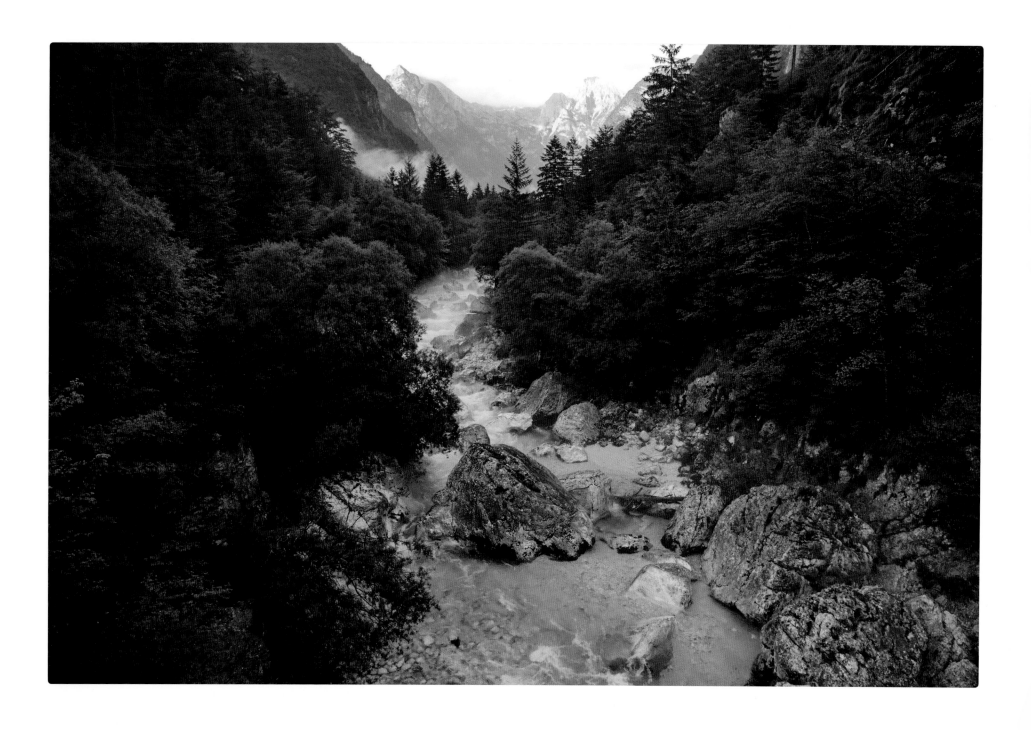

Soča, Slovenia

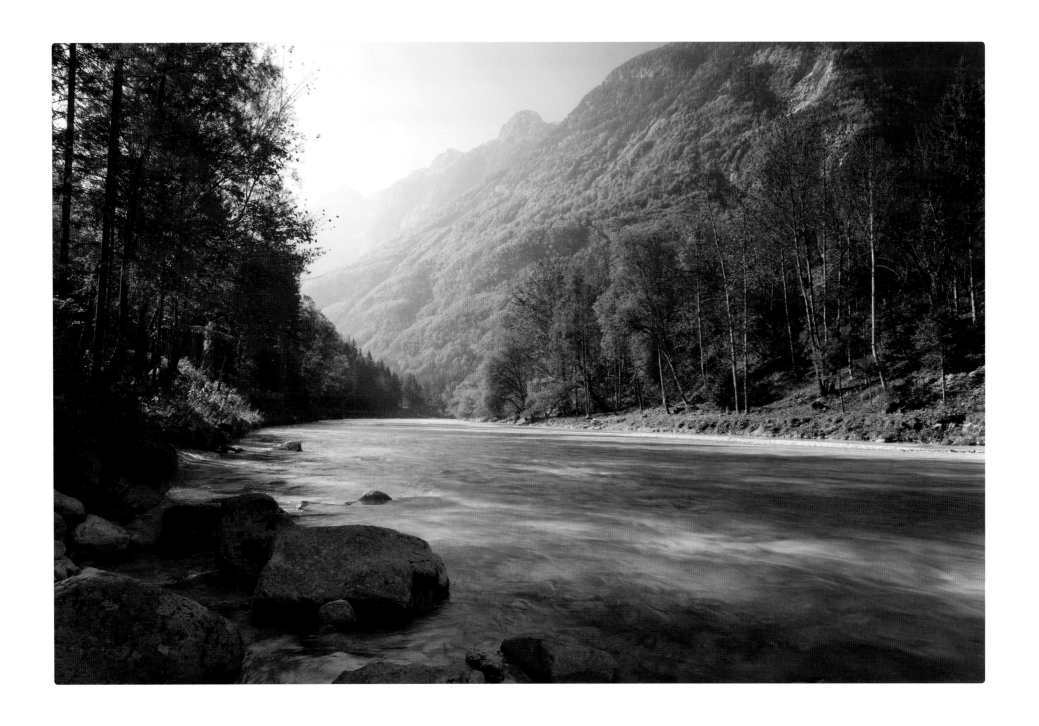

Soča, Slovenia

Soča, Slovenia

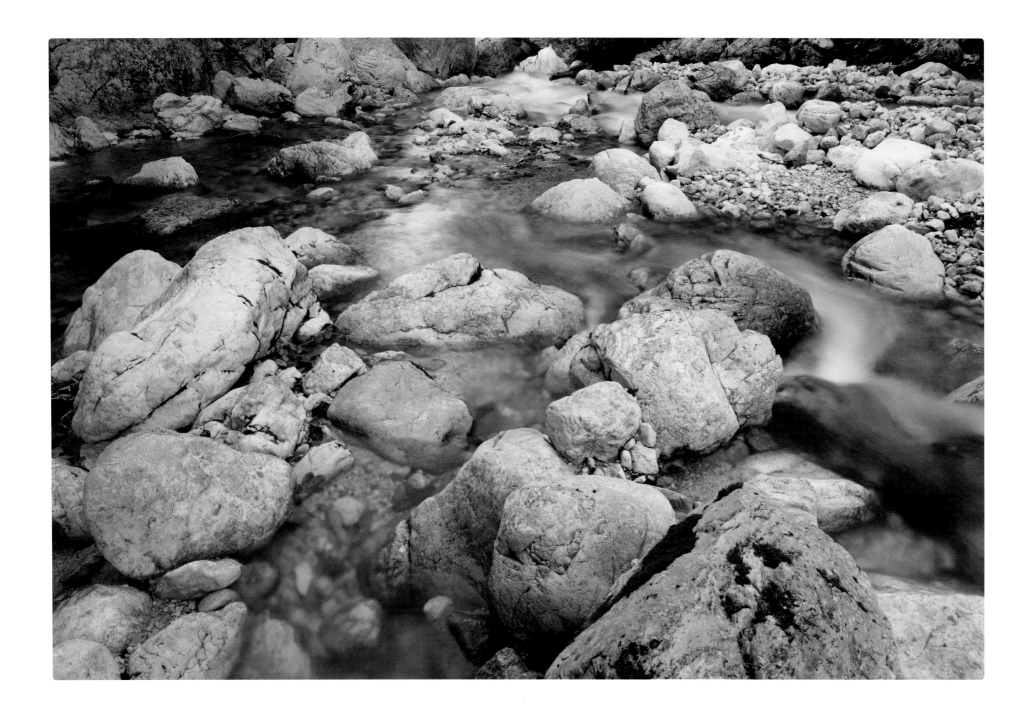

Soča, Slovenia

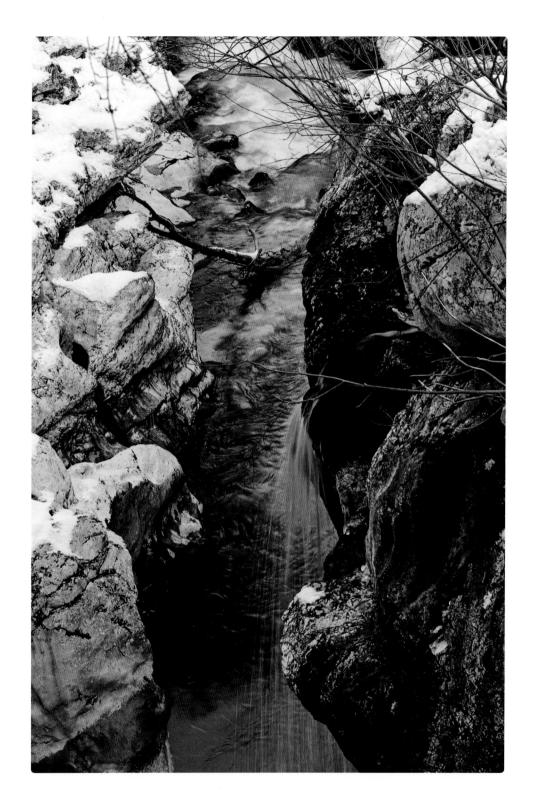

Soča, Slovenia

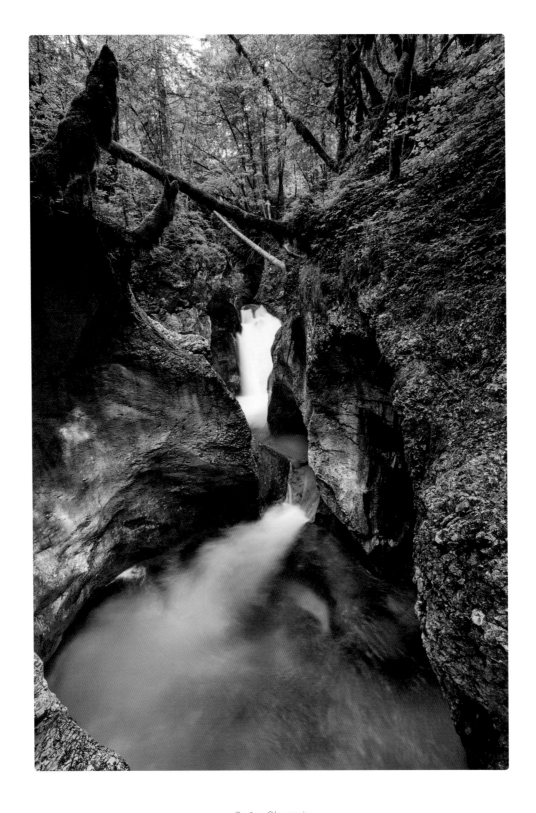

Soča, Slovenia

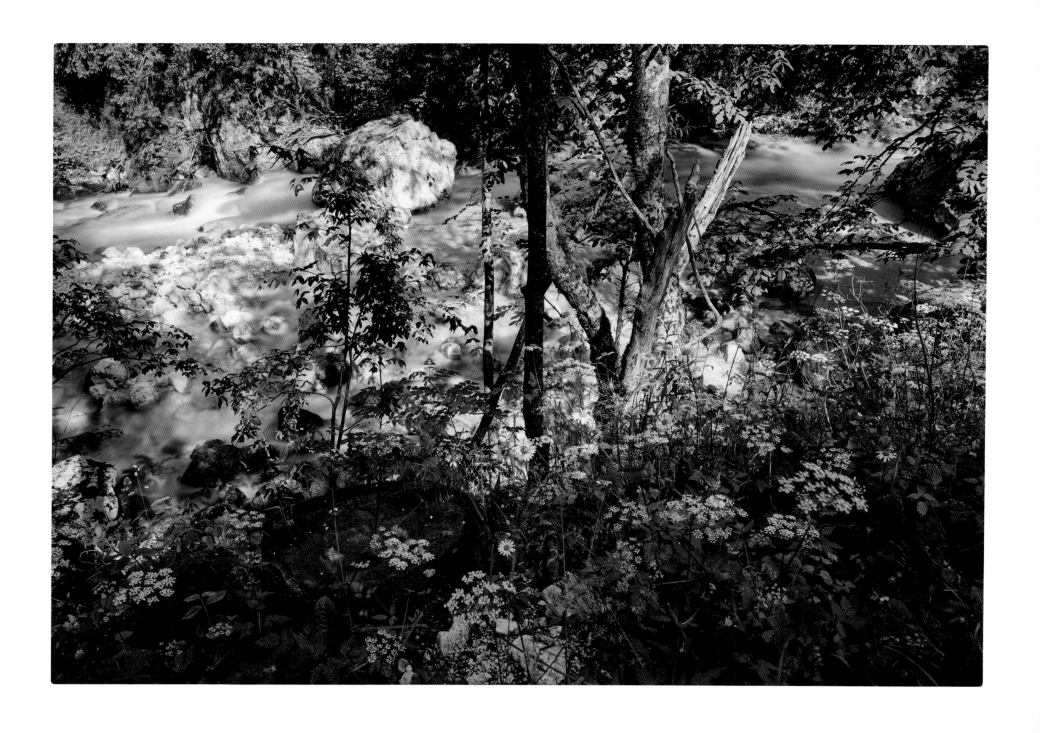

Soča, Slovenia

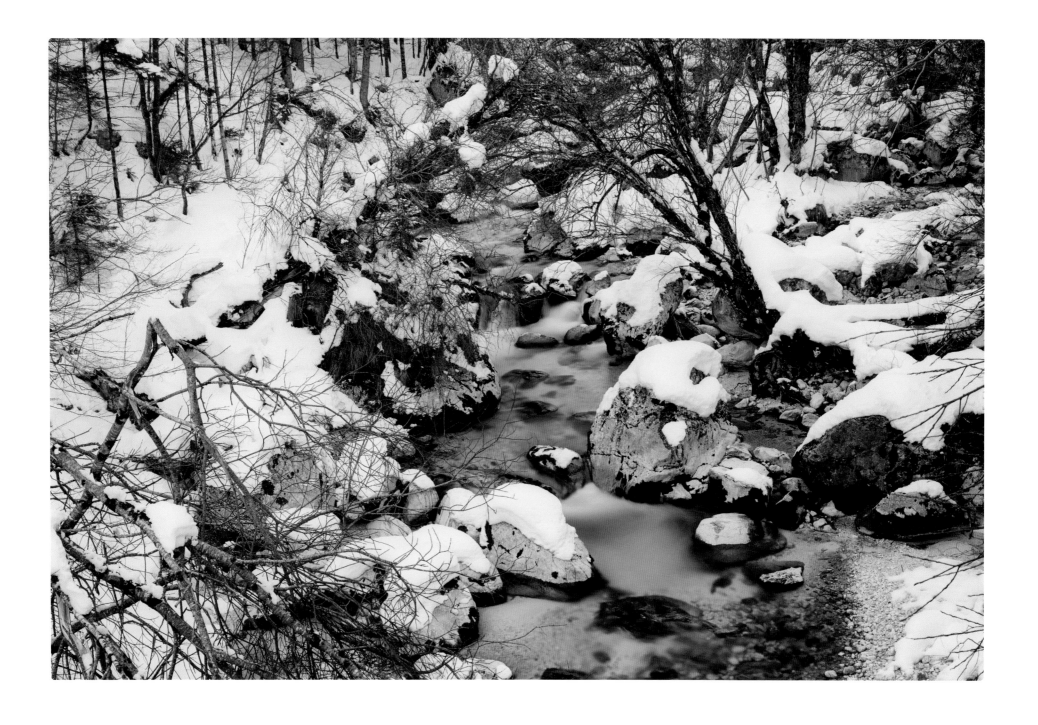

Soča, Slovenia

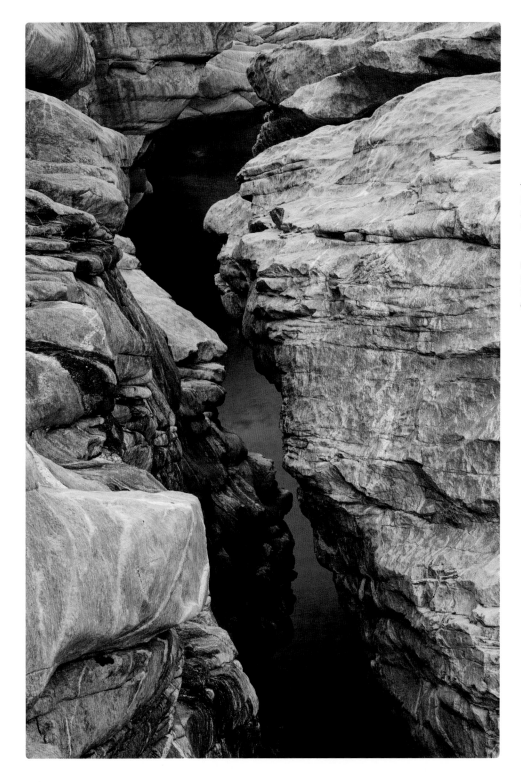

The modest one. In the neighboring valley right near Ponte Brolla, the Maggia river, though somewhat over-shadowed by the Verzasca, has its place in the spotlight. Here it traverses a deep granite valley.

Die Bescheidene. Gleich nebenan im Nachbartal hat die im Schatten der Verzasca stehende Maggia bei Ponte Brolle ihren großen Auftritt. Sie durchfließt hier eine tief eingeschnittene Granitschlucht.

The River Maggia, Switzerland

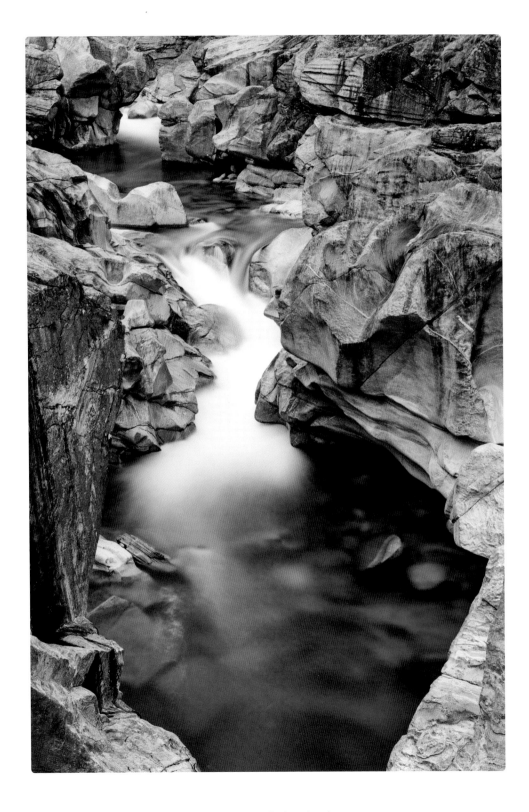

Verzasca, Switzerland

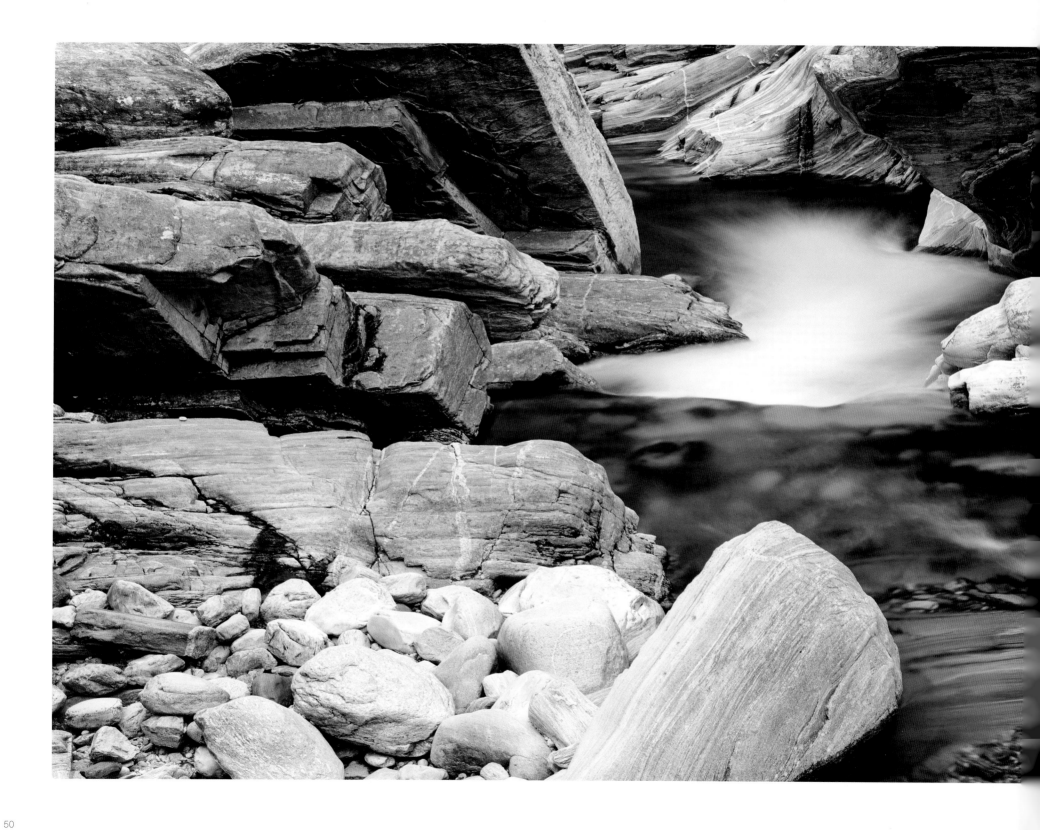

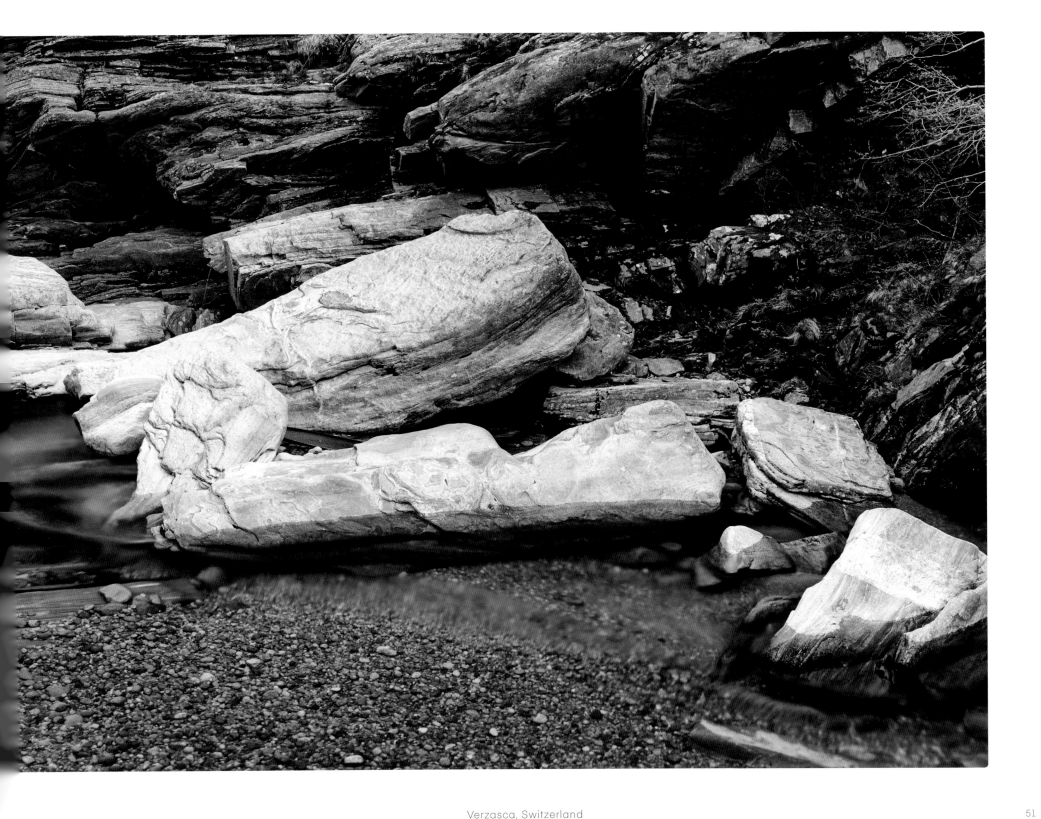

Verzasca, Switzerland

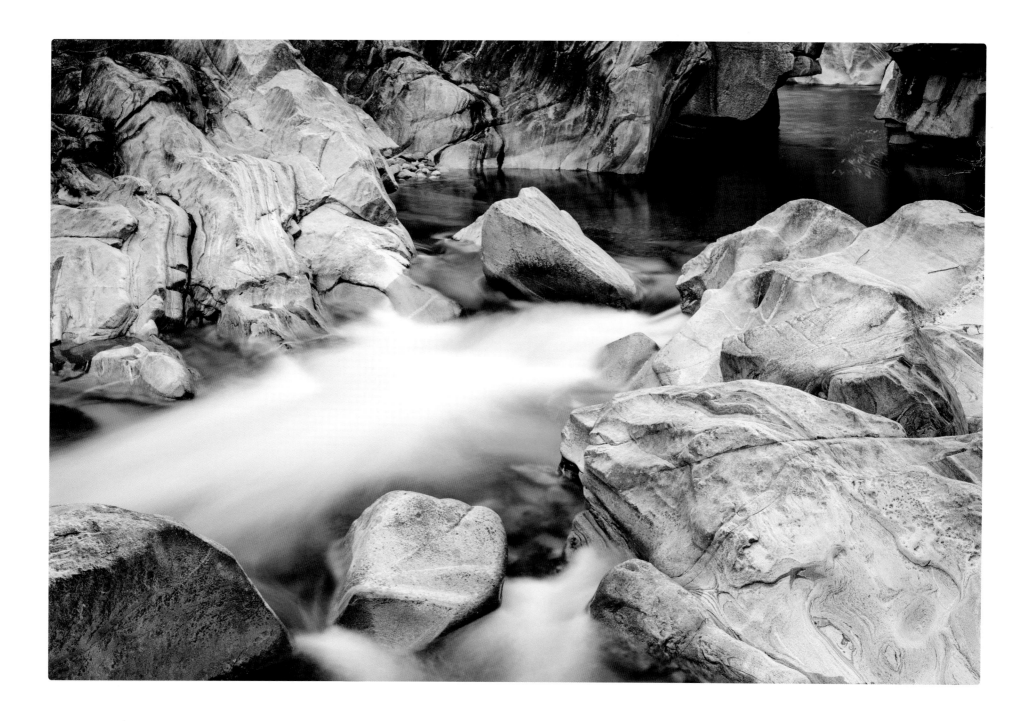

Verzasca, Switzerland

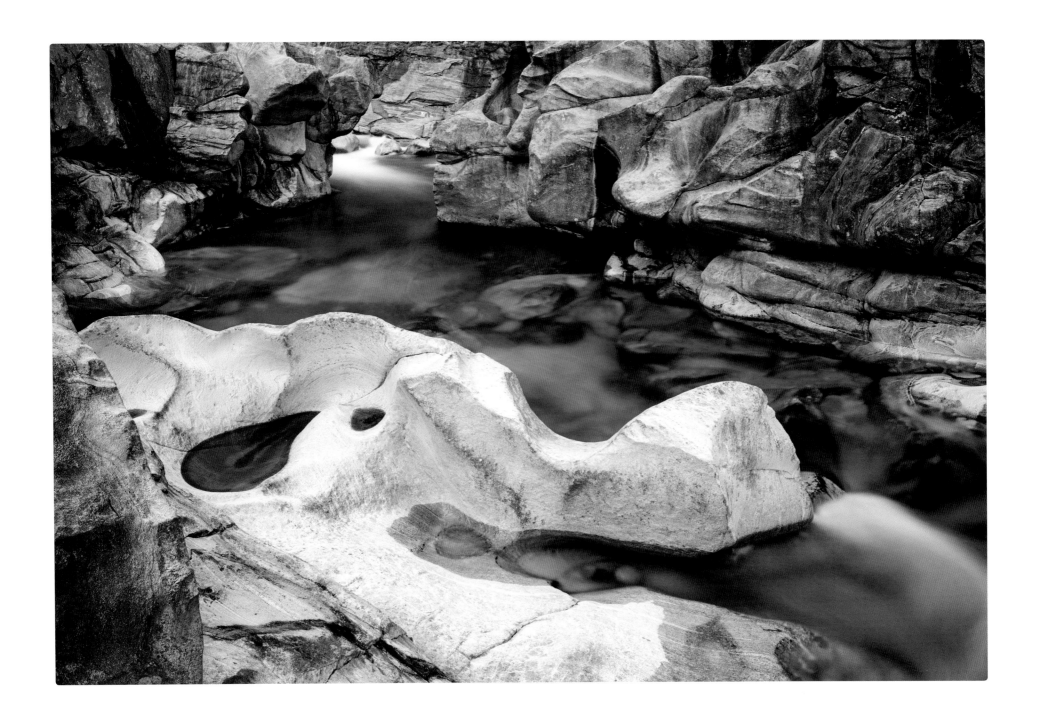

Verzasca, Switzerland

The cycle of life. Right now, there is little to indicate that this small river flowing through an idyllic landscape is about to enter the biggest and deepest canyon in Europe—the canyon itself was formed by the river's predecessors during the Ice Age. This picture captures one thing extremely well: the fact that spring is fall's mirror image. Most trees and shrubs do not keep their green leaves throughout the year; early in the year, they are predominantly yellow and brown and only slowly turn green through the course of spring. Late spring is often difficult to distinguish from early fall; inversely, late fall often resembles early spring.

Kreislauf des Lebens. Noch deutet hier wenig darauf hin, dass dieses Flüsschen gleich hinter diesem Idyll in einen der größten und tiefsten Canyons Europas einbiegen wird, den seine eiszeitlichen Vorgänger selbst einmal geschaffen haben. Was dieses Bild aber vor allem zeigt, ist etwas anderes: Der Frühling ist zum Herbst spiegelbildlich. Die meisten Bäume und Sträucher starten nicht grün, sondern überwiegend gelb und braun ins neue Leben und werden dann im weiteren Verlauf des Frühjahrs erst grün. Das späte Frühjahr lässt sich nicht so ohne Weiteres vom frühen Herbst unterscheiden. Ebenso wenig wie der späte Herbst vom frühen Frühling.

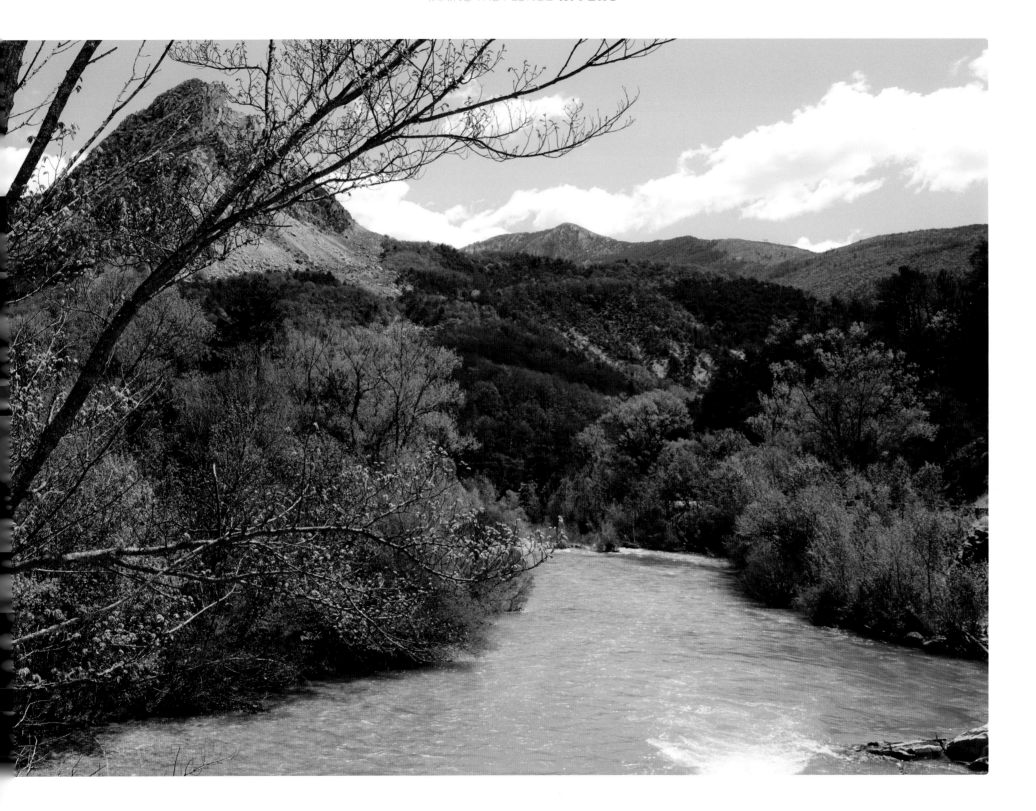

Verdon, France

A fairy tale landscape. For millions of years, the Li River, or Li Jiang, in the Chinese province of Guilin has been carving a unique fairy tale landscape out of karst stone. It inspired many fictional landscapes in movies such as *The Lord of the Rings* and *Star Wars*.

Zauberwelt. Der Li-Fluss in der chinesischen Provinz Guilin hat in Millionen Jahren eine märchenhafte Landschaft aus dem Karstgestein modelliert, wie es sie kein zweites Mal auf der Welt gibt. Zahlreich sind die davon inspirierten Filmlandschaften von *Der Herr der Ringe* bis *Star Wars*.

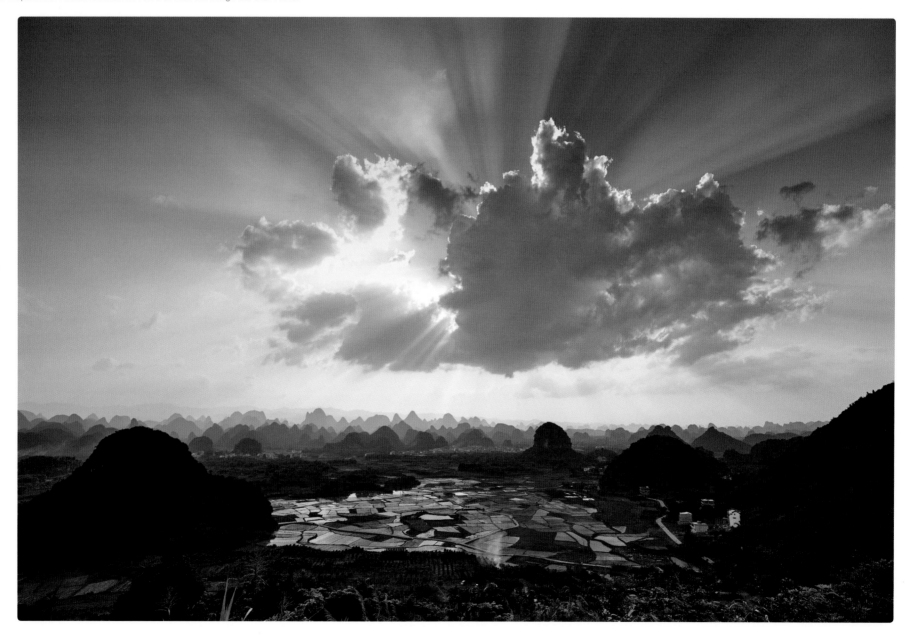

The Li River, China

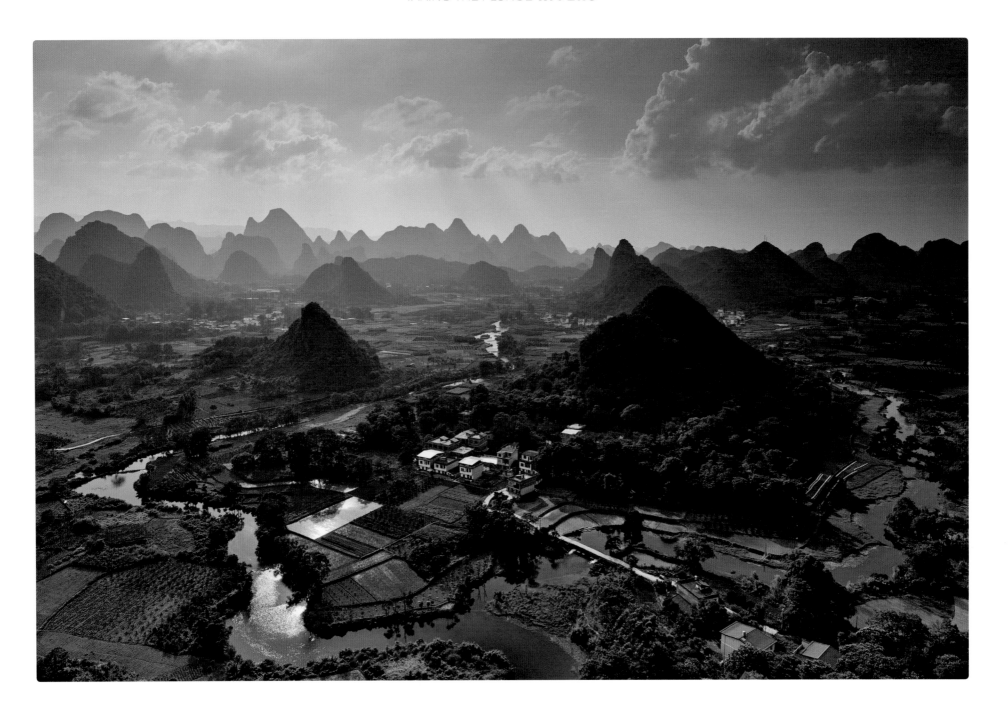

The Li River, China

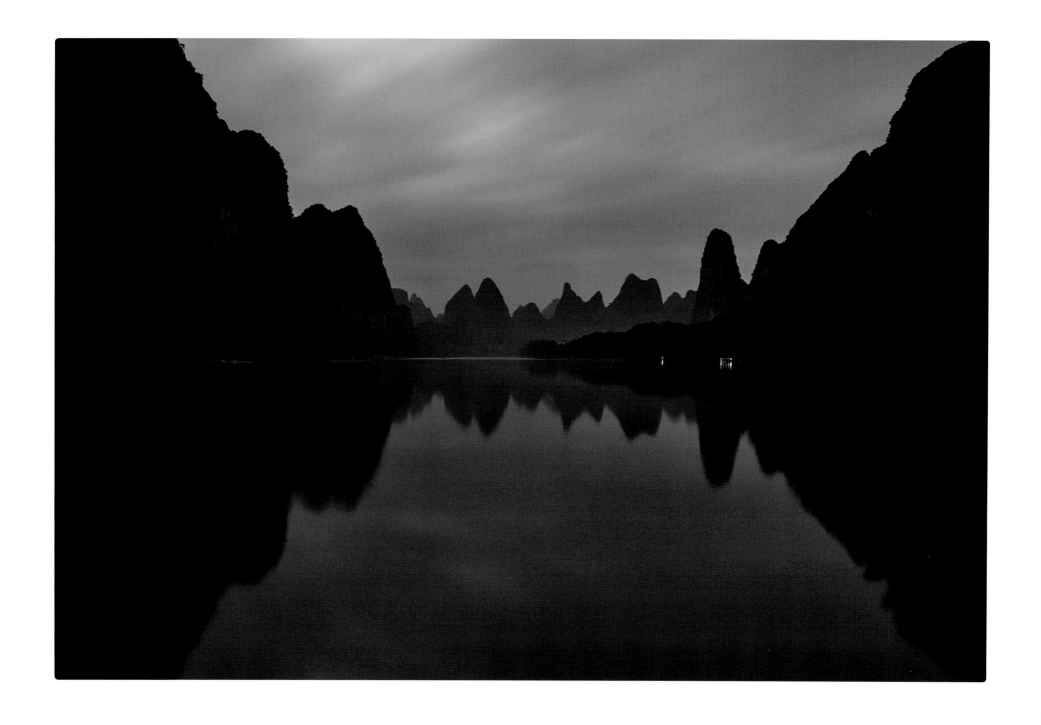

The Li River, China

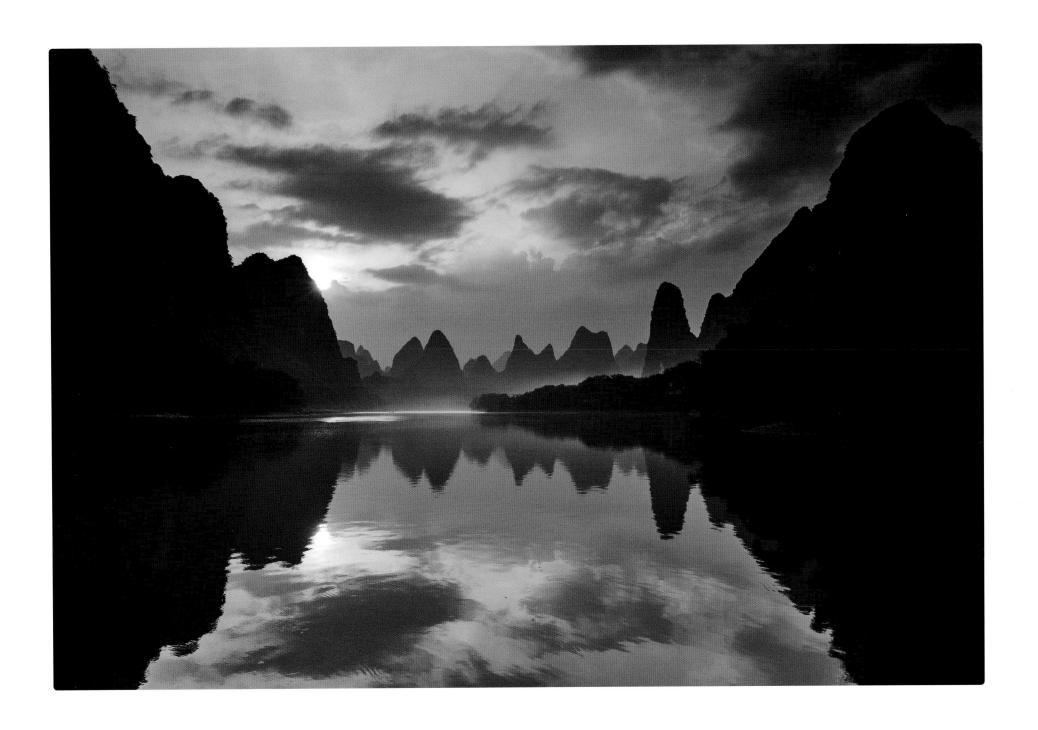

The Li River, China

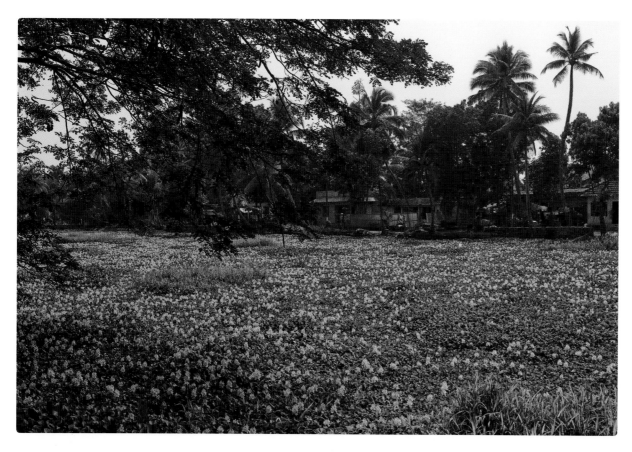

Waterways I. The so-called backwaters in Kerala, India, are a system of rivers, lakes, and channels which have been used for transport for hundreds of years. In recent years, population growth and its effects have tested the backwaters to the limit: pollution with organic as well as inorganic waste and the sudden spread of water hyacinths have taken over the waters.

Wasserstraßen I. Die „Backwaters" in Kerala/Indien sind ein jahrhundertealtes System aus Flüssen, Seen und Kanälen. Der zunehmende Bevölkerungsdruck und die damit verbundene Verschmutzung sowohl mit Nährstoffen als auch mit Müll sowie die ungebremste Ausdehnung der Wasserhyazinthen bringen das System an die Grenzen seiner Belastbarkeit.

Waterways II. The channel was completed in 1681. Its relevance for trade and economy aside, it also proves an excellent tool for deceleration. Floating down the channel in a house boat is a supremely soothing experience. Unfortunately, many of the roughly 42,000 plantain trees growing on the river banks are affected by a type of fungus which has already destroyed many of the trees in the area.

Wasserstraßen II. Der bereits 1681 fertiggestellte Kanal ist – neben seiner wirtschaftlichen Bedeutung – ein Garant für Entschleunigung. Es gibt wahrscheinlich wenig Beruhigenderes als eine Tour mit dem Hausboot hier auf dem Kanal. Leider sind viele der etwa 42.000 Platanen am Ufer seit 2005 mit einem Pilz befallen, der bereits zum Verlust vieler Bäume geführt hat.

Backwaters, Kerala, India

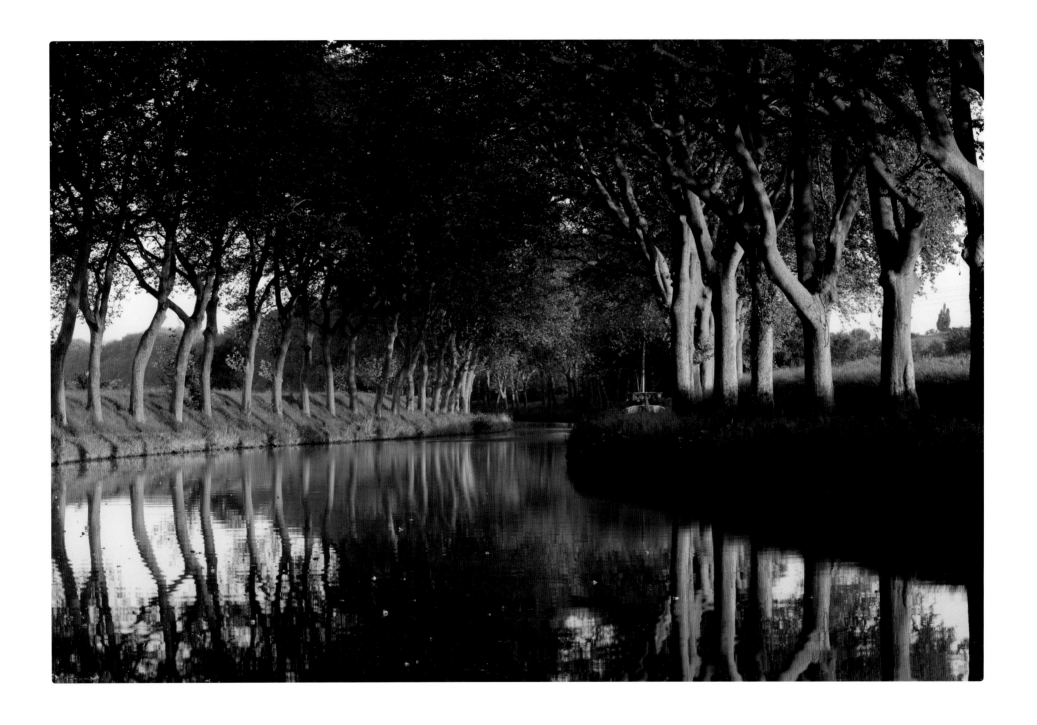

Canal du Midi, France

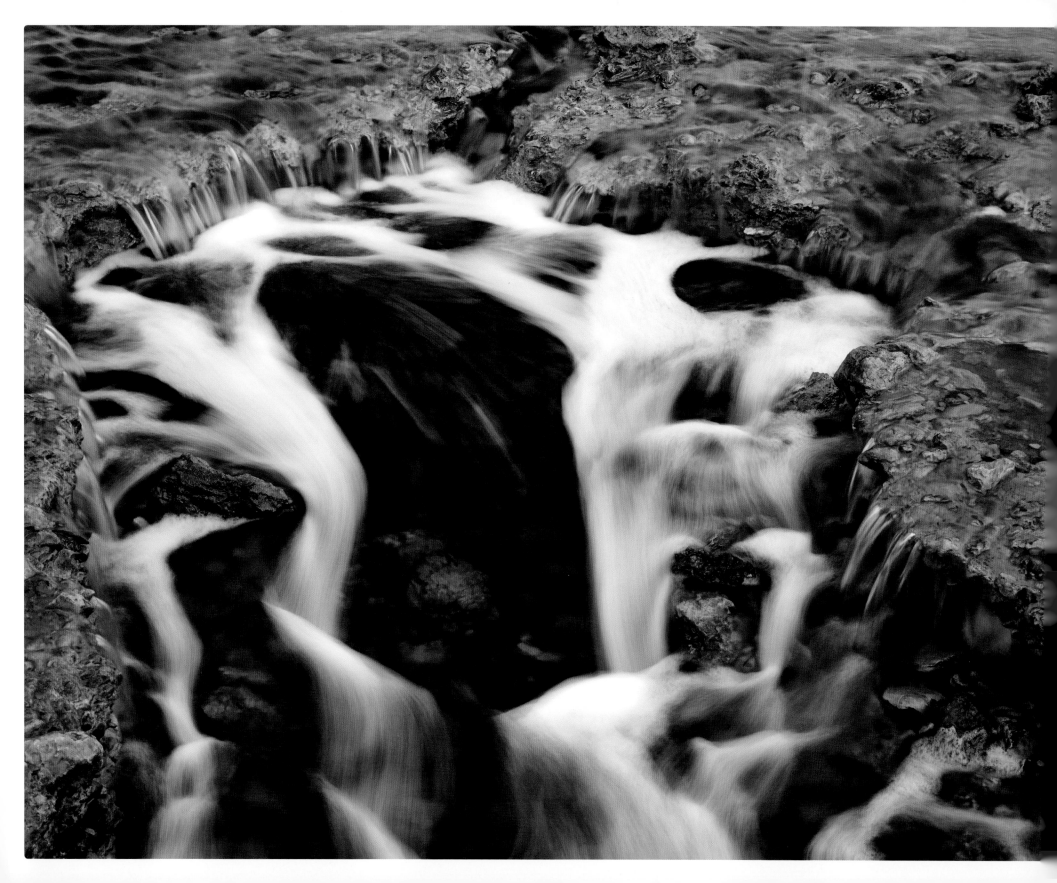

Rio Celeste & Rio Tinto

ATTRACTING ATTENTION

AUFFALLEN UM JEDEN PREIS

For some of the world's rivers, the usual range of colors that other rivers may limit themselves to is just not enough. Brownish-grey and green are far too boring, and clear, colorless waters are out of the question. Rio Celeste in Costa Rica, sporting a bright, almost luminous sky blue, and Rio Tinto in Spain, showing off its clear red and yellow hues, are two such snobs. As is often the case with water, the latter river's colour can be explained in chemical and biological terms; the explanation for the Rio Celeste's color can only be understood through physics.

A color always indicates something. It tells us whether a cherry is ripe enough to eat, or whether an insect is poisonous. We quickly learn to associate certain colors with certain features or characteristics. There are many exceptions, of course, but this rule still proves useful in everyday life. If an object has an unusual color that does not fit with our experience, we will treat it with care. The Rio Celeste's bright blue is still somewhat close to what we are familiar with, and yet it seems uncommon, almost strange. Its waters, though not highly toxic, can irritate the skin, and are not safe for drinking.

The Rio Tinto's color is even more decisively out of the ordinary; yet this case is even more difficult to explain than the previous one. The causes are more complicated than we had suspected for a long time. For over 4000 years, ore has been mined near the Rio Tinto. It is tempting to attribute the river's strange color to this fact alone: an ecological issue caused by humans. Yet during the preparations for a large renaturation programme, scientific research found that the causes are not at all straightforward, with natural causes playing a larger role than anticipated. The river's ecosystem turned out to be unexpectedly full of life, and very complex.

Ein paar Flüsse auf der Welt finden sich mit dem üblichen Farbspektrum, in dem andere sich bewegen, nicht ab. Braungrau und grün sind ihnen zu langweilig, und farblos geht schon gar nicht. Zwei dieser Snobs sind der Rio Celeste in Costa Rica in reinem, hell strahlendem Himmelblau und der Rio Tinto in Spanien in sattem Rot und Gelb. Während es sich hier – wie meistens im Zusammenhang mit Wasser – chemisch und biologisch erklären lässt, ist die Ursache beim Rio Celeste ein physikalisches Phänomen.

Farbe ist immer auch ein Indikator. Sie zeigt uns, ob eine Kirsche schon reif zum Essen oder ein Insekt giftig ist. Schnell lernen wir, Farben bestimmten Eigenschaften und Merkmalen zuzuordnen. Zwar gibt es viele Ausnahmen, aber im Alltag hilft es weiter. Passt ein Farbschema nicht ins gelernte Bild, werden wir vorsichtig. Das Hellblau des Rio Celeste liegt noch dicht am Gewohnten, ist aber doch sonderbar anders. Sein Wasser ist zwar nicht hoch toxisch, aber es kann die Haut reizen. Und trinken sollte man es auch nicht.

Beim Rio Tinto ist die Sachlage um einiges komplizierter, auch wenn seine Farbe uns zunächst eindeutig klarmacht, dass irgendetwas anders als üblich ist. Aber die Ursachen sind komplizierter als lange vermutet. Schon seit mehr als 4000 Jahren wird am Rio Tinto Erzabbau betrieben. Was liegt also näher, als eben in diesem die alleinige Ursache für die Färbung auszumachen. Eine menschengemachte Umweltkatastrophe also. Wissenschaftliche Untersuchungen im Rahmen einer geplanten Sanierung und Renaturierung offenbarten ein viel komplexeres Bild, in dem natürliche Ursachen eine weitaus größere Rolle spielen. Das komplexe Ökosystem des Flusses stellte sich als viel belebter und komplexer heraus als vermutet.

Rio Tinto, Spain

Rio Tinto, Spain

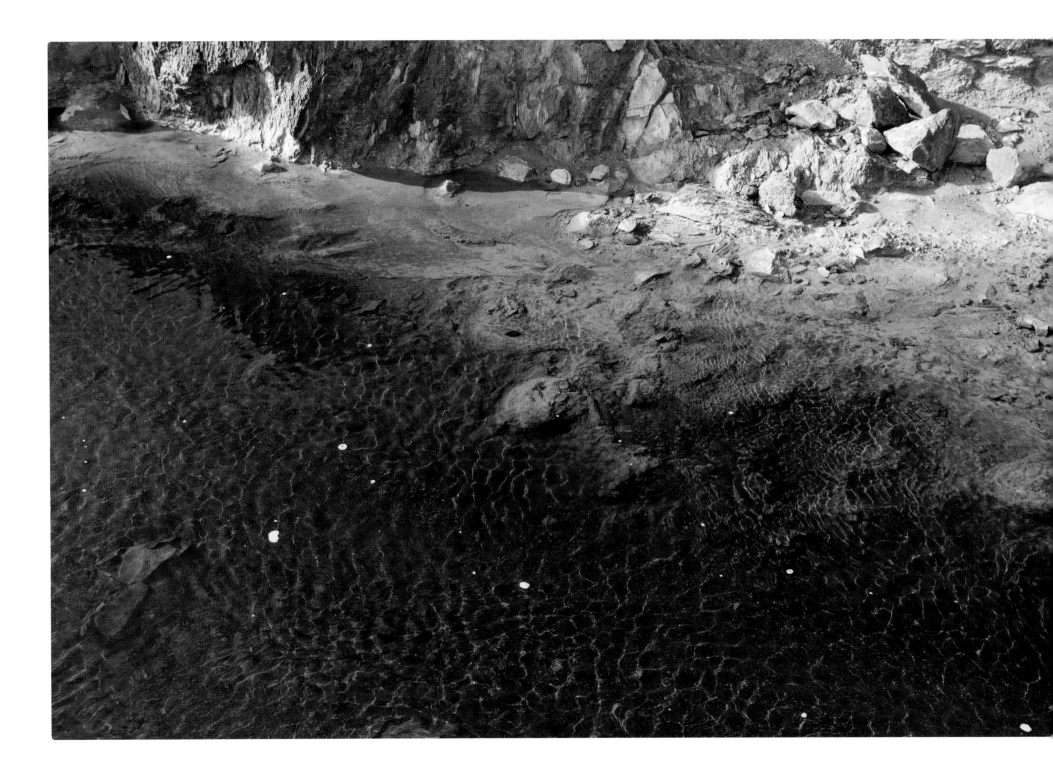

Rio Tinto, Spain

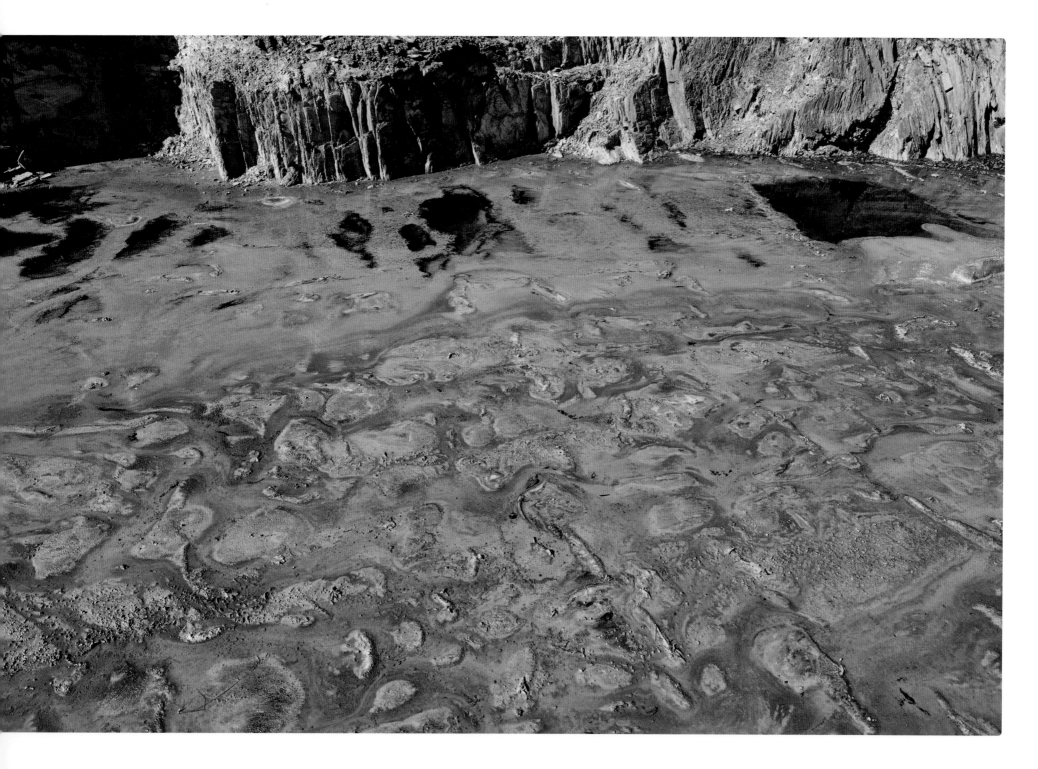

Rio Tinto, Spain

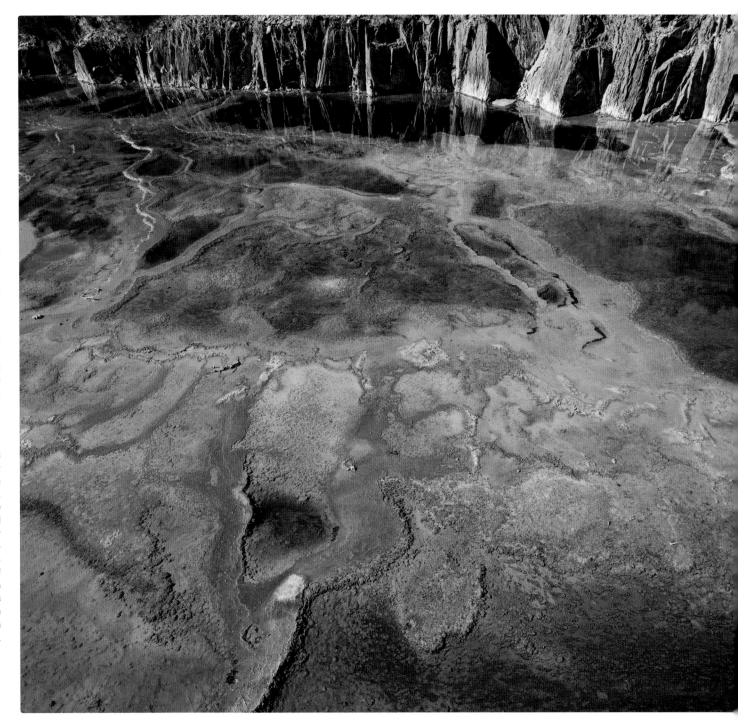

Unnaturally natural. Nothing here is quite as it seems. Everyone used to believe that the river has been polluted with copper from the mining industry. Of course, minerals from mining have been and are still entering the river. Yet, upon closer examination, hundreds of types of fungi, bacteria, and algae, most of them previously unknown, have been found. They feed on the river's minerals and their excrement contains large amounts of iron oxide, iron sulfate, and sulfuric acid. They are not alive despite the pollution in the river—they feed on it. Life here is not unlike life on Mars. This has always been the case; the mining industry is not to blame. Due to its unique characteristics, NASA stopped by to see this newly established nature conservation area which looks nothing like a natural biosphere.

Unnatürlich natürlich. Es ist nichts so, wie es scheint. Dass der Fluss mit dem Kupfer des Bergbaus verseucht ist, war lange gängige Meinung. Sicherlich wurden und werden durch den Bergbau Mineralien in den Fluss eingebracht. Aber erst genaue Untersuchungen zeigten, dass Hunderte Arten bisher weitgehend unbekannter Pilze, Bakterien und Algen sogar von den Mineralien des Flusses leben und unter anderem Eisenoxid, Eisensulfat und Schwefelsäure ausscheiden. Sie sind nicht nur immun gegen die „Verschmutzungen", sondern leben von ihnen. Es lebt sich hier wie auf dem Mars, und das schon seit Hunderttausenden Jahren und nicht erst, seitdem der Mensch Bergbau betreibt. Aus diesem Grund hat auch die NASA vorbeigeschaut. Hier, im aufgrund der Untersuchungsergebnisse neu eingerichteten Naturschutzgebiet, das so gar nicht wie eins aussehen will.

Rio Tinto, Spain

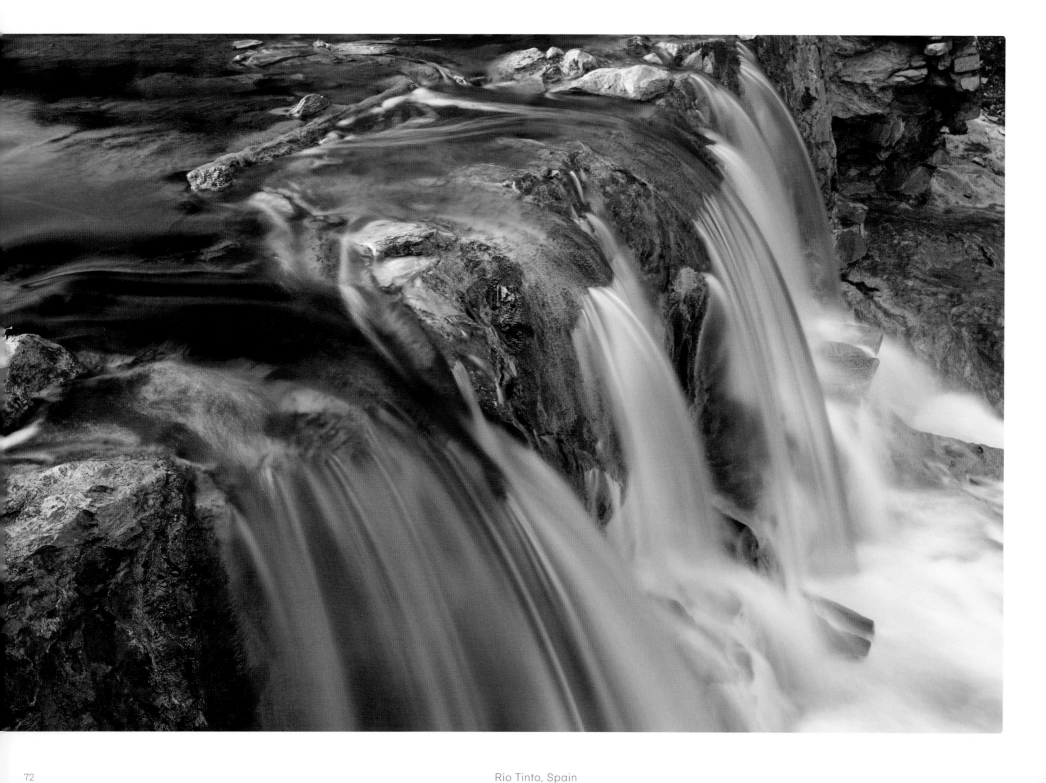

Rio Tinto, Spain

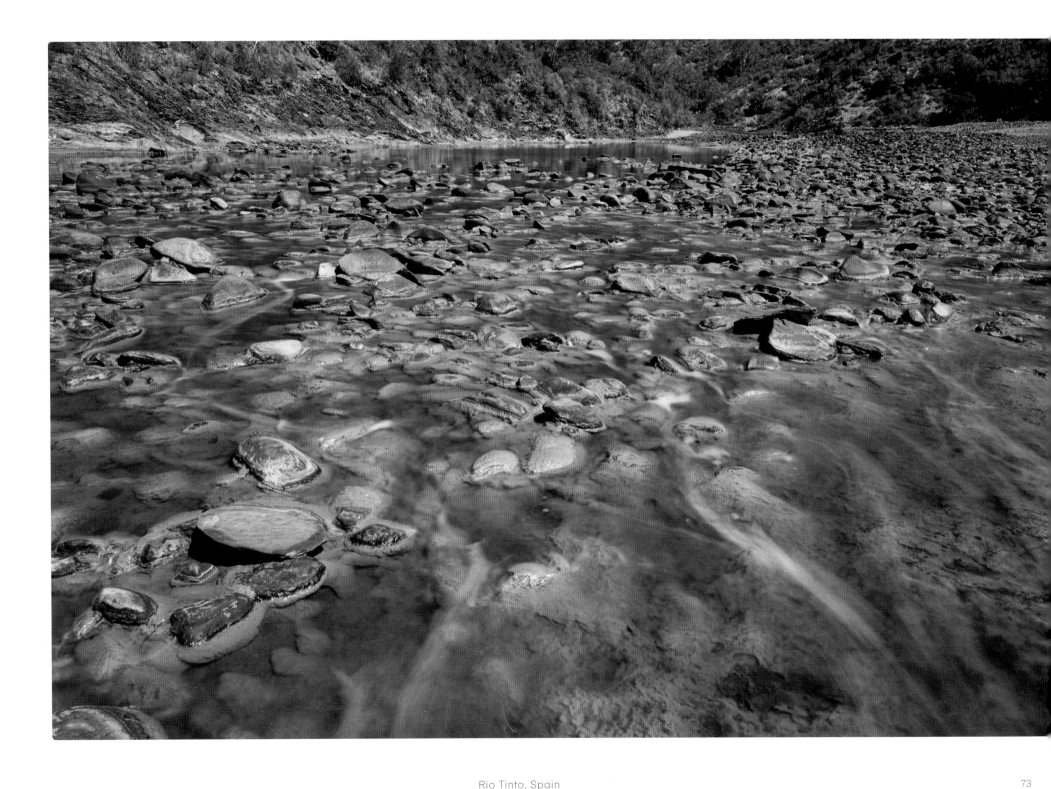

Rio Tinto, Spain

Rio Tinto, Spain

Rio Tinto, Spain

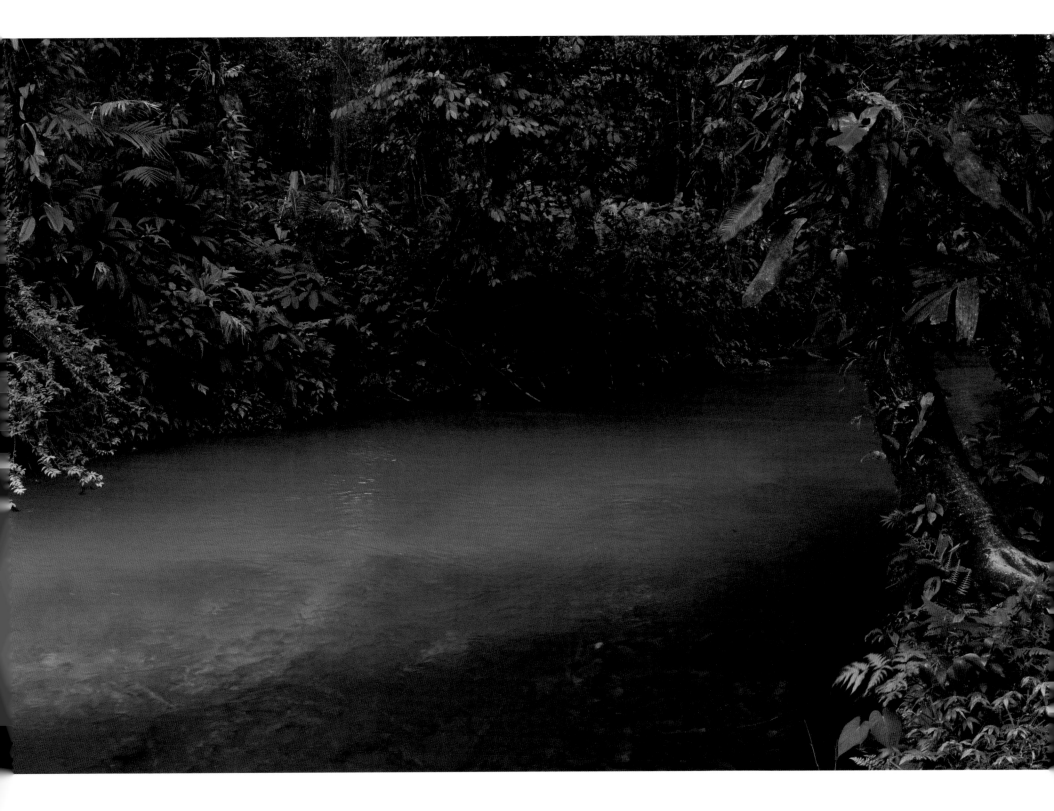

Rio Celeste, Costa Rica

Liquid sky. The aptly-named Rio Celeste in north-west Costa Rica really is sky blue—not turquoise, as is often claimed. One might expect its color to be the result of a chemical reaction, but this is not the case. It is a physical phenomenon.

The Rio Celeste is fed by two rivers: Sour Creek and Buenavista. Sour Creek is of volcanic origin and has a high, acidic pH value. Buenavista on the other hand carries a high concentration of tiny aluminum silicate particles. As the two rivers merge, the falling pH value increases the size of the aluminum silicate particles which in turn causes a so-called Mie scattering: a refraction of light which manifests as a result of the scattering of electromagnetic waves on spherical objects of a diameter roughly equivalent to the length of the waves. As a result, the water shines in a bright blue hue.

Flüssiger Himmel. Der Rio Celeste im Nordwesten Costa Ricas hat diesen Namen nicht grundlos. Seine wirklich himmelblaue – und nicht wie oft als Türkis beschriebene – Farbe entsteht nicht, wie man vermuten könnte, durch eine chemische Reaktion. Es ist vielmehr ein physikalisches Phänomen.

Der Rio Celeste speist sich aus den Flüssen Sour Creek und Buenavista. Während Sour Creek durch vulkanische Ursachen einen hohen, sauren pH-Wert aufweist, führt Buenavista eine hohe Konzentration von sehr kleinen Aluminiumsilikat-Partikeln mit sich. Beim Aufeinandertreffen beider Flüsse bewirkt der fallende pH-Wert eine Vergrößerung der Aluminiumsilikat-Partikel, was wiederum eine sogenannte „Mie-Streuung" auslöst. Das ist eine Lichtbrechung, die bei der Streuung elektromagnetischer Wellen an sphärischen Objekten entsteht, wenn deren Durchmesser etwa der Wellenlänge der Strahlung entspricht. Schon leuchtet das Wasser hellblau.

Rio Celeste, Costa Rica

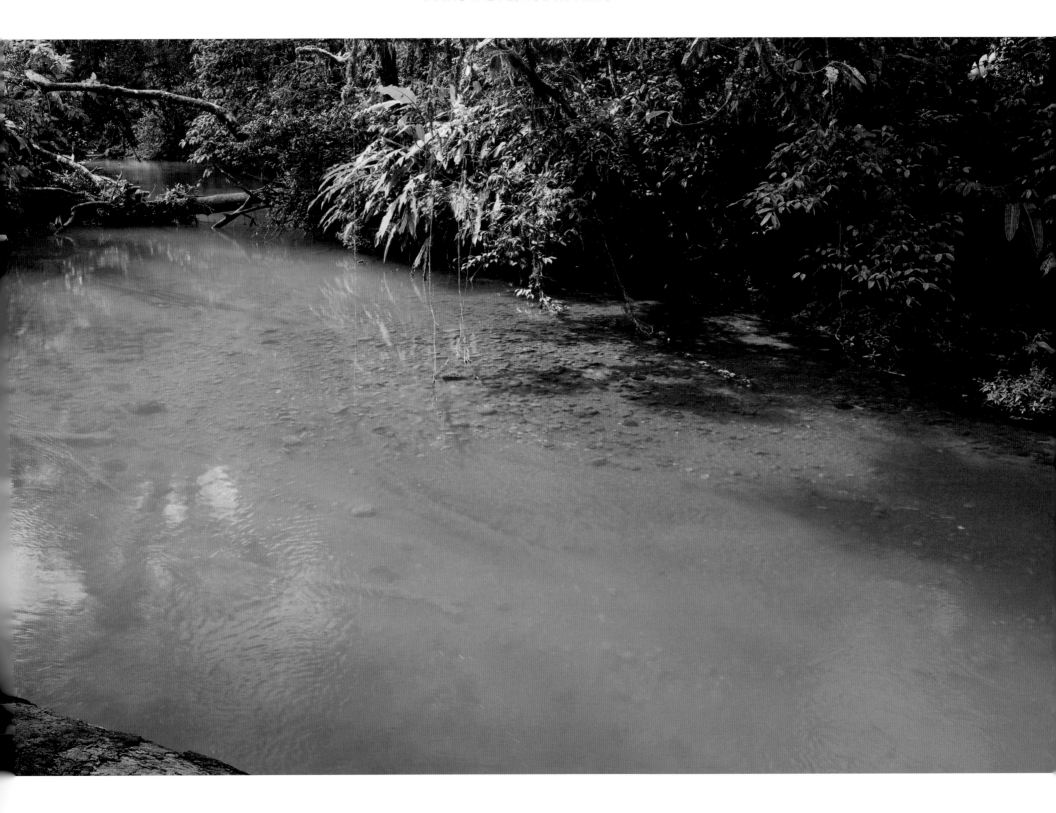

Rio Celeste, Costa Rica

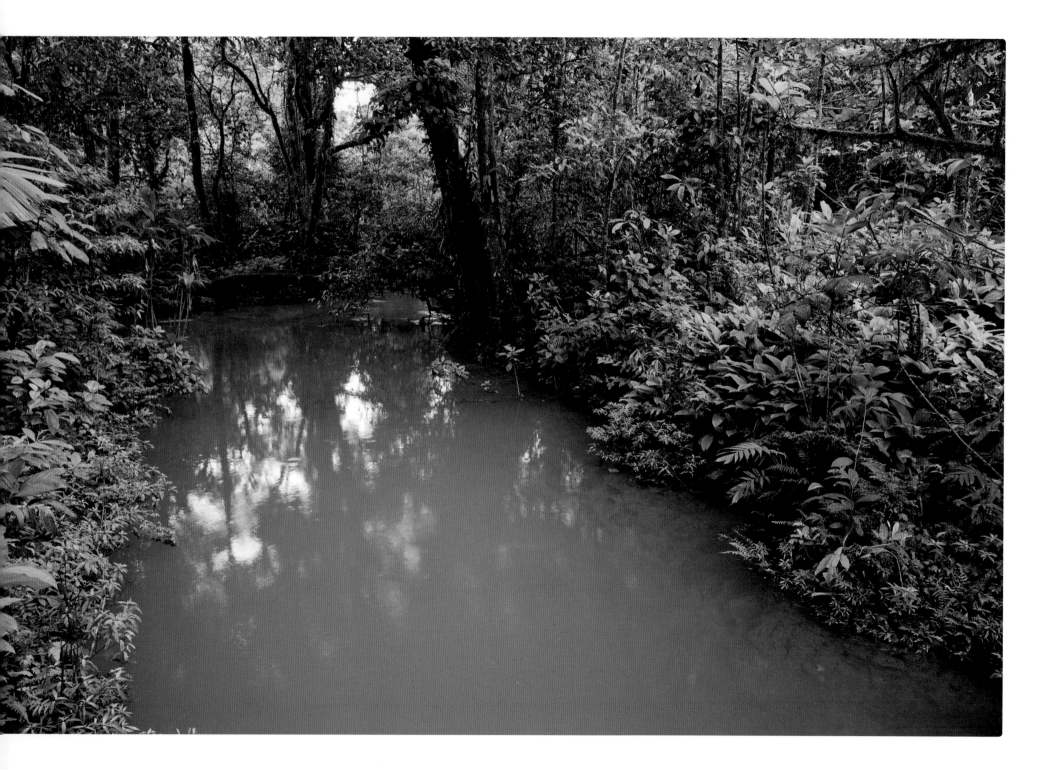

Rio Celeste, Costa Rica

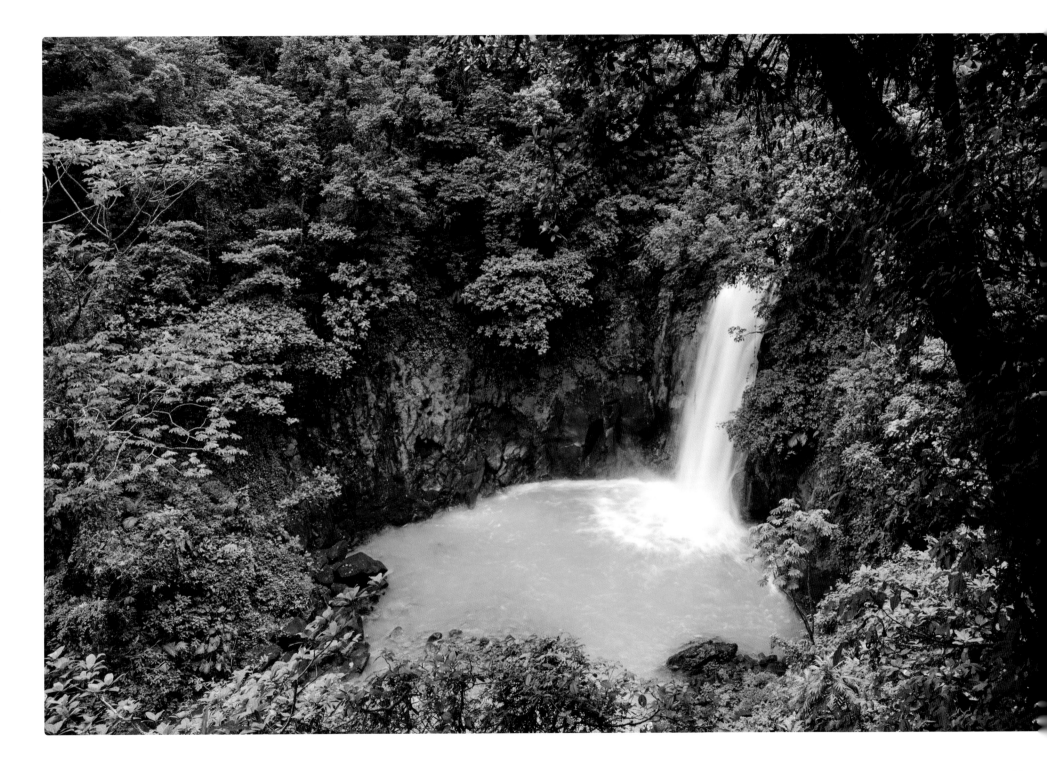

Rio Celeste, Costa Rica

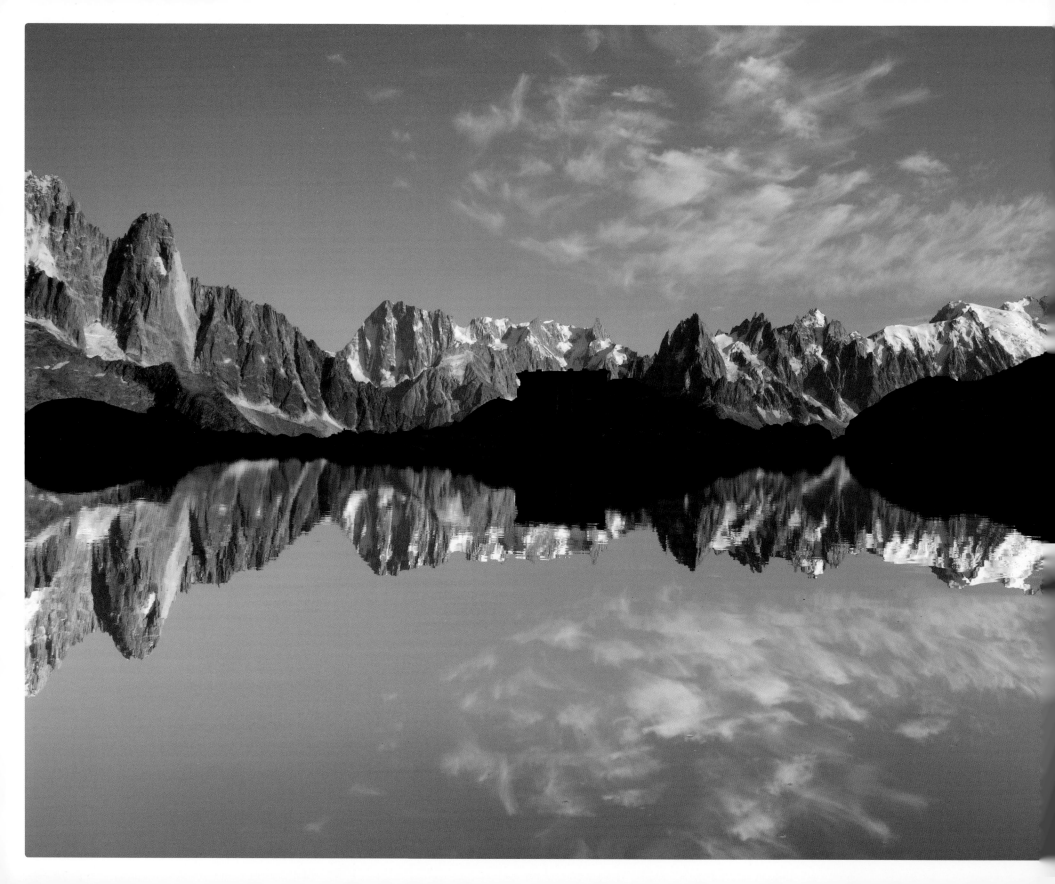

FRESH- OR SALTWATER LAKES

SÜSS ODER SALZIG SEEN

Lakes, more so than other bodies of water, are defined by their environs. Whether we consider a lake beautiful is largely determined by the landscape around it, not by the lake itself. Lakes can be a perfect mirror. The smaller the lake, the higher the chance of it forming a perfectly still surface and showing a reflection. The larger the lake, the more it behaves like the sea: there will be currents and waves. Yet even the world's largest lakes are still too small to have a clearly measurable tidal motion.

Mehr als andere Gewässer definieren sich Seen über die Umgebung, in die sie eingebettet sind. Ob wir einen See als schön empfinden, entscheidet zu einem großen Teil die ihn umgebende Landschaft und nicht der See selbst. Seen sind in der Lage, zum perfekten Spiegel zu werden. Es braucht nur einen windstillen Moment und man sieht doppelt. Je kleiner der See, desto besser funktioniert es und umso wahrscheinlicher kommt die Doppelung hinzu. Mit zunehmender Größe verhalten sich Seen dagegen mehr und mehr wie Meere. Es kommt zu Strömungen und Brandung. Aber für einen deutlich messbaren Tidenhub sind selbst die flächengrößten Seen der Erde zu klein.

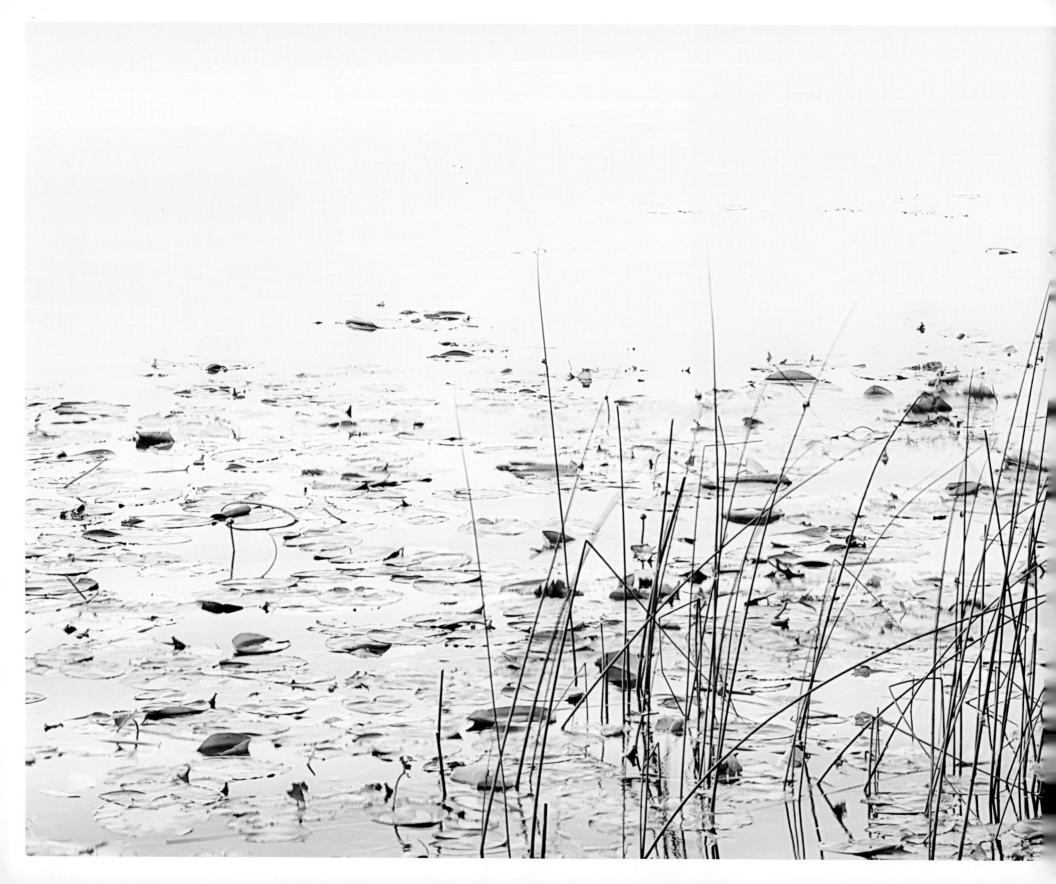

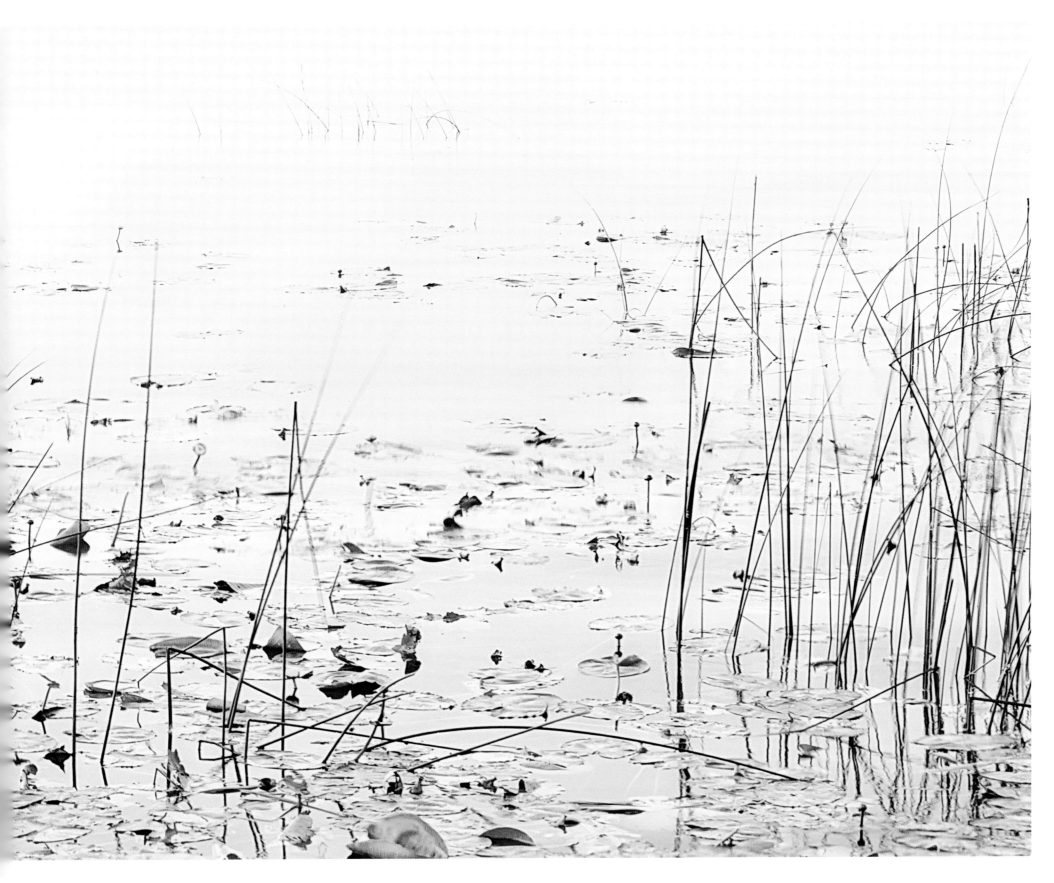

PUDDLE OR ASPIRING OCEAN

From puddles to bodies of water which are so big they are called seas—lakes come in many different variations and scales. Pond, pool, basin, lagoon, mountain lake, reservoir, or salt lake—a precise classification is often difficult. The term "lake" is rather broad: lakes are often understood to be any body of water in a basin surrounded by land.

Sometimes, the only criterion that stands between a puddle and a lake is size: two hectares, or five acres, are often seen as the minimum size for a body of standing water to qualify as a lake. They all have one thing in common though: they are completely surrounded by land and are, except by rivers, not connected to the sea. Linguistically, there are several examples of lakes which are called seas. The IJsselmeer in the Netherlands is called Lake IJssel in English but its Dutch name literally means IJssel Sea. The same goes for the Steinhuder Meer—Steinhuder Sea—in Germany. The German word for lake—der See—already sounds a lot like the English sea, and even within the German language it can be used to refer to an ocean at the change of a pronoun: die See. The lake is masculine, the sea is feminine, yet the word itself remains the same.

Two lakes stand out amongst the countless lakes on Earth. The Caspian Sea has a larger surface area than the next eight largest lakes combined. Lake Baikal is another record holder: although its surface area may not be all that impressive (it is number eight in the world), its volume is bigger by far than that of any other freshwater lake.

FRESH OR SALT WATER

Most lakes are freshwater lakes. There are, however, varying degrees and levels of salt and soda content. Soda is a carbonate salt, a type of sodium carbonate, and it forms due to evaporation at the edge of salt lakes. The most well-known salt lakes are the Caspian Sea and the Dead Sea; at 1,412 feet below sea level, the latter is the lowest lake on earth. The highest navigable lake on earth is Lake Titicaca at an altitude of 12,507 feet, located between Peru and Bolivia; it is also the largest lake in South America. About two thirds of the world's lakes are located in Canada. Blue Lake in New Zealand is considered to be the world's clearest lake. Its clearness comes close to that of distilled water.

LASTING IMPRESSION

Most lakes on earth are glacial lakes, for instance, the Great Lakes in North America. They formed after the glaciers from the last ice age had melted. Tectonic lakes such as Lake Baikal or Lake Tanganyika in Africa are the result of the Earth's crust pushing and deforming. Crater lakes such as the maar lakes in the Eifel, a mountain range in Germany, as well as Crater Lake in Oregon are the result of volcanic eruptions. Some lakes, for example the Dutch IJsselmeer mentioned above, are really closed off inland bays. Many lakes are man-made. Quarry ponds are often used as a means to mask old mining sites and compensate for the damage done to nature. Reservoirs can offer drinking water and produce energy. With all these alterations to nature, we walk a fine line between economy and ecology, especially in Asia and in the South American rainforest areas. Often the emphasis is on the economic benefits, and irreparable damage is done to nature. The ten largest lakes contain about 85 percent of all lake water in the world. Lake Vostok is one of the world's last big unknowns. At roughly 13,100 feet below the surface of the Antarctic ice, probably due to the tremendous pressure, its water does not freeze despite temperatures of 26 degrees, and it contains 50 times more oxygen than lakes on the surface.

NO LAKE CAN LAST FOREVER

Lakes can dry out naturally or due to human interference, as was the case for the now sadly famous Aral Sea, a lake formerly located between Kazakhstan and Uzbekistan. Artificial outflows to irrigate cotton fields have almost exhausted the water reserves and inflow, and so the world's fourth biggest lake became a desert of salt completely devoid of life. Lake Eyre in Australia only fills a handful of times per century; usually, it is dry. Lakes in general have a tendency to disappear. Lake Constance, for instance, will disappear one day in the not so distant future due to sediment brought in by the Rhine river.

PFÜTZE ODER MÖCHTEGERNMEER

Von der Pfütze bis zu Seen, die so groß sind, dass sie Meer genannt werden, gibt es so viele Variationen, wie es Seen gibt. Teich, Tümpel, Weiher, Bergsee, Stausee, Brackwassersee oder Salzsee – genaue Zuordnungen sind schwierig. So gelten nach einer Sichtweise alle Wasseransammlungen in Senken als Seen, nach einer anderen sind Seen nur solche, die eine über einen längeren Zeitraum ausgebildete Temperaturstaffelung aufweisen. Nach dieser Definition fallen sogar große Steppenseen wie der Neusiedler See heraus und gelten nicht als „echte" Seen. Manchen gilt auch einfach die Größe als Maß, ab wann aus einer Pfütze ein See wird. So wird oft ein Hektar – also 10.000 Quadratmeter – als Untergrenze genannt. Eine Gemeinsamkeit haben aber alle: Sie sind komplett von Land umgeben und haben keine Verbindung zum Meer. Höchstens eine sprachliche. Etwas verwirrend insbesondere für Süddeutsche wird im Niederdeutschen und im Niederländischen aus See Meer und umgekehrt. Als Beispiele seien das IJsselmeer in Holland und das Steinhuder Meer in Niedersachsen genannt, während die Nord- und Ostsee – trotz verhältnismäßig eher bescheidener Größe – eindeutig Meere sind. Jeder See stellt ein eigenes, mehr oder weniger abgeschlossenes Ökosystem dar.

Zwei Seen stechen aus der Masse der Seen auf der Welt ganz eindeutig heraus. Das Kaspische Meer ist seiner Fläche nach größer als die acht nächstkleineren Seen zusammen. Der andere Rekordhalter ist der Baikalsee: Während seine Fläche eher bescheiden ist (er liegt weltweit auf Platz acht), ist sein Volumen das mit riesigem Abstand größte aller Süßwasserseen.

SÜß ODER SALZIG

Die meisten Seen sind mit Süßwasser gefüllt. Daneben gibt es aber auch alle Abstufungen des Salz- oder Sodagehalts. Soda ist ein Salzmineral, eine Form des Natriumkarbonats, und entsteht unter anderem durch Verdunstung an den Rändern von Salzseen. Die bekanntesten Salzseen sind das Kaspische und das Tote Meer, das mit 420 Meter unter dem Meeresspiegel auch der tiefstgelegene See der Erde ist. Der weltweit höchstgelegene schiffbare und gleichzeitig größte See Südamerikas ist der auf 3810 Meter gelegene Titicacasee zwischen Peru und Bolivien. Alleine in Kanada befinden sich rund zwei Drittel aller Seen der Erde. Als der klarste See gilt der Blue Lake in Neuseeland, dessen Klarheit an die von destilliertem Wasser herankommt.

BLEIBENDER EINDRUCK

Die meisten Seen auf der Erde sind Glazialseen wie die Großen Seen in Nordamerika. Sie entstanden beim Abschmelzen der Gletscher nach der letzten Eiszeit. Tektonische Seen wie der Baikal- oder der Tanganjikasee in Afrika entstanden durch die Dehnung der Erdkruste, Kraterseen wie die Maare der Eifel oder der aus dem Vorwort bereits bekannte Crater Lake in Oregon als Folge von Vulkanausbrüchen. Auch durch Eindeichung von Meeresbuchten entstehen Seen wie das IJsselmeer. Viele Seen sind menschengemacht. Während Baggerseen uns meistens die Freizeit verschönern und alte Tagebauwunden verstecken sollen, dienen Stauseen als Trinkwasserreservoirs und der Stromgewinnung. Ein gerade in den Regenwaldgebieten Südamerikas und in Asien schwieriger Spagat zwischen Ökologie und Ökonomie, bei dem Letztere meist als Sieger hervorgeht und die Natur auf der Strecke bleibt. Die zehn größten Seen der Erde enthalten circa 85 Prozent allen Seewassers. Eines der letzten großen Geheimnisse auf unserer Erde ist der Wostoksee etwa 4000 Meter unter dem antarktischen Eispanzer. Aufgrund des hohen Drucks ist das Wasser trotz -3 Grad nicht gefroren und der Sauerstoffgehalt etwa 50-mal höher als in Seen an der Oberfläche.

KEIN SEE WÄHRT EWIG

Seen können austrocknen oder ihnen wird – wie dem zu trauriger Berühmtheit gekommenen Aralsee zwischen Kasachstan und Usbekistan – das Wasser abgegraben. Der fast unstillbare Wasserdurst endloser Baumwollfelder hat seinen Wasserzufluss fast zum Erliegen gebracht und aus dem einst viertgrößten See der Erde eine leblose Salzwüste werden lassen. Der Eyresee im Outback Australiens ist nur wenige Male pro Jahrhundert gefüllt und meistens ausgetrocknet. Aber Seen haben ganz generell die Tendenz zu vergehen. So wird beispielsweise der Bodensee in nicht allzu ferner Zukunft allein durch den Sedimenteintrag des Rheins zugeschüttet worden sein.

Pages 84–85

Picture puzzle. Vegetation that breaks through the water's surface, with roots in the earth near the shore, is characteristic of a body of standing water. A river's current would be too strong to withstand for any plants other than trees. Thus, we know that this must be a lake even though we cannot see the lake itself.

Suchbild. Über die Wasserlinie hinausragende, im Erdreich wurzelnde Vegetation ist charakteristisch für ein stehendes Gewässer. Der Strömungsdruck eines Fließgewässers ist zu stark, als dass Pflanzen, mit Ausnahme von Bäumen, dem standhalten könnten. So erkennt man hier einen See, ohne einen See sehen zu können.

A classic. Here in California, Ansel Adams created his masterpieces and founded a new school of great American landscape photographers. This typical image follows in that tradition and depicts an iconic American landscape—in black and white, as it proper. With it, I would like to express my deep respect for this influential and pioneering artist.

Klassisch. Hier in Kalifornien schuf Ansel Adams seine Meisterwerke und begründete damit die große Tradition amerikanischer Landschaftsfotografie. Mit diesem klassischen Sujet, einer Ikone amerikanischer Landschaften – wie es sich gehört, in Schwarz-Weiß – möchte ich diesem stilbildenden und einflussreichen Künstler meine Hochachtung bezeugen.

Lake Tahoe, California, USA

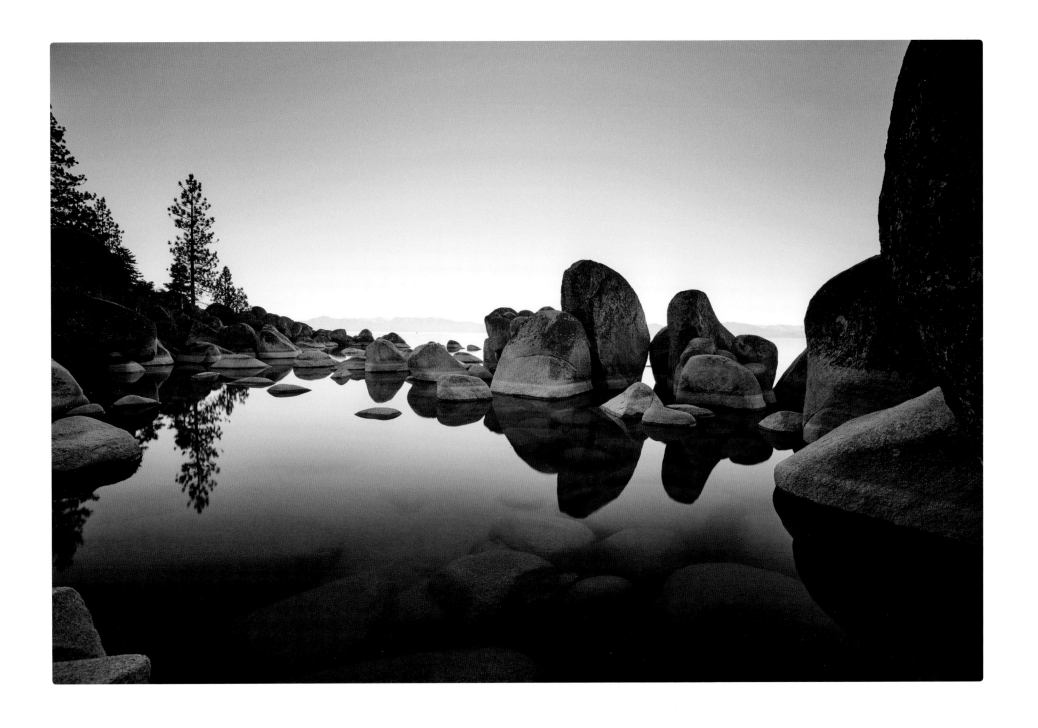

Lake Tahoe, California, USA

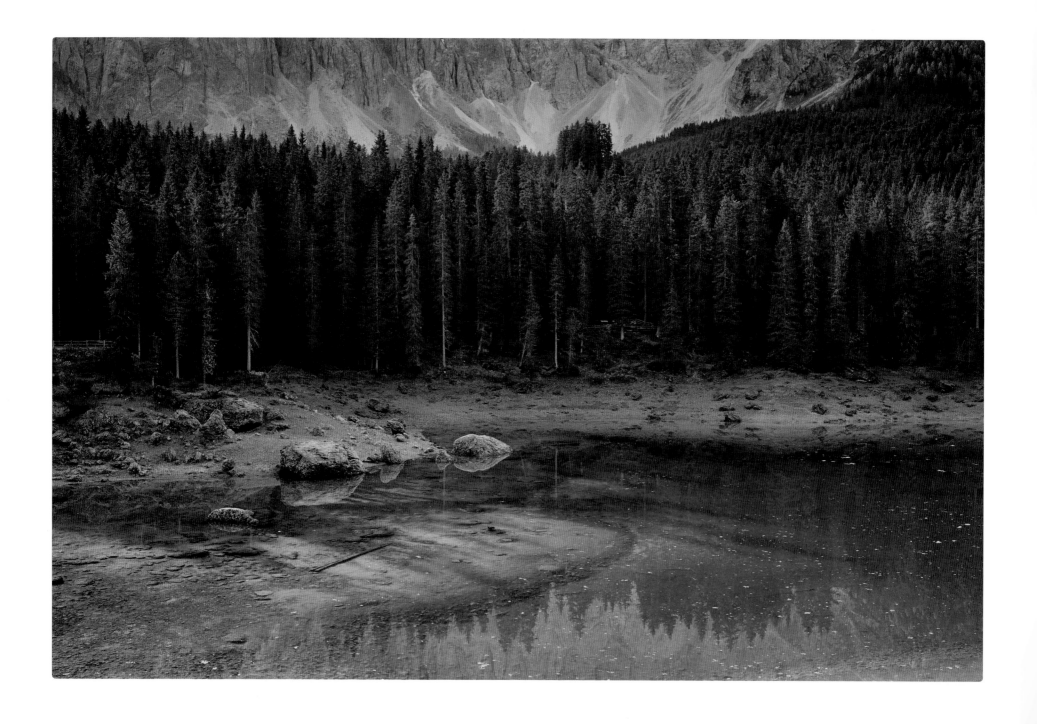

Lake Karer, Italy

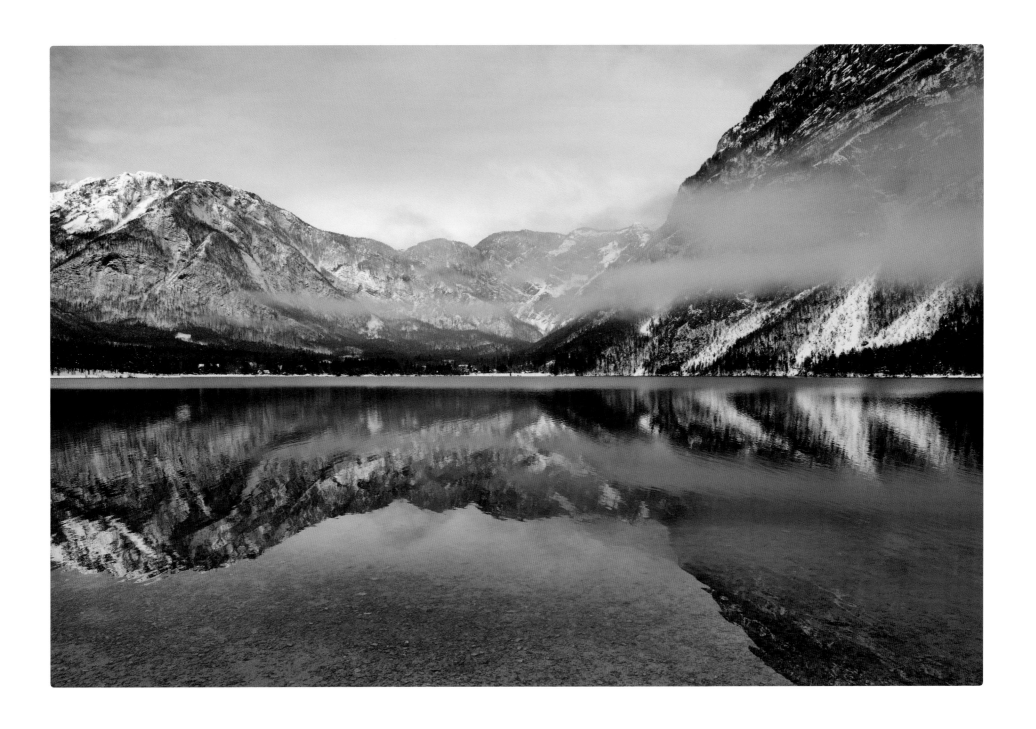

Lake Bohinj, Slovenia

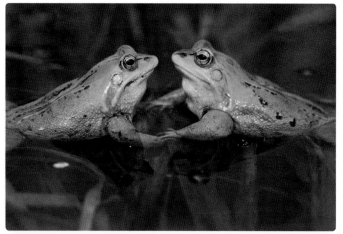

So blue. Once a year, in early spring, the otherwise plain brown male moor frog turns bright blue and goes forth to look for a mate. In its folly it will try and mount almost anything that crosses its path. Sometimes, a common toad is the chosen one. This particular toad almost drowned due to the overwhelming number of hormonal males—a narrow escape. Since it is difficult to determine this annual event's time or location in advance, only a few lucky photographers get to witness and document this annual event. To make matters worse, the spectacle only lasts for two to three days at most. After that, the blue frogs change and once again turn into plain brown moor frogs.

Blaumänner. Einmal im Jahr, im frühen Frühjahr, verwandeln sich die sonst unscheinbar braunen Männchen der Moorfrösche in hellblau strahlende Draufgänger auf der Suche nach Weibchen. Liebestoll versuchen sie alles zu begatten, was nicht schnell genug das Weite sucht. Manchmal erwischt es dabei auch eine Erdkröte. In diesem Fall ist sie angesichts der überwältigenden Überzahl hormongesteuerter Froschmänner nur knapp dem Tod durch Ertrinken entkommen. Da man weder Ort noch Zeitpunkt wirklich vorhersehen kann, gehört auch viel Glück dazu, dieses Naturschauspiel erleben zu dürfen. Erschwerend kommt außerdem hinzu, dass das Spektakel höchstens zwei bis drei Tage dauert. Danach werden die Blaumänner wieder unscheinbare braune Moorfrösche.

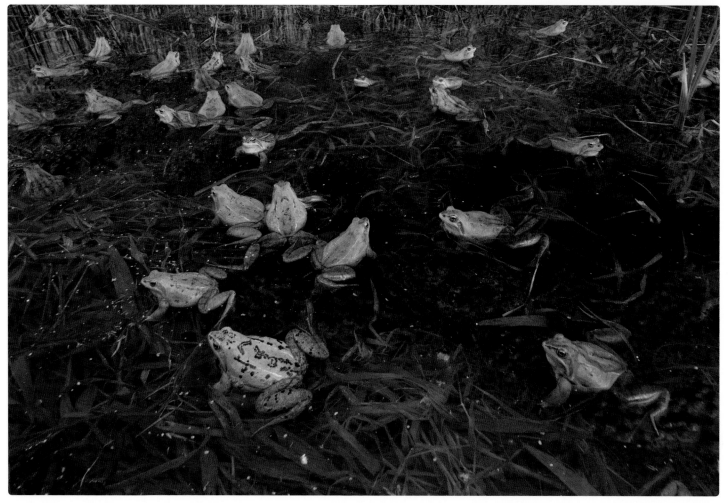

Moor frogs, Berlin area, Germany

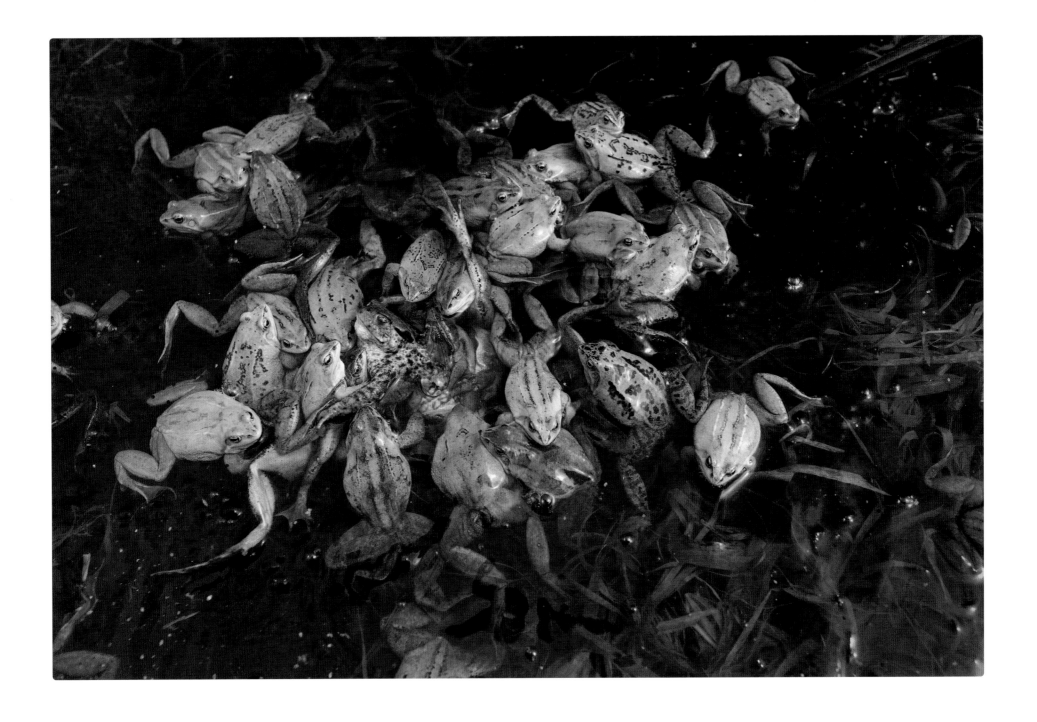

Moor frogs, Berlin area, Germany

Pond near Rio Tinto, Spain

Pond near Rio Tinto, Spain

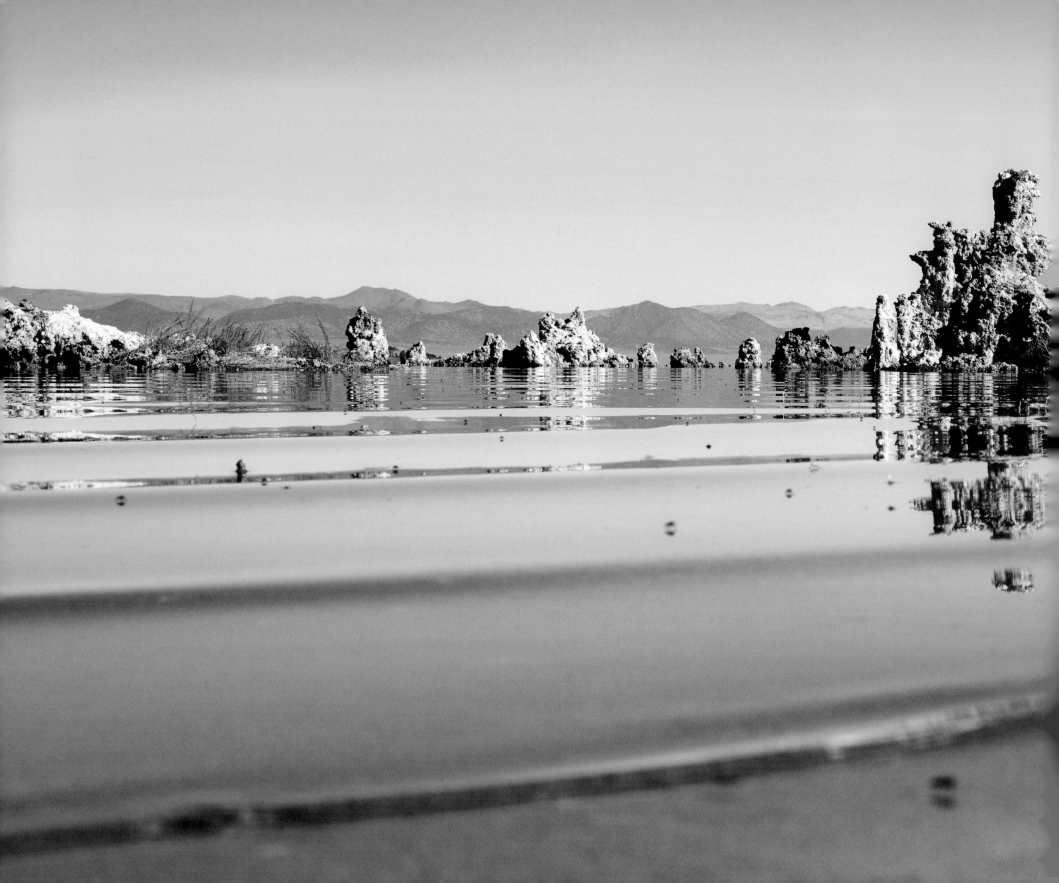

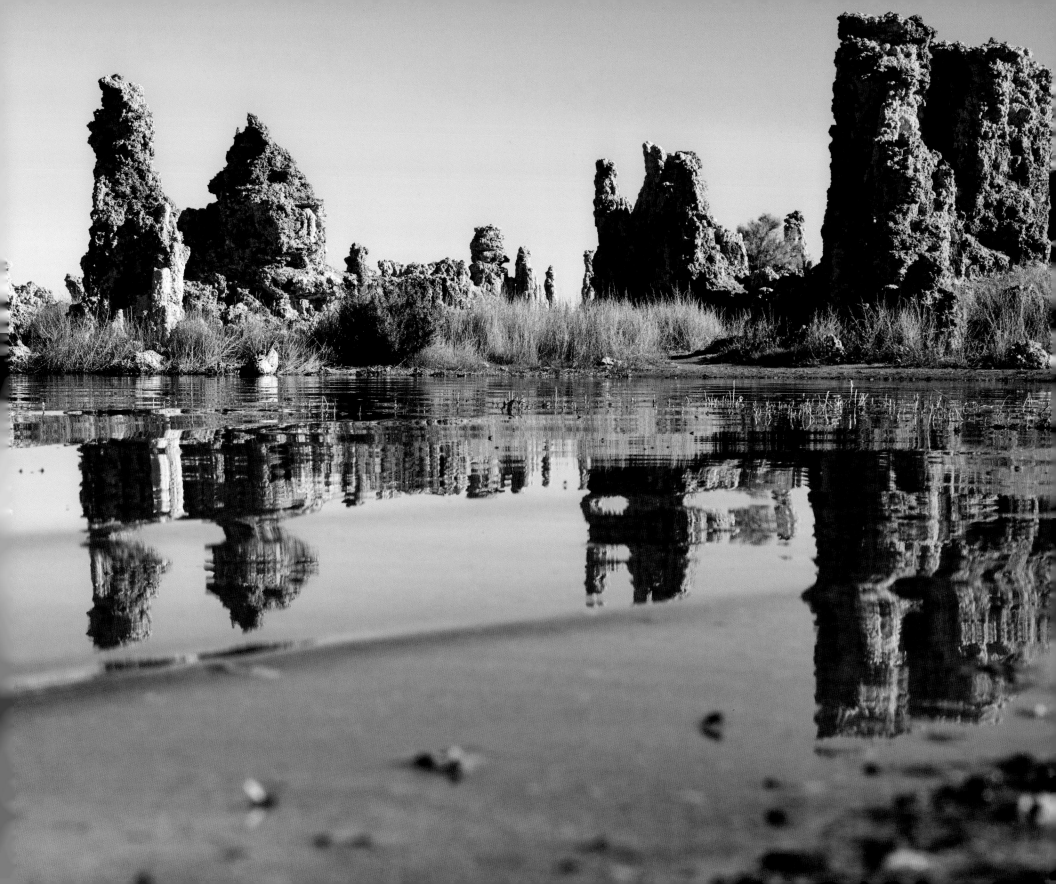

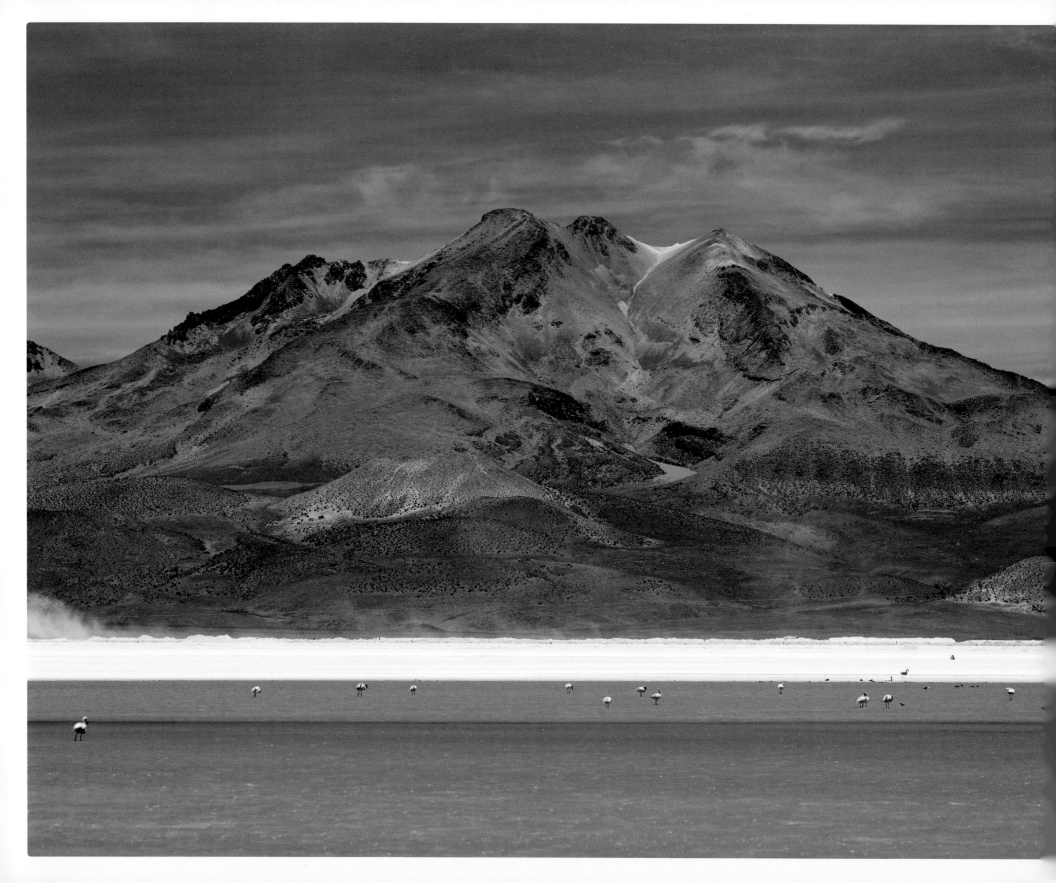

Chile, Bolivia, Kenya

TOO MUCH SALT
VERSALZEN

Many lakes contain salt and are alkaline to some degree. The most famous example of this is the Dead Sea, located between Israel, the West Bank, and Jordan. Despite a salinity of 28 percent, it is not quite the lake with the world's highest salt content. Some lakes in the Antarctic Dry Valleys have a salinity of more than 40 percent, which is why their waters do not freeze. Each salt lake has its own unique concentration of salt and other substances. No two salt lakes are alike.

Wherever there is an alkaline or salt lake, flamingos are not far away. There are five or six (depending on which scientific criteria you subscribe to) different types of flamingo in Africa, Europe, and parts of the Americas. The past few years have seen some wild flamingos make their home in Germany. They are experts at adapting to their surroundings and can survive in extremely cold as well as very hot temperatures; they can breed at altitudes of more than 15,000 feet. Often, they appear as a bright pink spot in otherwise desolate, brown surroundings, and are rarely seen in flight.

The soda lakes in Eastern Africa, like Lake Nakuru and Lake Bogoria in Kenya, are home to some of the largest flamingo colonies of up to 1 million individuals. I found the lagoons in the Atacama Desert to be particularly beautiful. The waters there oscillate between yellow, green, red, and even violet. It offers a stunning contrast to the reddish-brown, often snowcapped Andean mountains and volcanoes that tower up to 23,000 feet above them. Not only is the natural beauty here breathtaking: most of these lakes are located at between 10,000 and 17,000 feet of altitude, where the air starts to get noticeably thinner. To me, this is one of the most beautiful landscapes on earth.

Viele Seen auf unserer Erde sind mehr oder weniger alkalisch und salzhaltig. Bekanntestes Beispiel dafür ist das Tote Meer zwischen Israel, dem Westjordanland und Jordanien. Aber der See ist mit durchschnittlich 28 Prozent Salzgehalt nicht das salzhaltigste Gewässer. Einige Seen in den Antarktischen Trockentälern schaffen deutlich über 40 Prozent, weswegen das Wasser in ihnen auch nicht gefriert. Die Zusammensetzung der Salzmischungen und deren prozentualer Anteil am Gesamtvolumen sind so unterschiedlich, wie es Salzseen gibt. Keiner ist wie der andere.

Überall, wo es alkalische und/oder salzhaltige Seen gibt, ist wenigstens eine der (je nach wissenschaftlicher Zählweise) fünf oder sechs Flamingoarten nicht weit. Zumindest in Afrika, Europa und allen Teilen Amerikas. Seit einigen Jahren gibt es sogar in Deutschland einige dauerhaft lebende Exemplare. Perfekt an die extremen Lebensbedingungen angepasst, überstehen sie eisige Kälte, extreme Hitze und brüten bis zu einer Höhenlage von 4700 Meter. Ein rosafarbener – eher selten fliegender – Farbkleks in einer oftmals wüstenhaften und meist braunen Umgebung.

Neben den großen Natronseen Ostafrikas wie dem Nakuru- und dem Bogoriasee in Kenia, in denen mit bis zu einer Million Tieren die größten Kolonien leben, haben es mir besonders die als „Lagunen" bezeichneten Salzseen in der Atacama-Wüste Südamerikas angetan. Das Farbspektrum des Wassers dort reicht von Gelb über Grün bis sogar zu Rot und Violett. Es kontrastiert mit den meist rotbraunen, oft schneebedeckten Bergen und Vulkankegeln der Anden, die bis 7000 Meter aufragen. Nicht nur wegen des grandiosen Anblicks bleibt einem da die Luft weg. Die Lage der meisten Seen zwischen 3000 und 5000 Metern tut ein Übriges. Für mich eine der schönsten Landschaften der Erde.

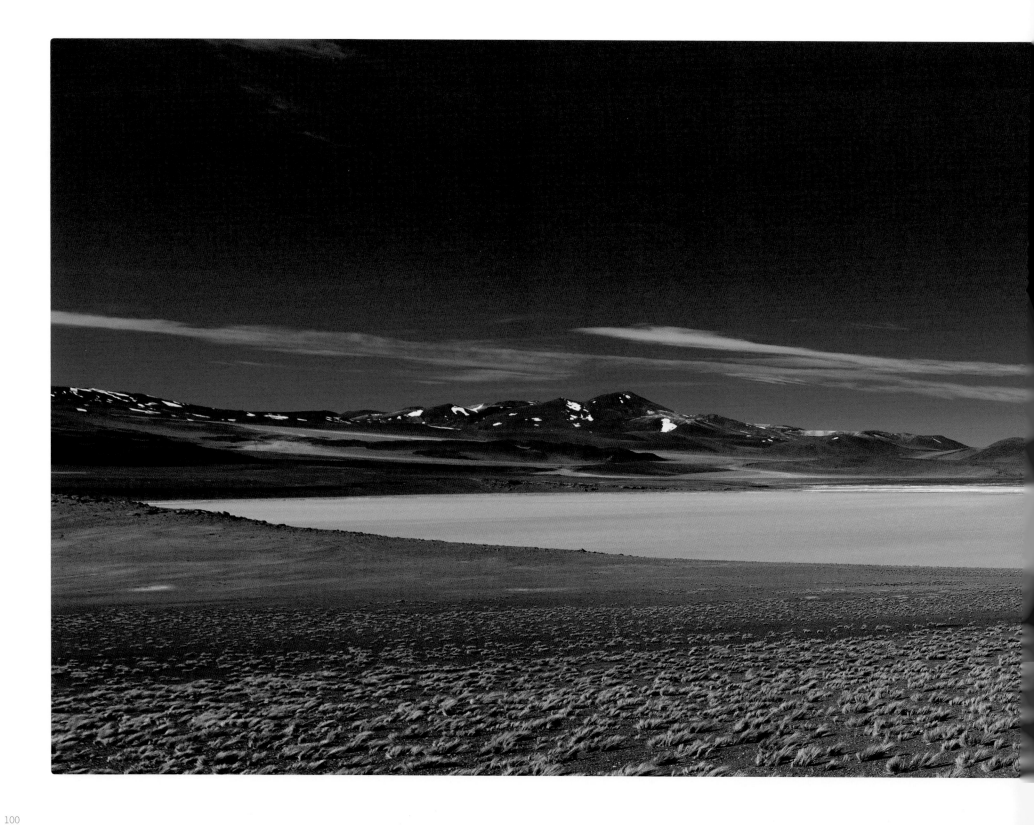

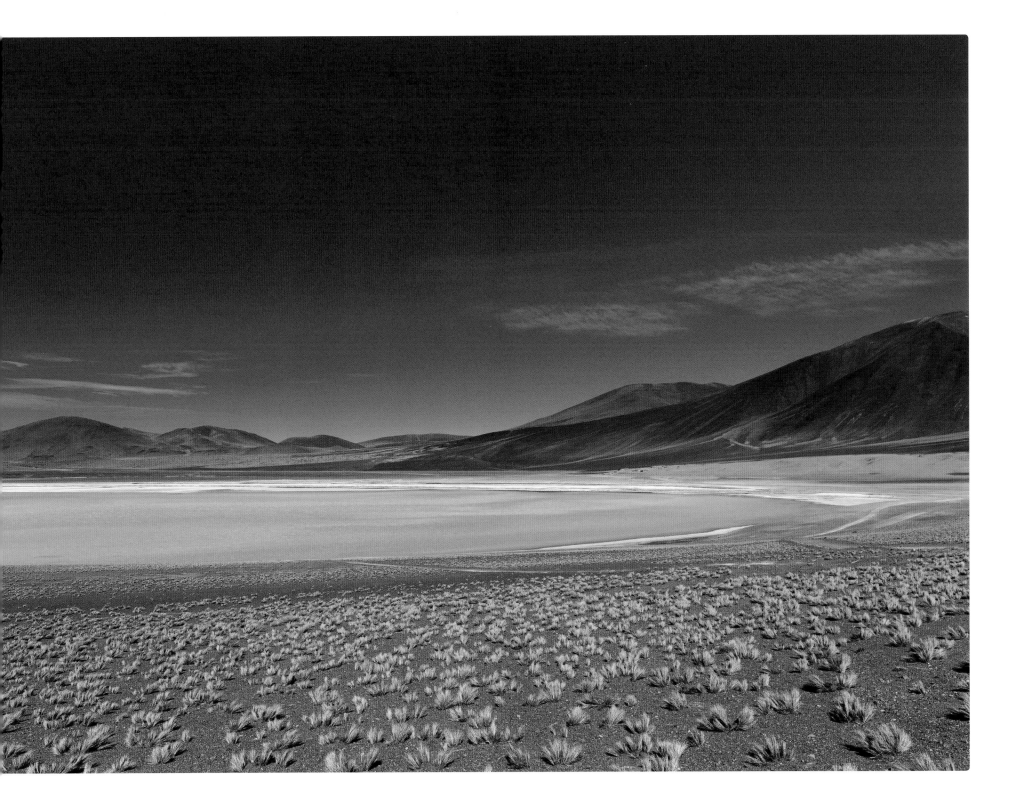

Laguna Miscanti, Chile

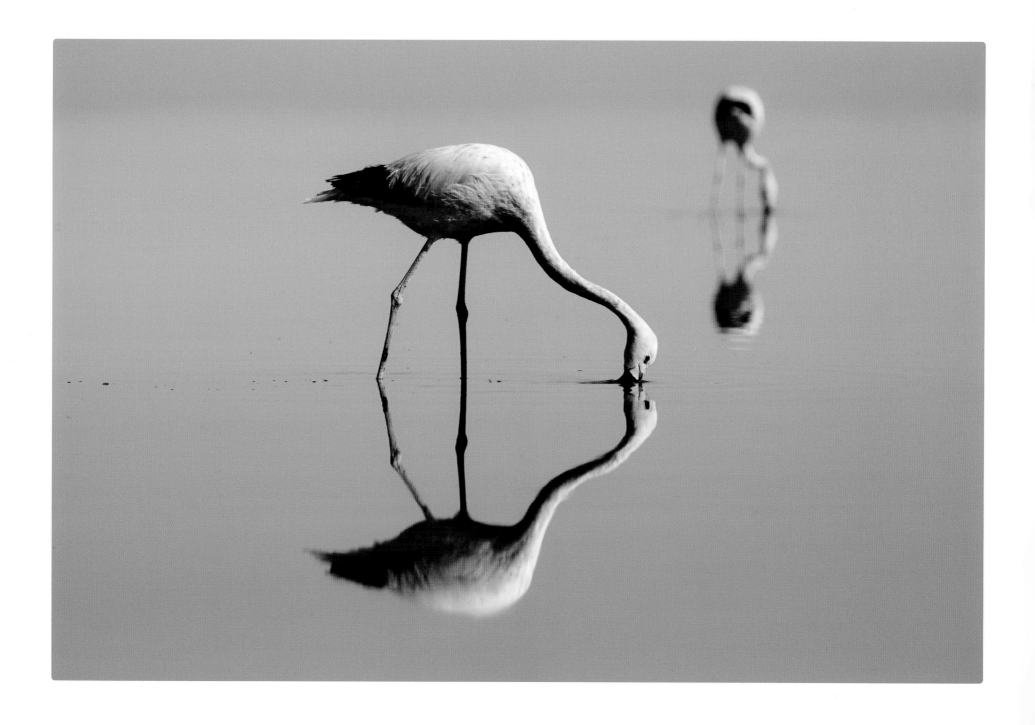

Salar de Atacama, Chile

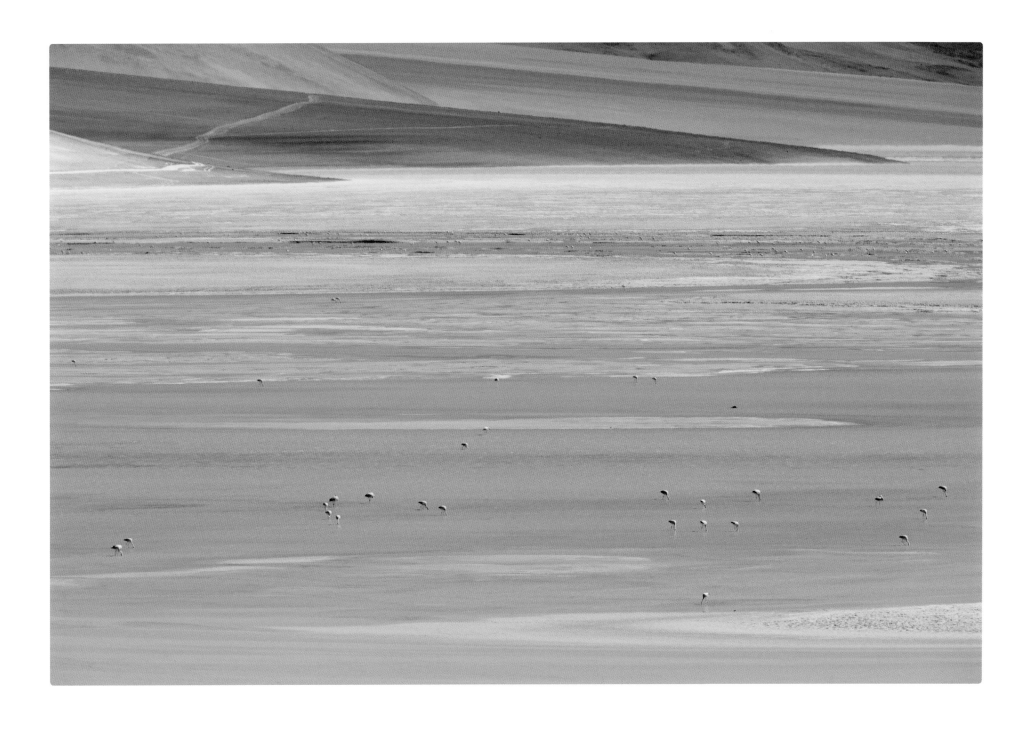

Aguas Calientes, Chile

Laguna Verde, Bolivia

Salar de Maricunga, Chile

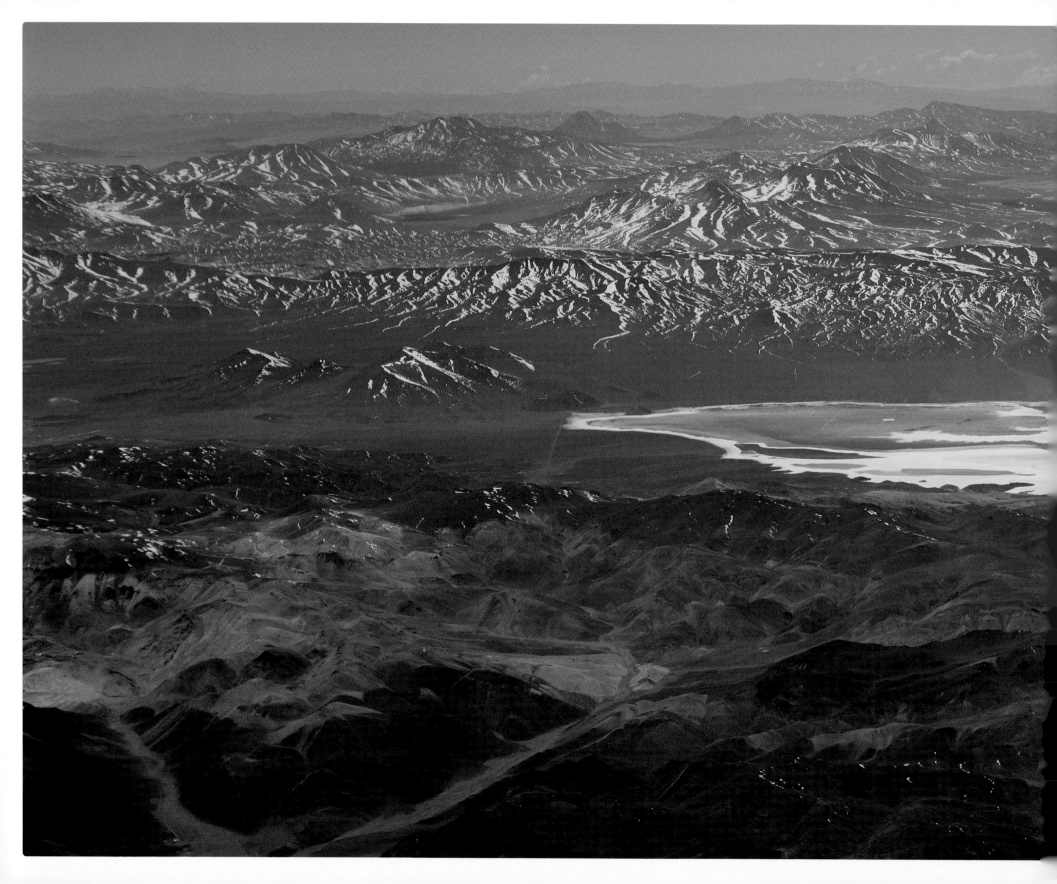

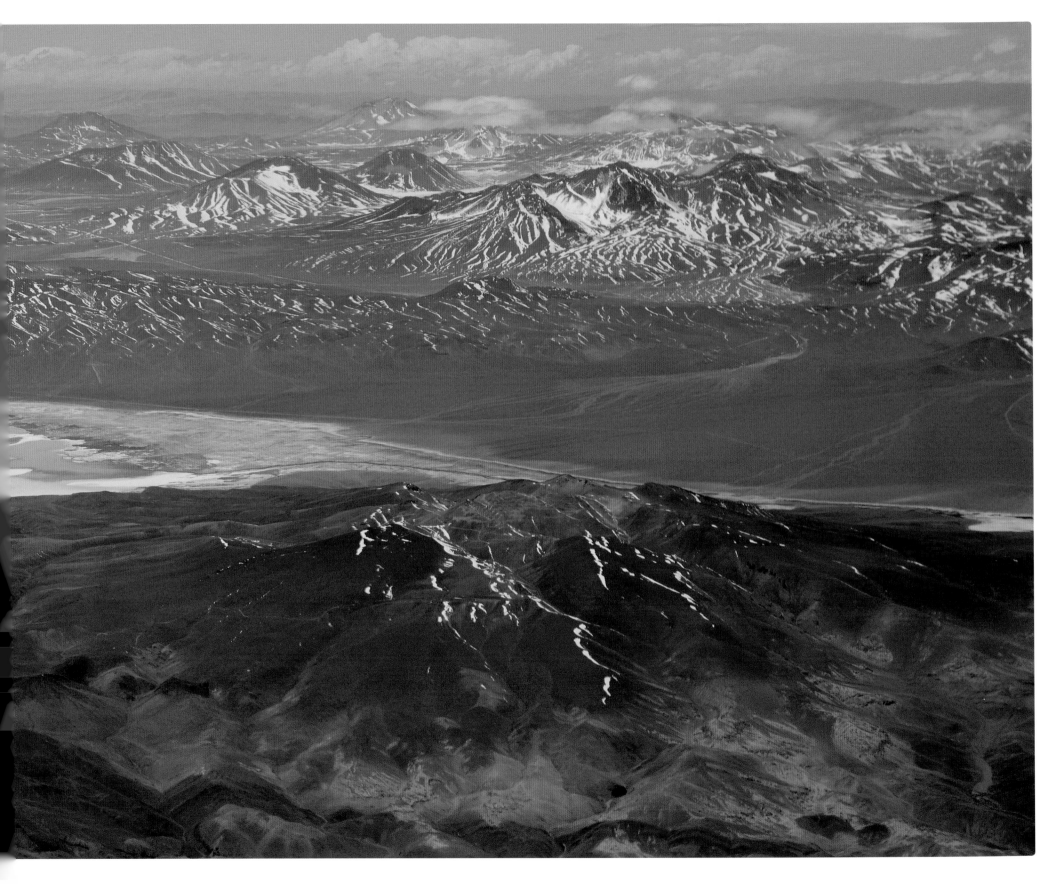

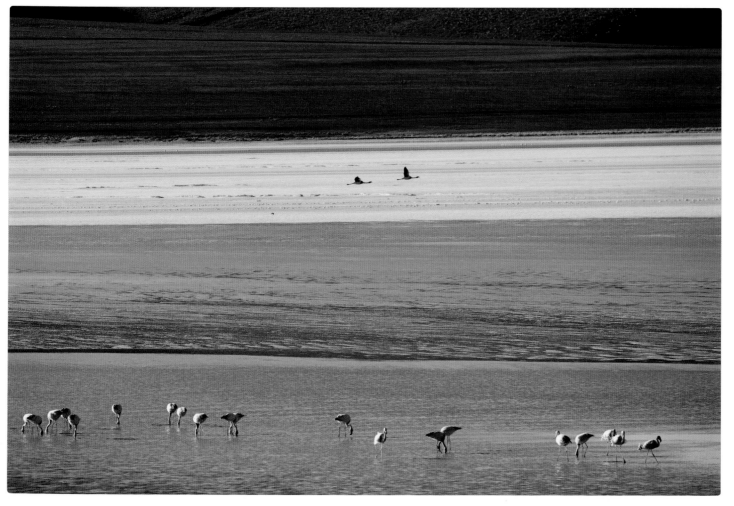

Multicolor. Laguna Colorada in the altiplano of Bolivia may be one of the most famous and certainly one of the most beautiful lagoons in the Atacama Desert. Depending on the water levels and the position of the sun, the water's color oscillates between various shades of red and violet-blue; flamingos are always present.

A small hill near the shore seems to be waiting for a photographer to make use of this higher vantage point and capture the scene at an ideal angle.

Vielfarbig. Die Laguna Colorada auf dem Altiplano in Bolivien ist die vielleicht bekannteste und ganz sicher eine der schönsten Lagunen in der Atacama. Je nach Sonnen- und Wasserstand oszilliert die Farbe des Wassers zwischen allen Rot- und Blauviolett-tönen und die Anwesenheit von Flamingos ist garantiert.

Wie für Fotografen gemacht ist eine kleine Anhöhe nah am Ufer. So können problem-los Bilder aus erhöhter Perspektive gemacht werden.

Laguna Colorada, Bolivia

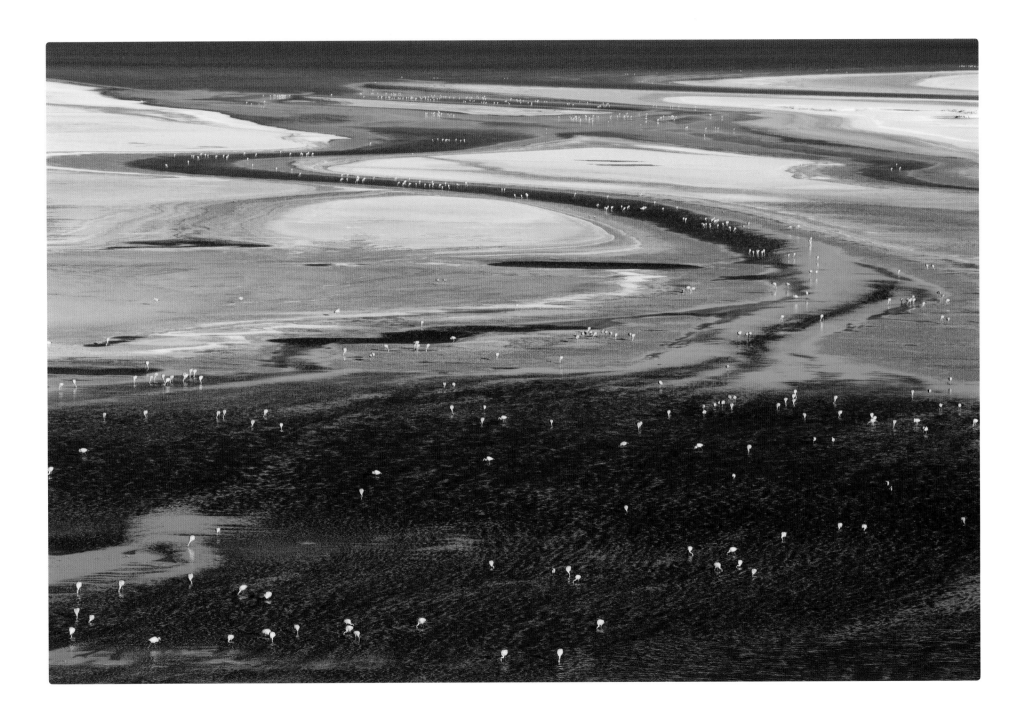

Laguna Colorada, Bolivia

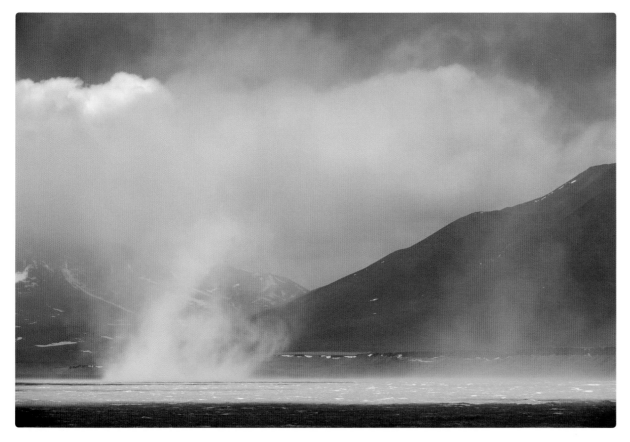

Counting lagoons. In the Atacama Desert, Laguna Verde is more of a blanket term rather than an individual name—there are quite a few of them. Yet none of the other lagoons can compare with the Laguna Verde that is located in the southern part of the Atacama Desert, near Copiapó. On the way there, everything seemed ordinary. Storms of up to 60 mph, and not a soul in sight. Then, after hours of driving, suddenly it appears: a bright neon turquoise lay ahead of me. Even when seen through the dusty storm clouds, the water was a clear greenish-blue. The main issue I encountered as I was photographing the scene was that within seconds, both my camera and I were covered in a film of salt, making it impossible to take pictures. The salt in the air felt like a sandblaster, and when I opened the car door it was very nearly torn off by the strong gusts. Three years later, I returned to the same spot and this time, the weather was more forgiving; the wind seemed to be taking a break.

Einmal durchzählen. Laguna Verde ist in der Atacama eher ein Sammelbegriff als ein individueller Name. Es gibt einige davon. Aber keine Lagune ist wie diese im südlichen Teil der Atacama auf Höhe der Stadt Copiapó. Beim ersten Besuch war es wie fast immer. Sturm deutlich schneller als 100 km/h und keine Menschenseele weit und breit. Kommt man nach stundenlanger Fahrt über die letzte Anhöhe, liegt sie plötzlich vor einem. Ein Türkis wie Neonfarbe strahlte mir entgegen. Selbst durch Sturmböen aufgewirbeltes Wasser leuchtete grünblau. Das Problem dabei: Nach wenigen Sekunden war ich ebenso wie meine Kamera mit Salz paniert und ein Fotografieren wurde unmöglich. Das Salz in der Sturmluft wirkte wie ein Sandstrahlgebläse und nur mit Glück wurde die Autotür beim Öffnen des Wagens nicht abgerissen. Drei Jahre später an der gleichen Stelle hatte das Wetter ein Einsehen und der Wind Pause.

Laguna Verde, Chile

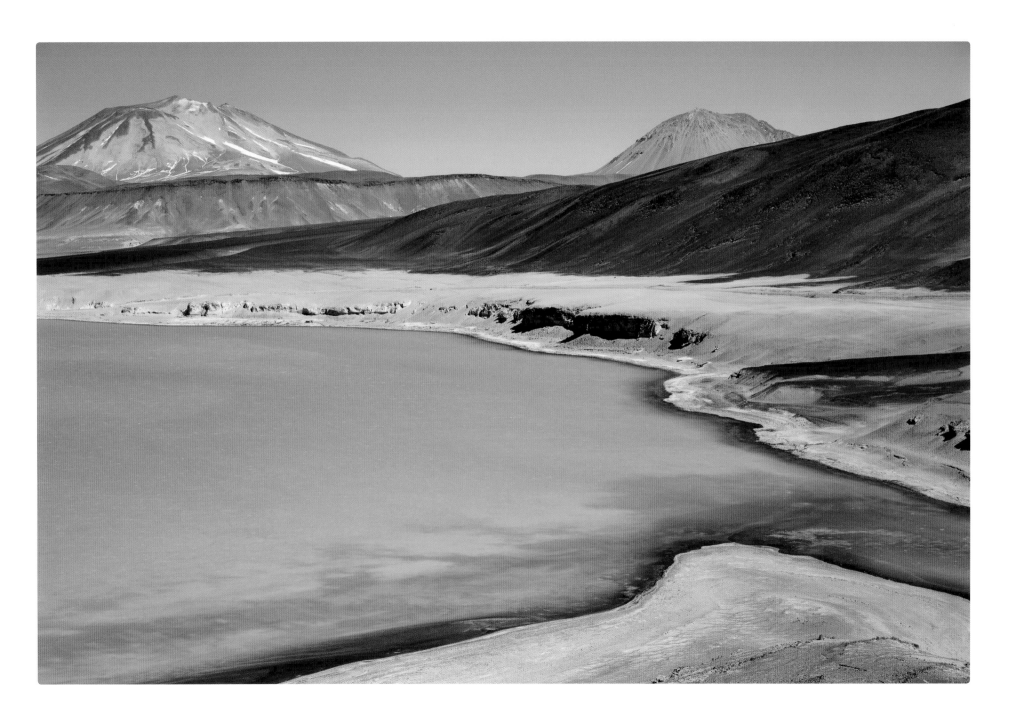

Laguna Verde, Chile

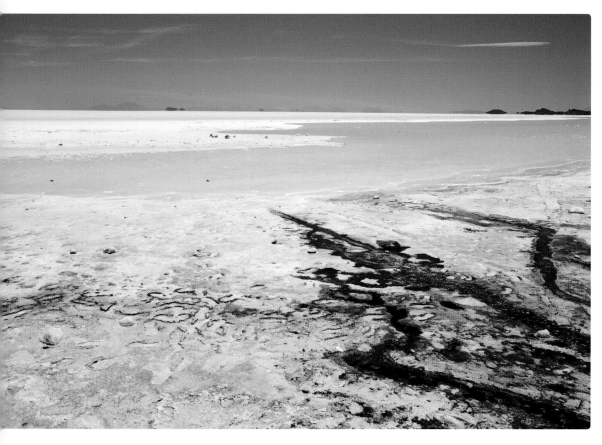

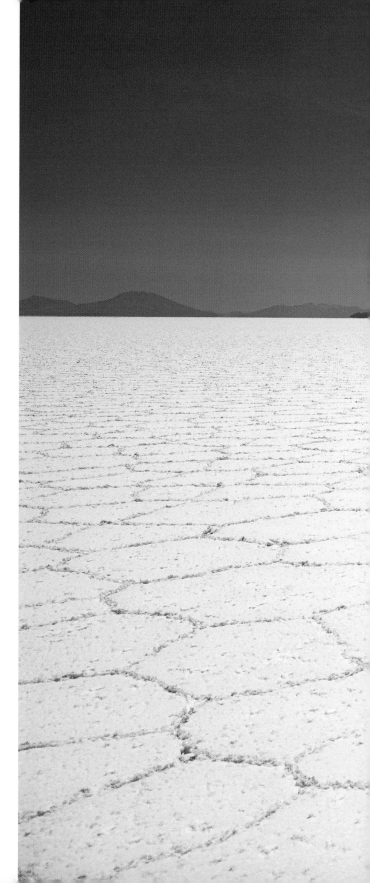

Salt on our skin. Salar de Uyuni stretches out—salt as far as the eye can see. It is probably one of the most extreme forms a salt lake can take. The ground at the access points to the lake is soft and squishy, while on the lake itself, several feet of salt as hard as concrete cover the water below. The world's largest lithium reserves are buried here. Luckily, it is only being extracted in a small area of this lake so far. Yet it would be naïve to think that these extraction works will not grow over time. All we can really hope for is that once profits are split and redistributed, Bolivians will receive their fair share.

Salz auf unserer Haut. Salz, so weit das Auge reicht – und sicher die extremste Form des Salzsees – ist der Salar de Uyuni. Auf einer der Zufahrten zum See ist es noch matschig, während auf dem See viele Meter betonharten Salzes das Wasser darunter verbergen. Hier lagern die größten Lithiumvorräte der Erde. Zum Glück betrifft der Abbau bisher nur einen sehr kleinen Teil des Sees. Doch es wäre naiv zu hoffen, dass dieser sich nicht vergrößern wird. Was bleibt, ist, Bolivien eine glückliche Hand bei der Verteilung der Gewinne zu wünschen.

Salar de Uyuni, Bolivia

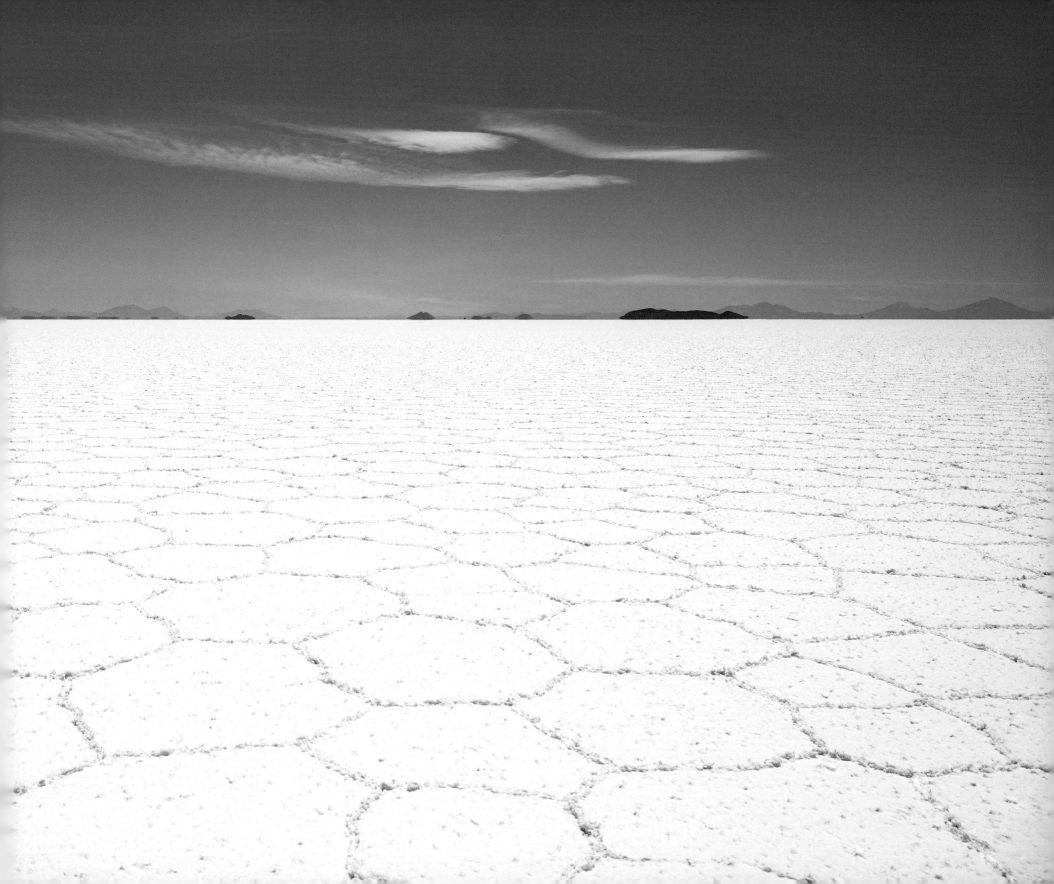

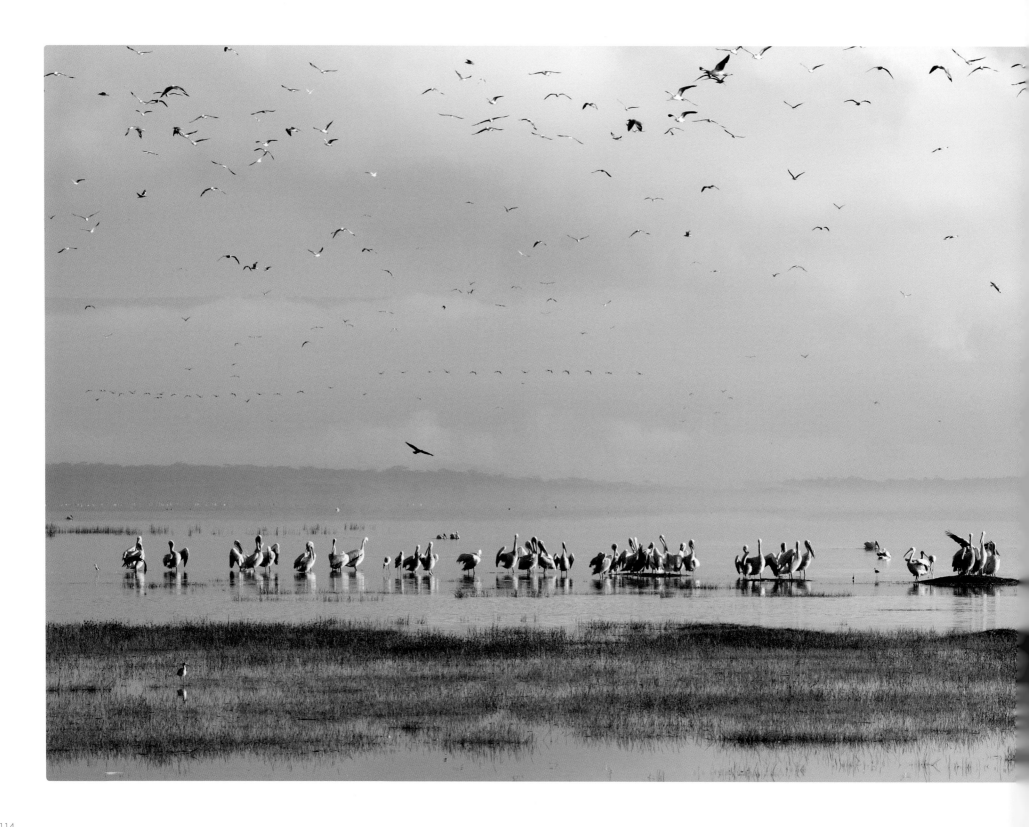

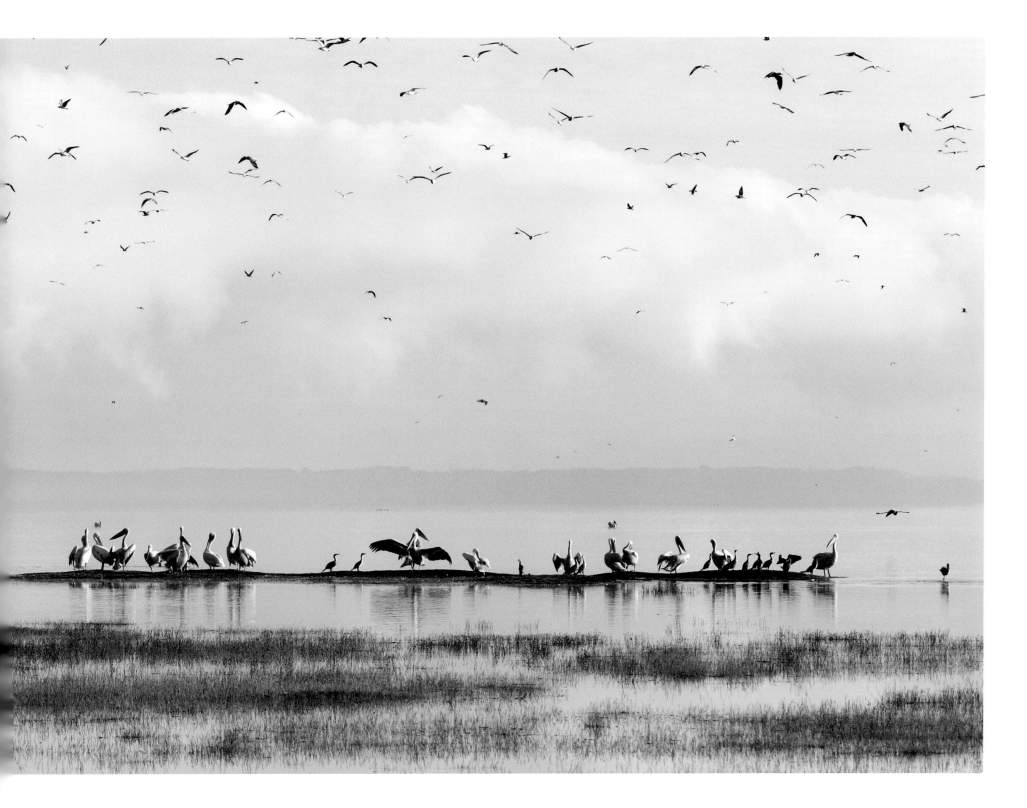

Lake Nakuru, Kenya

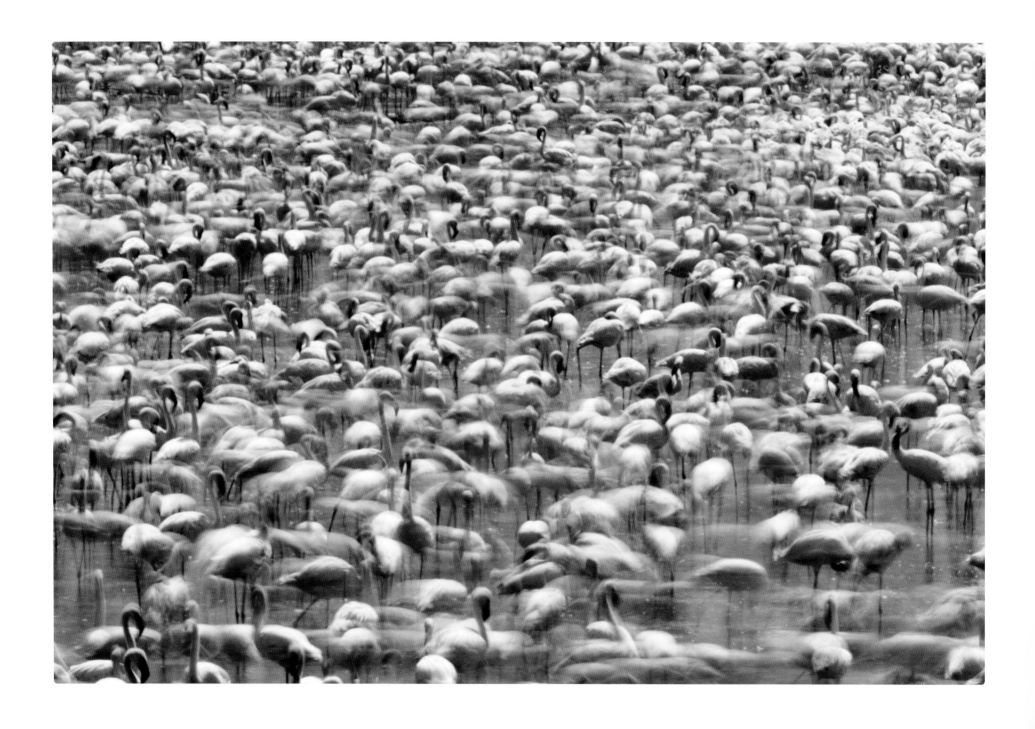

Lake Bogoria, Kenya

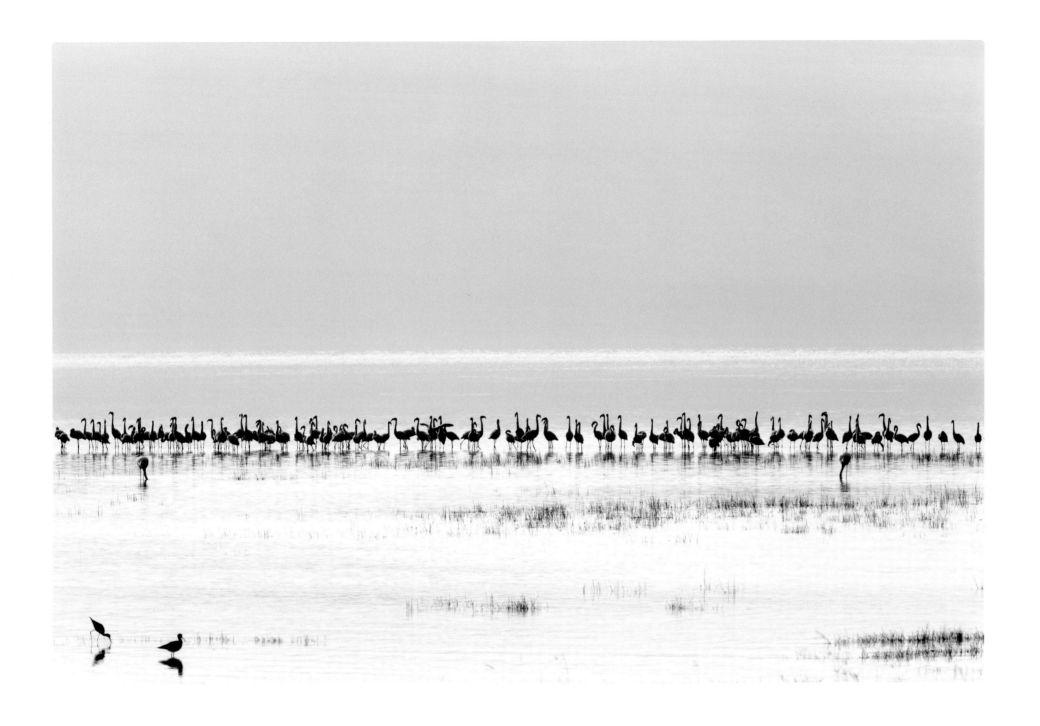

Lake Nakuru, Kenya

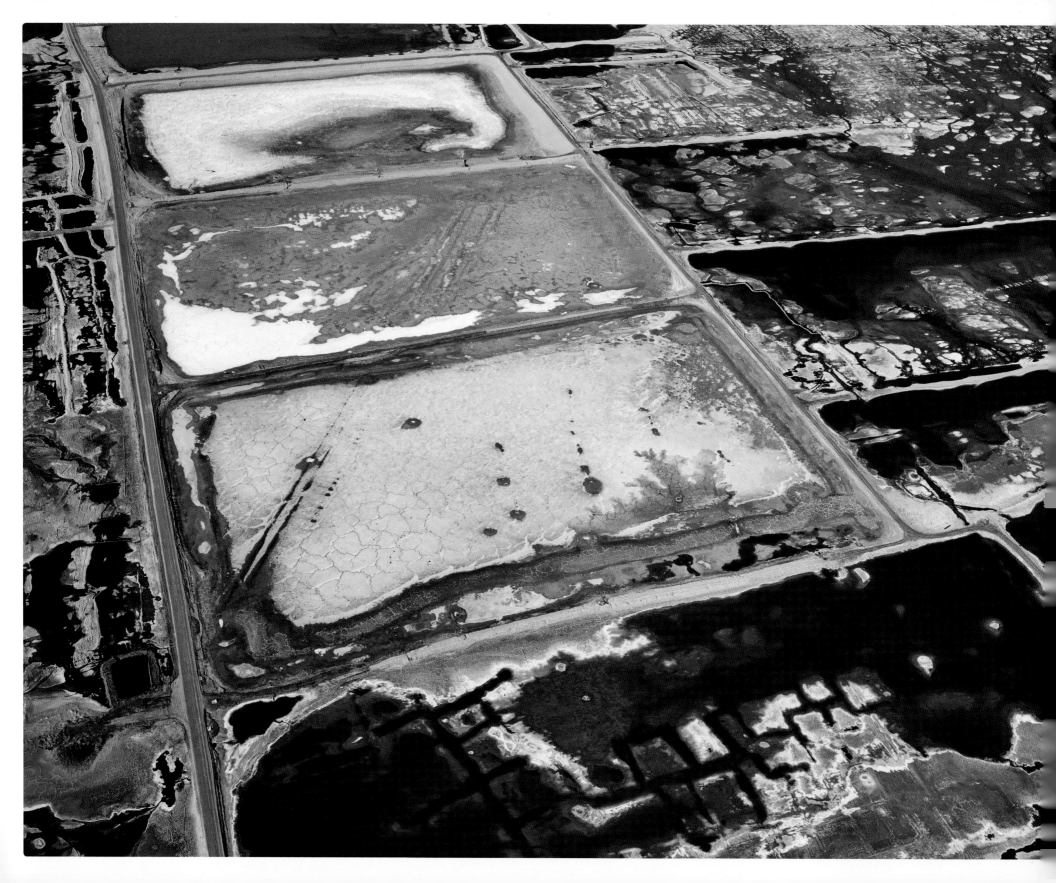

BEWILDERING BEAUTY

VERSTÖRENDE SCHÖNHEIT

The German philosopher Walter Benjamin wrote in his essay *A Short History of Photography*, in which he discussed the question whether photography can be art: "Nothing can be a testament to culture without at the same time being a testament to barbarism." Owens Lake is a prime example that supports this claim. It is a testament to beauty which does not distinguish between categories like good or evil.

The lake in Owens Valley, California, had been used for irrigation by the surrounding farms for a long time. It was not until Los Angeles began diverting its waters on a larger scale that the lake dried out altogether. To make matters worse, salt and mineral mining was widespread in the surrounding mountains. The consequences were disastrous. Dust storms covered the area in toxic clouds, and incidents of cancer and other serious diseases in humans living nearby rose. Yet only when the military began to protest, because the dust was damaging their airplanes, was a plan of action developed.

After a series of measures which at first seemed to make the situation even worse, human interference at Owens River has been minimized and the lake's waters are no longer redirected. It is still far from restored, though; nature's systems and man-made structures now exist side by side. When seen from above, various colors and shapes compete with one another and command the viewer to press the shutter button.

Der deutsche Philosoph Walter Benjamin, der mit seiner Schrift *Kleine Geschichte der Photographie* zur Diskussion, ob Fotografie Kunst sein kann, beigetragen hat, schrieb: „Es ist niemals ein Dokument der Kultur, ohne zugleich ein solches der Barbarei zu sein." Der Owens Lake ist ein Paradebeispiel dafür. Er ist ebenso ein Beleg für die Schönheit, welche Kategorien wie gut oder böse nicht kennt.

Der See im kalifornischen Owens Valley wurde schon früh zur Bewässerung der umliegenden Farmen angezapft. Aber erst nachdem die Metropole Los Angeles das Wasser in großem Stil abgezweigt hatte, trocknete der See vollständig aus. Hinzu kamen Salz- und Mineralienabbau jedweder Art in den umliegenden Bergen. Das hatte fatale Folgen. Staubstürme legten einen hoch toxischen Dunst über die Gegend, Menschen erkrankten gehäuft an Krebs und anderen schwerwiegenden Leiden. Erst nachdem sich auch das Militär eingeschaltet hatte, weil der Staub ihre Flugzeuge gefährdete, entwickelte man einen Plan dagegen.

Nach einer Reihe von Maßnahmen, die zum Teil die Lage eher verschlimmerten, lässt man heute dem Owens River und damit dem See einen Teil des Wassers. Noch weit entfernt davon, renaturiert zu sein, gehen menschengemachte und natürliche Strukturen ineinander über. Aus der Luft betrachtet wetteifern Formen und Farben um die Aufmerksamkeit und die Macht des Fingers am Auslöser.

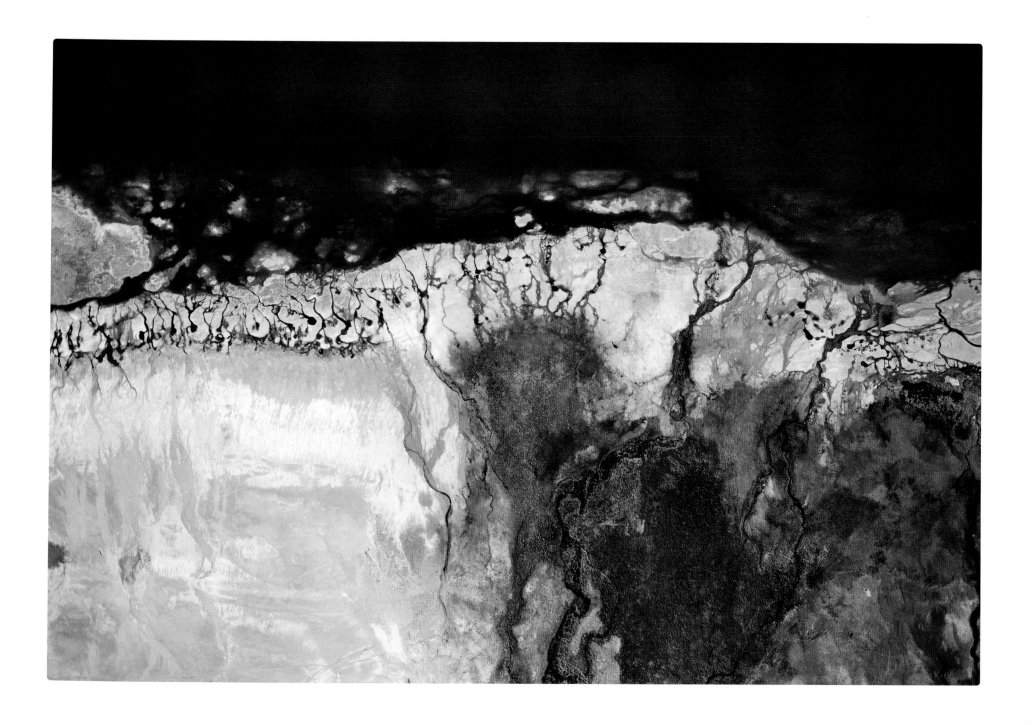

Owens Lake, California, USA

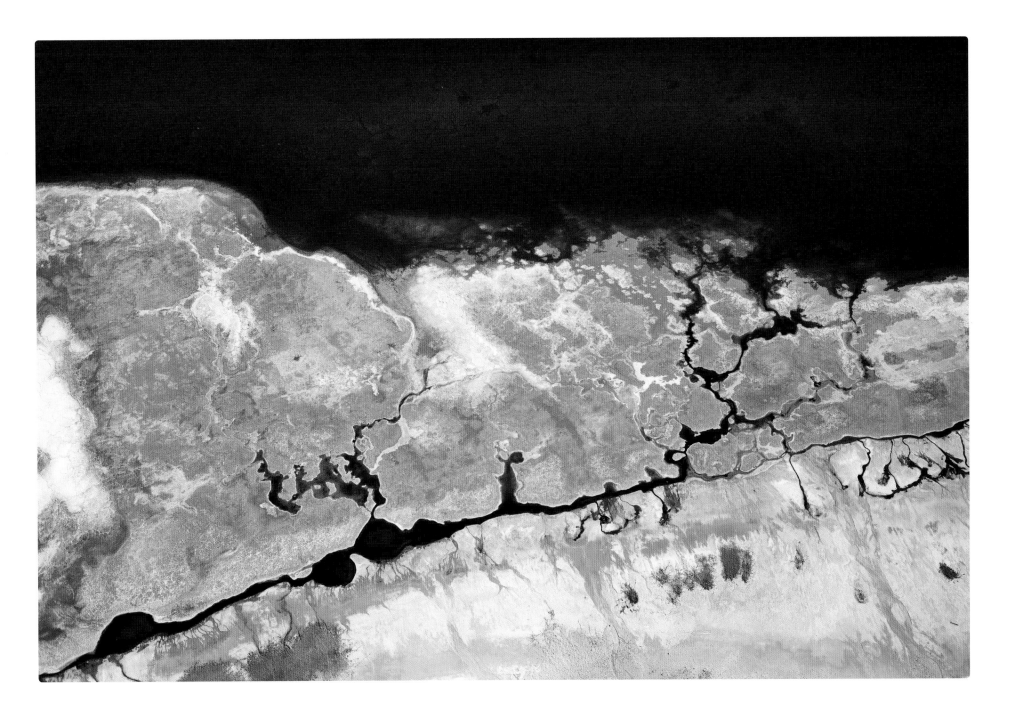

Owens Lake, California, USA

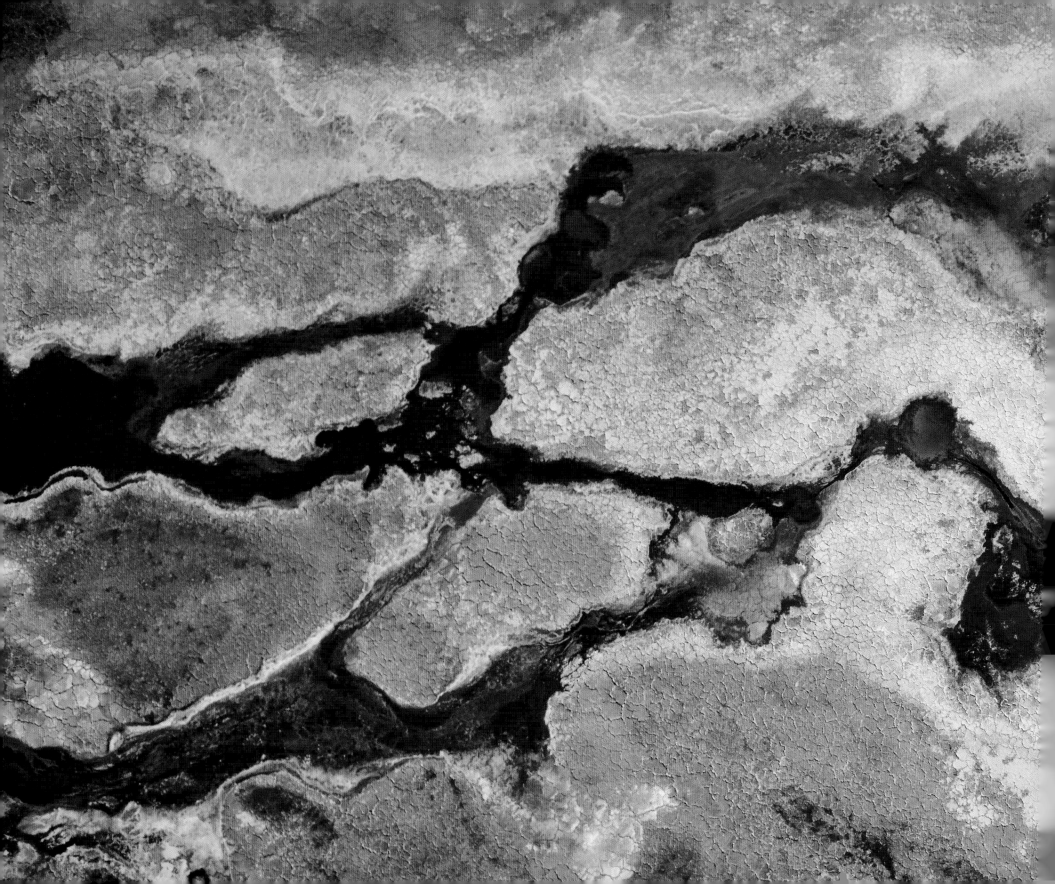

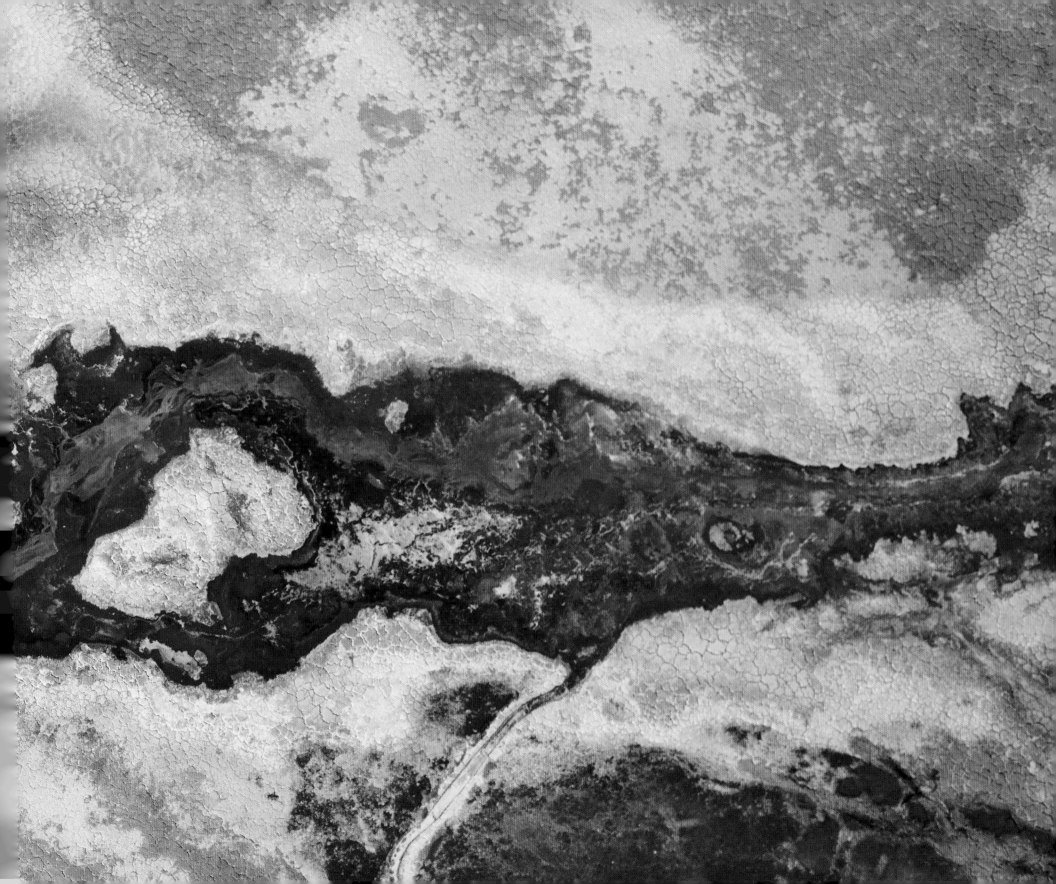

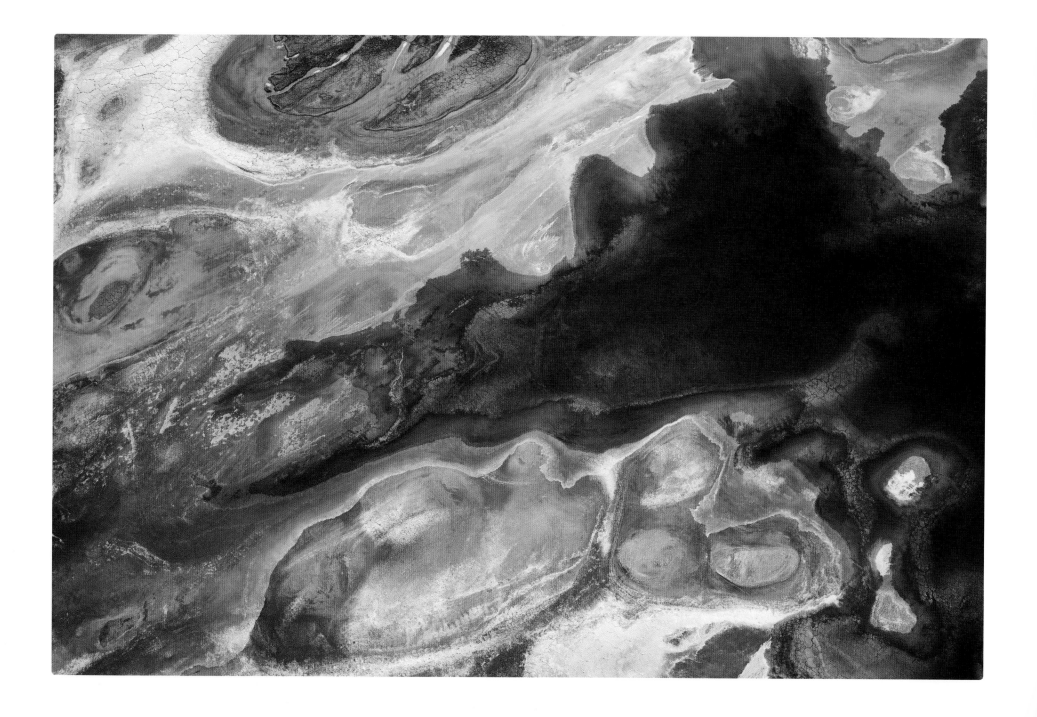

Owens Lake, California, USA

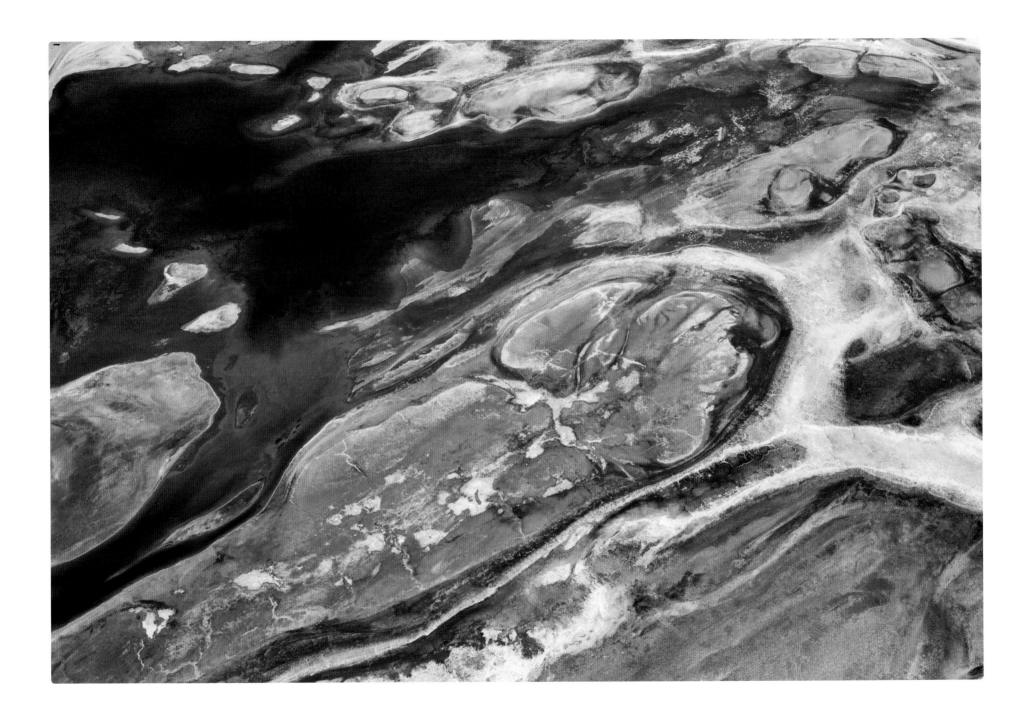

Owens Lake, California, USA

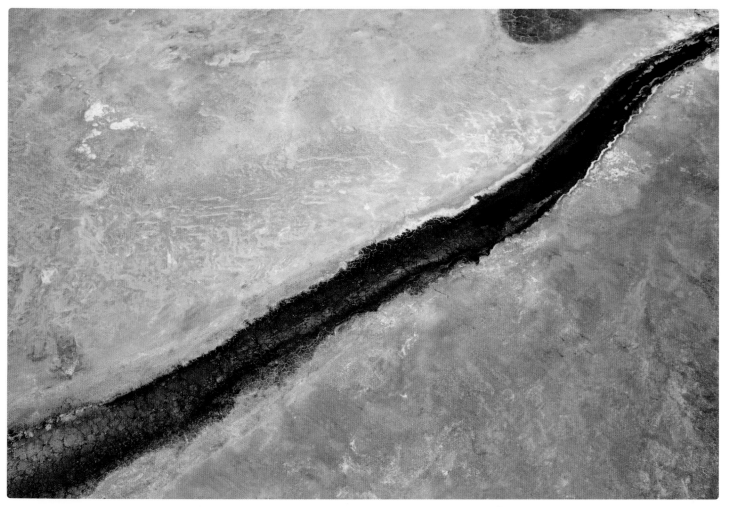

Such is life. You should never leave traces when taking photographs. Unfortunately, I did not quite manage to follow this rule when I was at Lake Owens. Just after taking the first photograph, my camera lense came loos and fell. I saw it vanishing from the corner of my eyes; then it disappeared and probably shattered into a millio pieces. Such is life. Luckily, I had brought a secret weapon: my extremely sharp 40mm pancake lens. The pilot had to change the altitude a bit in order for me to take clear pictures with the new lens but the photoshoot still took place. In aerial photography, the clock is ticking and every minute counts.

Shit happens. Man soll keine Spuren beim Fotografieren hinterlassen. Das ist mir dort nicht ganz gelungen. Gleic nach den ersten Bildern über dem Zielgebiet stürzte mein Objektiv ab. Ich sah es gerade noch aus dem Augenwinkel, bevor es mit Sicherheit in tausend Teile zerschmettert wurde. Shit happens! Zum Glück hatte ich meine Geheimwaffe noch mit an Bord. Das ist ein 40-mm-Pancake-Objektiv und seines Zeichens extrem scharf. Der Pilot musste zwar deswegen mehr in der Hö variieren, aber das Shooting war gerettet. Denn bei Luft aufnahmen läuft die Uhr und jede Minute zählt.

Owens Lake, California, USA

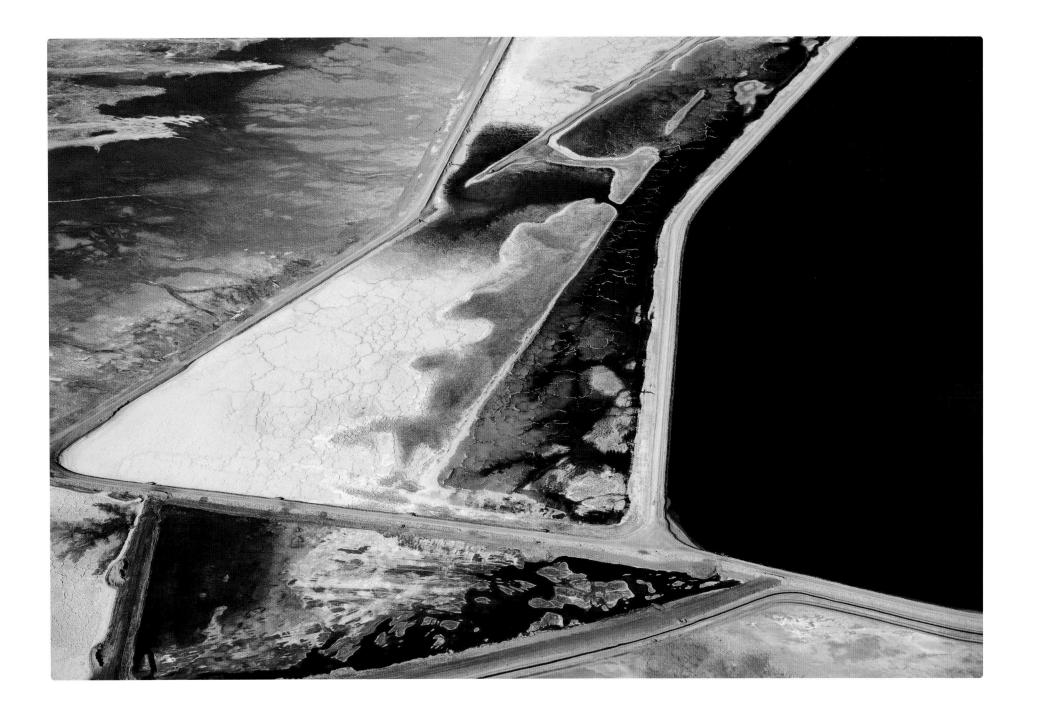

Owens Lake, California, USA

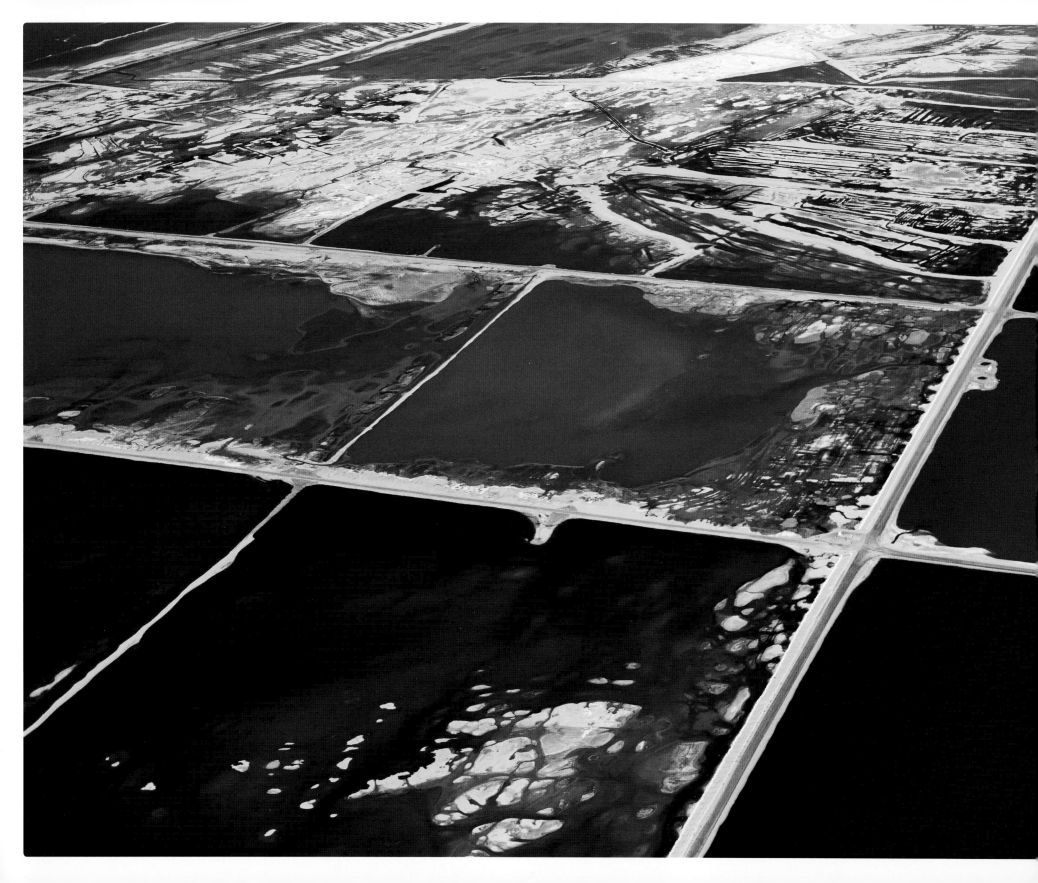

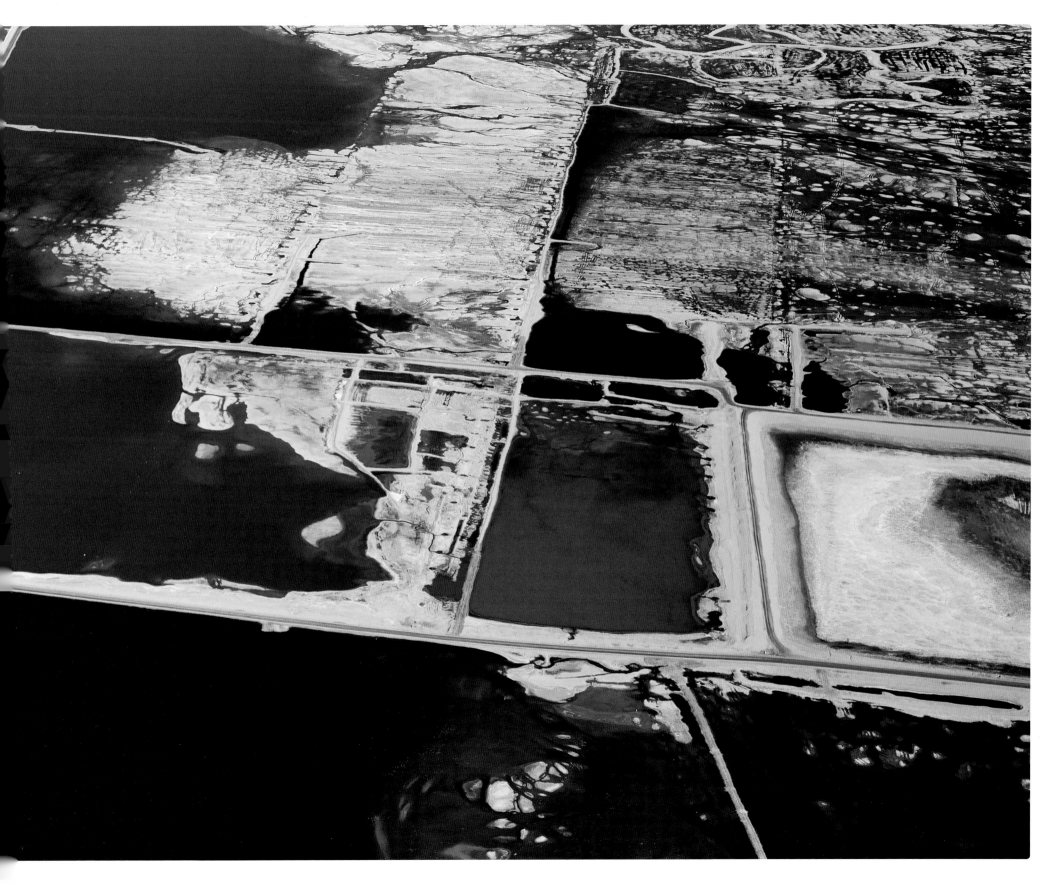

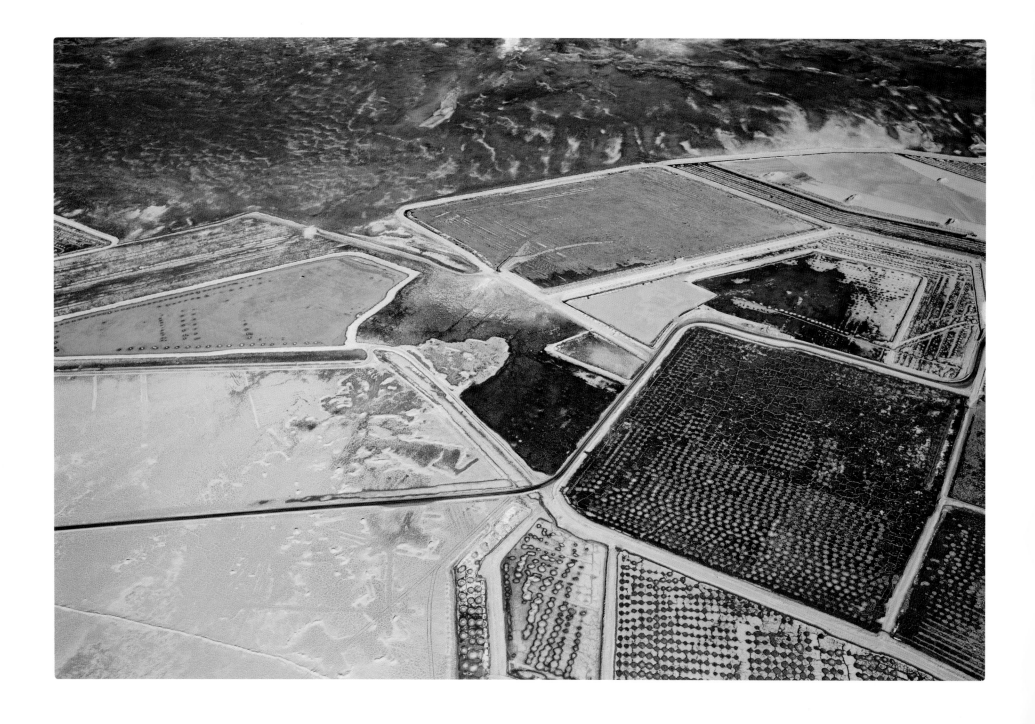

Owens Lake, California, USA

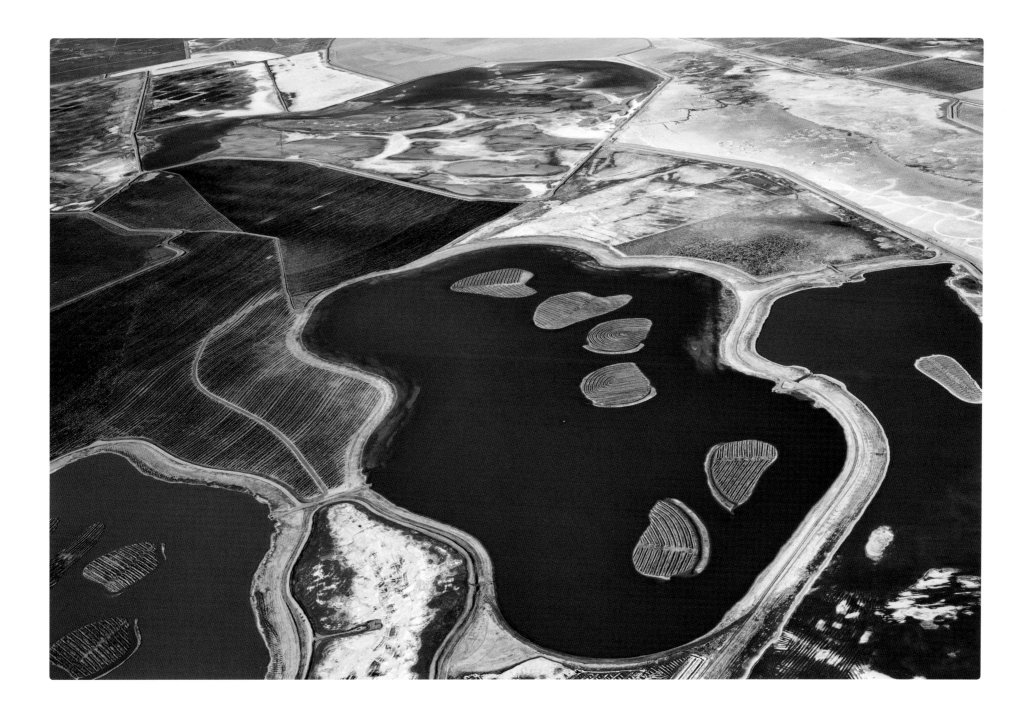

Owens Lake, California, USA

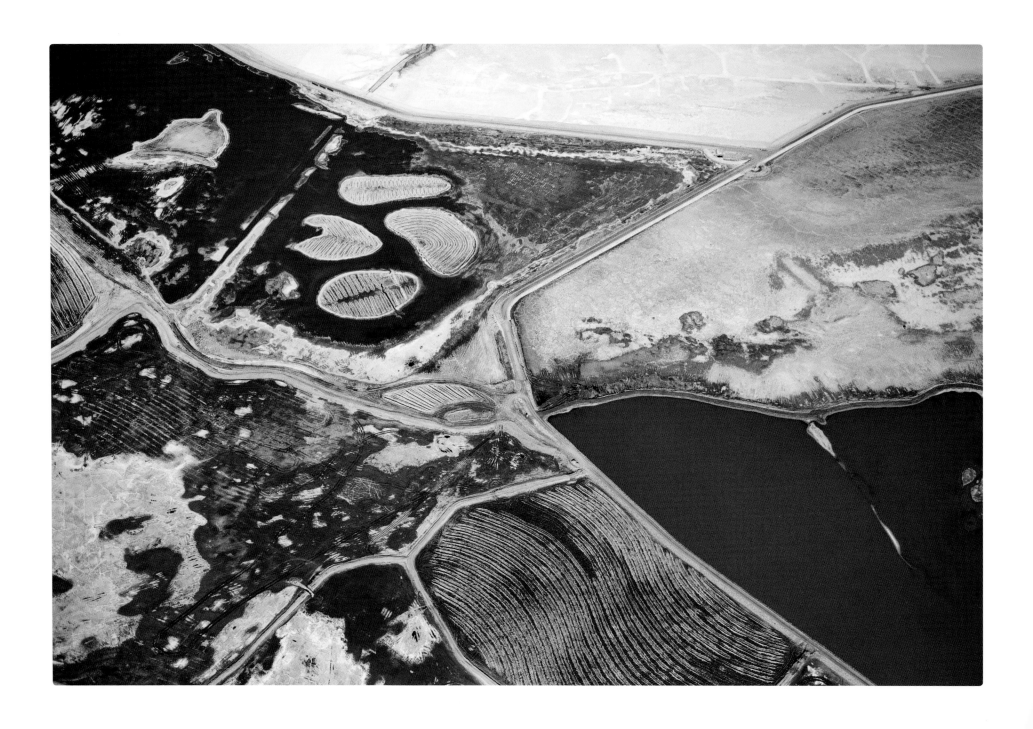

Owens Lake, California, USA

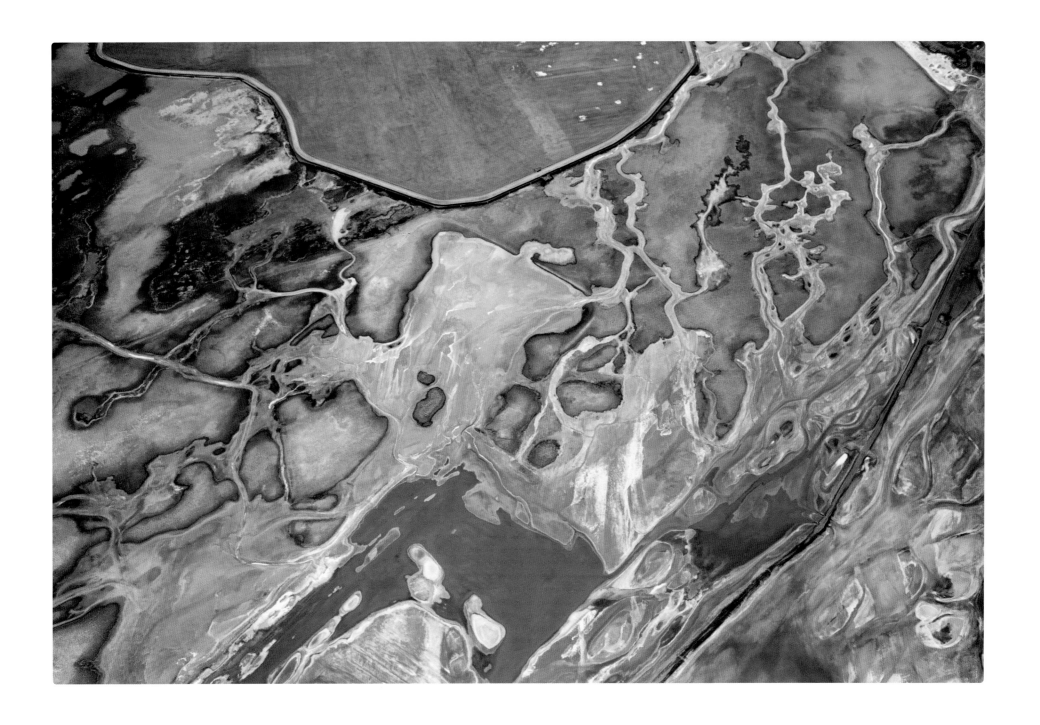

Owens Lake, California, USA

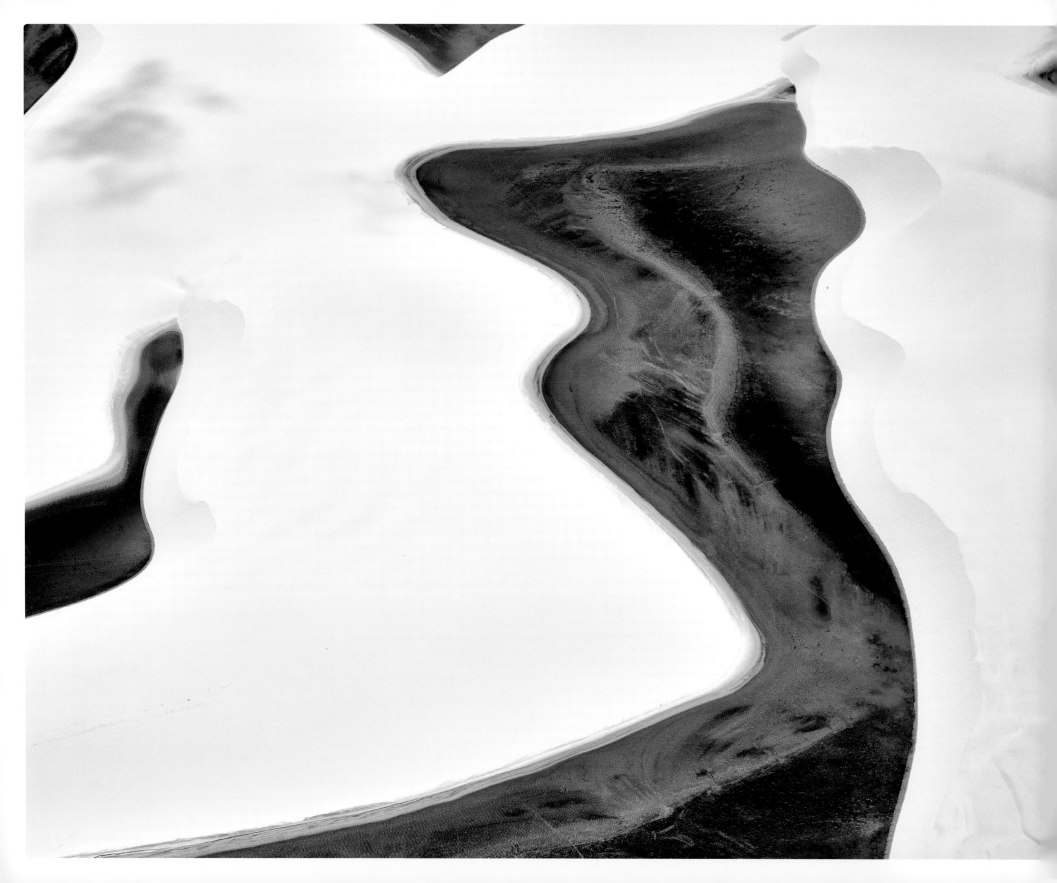

ALL ARE ONE

ALLE SIND EINER

Lençois means bed sheet in Portuguese, and it is easy to see where this name comes from. Each year during the rainy season from January until July, the basins between these bright white sand dunes fill with rain water. Over the course of the second half of the year, they slowly dry out again. An impermeable layer at the bottom of the lake prevents the water from being absorbed by the ground immediately, and so each year, Brazil's only desert turns into a vast landscape of lakes which changes almost daily. The contrast between the lakes' individual water levels is stunning. Some are still filled to the brim with fresh water, others are almost dry already. This means that soluble minerals occur in higher concentration; algae, bacteria, and excrement left behind by herds of goats also contribute to the discoloration in the lakes with more water loss. Brown streams heavy with sediments and smaller rivers coming from the Amazon area cut through the landscape.

Yet what appears to be several small lakes is in fact one large lake. Its waterline is simply the subterranean water level, with dunes emerging here and there. A small detail that has far-reaching effects. What a glorious feeling it is to jump into one of the many lakes after having taken photographs at temperatures of 95 degrees with no shade anywhere! Being able to go for a swim makes this small—roughly 44 by 15 miles—patch of sandy desert in north-eastern Brazil a very special place; it is the only desert of this kind in the world.

Lençois bedeutet Bettlaken im Portugiesischen, und beim Betrachten der folgenden Bilder wird klar, woher dieser Name kommt. Jedes Jahr füllen sich die Senken der strahlend weißen Sanddünen in der Regenzeit ab Januar bis in den Juli mit Regenwasser, um dann im weiteren Verlauf des Jahres langsam wieder auszutrocknen. Eine wasserundurchlässige Schicht darunter verhindert ein Versickern und Brasiliens einzige Wüste verwandelt sich im Jahreszyklus in eine riesige Seenlandschaft, die sich beinahe täglich verändert. Der besondere Reiz ist das Zusammenspiel von mehr oder weniger gefüllten Seen. Während die einen noch voll Frischwasser sind, sind andere schon halb ausgetrocknet. Dadurch steigt die Konzentration gelöster Mineralien; Algen, Bakterien und von Ziegen der hier lebenden Menschen eingebrachte Exkremente verstärken die farbliche Veränderung. Außerdem strukturieren braune, sedimentbeladene Bäche und kleinere Flüsse, aus dem Amazonasgebiet kommend, die Szenerie.

Was nach vielen kleinen Seen aussieht, ist aber in Wirklichkeit ein großer. Die Wasserlinie ist nämlich nichts anderes als der Grundwasserspiegel, der von den Dünen unterbrochen wird, weil sie darüber hinausragen. Kleine Ursache, große Wirkung. Was für ein Spaß, nach schweißtreibender Fotografie bei 35 Grad im nicht vorhandenen Schatten in einen der zahlreichen Seen zu springen! Auch das macht die circa 70 mal 25 Kilometer kleine Sandwüste ganz im Nordosten Brasiliens besonders und weltweit einzigartig.

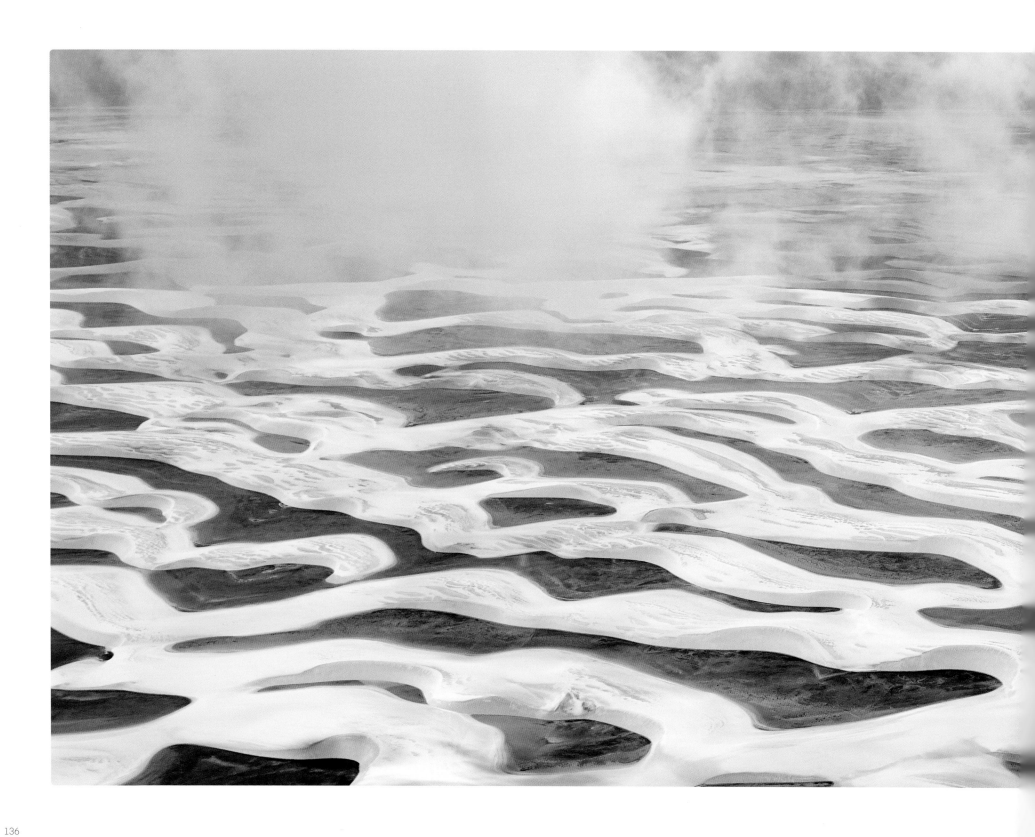

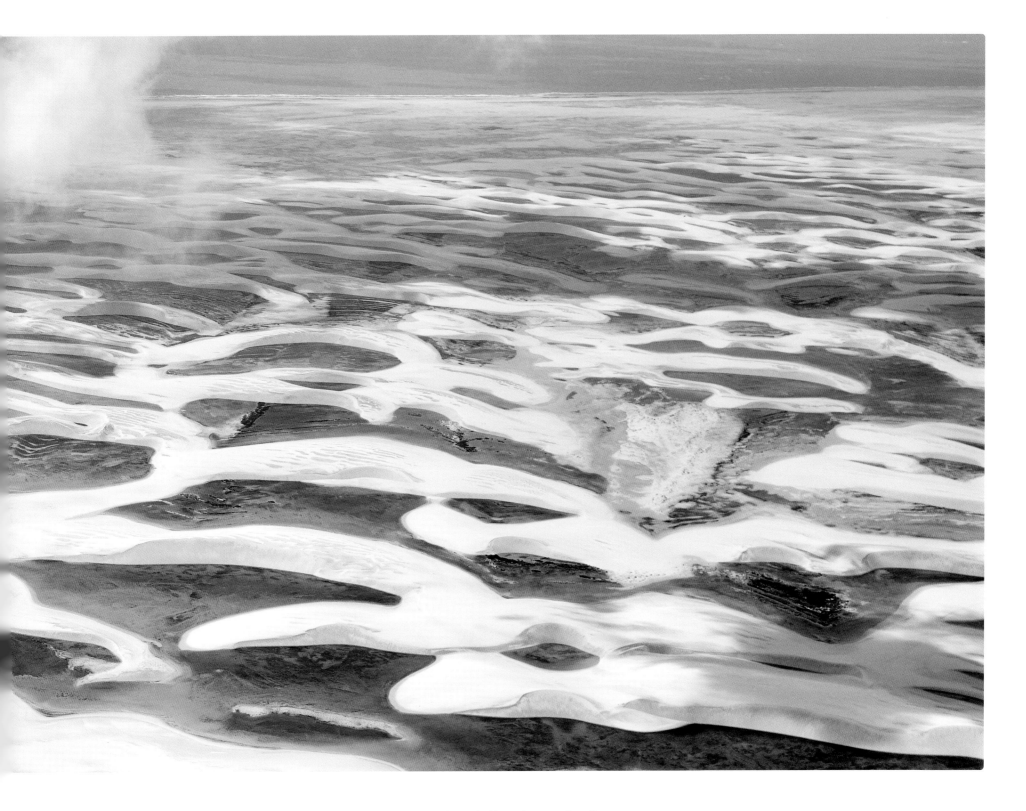

Lençois Maranhenses, Brazil

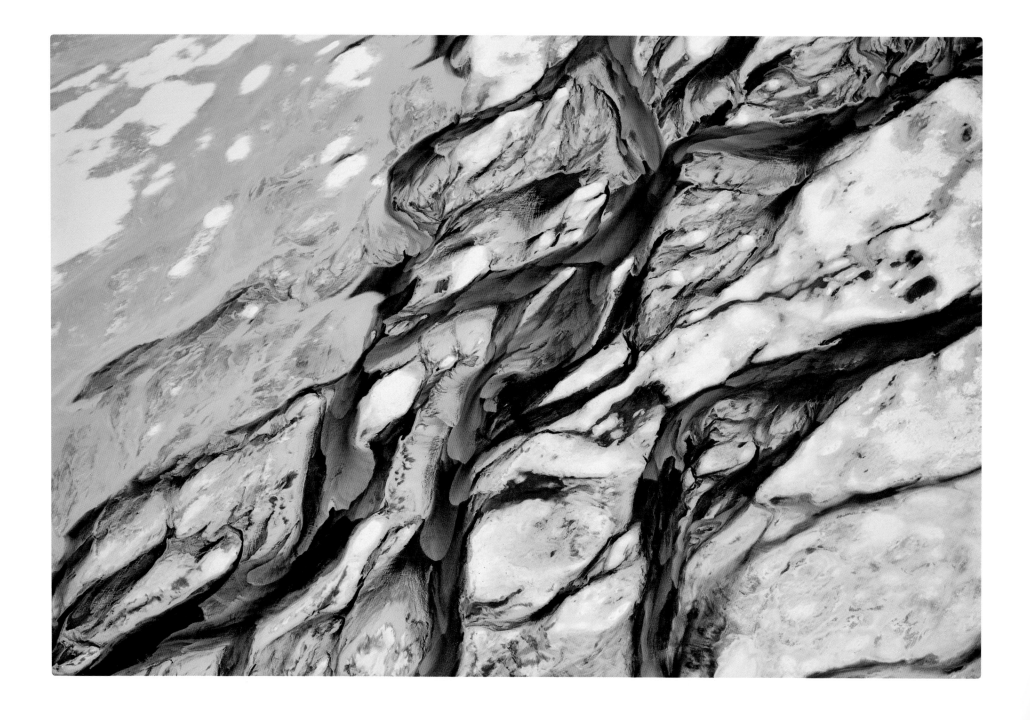

Lençois Maranhenses, Brazil

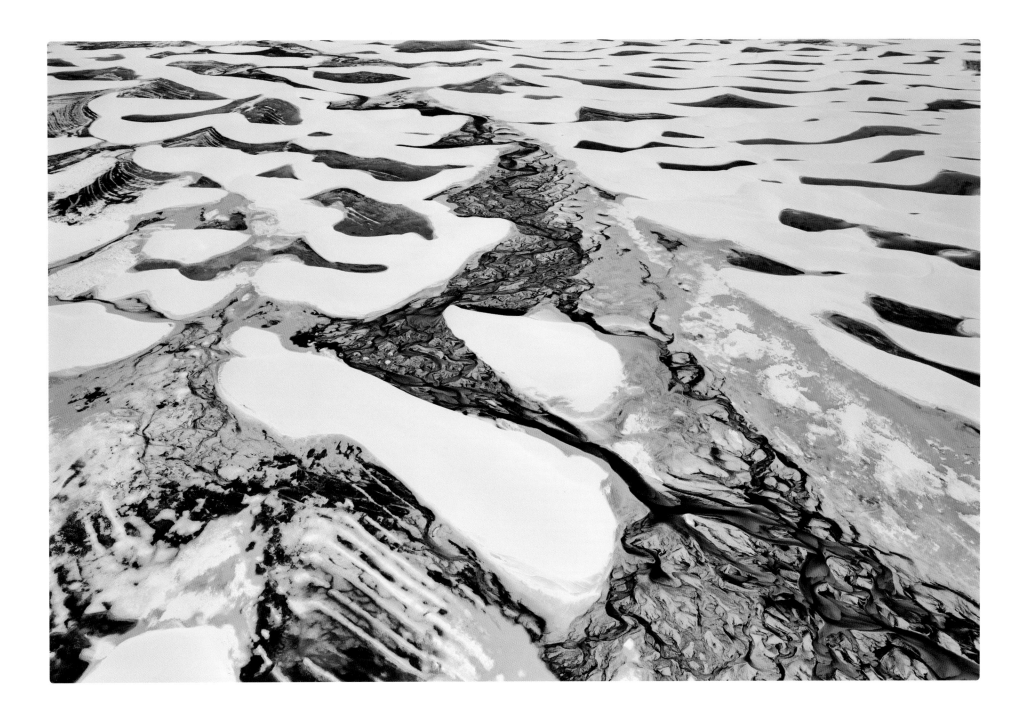

Lençois Maranhenses, Brazil

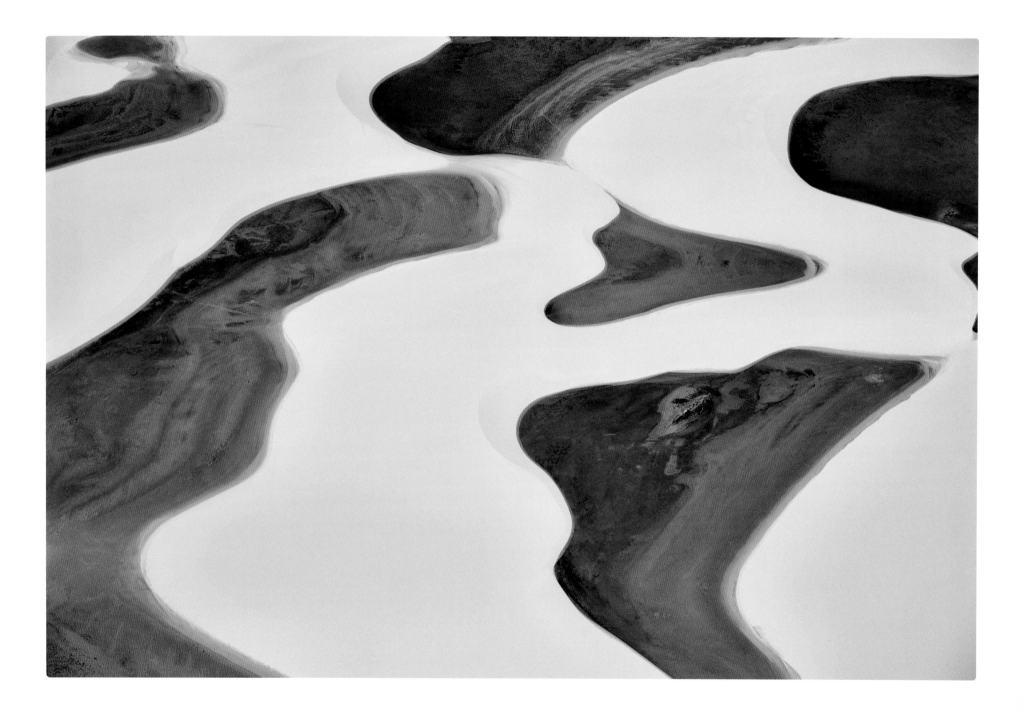

Lençois Maranhenses, Brazil

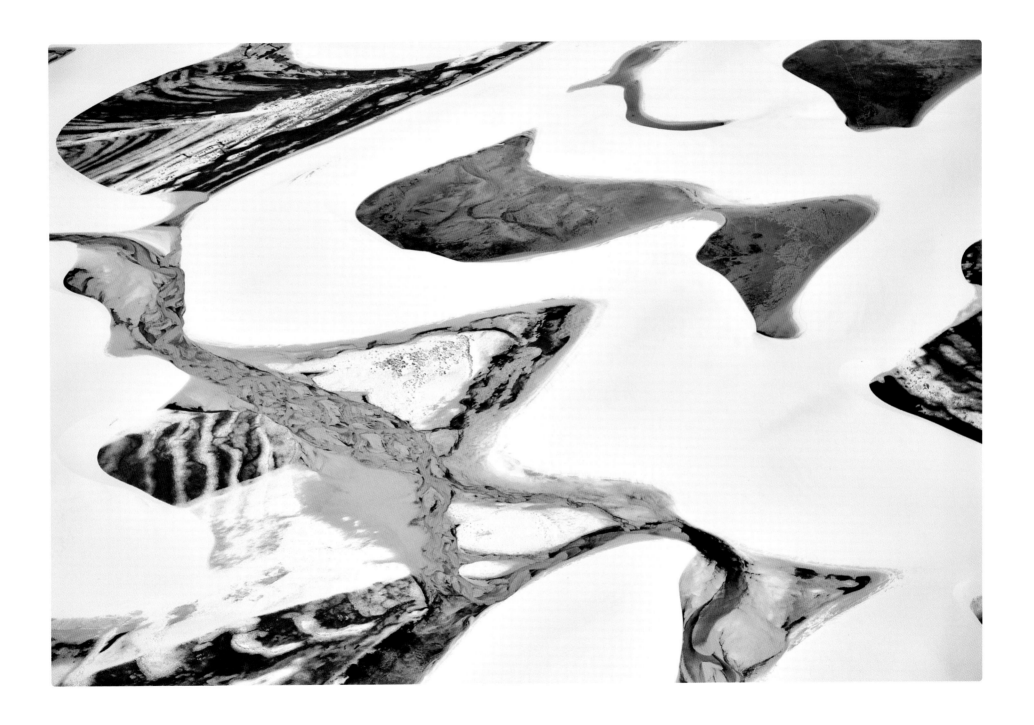

Lençois Maranhenses, Brazil

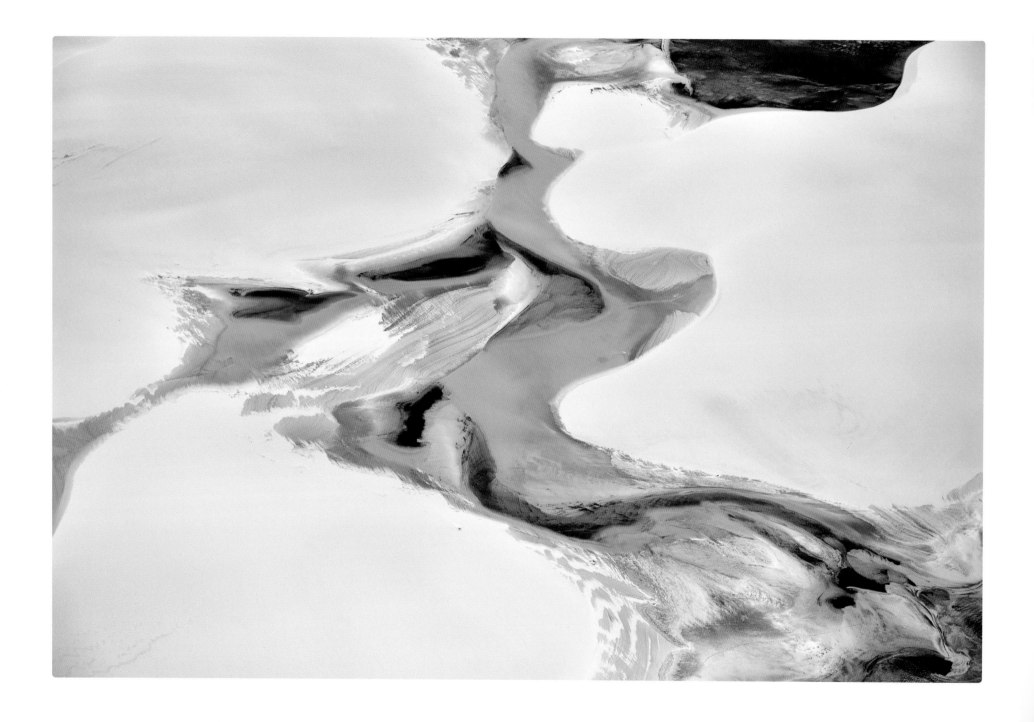

Lençois Maranhenses, Brazil

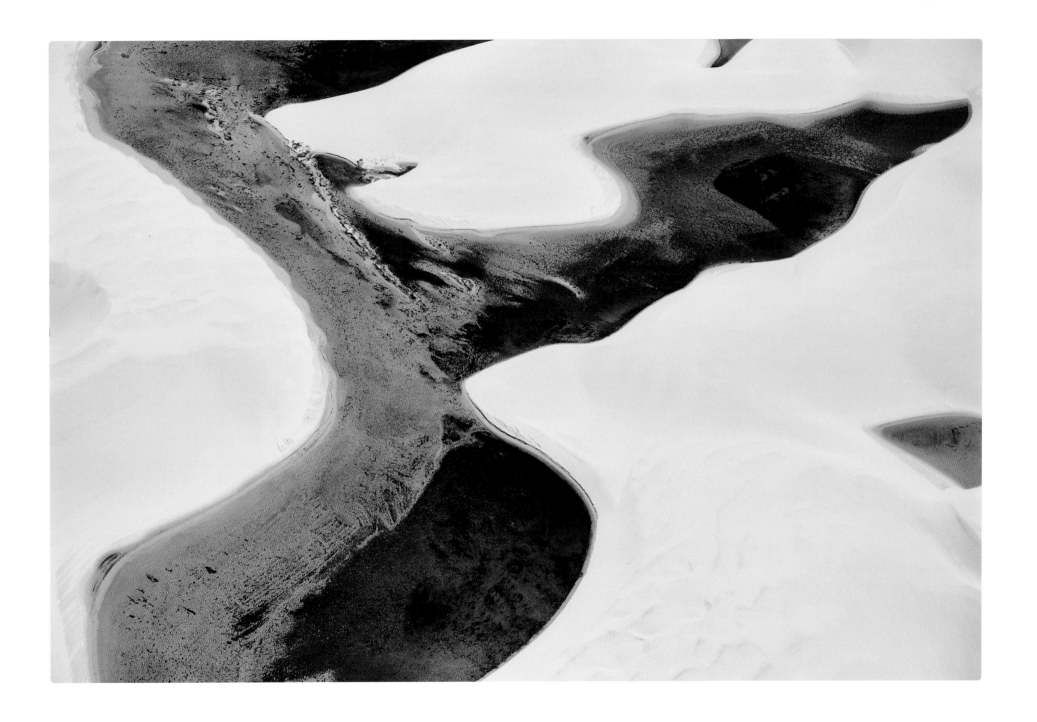

Lençois Maranhenses, Brazil

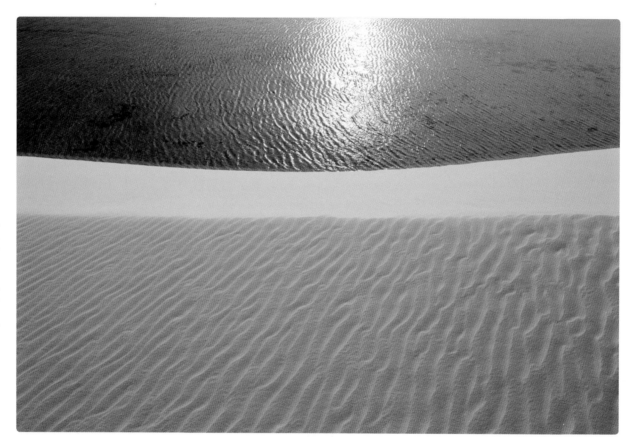

Similarities are not a coincidence.
The dunes' fine sand looks just like water, and both sand and water display very similar structures.

Ähnlichkeiten sind nicht zufällig.
Der feine Sand der Dünen verhält sich sehr ähnlich wie Wasser, was man an den identischen Mustern gut erkennen kann.

Lençois Maranhenses, Brazil

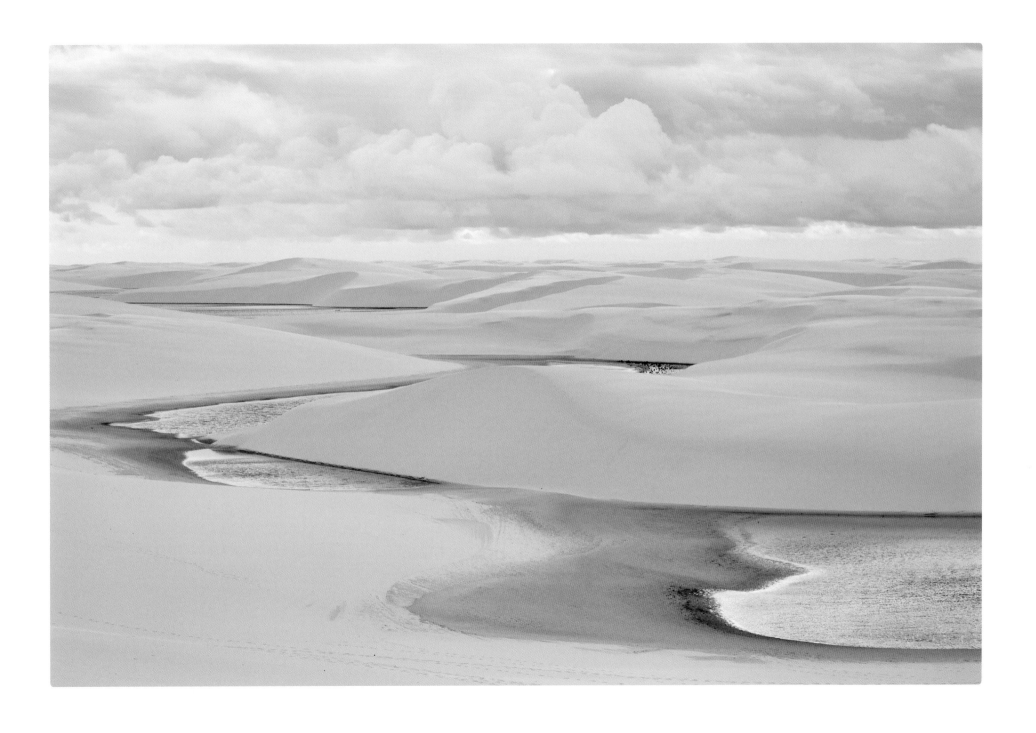

Lençois Maranhenses, Brazil

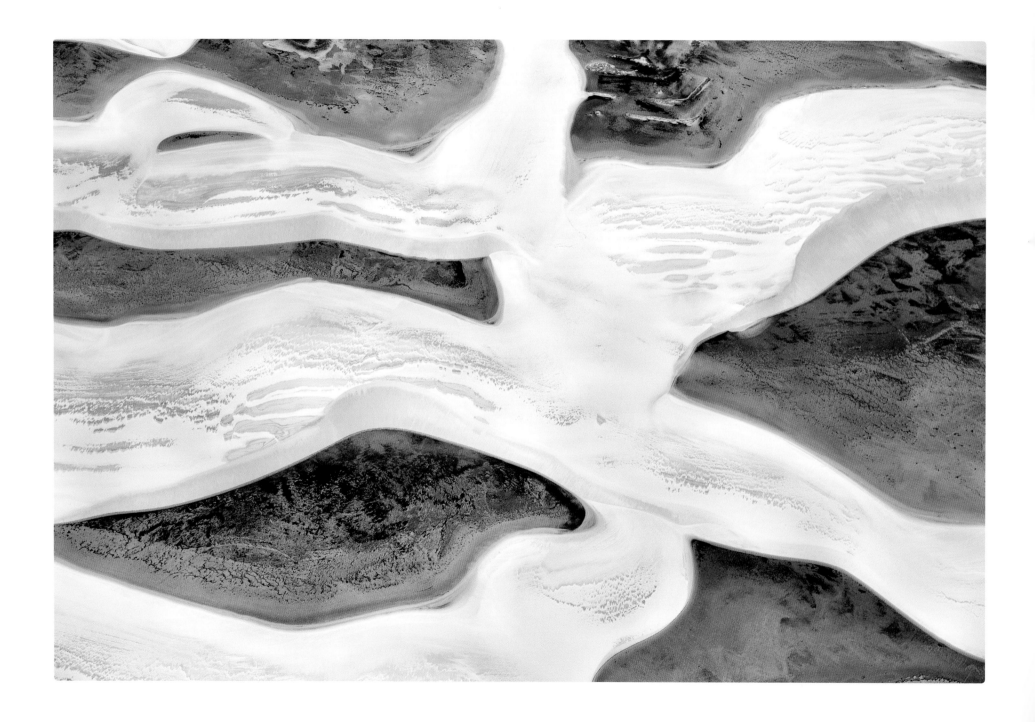

Lençois Maranhenses, Brazil

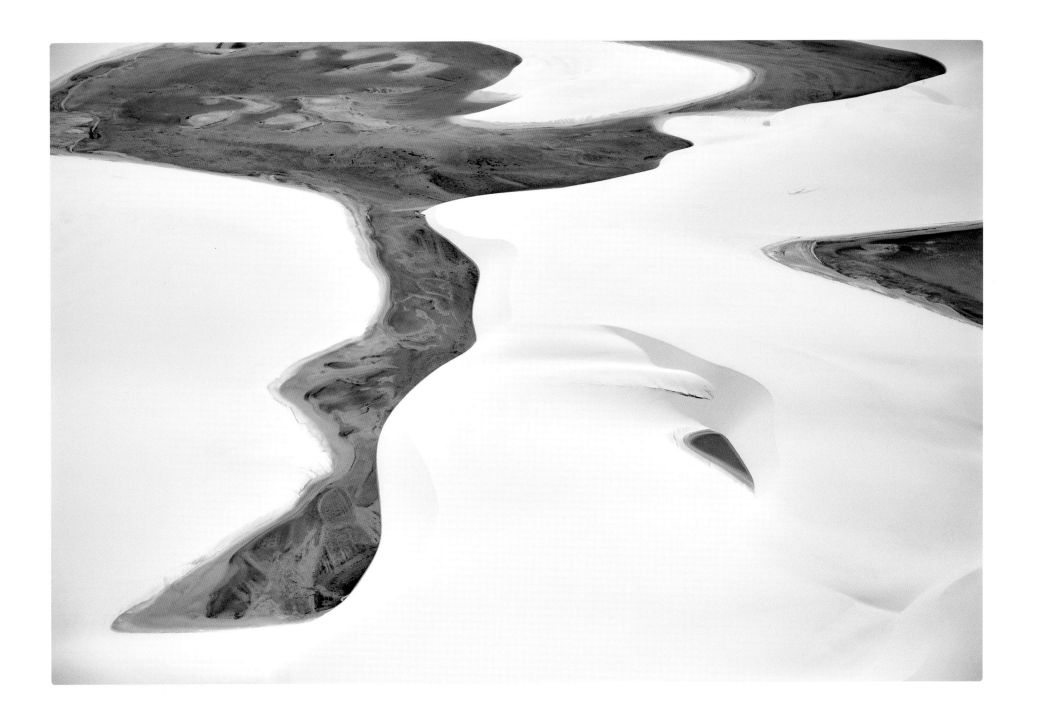

Lençois Maranhenses, Brazil

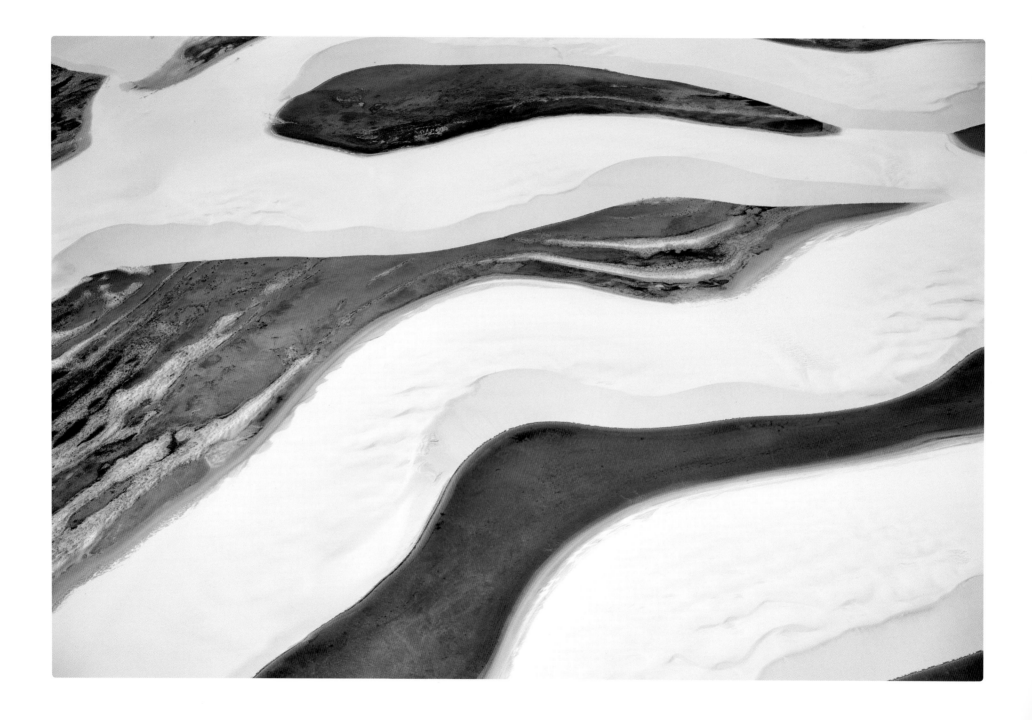

Lençois Maranhenses, Brazil

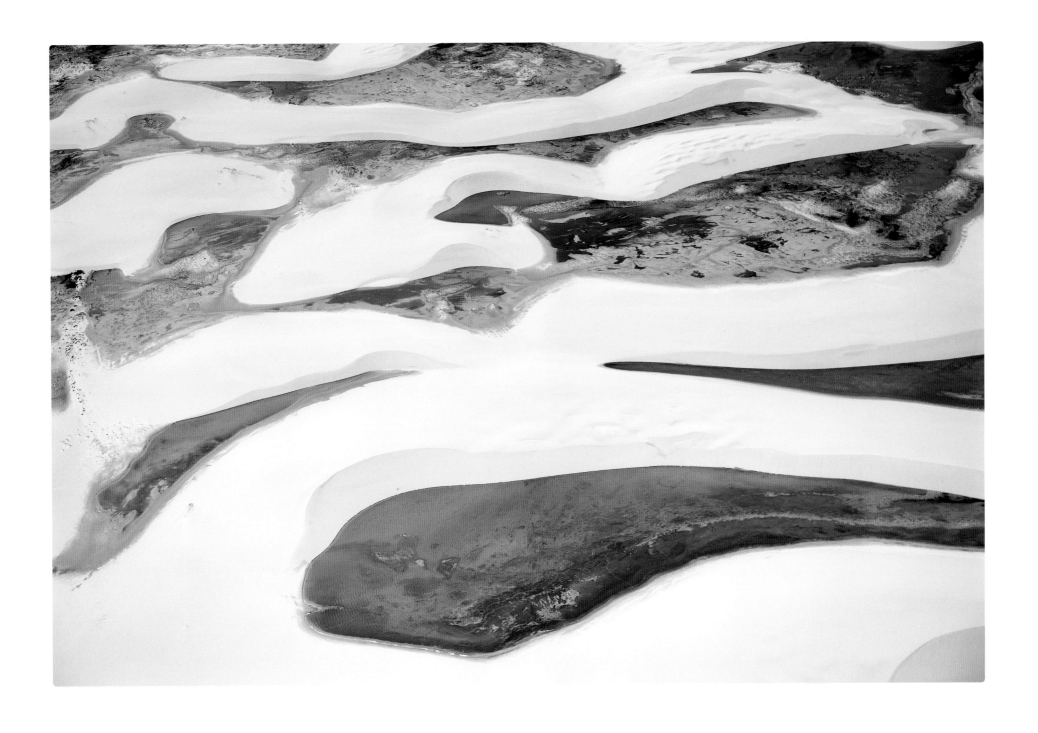

Lençois Maranhenses, Brazil

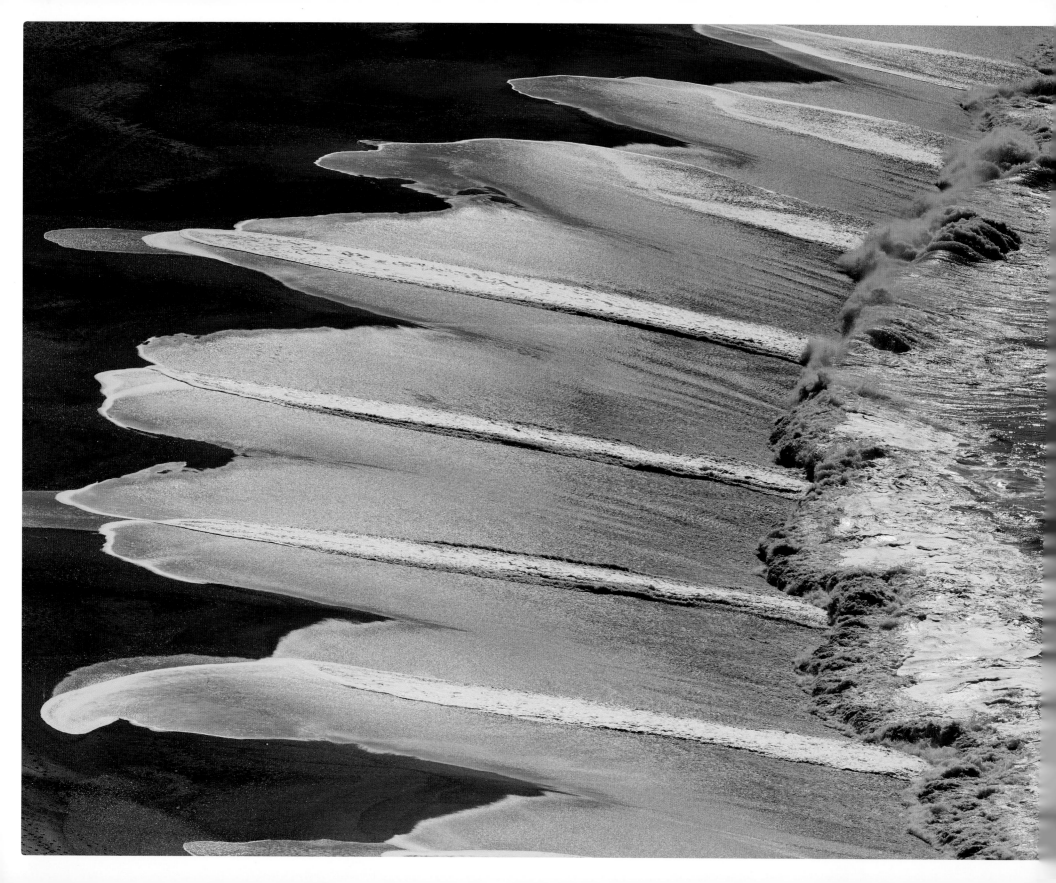

TRUE GREATNESS THE SEA

WAHRE GRÖSSE MEER

Our perception of the sea is mostly limited to three of its aspects: the coastline, the straight or very slightly curved horizon, and the seemingly endless void we are confronted with due to the fact that there is no visible opposite coastline. Nothing blocks the view, there is no beginning and no end. The point where water and land meet—the coast—defines the location and is the only point of reference for us to determine where we are. Dynamic movement, the waves' peaks and troughs, this immediate, unadulterated experience of the elements at whose mercy we find ourselves; anyone who has ever been sea sick knows this feeling all too well.

Unsere Wahrnehmung der Meere basiert im Wesentlichen auf drei Dingen: der Küste, dem geraden, eigentlich leicht gebogenen Horizont und der scheinbaren Endlosigkeit durch das fehlende Gegenüber. Nichts verstellt den Blick, kein Anfang und kein Ende. Erst der Punkt, an dem Wasser und Land aufeinandertreffen – die Küste –, definiert und klärt den Ort, gibt Hinweise darauf, wo man sich befindet. Mitten auf dem Meer könnte das wohl niemand ohne Hilfsmittel erkennen. Bewegung, Dynamik, das Auf und Ab der Wellen, das direkte Empfinden der Naturgewalten, denen wir ausgeliefert sind; jeder, der einmal seekrank war, kann davon berichten.

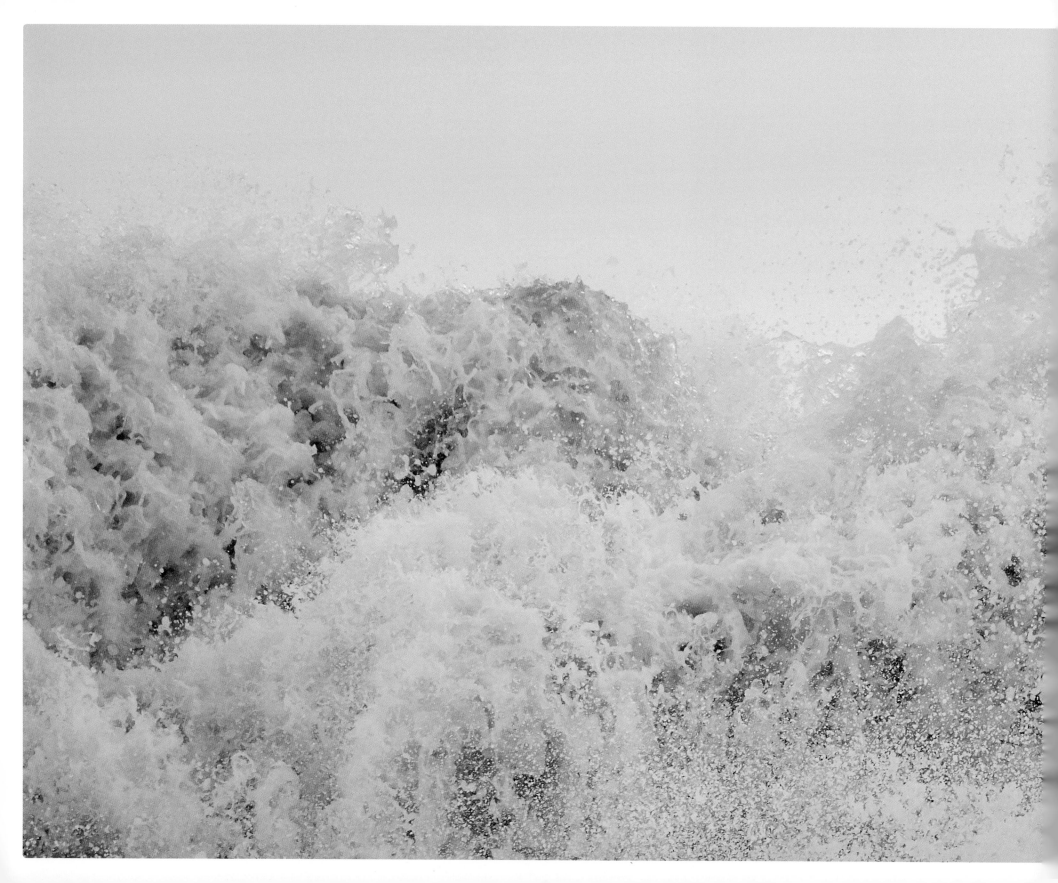

THE BIG FIVE

There are five oceans on our planet: the Pacific, Atlantic, Indian, Arctic, and Southern oceans. They are joined by a multitude of small and marginal seas such as the North Sea, the Baltic Sea, the Mediterranean Sea, and the Caribbean Sea. With an average degree of salinity of 3.5 percent, their waters are all connected, and they cover more than two thirds of the Earth's surface. Marine flora produces about 70 percent of oxygen in the atmosphere. The Pacific Ocean alone covers roughly one third of the Earth's surface and contains more than 50 percent of all sea water. It is directly linked to all other oceans. Its surface is as big as that of Earth's land masses combined, with Africa doubled. About 96.5 percent of all water is sea water, and it would fill a cube whose edges are 684 miles long. In terms of volume, that may appear very little, but it reflects just how shallow the sea really is—the deepest point lies at just over 36,000 feet. Looking at our planet's mass, sea water really just covers its surface. Size is always relative.

UP AND DOWN

Oceans are the only bodies of water large enough to be subject to tidal movements. The tidal range—the difference between high and low tide—is caused by the moon's gravitational force and can reach almost 50 feet in Brittany and at Canada's Atlantic coast; for the Baltic Sea, it measures a few inches, and in the Mediterranean, it is hardly noticeable at all.

TRUE GREATNESS

Due to the curvature of the earth, we can only see just over three miles into the distance when standing on a beach. Long before it was confirmed that the earth was a sphere, our seafaring ancestors already knew that there was more than just a void waiting beyond the horizon. In Columbus' days, sailors had to climb up to the crow's nest to gain a higher vantage point and look ahead into the distance to see where they would be that evening. Yet the progress a ship could make in a day was small when compared to the ocean's size. The human mind struggles to grasp dimensions of this magnitude. In those days, sailors could grasp a hint of the sheer scale of the sea when after weeks on the ship, they still saw the same horizon and nothing else. They were almost completely exposed to the elements and often did not know when they were due to arrive, or what kind of country they would set foot on. Going further back still, a few thousand years into the past, the ocean was an insurmountable obstacle. It comes as no surprise that this alien and dangerous place inspired humans more than almost any other place on Earth. Countless myths and legends are told about the sea. Recently it emerged that some of these tales are based on reality. A few years ago, the existence of rogue waves was confirmed. Many "sea monsters" which had been written off as legends were spotted and recorded—the giant squid, for instance. The biggest specimens can grow up to 60 feet long.

LOSING WHAT WE DO NOT KNOW

The ocean, this great dream, this stage on which some of humanity's biggest achievements unfold, is the reason why I can write these lines. Life began in the oceans. We are, in a sense, all children of the sea. It seems like eternity itself, yet in its key roles— it regulates climate, it acts as a habitat, and also as a source of food—it is finite enough to put the planet at risk. The biggest threat is climate change and its accompanying effects of, amongst others, increasingly acidic waters and coral bleaching; beyond this, there are issues such as overfishing and pollution, especially with plastic. We are in the process of losing a treasure which is still largely unknown to us. It seems easier sometimes to look up at the sky and the universe above us rather than down into the depths. Relative to the oceans' size, only a small proportion of them have been explored thoroughly, and we will lose countless forms of plants and wildlife before we even get to see them. We know too much and have seen too little. We know that human interference in nature has far-reaching, often disastrous and irreversible consequences. Yet we have seen so little with our own eyes, as we learned recently when we discovered coral reefs off the coast of Italy, and another one just outside the Amazon River delta in Brazil. Even in places where we thought we had seen everything there was to see, the sea still keeps surprises in store for us.

DIE GROSSEN FÜNF

Es gibt fünf Ozeane auf unserem Planeten – Pazifik, Atlantik, Indischer Ozean, Nordpolarmeer und Antarktisches Meer – und eine Vielzahl von Meeren und Nebenmeeren wie die Nord- und Ostsee, das Mittelmeer oder das Karibische Meer. Sie führen Salzwasser mit einer Salzkonzentration von durchschnittlich 3,5 Prozent, bedecken gut zwei Drittel der Erdoberfläche und sind alle miteinander verbunden. Die Meeresflora produziert rund 70 Prozent des atmosphärischen Sauerstoffs. Allein der Pazifik bedeckt ein Drittel der Erdoberfläche und enthält über 50 Prozent des gesamten Wassers. Er ist mit allen anderen Ozeanen direkt verbunden. Alle Landflächen der Erde und noch ein zweites Afrika würden bequem hineinpassen. Circa 96,5 Prozent allen Wassers ist Meerwasser und es würde einen Würfel mit gut 1100 Kilometer Kantenlänge füllen. So ausgedrückt klingt das nach sehr wenig, was aber zeigt, wie flach selbst die mit rund 11.000 Metern tiefste Stelle im Meer ist. Denn gemessen an der Größe unseres Planeten bedeckt Meerwasser nur seine oberste Oberfläche. Auch Größe ist relativ.

AUF UND AB

Nur Meere sind groß genug, dass die Gezeitenkräfte nennenswerte Tiden entstehen lassen. Der auch als Tidenhub bezeichnete Unterschied zwischen Ebbe und Flut, der durch die Gravitationskraft des Mondes entsteht, kann – wie in der Bretagne und an der kanadischen Atlantikküste – bis zu 15 Meter betragen, während er an der Ostsee nur wenige Zentimeter ausmacht und am Mittelmeer kaum noch spürbar ist.

WAHRE GRÖSSE

Aufgrund der Krümmung der Erde kann man am Strand stehend nur etwa fünf Kilometer weit sehen. Aber dass es hinter dem Horizont weitergeht, wussten auch schon unsere seefahrenden Vorfahren, lange bevor die Erde offiziell zur Kugel erklärt wurde. Im hochgelegenen Ausguck eines Segelschiffs zu Kolumbus' Zeiten konnte man schon sehen, wo man abends oder am nächsten Tag sein würde. Weit kam man allerdings nicht an so einem Tag, nimmt man die Größe des Meeres als Maßstab. Zu groß sind die Dimensionen und für einen Menschen kaum zu erfassen. Eine Ahnung der Größe konnten Seefahrer früherer Zeiten erhalten, wenn sie selbst nach Wochen auf dem Wasser den scheinbar immer noch gleichen Horizont und sonst nichts zu sehen bekamen. Sie waren den Naturgewalten eher mehr den weniger schutzlos ausgeliefert, oft ohne zu wissen, wann sie ankommen und welche Art von Land sie erwarten würde. Davor, wenige Tausend Jahre weiter in der Vergangenheit, war der Ozean noch eine unüberwindbare Grenze. Kein Wunder, dass dieser so fremde und gefährliche Raum die Fantasie der Menschen wie kaum ein anderer beflügelte. Ungezählte Mythen und Legenden haben wir dem Meer zu verdanken. Wobei sich einige davon gerade in jüngster Vergangenheit als wahr herausgestellt haben. So sind erst seit wenigen Jahren Monsterwellen belegt und dokumentiert. Viele als Fabelwesen abgetane „Seeungeheuer" wurden tatsächlich gesichtet und dokumentiert – wie beispielsweise die Riesenkalmare. Die größten Exemplare erreichen 18 Meter Gesamtlänge.

VERLIEREN OHNE KENNEN

Menschheitsgeschichte ist der Grund dafür, dass ich diese Zeilen schreiben kann. Im Meer entstand das Leben. Schaumgeboren sind wir. Schiere Endlosigkeit und doch endlich genug, um es in seiner Funktion als Klimakonstante, Lebensraum und Nahrungsspender ernsthaft zu gefährden. Die größten Gefahren stellen der Klimawandel und die damit einhergehende Übersäuerung des Wassers, das Ausbleichen der Korallen, die Überfischung und die Vermüllung mit Plastik dar. Wir sind dabei, einen Schatz zu verlieren, den wir in weiten Teilen nicht einmal kennen. Es ist so viel einfacher, nach oben ins Universum zu blicken als nach unten in die Tiefen der Meere. Wenig bis nichts im Vergleich zur Größe ist erforscht und unzählige Arten der Flora und Fauna werden verloren gehen, bevor sie jemand überhaupt zu Gesicht bekommen hat. Wir wissen weit mehr, als wir kennen. Wir wissen genug, um die Dramatik der menschengemachten Veränderungen zu verstehen. Gleichzeitig kennen wir sehr wenig. Das zeigt die erst kürzlich gemachte Entdeckung eines Korallenriffs vor Italien und eines weiteren vor dem Amazonasdelta vor Brasilien. Selbst dort, wo man glaubt, alles zu kennen, hält das Meer noch Überraschungen für uns bereit.

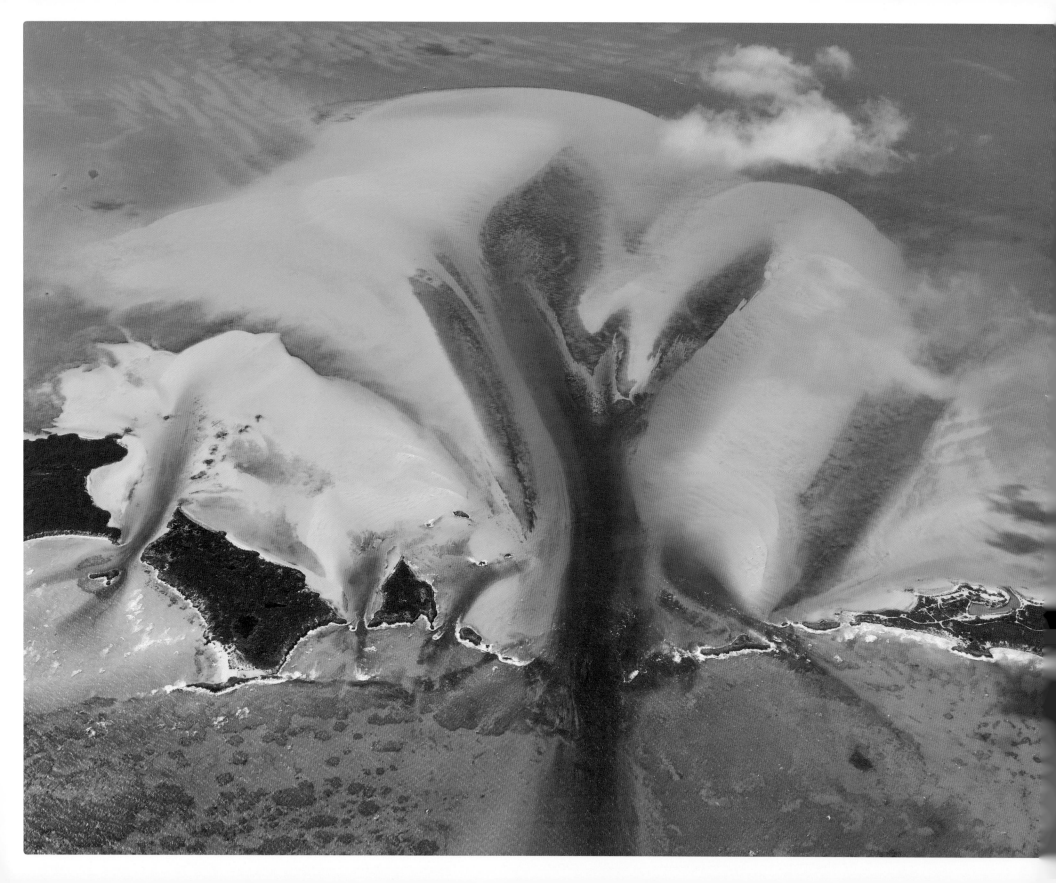

SYMPHONY IN TURQUOISE

SYMPHONIE IN TÜRKIS

The color turquoise seems to me most at home, to be most at ease in the Bahamas' clear waters. The water surrounding the Exumas—a group of islands—is very shallow. It surrounds the islands like a translucent, silky veil. The water's depth, the sand's color, the wind, and the currents play together to create a visual symphony of countless shades of turquoise. The sandy beaches' bright white, and the vegetation's twilight, join this colorful melody in a triad of contrasts, yet in perfect harmony. The view from the beach is already impressive, but if you are lucky enough to see it from high above in the air, it is just magnificent. There are no natural points of elevation on these islands, and so a higher vantage point from which to marvel at this masterpiece carefully crafted by nature used to be the exclusive privilege of birds, bats, and flying insects. Luckily, with a helping hand from modern technology, we humans can now claim flight as one of our abilities. And the Bahamas are one of the best reasons to want to be airborne.

The Bahamas are a group of more than 700 islands. They are spread out across an area of more than 5400 square miles, located just to the southeast of Florida. Only about 30 of the islands are inhabited. About 360 of the Bahamas' islands make up the Exumas which cut through the Tropic of Cancer from north to south. Counting islands is not as simple as it may sound. Sometimes, two islands are separated by mere inches of sea water, and it is difficult to determine whether a piece of land is still part of the main island or constitutes a new, independent island. In 1492, Christopher Columbus paved the way for modernity right here in the Bahamas when he made landfall on San Salvador Island, convinced to have discovered an all-water route to the East Indies. A mistake with far-reaching consequences.

Nirgendwo sonst scheint die Farbe Türkis so zu Hause, so selbstverständlich zu sein wie hier, in den Gewässern der Bahamas. Das um die Inselkette der Exumas besonders seichte Wasser des Karibischen Meeres umfließt diese wie ein transluzenter (durchscheinender) seidener Stoff. Eine visuelle Symphonie ungezählter Türkistöne ergibt sich aus dem Zusammenspiel von Wassertiefe, Sandfarben, Wind und Strömungen. Kombiniert mit dem strahlenden Weiß der Strände und dem Dunkel der Vegetation entsteht in geradezu kontrapunktischer Manier ein Dreiklang von kontrastvoller, aber perfekter Harmonie. Spektakulär schon vom Strand aus betrachtet, wird es buchstäblich überirdisch schön, wenn man das Glück hat, es aus der Luft betrachten zu können. Da natürliche Erhebungen in diesem Insellabyrinth fehlen, war es lange Zeit Vögeln, Fledermäusen und fliegenden Insekten vorbehalten, dieses Gesamtkunstwerk der Natur bestaunen zu dürfen. Glücklicherweise gehören wir heute dank technischer Hilfsmittel auch zum flugfähigen Teil der Fauna. Die Bahamas sind einer der besten Gründe dafür.

Die mehr als 700 Inseln der Bahamas verteilen sich südöstlich von Florida über eine Fläche von 14.000 Quadratkilometer. Nur etwa 30 davon sind bewohnt. Circa 360 Inseln wiederum bilden innerhalb der Bahamas die Kette der Exumas, die in einer Nord-Süd-Richtung den Wendekreis des Krebses durchschneiden. Inseln zu zählen ist allerdings nicht so einfach, wie es sich anhört. Manchmal trennen zwei Inseln nur wenige Zentimeter Meerwasser und es ist oft schwer zu entscheiden, ob das entsprechende Stück Land nur Teil der Mutterinsel ist oder eine eigene Insel darstellt. 1492 öffnete Christoph Kolumbus die Tür zur Neuzeit genau hier auf den Bahamas, als er, festen Glaubens, einen Seeweg nach Indien gefunden zu haben, am Strand von San Salvador an Land ging. Ein folgenschwerer Irrtum.

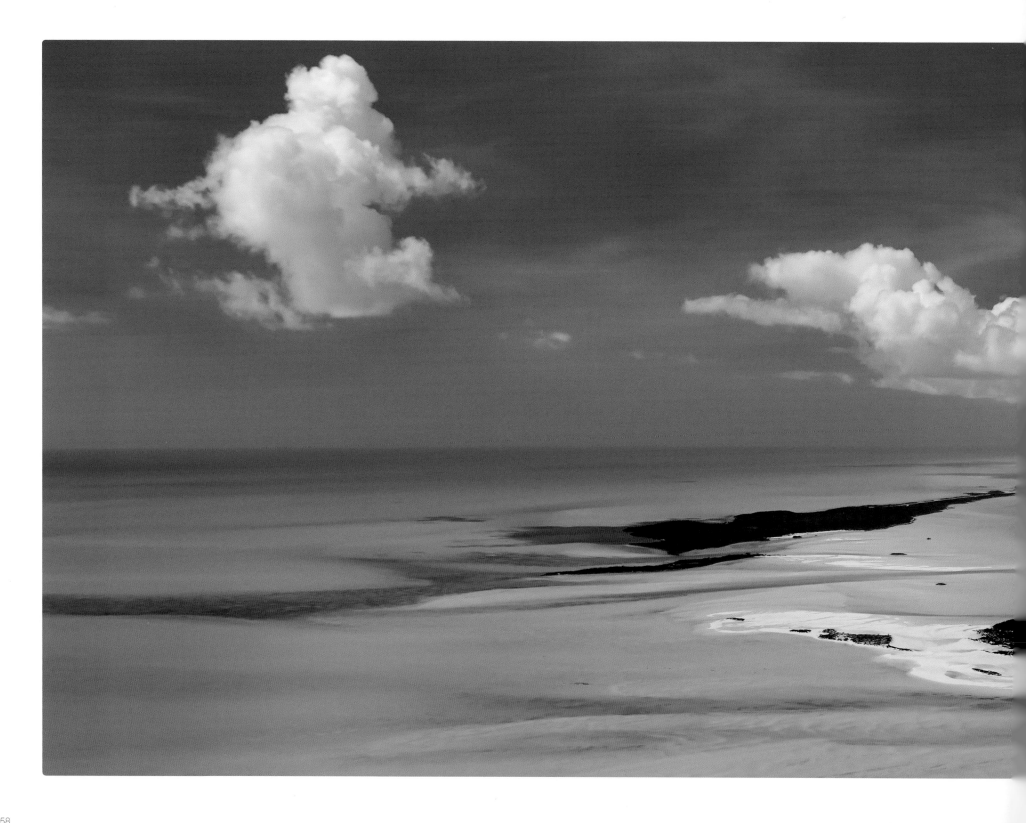

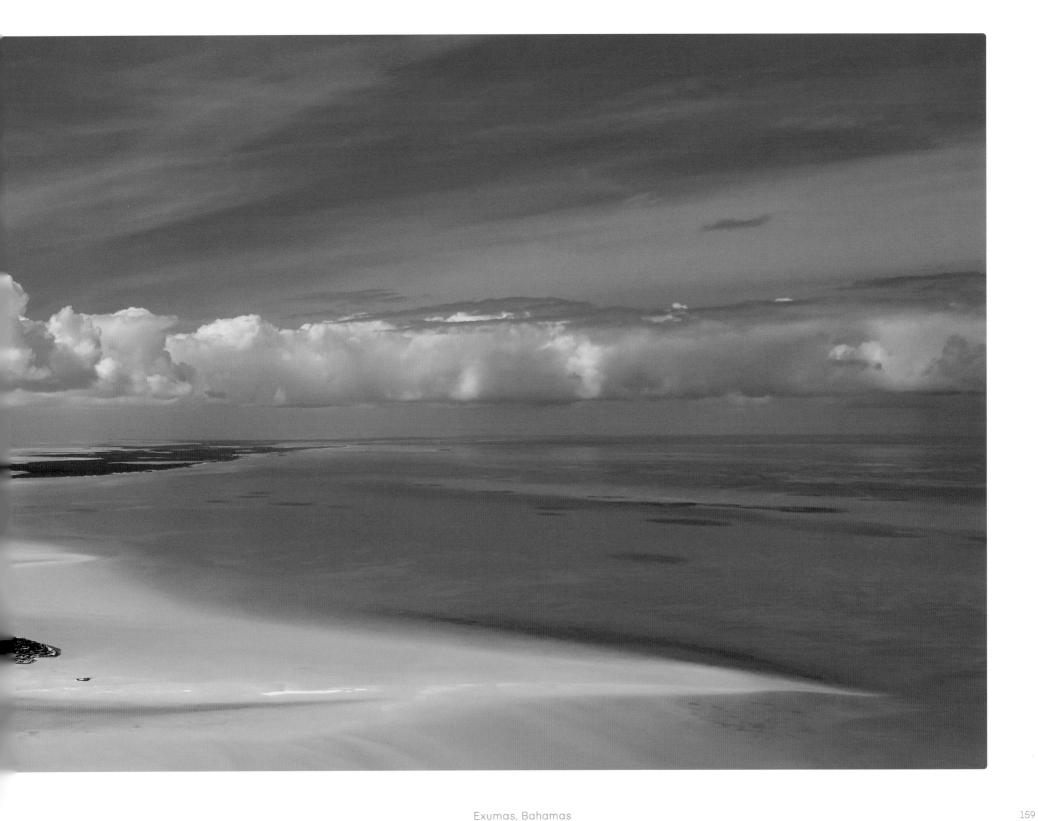

Exumas, Bahamas

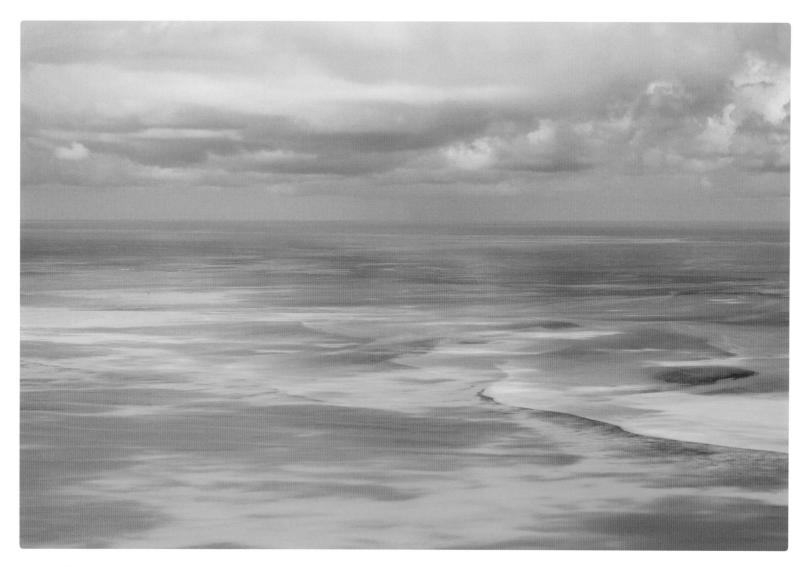

The sky is illuminated. The water's color is so luminous, and its reflections so intense, that even the clouds above are bathed in its hue.

Der Himmel leuchtet. Die Farbe des Wassers leuchtet und reflektiert so stark, dass sogar die Unterseiten der Wolken die Farbe annehmen.

Exumas, Bahamas

Exumas, Bahamas

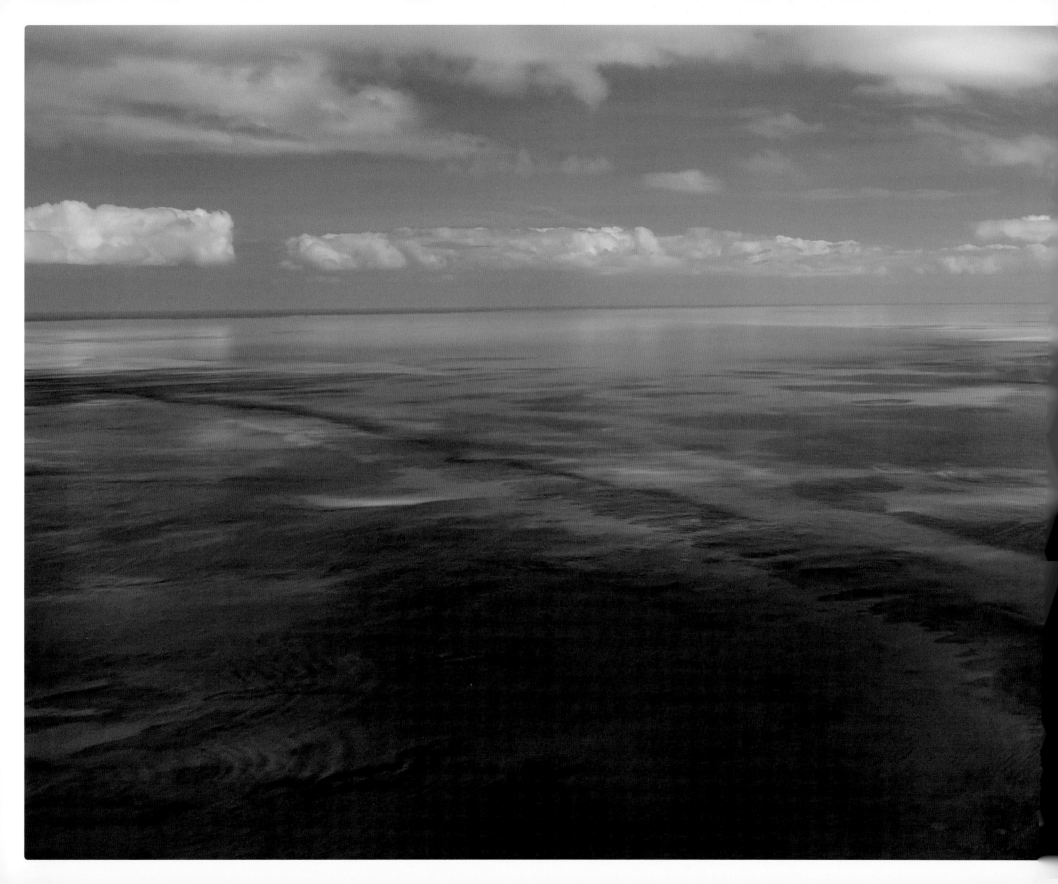

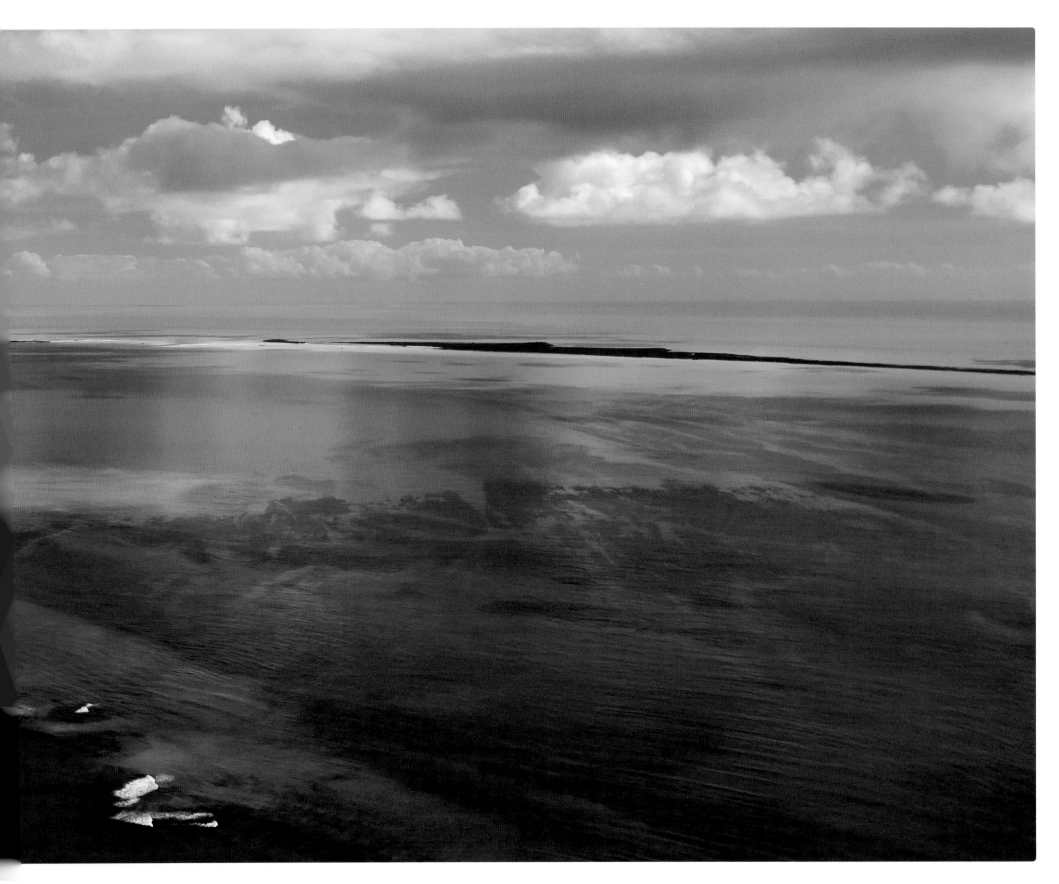

Abyss. So-called blue holes are a common phenomenon in the Bahamas. They appear both on land and just off the coasts. Forming a more or less perfect circle, they can reach depths of more than 500 feet. The famous Dean's Blue Hole, pictured right, is a popular spot for freediving contests.

Abyss. Sogenannte „Blue Holes" kommen auf den Bahamas sehr oft vor. Es gibt sie sowohl an Land als auch vor den Küsten. Sie sind mehr oder weniger kreisrund und können mehrere Hundert Meter tief sein. Im berühmten Dean's Blue Hole rechts finden regelmäßig Wettbewerbe im Apnoetauchen statt.

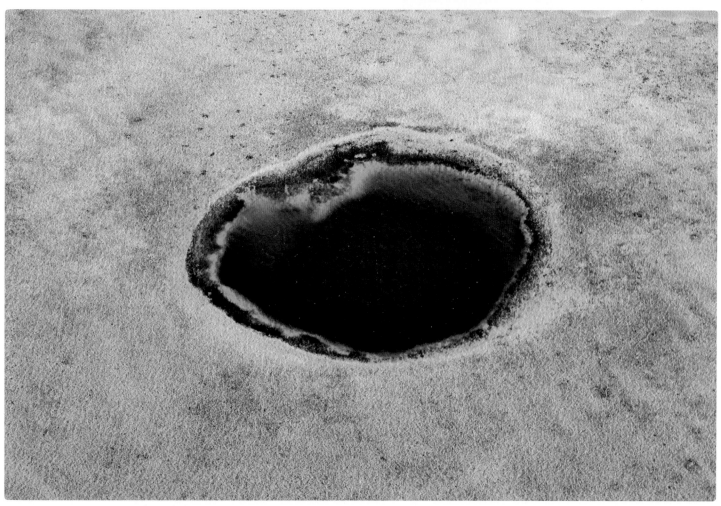

Long Island, Bahamas

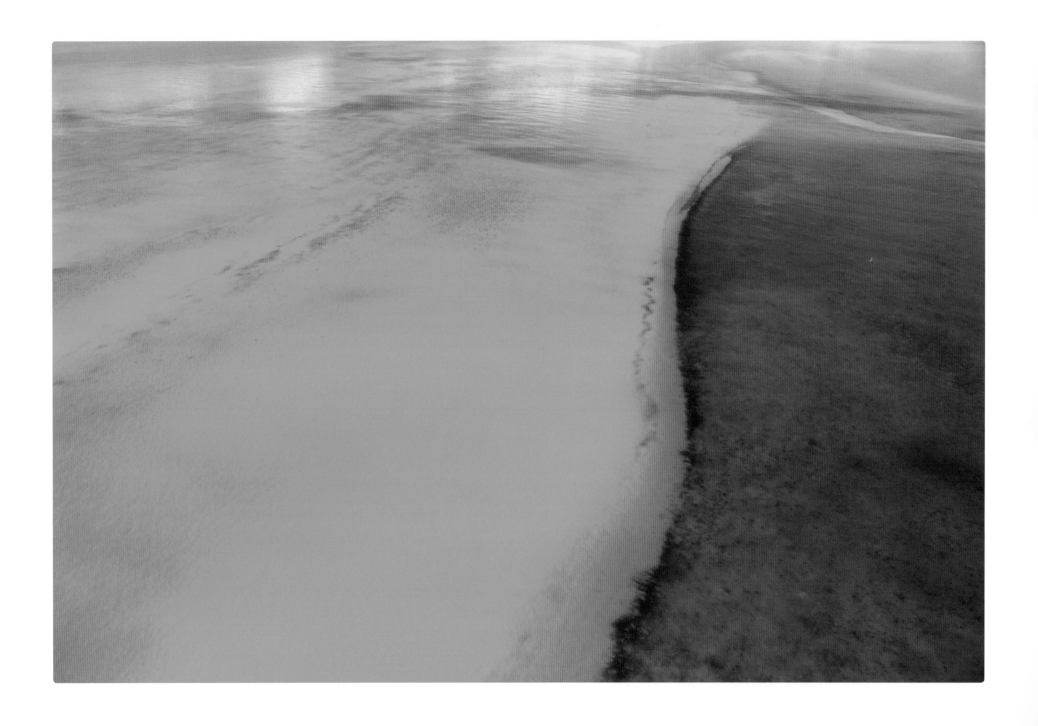

Exumas, Bahamas

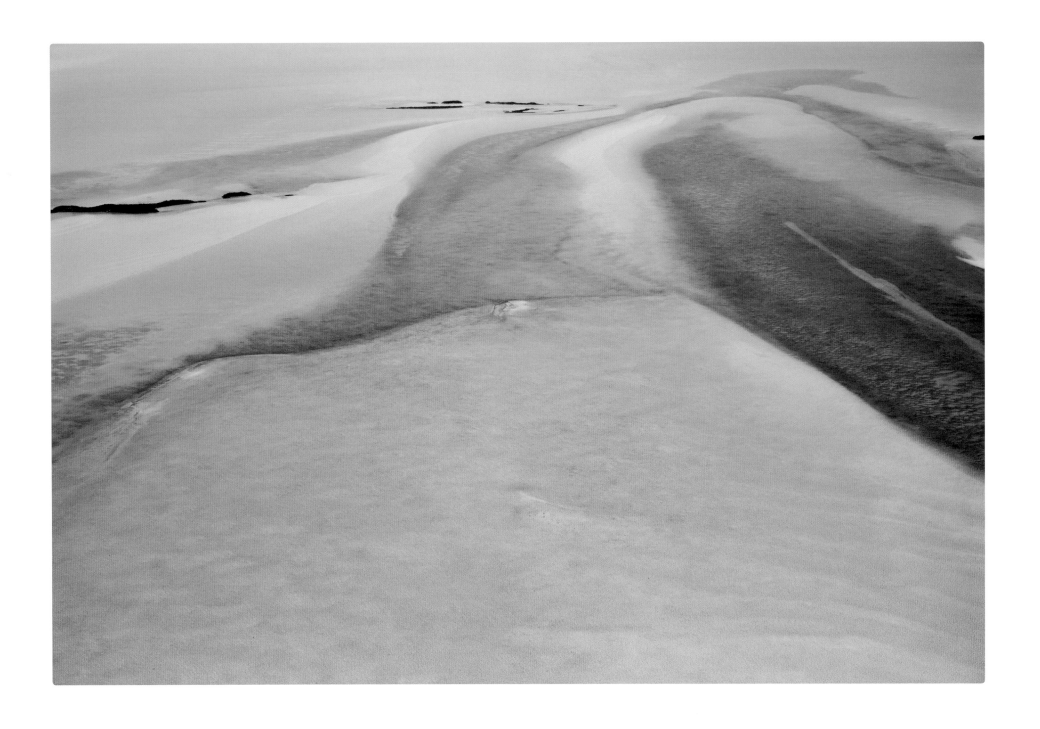

Exumas, Bahamas

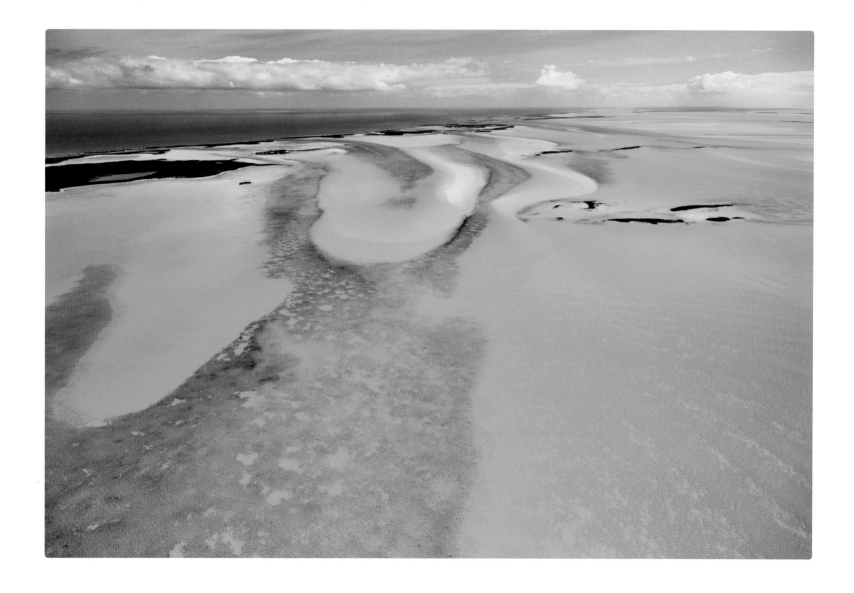

Exumas, Bahamas

Exumas, Bahamas

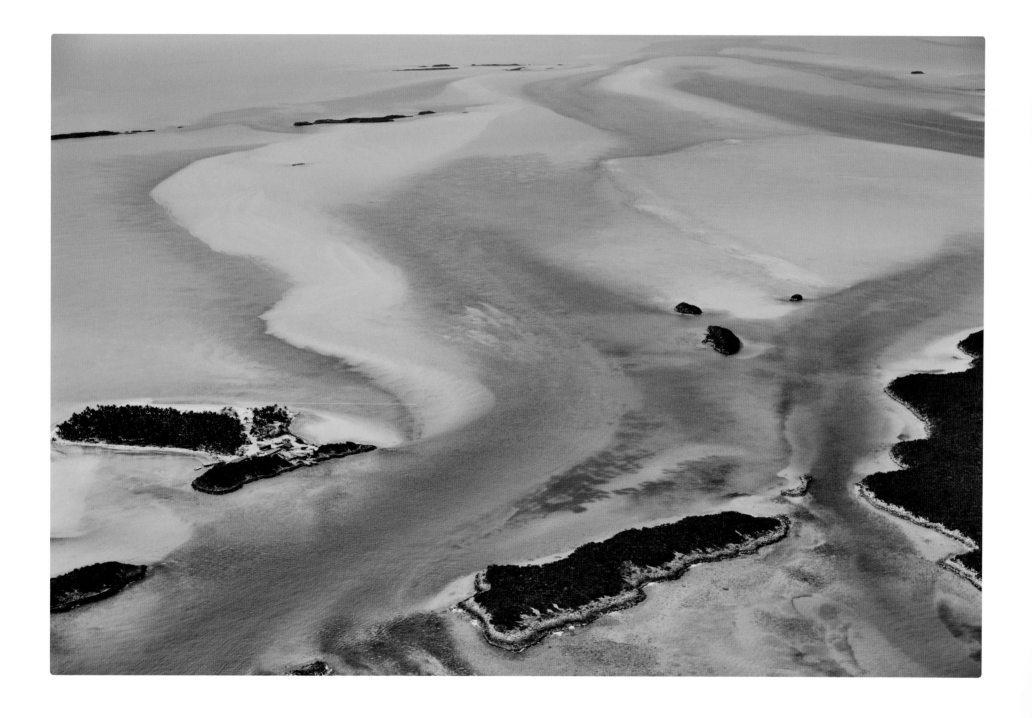

Exumas, Bahamas

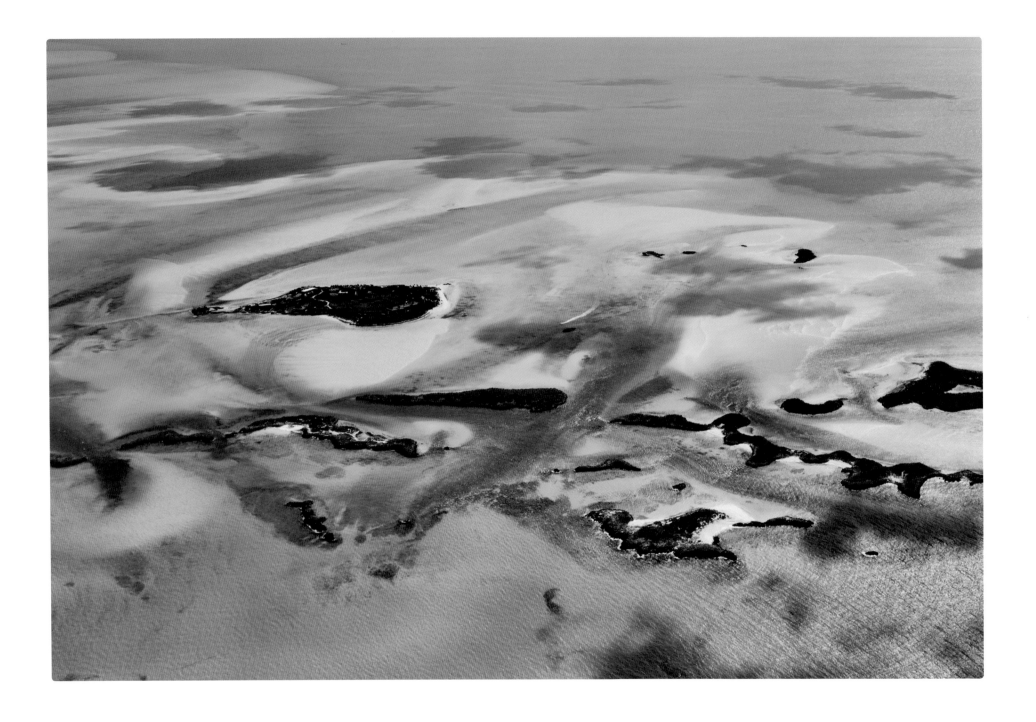

Exumas, Bahamas

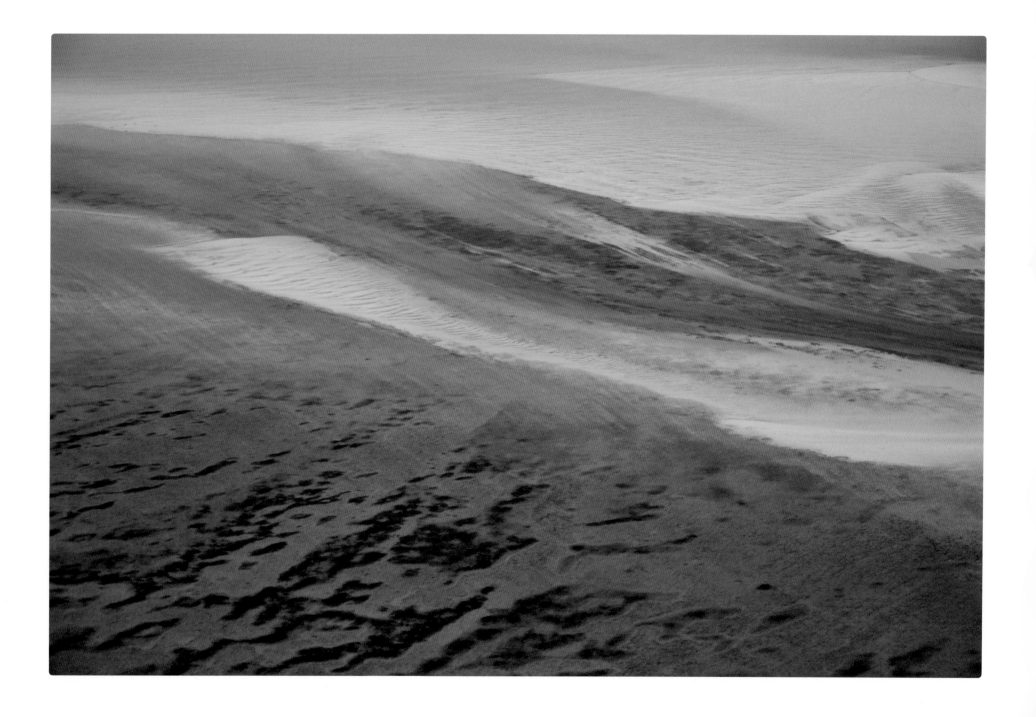

Exumas, Bahamas

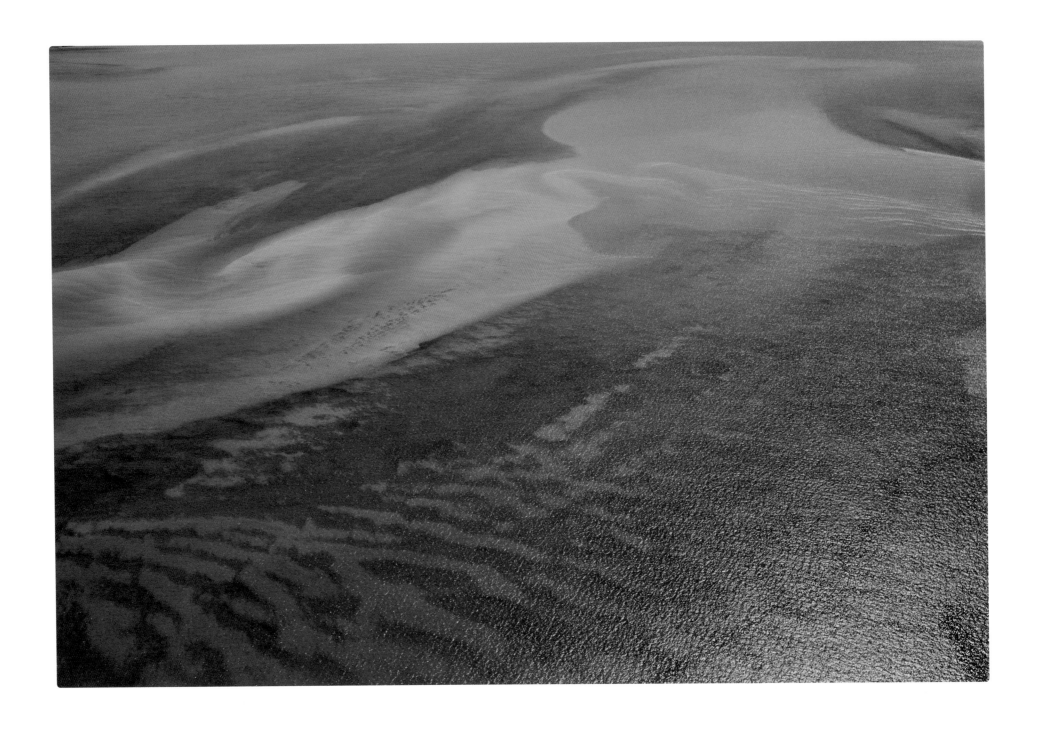

Exumas, Bahamas

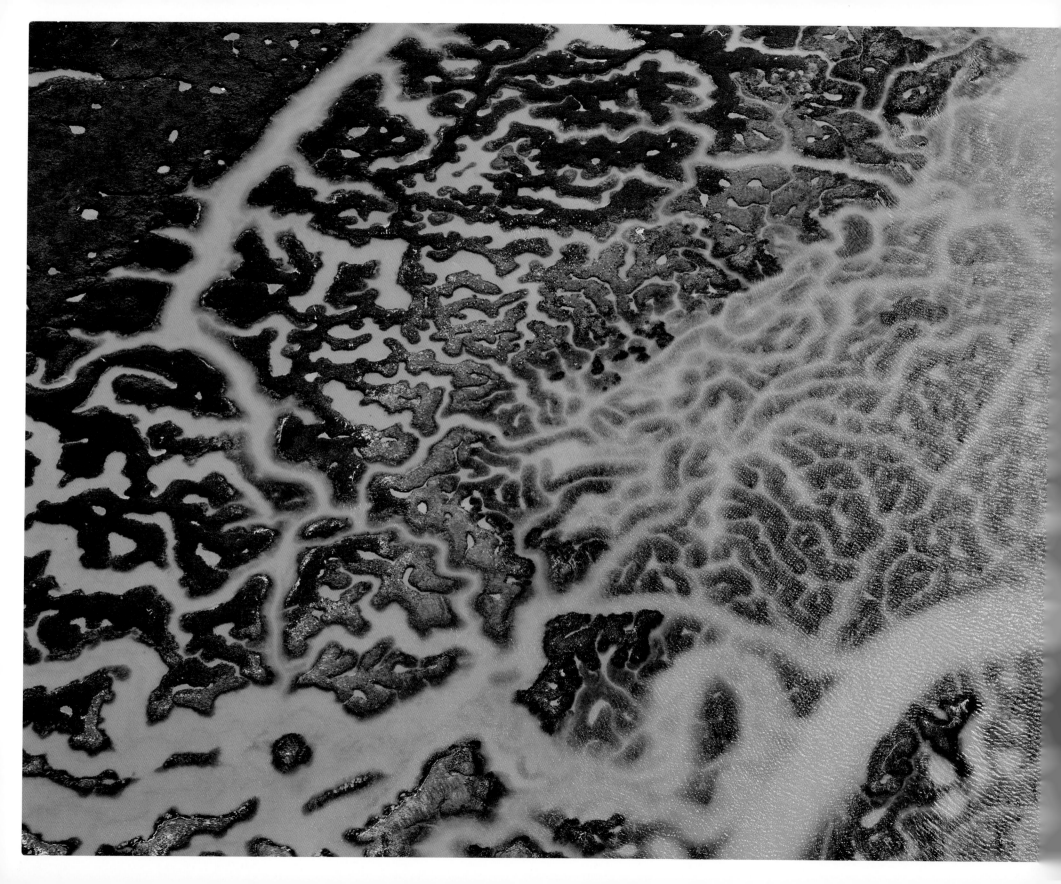

TRANSFORMATION

TRANSFORMATION

The Bay of Cádiz in Spain is an excellent example for how natural processes and human interference in nature can work together and improve biodiversity. This intricate system of artificial ponds and marshes is fed by two rivers as well as tidal movements. Although at just a few square miles, it is rather small, it is a unique project—no other place in the world has anything comparable. A well-tuned system of dikes and locks regulates the water level and facilitates fishing in spring. While in some cases, salt basins lie desolate and unutilized, there are also traditional, extensive, and environmentally friendly forms of aquaculture for gilthead seabream and sea bass.

Some meadows owe their high biodiversity to farmers' gentle, non-intrusive cultivation. The situation with the aquaculture here is very similar, and abandoning it would be a great loss for the natural environment. Various types of birds, fish, sea shells, and plants exist here in an extraordinary symbiosis of natural structures and human modifications. Sometimes human interference in natural habitats can have positive effects. It would be a tragedy if there were eventually nobody to take over and continue the work here in this aquaculture, and if instead, large-scale industry were to take over.

From a lower vantage point on the ground we cannot see it, but once we are in the air, the fascinating, brain-like structures below us are revealed. It feels like a metaphor. We, too, are a part of nature, part of a bigger picture and the bigger picture is a part of us.

Die Bucht von Cádiz ist ein Paradebeispiel für das Ineinandergreifen natürlicher Prozesse und menschengemachter Umformung und Nutzung bei gleichzeitiger Steigerung der Biodiversität. Das von zwei Flüssen und den Gezeiten gespeiste System aus angelegten Teichen und Marschen ist mit wenigen Quadratkilometern eher klein, aber dafür – auch im weltweiten Vergleich – einzigartig. Ein ausgeklügeltes System aus Deichen und Schleusen regelt den Wasserstand und ermöglicht im Frühjahr das Abfischen. Während auf der einen Seite Salzbecken verwaisen und nicht mehr genutzt werden, existiert parallel dazu eine traditionell extensive und umweltverträgliche Form der Aquakultur von Dorade und Wolfsbarsch.

Ähnlich wie bei ökologisch wertvollen Wiesen, die auch erst durch die schonende Kultivierung durch Bauern zu ihrer beeindruckenden Biodiversität gekommen sind, wäre auch hier das Aufgeben der traditionellen Wasserwirtschaft ein großer Verlust. Viele Arten an Vögeln, Fischen, Muscheln und Pflanzen leben gerade von dieser einzigartigen Symbiose aus natürlichen Gegebenheiten und menschlicher Modifikation. Manchmal entsteht auch Gutes, wenn der Mensch einen Lebensraum verändert. Schade wäre nur, wenn sich niemand mehr findet, der die mühsame Arbeit fortführt, und die ökologische Aquakultur einer industriellen, nicht nachhaltigen Form weichen muss.

Vom Boden aus ahnt man nicht, welche fantastischen, gehirnartigen Strukturen sich bei der Betrachtung aus der Luft offenbaren. Deutlicher könnte die Symbolik dabei nicht sein. Auch wir Menschen sind Teil der Natur, Teil des Ganzen und das Ganze ist ein Teil von uns.

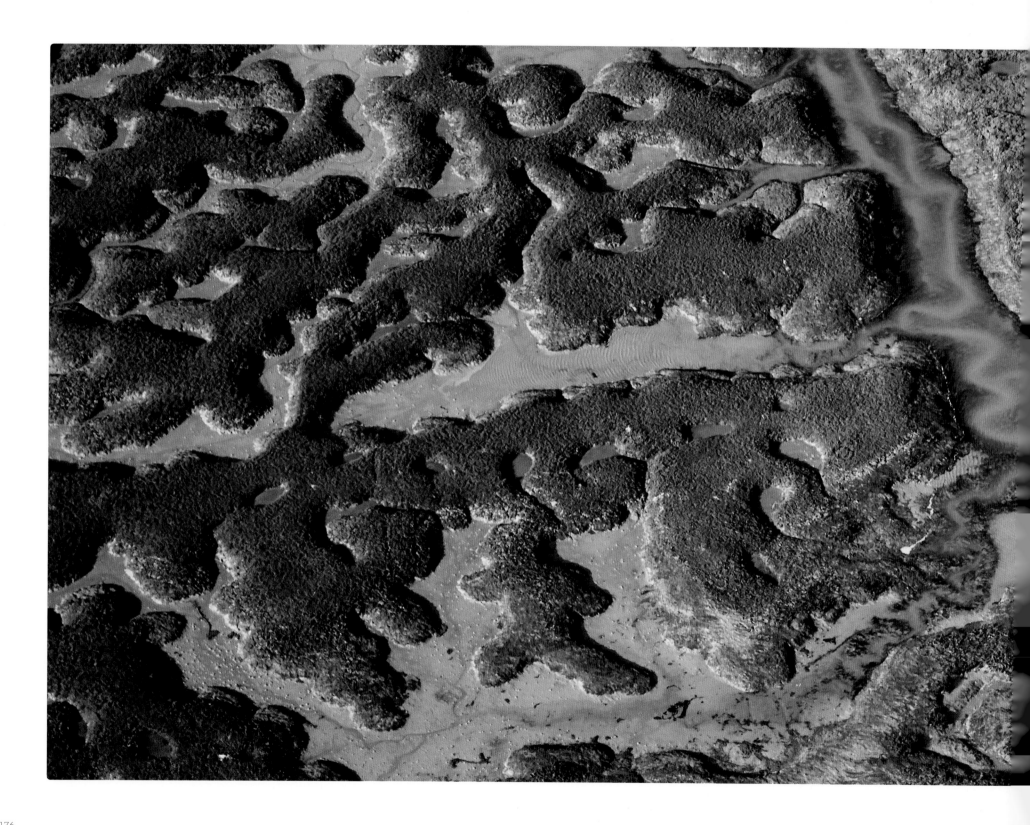

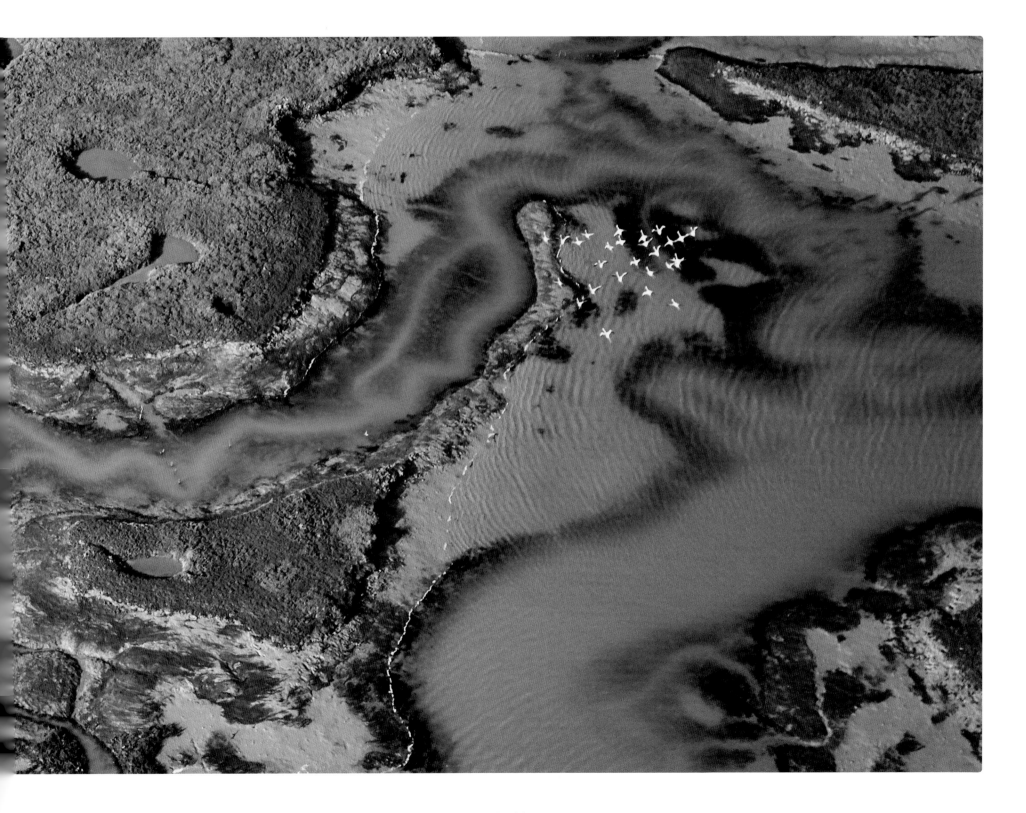

Bay of Cádiz, Spain

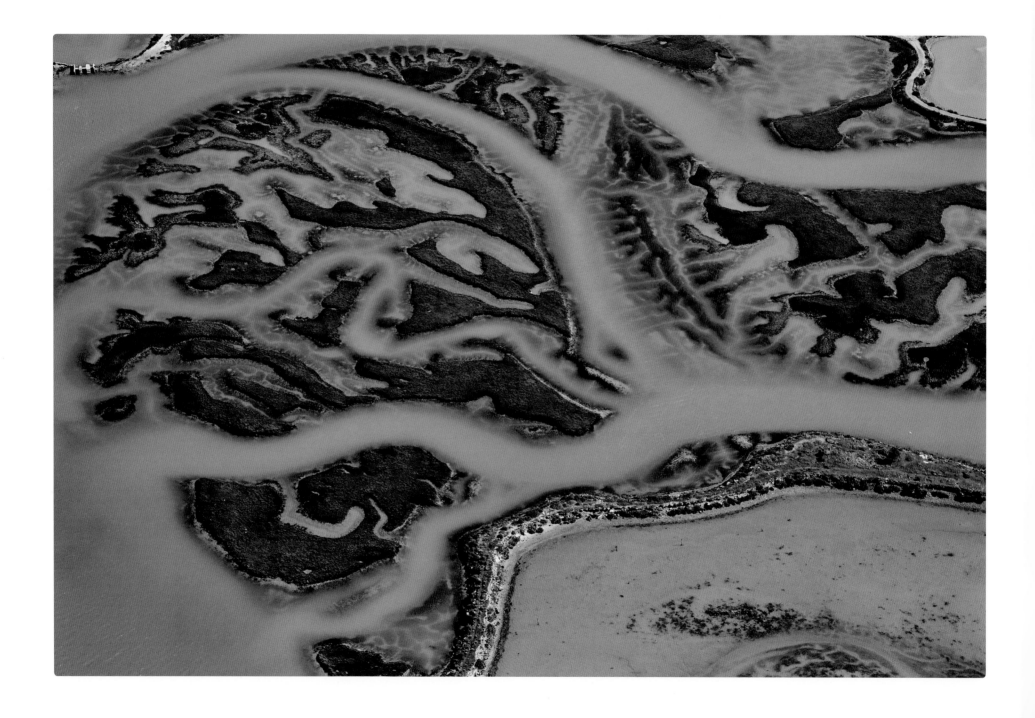

Bay of Cádiz, Spain

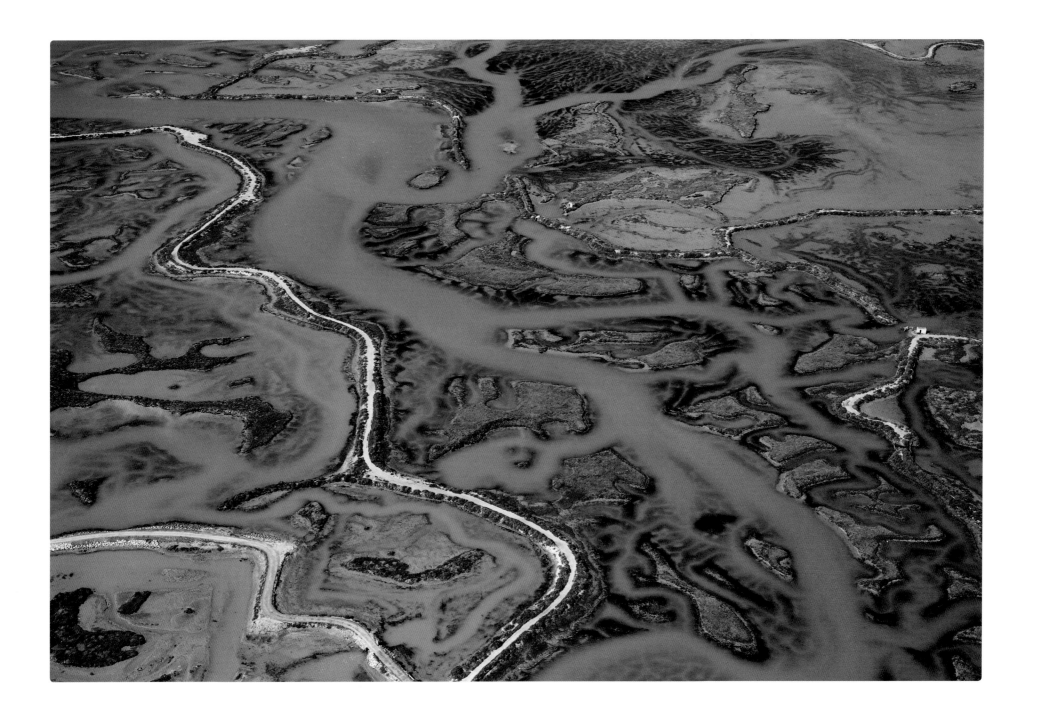

Bay of Cádiz, Spain

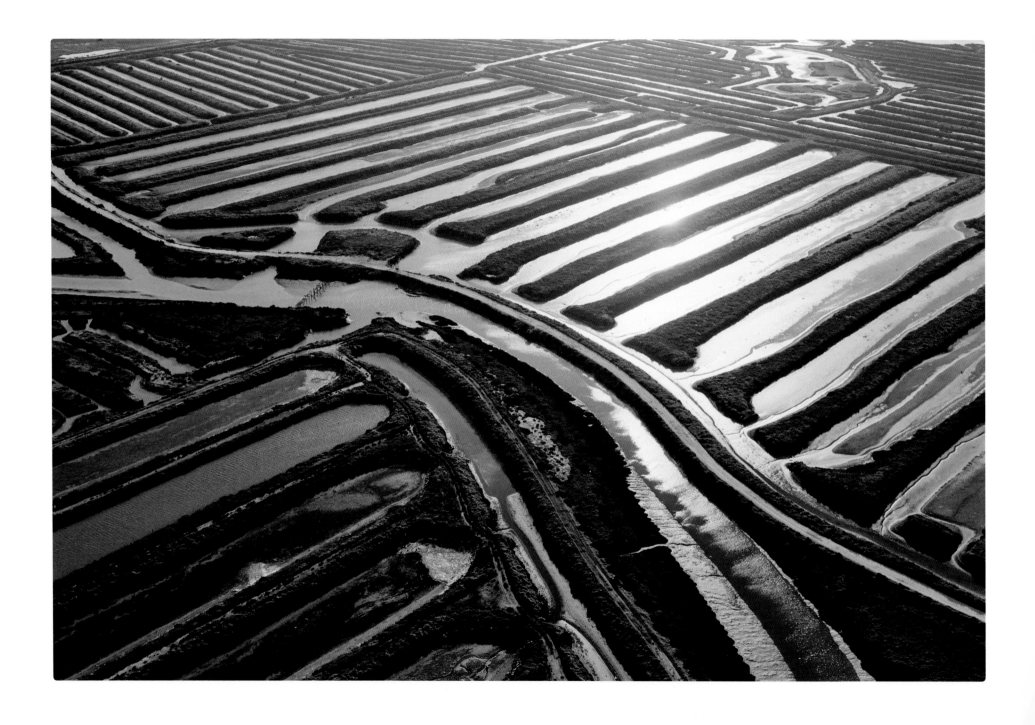

Bay of Cádiz, Spain

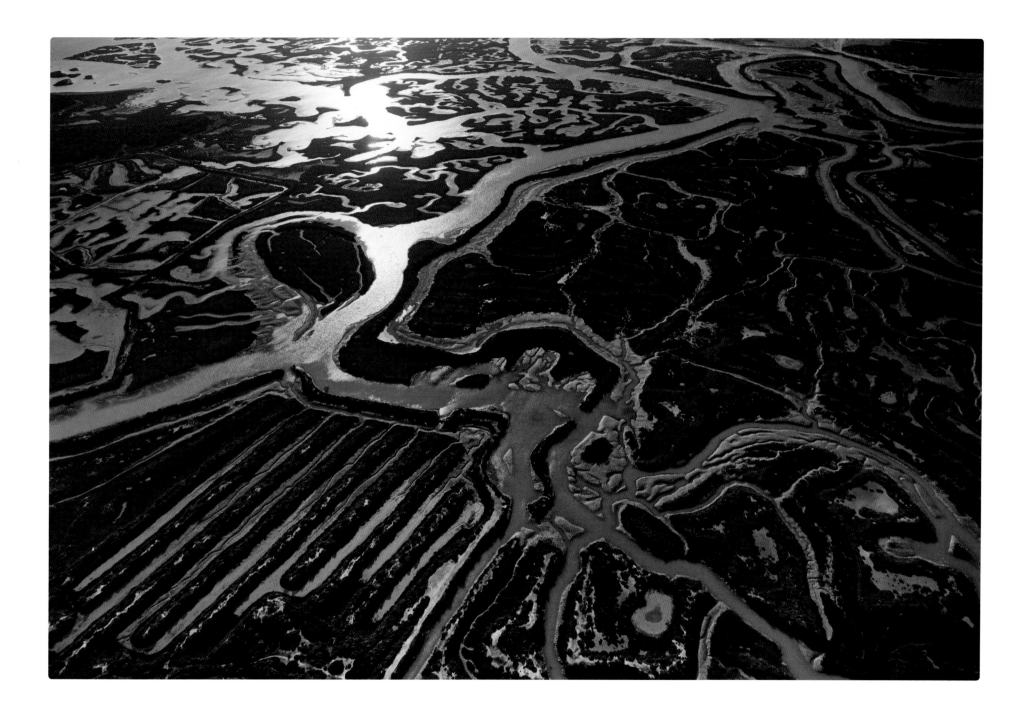

Bay of Cádiz, Spain

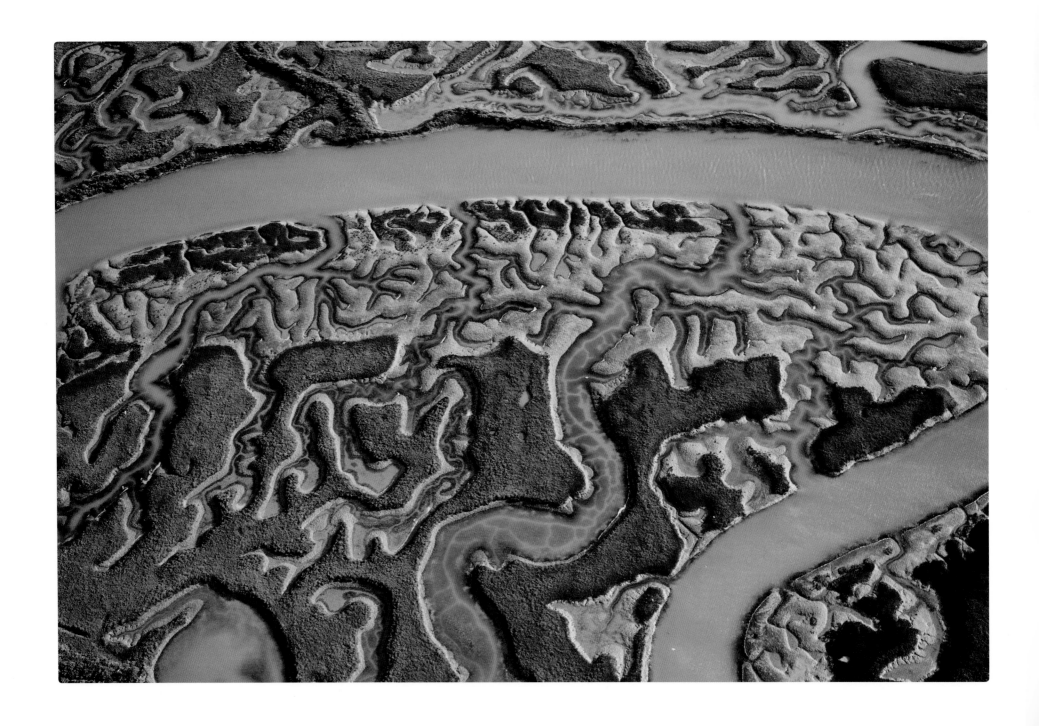

Bay of Cádiz, Spain

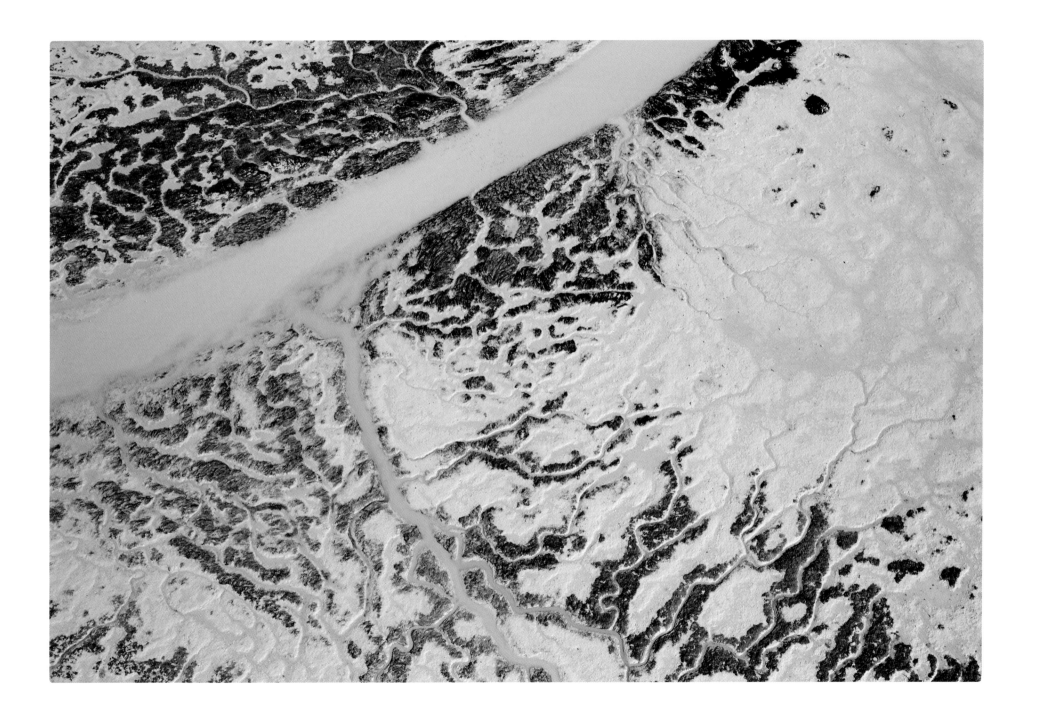

Bay of Cádiz, Spain

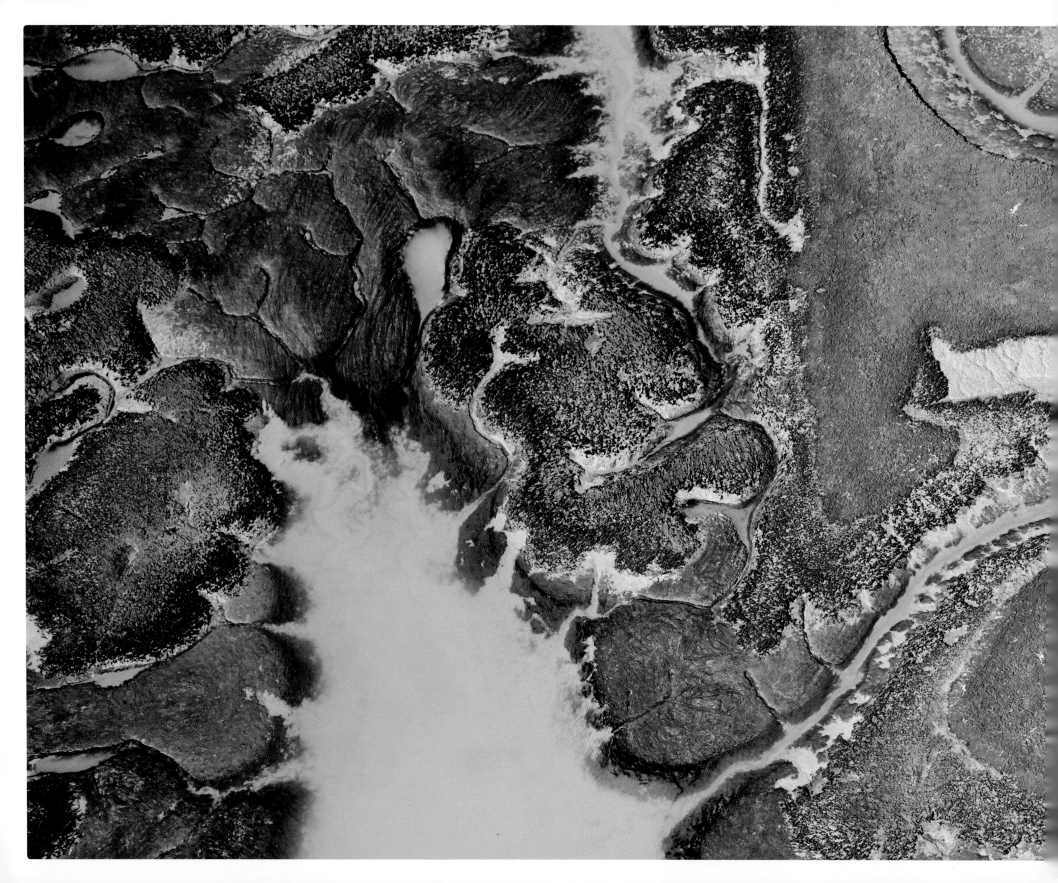

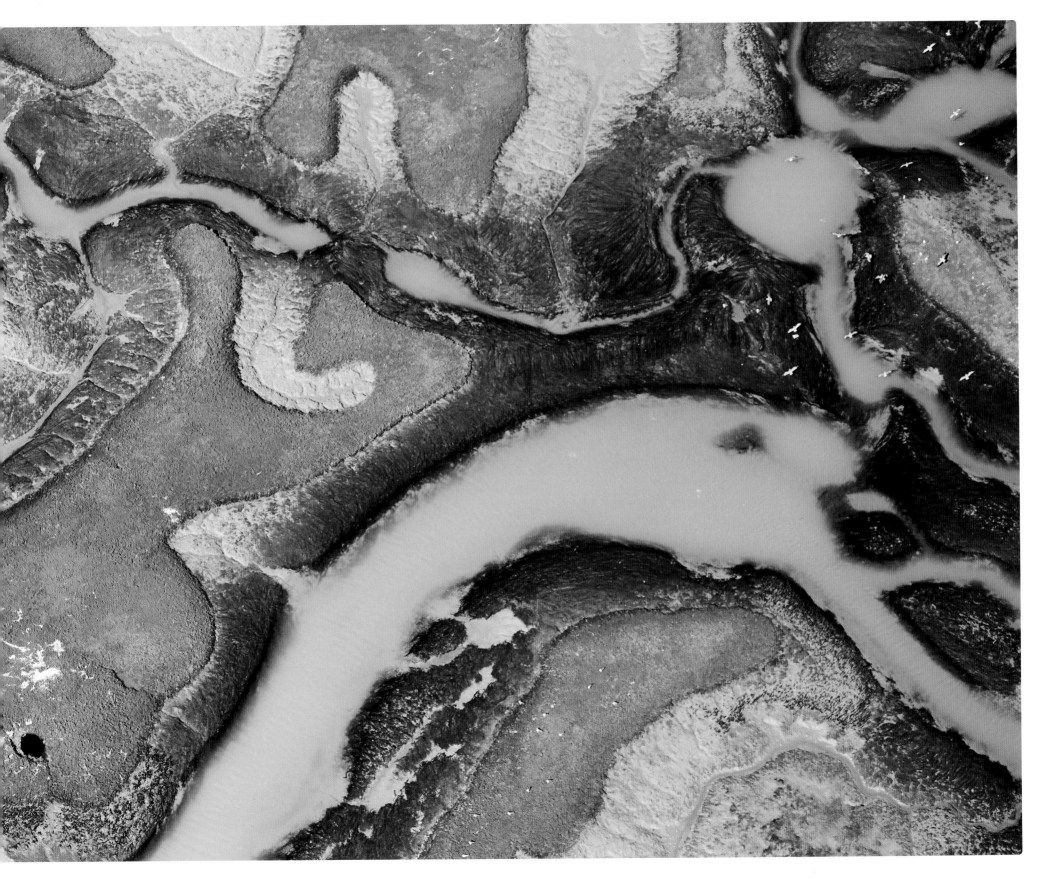

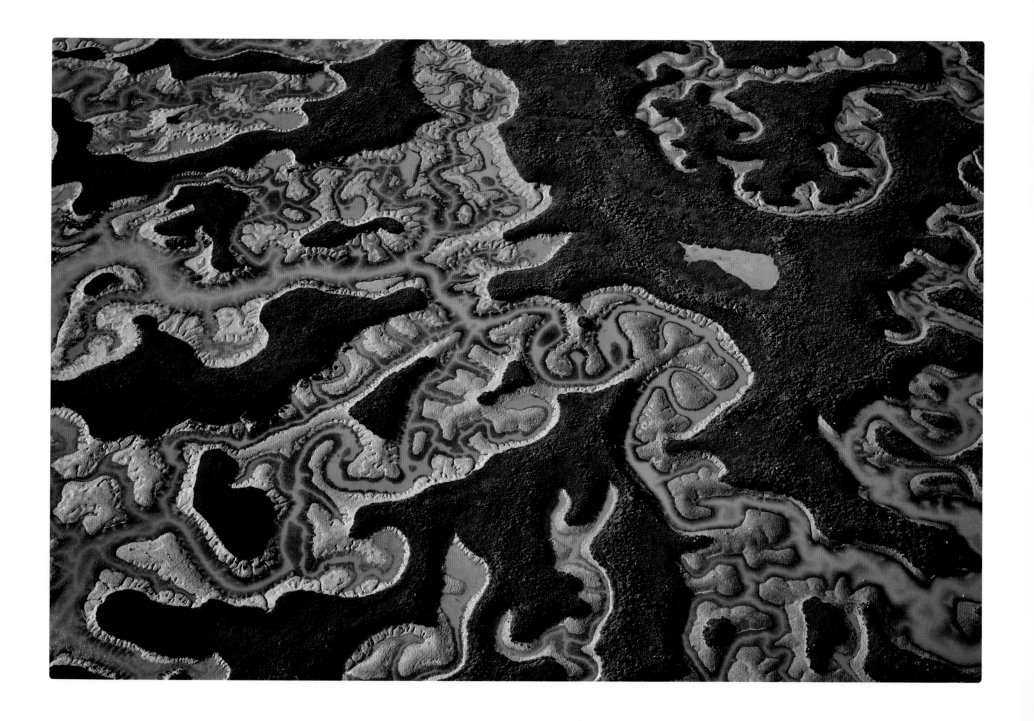

Bay of Cádiz, Spain

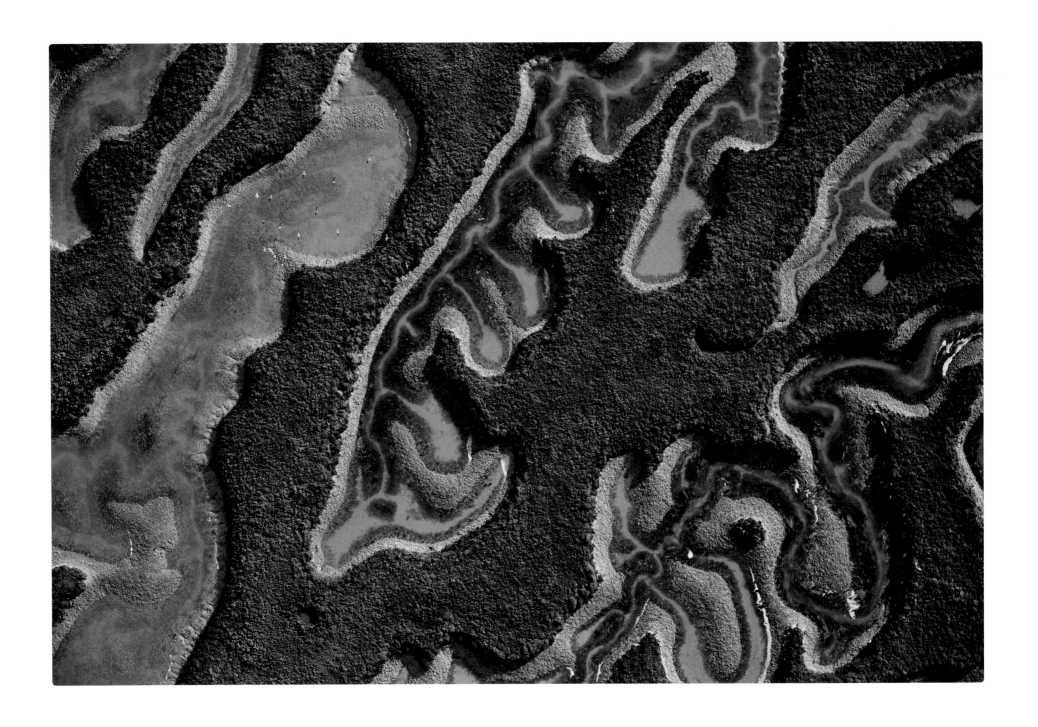

Bay of Cádiz, Spain

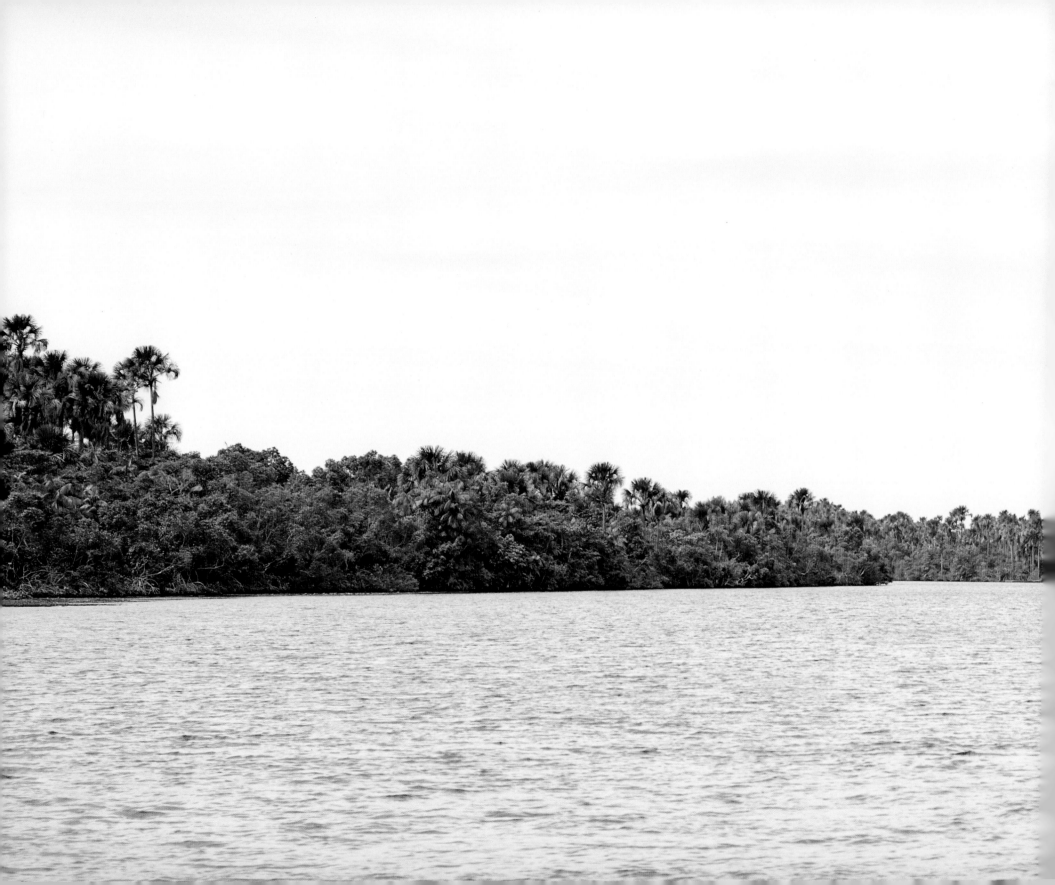

Pages 188–189

More sea than river. The Parnaíba River delta in northeastern Brazil is one of the world's largest deltas. The Atlantic Ocean reaches so far in land at this point, it is more sea than river. In this mixture of fresh and salt water, a unique mix of plants and wildlife has adapted to these unusual surroundings.

Mehr Meer als Fluss. Das Delta des Parnaíba-Flusses im Nordosten Brasiliens ist eines der größten der Welt. Aber eigentlich ist es mehr Meer als Fluss, weil der Atlantik hier weit ins Landesinnere hereindrückt. Eine einzigartige Flora und Fauna hat sich an die sehr variable Mischung aus Süß-, Brack- und Salzwasser angepasst.

Nursery. Just like all other mangrove forests, this expansive mangrove forest on Long Island in the Bahamas is incredibly valuable for the sea. It offers safety and acts as a nursery for many sea creatures, while at the same time also cleaning the seas and protecting the coastline. If we destroy the mangroves, we also destroy the sea.

Kinderstube. Dieser im besten Sinn ausufernde Mangrovenwald auf Long Island auf den Bahamas ist – wie alle Mangrovenwälder – von unschätzbarem Wert für die Meere. Rückzugsort und Kinderstube vieler Meeresbewohner, Kläranlage und Küstenschutz. Zerstört man die Mangroven, zerstört man das Leben im Meer gleich mit.

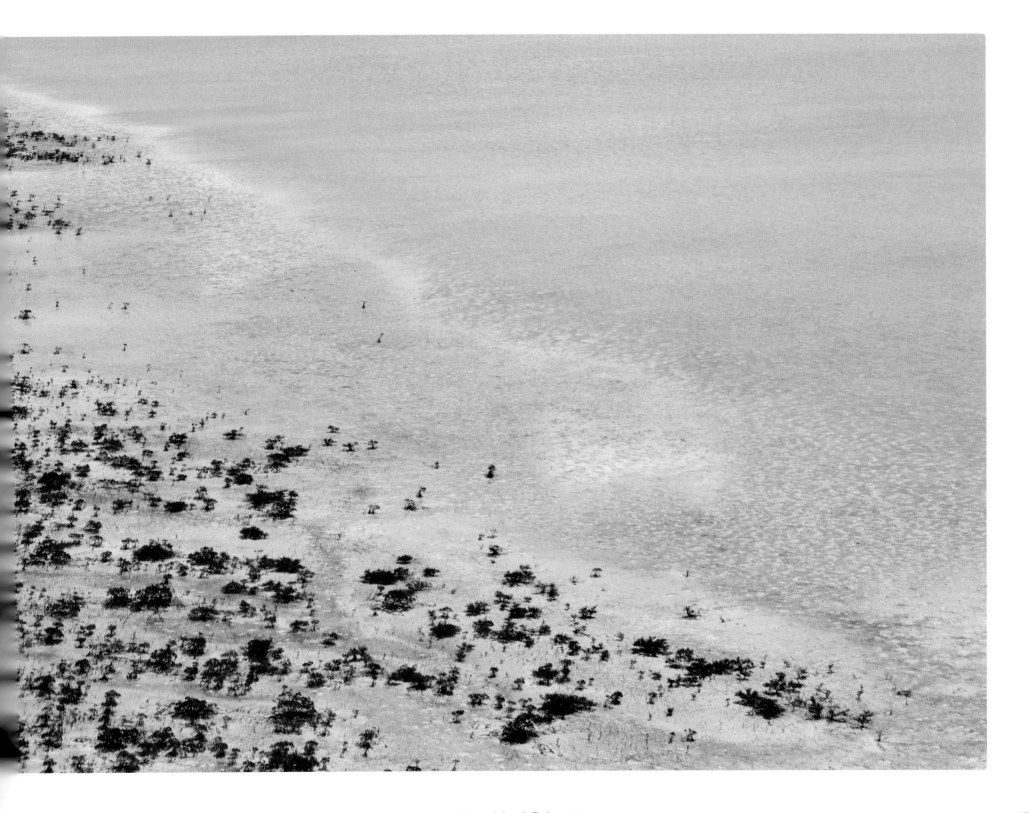

Long Island, Bahamas

English Channel, Great Britain

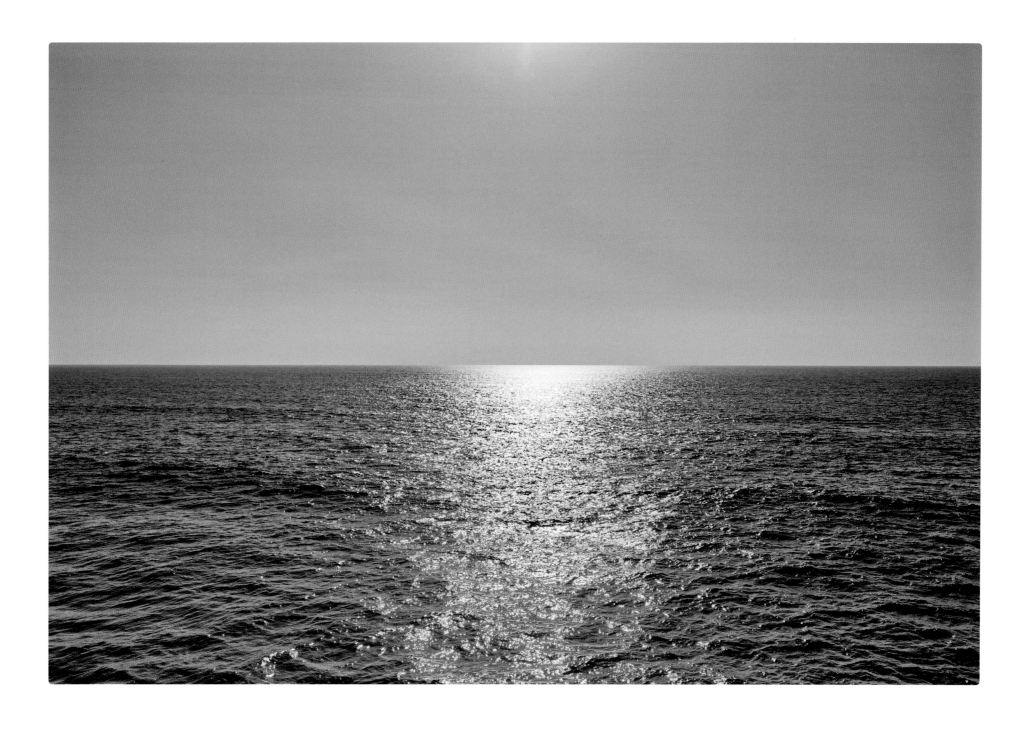

Pacific Ocean, Mexico

Lofoten, Norway

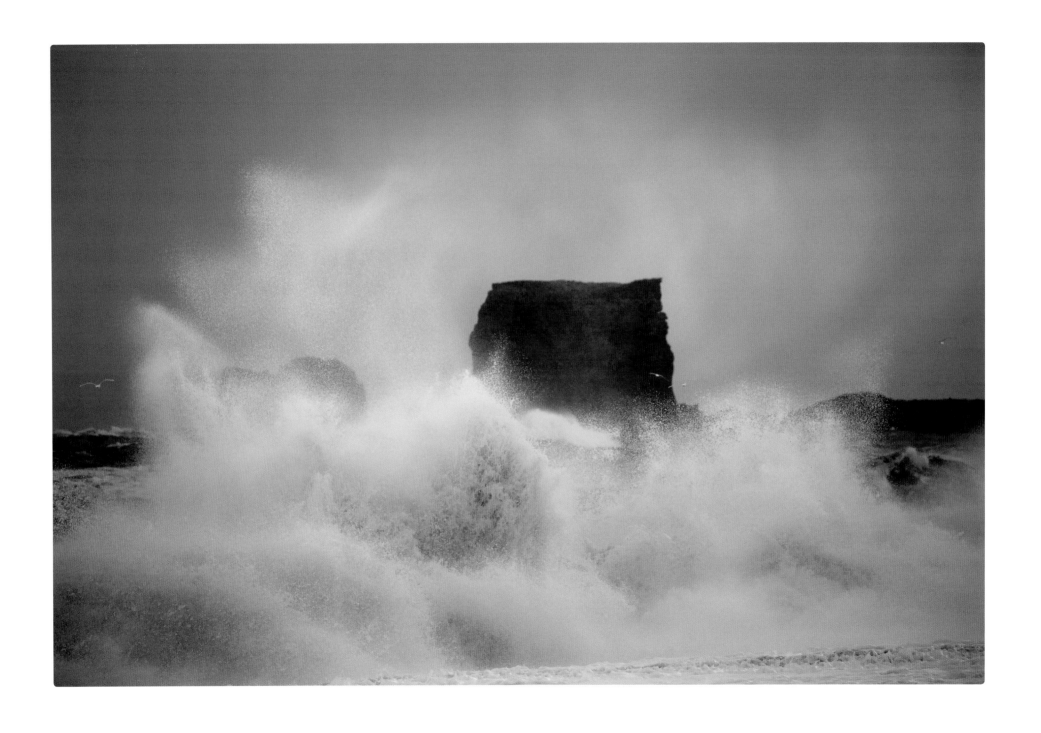

Iceland

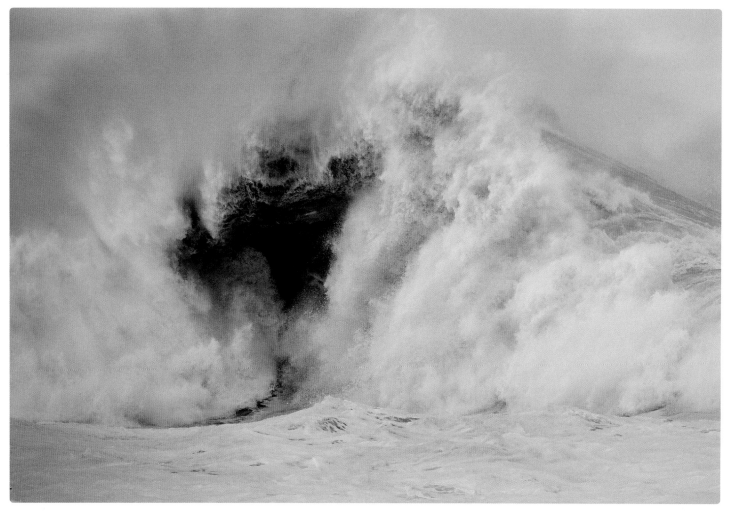

A momentous funnel. Ever since Garrett McNamara, a professional American surfer, rode a 75 foot wave here in 2011, this spot has turned into a mecca for high level surfers. Yet there are even higher waves. With up to 100 feet of height (unconfirmed), this place is said to have the world's highest waves—usually occurring between September and February. The main cause for this phenomenon is the undersea Nazaré Canyon. It is 140 miles long and 16,000 feet deep and ends just before the coast of Nazarés, Portugal. The sea floor here is very steep and within a very short distance it reaches beach levels.

Ein Trichter mit Folgen. Seitdem der amerikanische Surfprofi Garrett McNamara 2011 hier eine 23 Meter hohe Welle surfte, ist der kleine Ort zum neuen Mekka der Surfelite geworden. Aber es geht noch höher. Mit bis zu 30 Metern (unbestätigter) Höhe gibt es hier – meistens zwischen September und Februar – die höchsten Wellen der Welt. Die dafür hauptsächlich verantwortliche Ursache ist der unterseeische Nazaré Canyon. Hier geht es auf 230 Kilometer Länge bis 5000 Meter in die Tiefe. Sein Ende befindet sich direkt vor der Küste Nazarés. Auf extrem kurzer Distanz steigt der Meeresboden auf Strandniveau.

Nazaré, Portugal

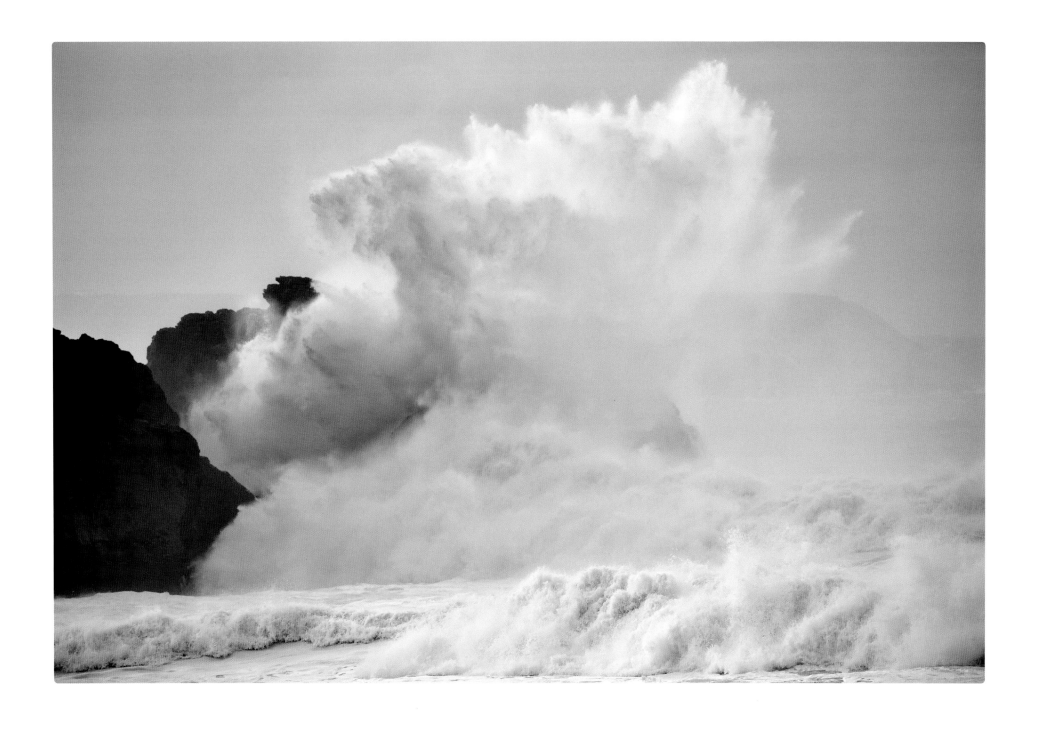

Nazaré, Portugal

Nazaré, Portugal

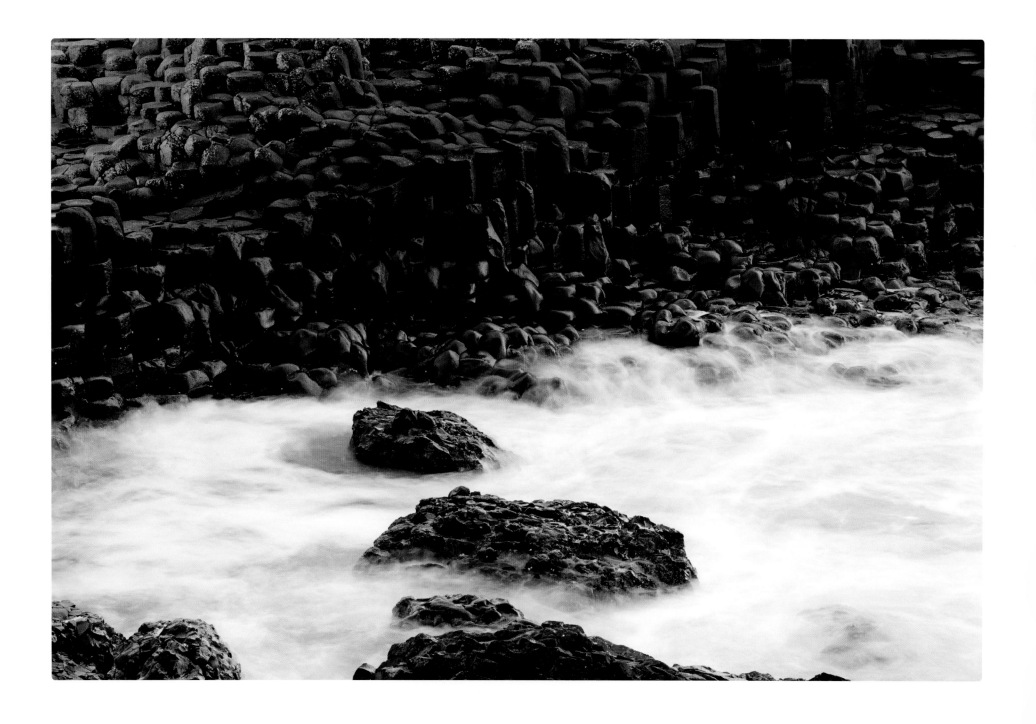

Giant's Causeway, Northern Ireland, Great Britain

Giant's Causeway. It is made up of roughly 40,000 basalt columns which are around 60 million years old. About half of the columns are hexagonal, but some of them are square, pentagonal, heptagonal, or octagonal. The tallest of the columns are about 39 feet high, and the stone is as thick as 82 feet in some places.

The basalt causeway most likely formed as a result of cooling, solidified lava streams. Vertical basalt columns may form when lava cools down very slowly and steadily. Cracks appear in the material due to tension; these cracks then form the column structures. The tension is the result of the material's cooling and shrinking, and the cracks run vertical to the area that is cooling down.

Der Damm der Riesen. Er besteht aus etwa 40.000 gleichmäßig geformten Basaltsäulen, die ein Alter von etwa 60 Millionen Jahren aufweisen. Etwa die Hälfte der Säulen hat einen sechseckigen Querschnitt, es treten jedoch auch solche mit vier, fünf, sieben oder acht Ecken auf. Die größten der Steinsäulen haben eine Höhe von zwölf Metern. Die Gesteinsschicht ist bis zu 25 Meter dick.

Die Entstehung des Basaltdammes wird auf die Abkühlung heißer Lava zurückgeführt. Formationen senkrechter Basaltsäulen können bei sehr langsamer und gleichmäßiger Abkühlung von Lava entstehen. Die Säulenstruktur bildet sich dabei aus langsam in das Material hineinlaufenden Spannungsrissen. Diese entstehen durch die Abkühlung und Schrumpfung des Materials und breiten sich senkrecht zur Abkühlungsfläche aus.

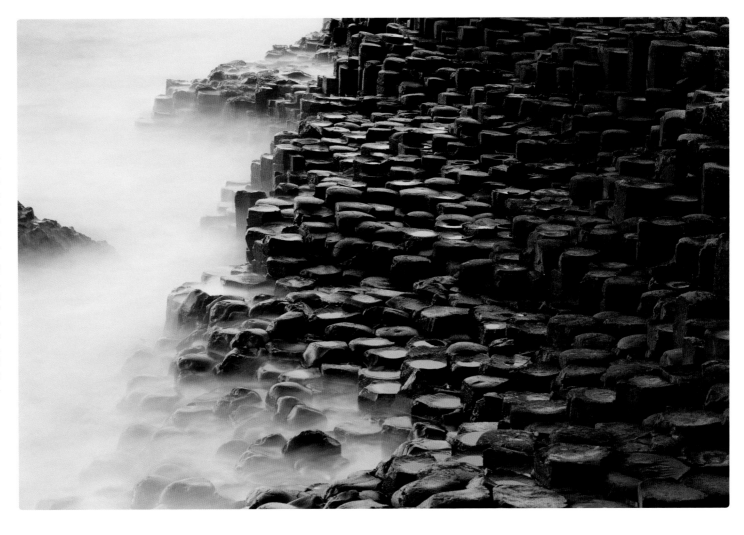

Giant's Causeway, Northern Ireland, Great Britain

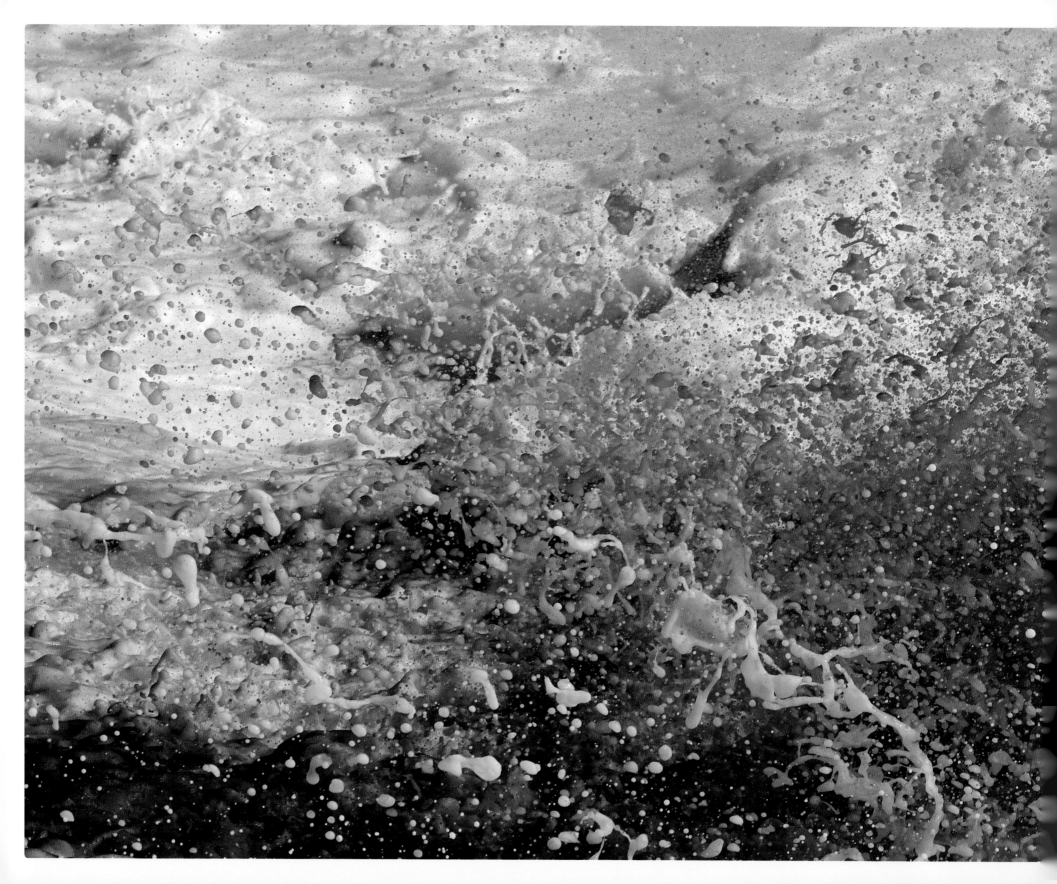

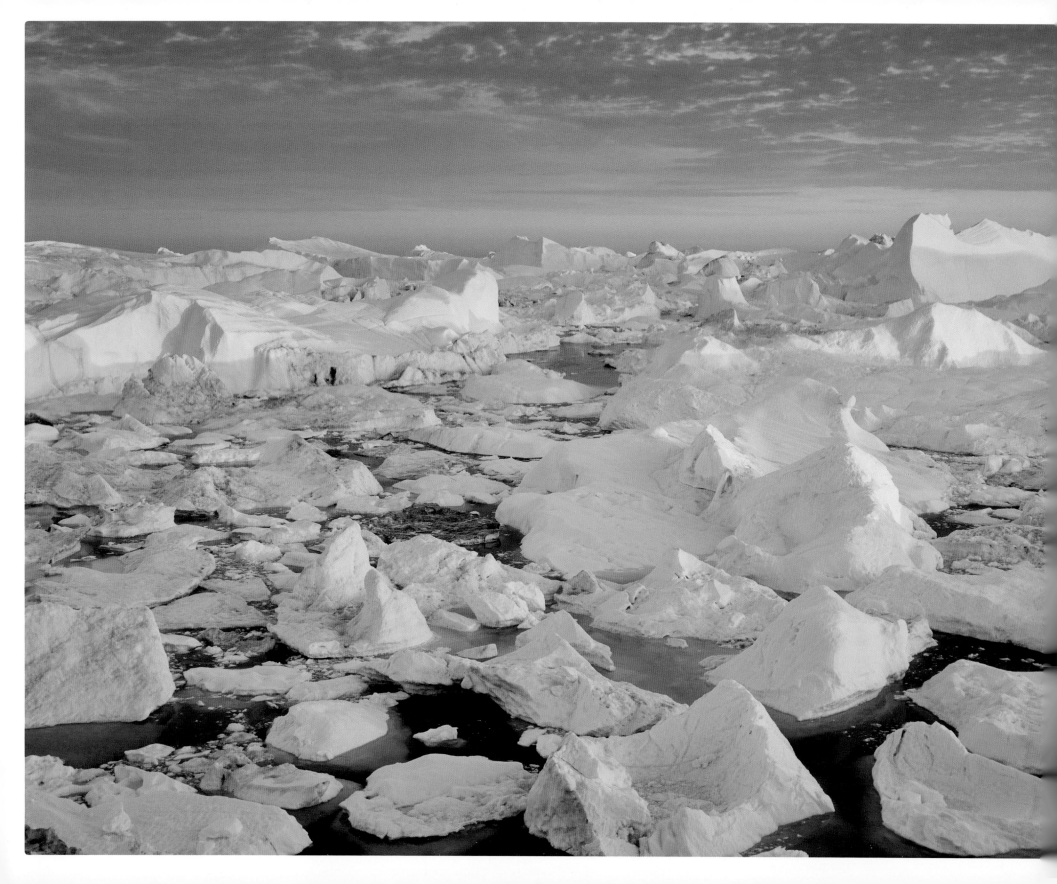

THE END OF PERMANENCE

EWIG AUF ZEIT

It is time to cross out the "perma" in permafrost. Nowhere is the rapid speed at which climate change is unfolding more apparent than at the poles. Even Antarctica's thick layers of ice, which were thought to be stable until very recently, are beginning to catch up with the Arctic's rapidly melting ice. The polar bear, robbed of its natural habitat, has become a symbol and a reminder that we need to act. For many people who are passionate about nature and conservation, an encounter with a polar bear—Ursus maritimus—is one of the most exciting moments in life. For me, it was a moment full of gratitude and most certainly one of the most fascinating and enriching moments of my life.

But polar bears and other animals aside, the polar regions have another, altogether different allure. 19th century impressionists were fascinated with the light in Provence; nowadays, photographers are crazy about the light at the north and south poles. At the equator, a sunset barely lasts long enough for the photographer to set up the tripod; at the poles, we have all the time in the world. Soft, warm light surrounds us all day—and in summer, the sun does not set at all.

Cold, hard ice and warm, soft light—by no means a modest and subtle setting. This stark contrast produces overwhelming results. Mountains of ice, glaciers, flocks of birds and schools of fish, whales, polar bears. For how long will we be able to enjoy such sights? The permafrost, this landscape of ice, is one of the most vulnerable habitats on earth, and worthy of our protection. Unfortunately, it will not be as easy as setting up a fence and regulating access.

Es ist an der Zeit, das „Ewige" am „Ewigen Eis" zu streichen. Mit atemberaubender Geschwindigkeit beschleunigt sich der Klimawandel gerade an den Polen. Selbst das lange als relativ stabil geglaubte Eis der Antarktis macht sich auf, die Arktis in Sachen Schmelzgeschwindigkeit einzuholen. Symbol und Mahnung, endlich etwas dagegen zu tun, ist der seiner Lebensgrundlage beraubte Eisbär. Die Begegnung mit Vertretern der Art Ursus maritimus gehört für viele naturbegeisterte Menschen sicher zum Höhepunkt dessen, was man erleben kann. Für mich persönlich waren es Momente tiefer Dankbarkeit und ganz sicher einige der beglückendsten Begegnungen in meinem Leben.

Aber die Polargebiete haben darüber hinaus einen ganz eigenen Reiz, unabhängig von Eisbär und Co. Während die impressionistischen Maler des späten 19. Jahrhunderts vom Licht der Provence schwärmten, begeistern sich die meisten Fotografen für das Licht des Nordens und seiner Antipode. Während am Äquator ein Sonnenuntergang kaum lange genug dauert, um das Stativ aufzustellen, hat man nahe an den Polen schier endlos Zeit. Weiches, warmes Licht, oft den ganzen Tag – und im Sommer auch in der Nacht.

Kaltes, hartes Eis und warmes, weiches Licht. Dezent und subtil geht anders, könnte man meinen. So hart der Kontrast, so überwältigend das Ergebnis. Eisberge und Gletscher, Vogel- und Fischschwärme, Wale und Eisbären. Wie lange noch wird man es erleben können? Das viel zitierte „Ewige Eis" ist einer der am meisten schützenswerten Lebensräume der Erde. Aber leider reicht das Aufstellen eines Zauns mit Eintrittsbeschränkung nicht aus.

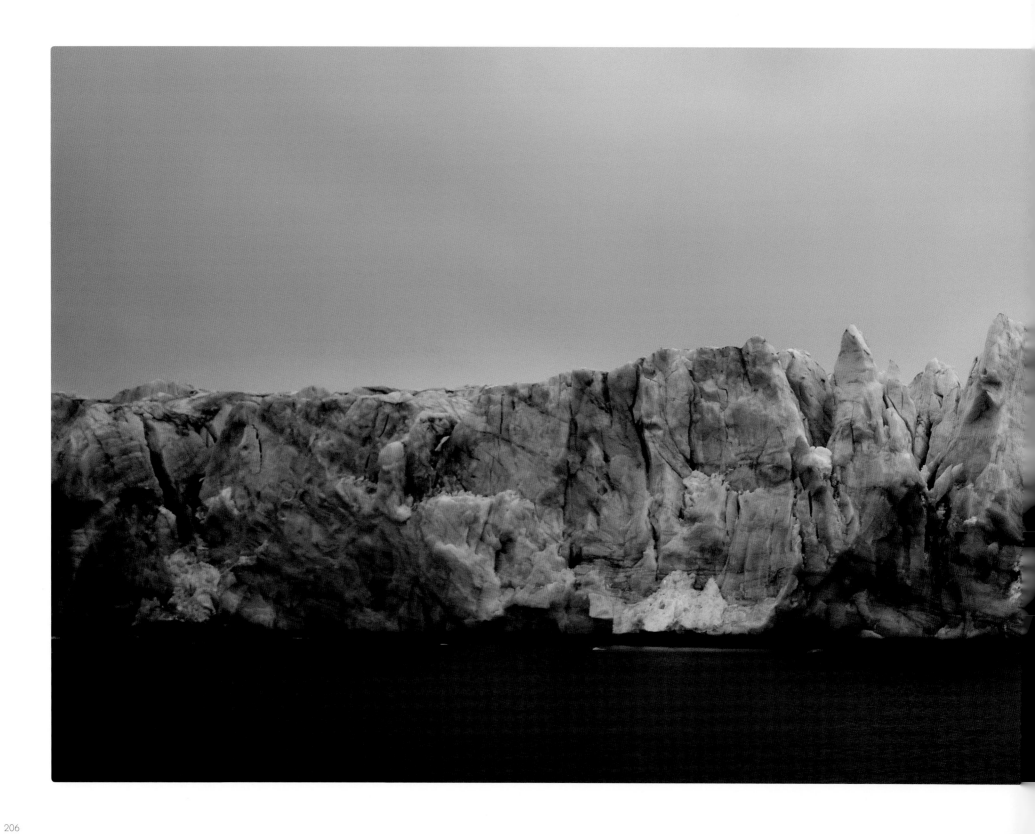

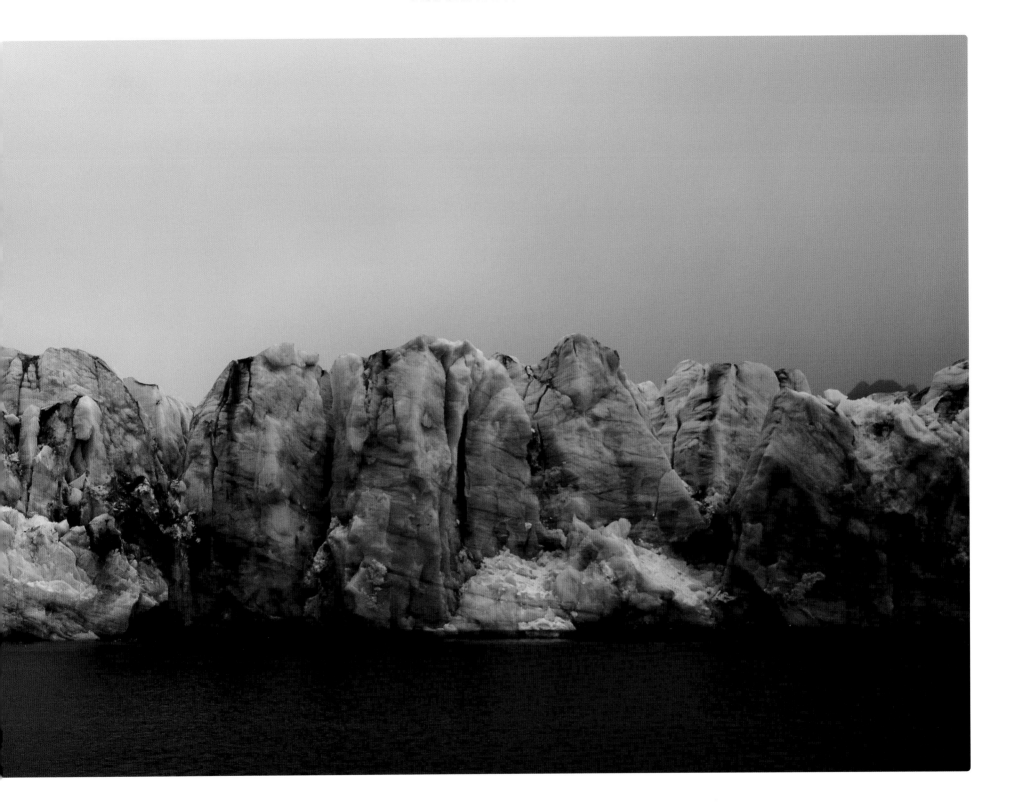

Monaco Glacier, Svalbard, Norway

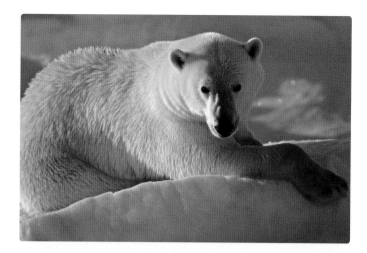

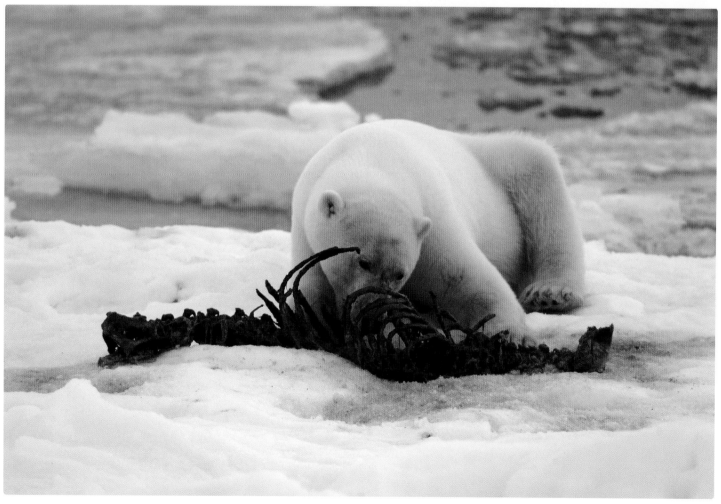

Cutting close to the bone. Who does not enjoy nibbling the soft meat close to the bone when eating spare ribs? This young female has mastered the art of stripping the skeleton of what once was a seal almost completely of its flesh. Now the bones lie on a bloodied patch of ice. Our presence did not seem to perturb her in the slightest. It was a year of plenty for the polar bears of Svalbard, but each year, life gets harder for this species.

Das Beste ist am Knochen. Nagen Sie auch so gerne den Knochen vom Kotelett ab? Dieses junge Weibchen ist Meisterin darin. Perfekt abgenagt liegt das, was einmal eine Robbe war, auf dem blutgetränkten Eis. Auch unsere Anwesenheit hat sie nicht im Geringsten beeindruckt. Es war ein gutes Jahr für Eisbären auf Spitzbergen. Aber es wird mit jedem weiteren Jahr schwieriger.

Svalbard, Norway

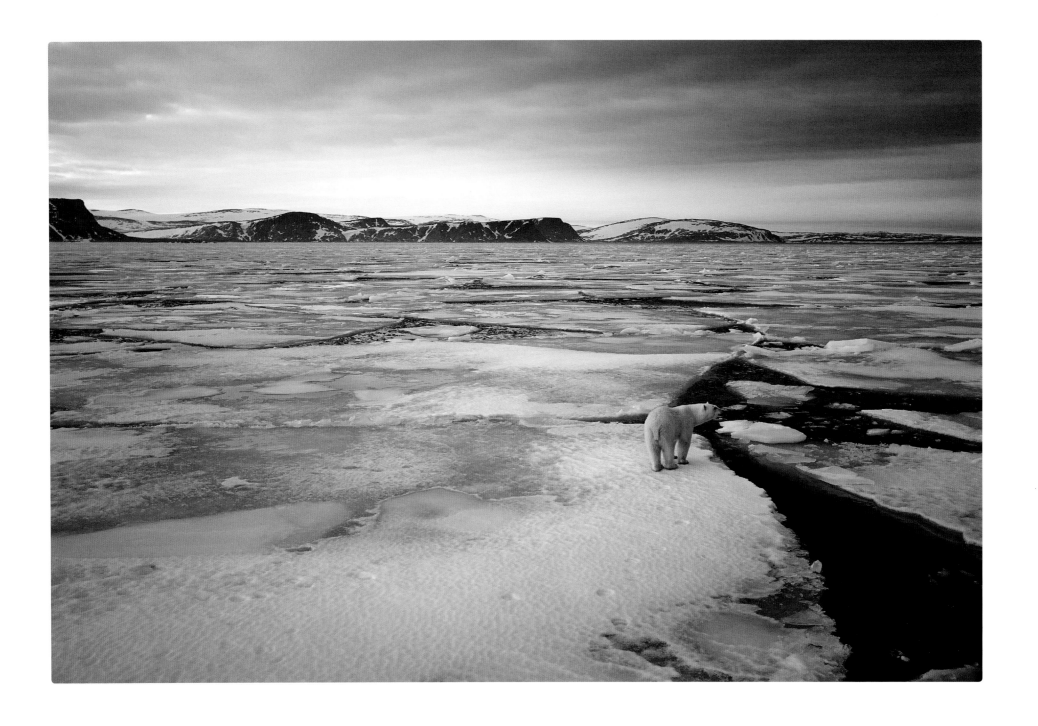

Svalbard, Norway

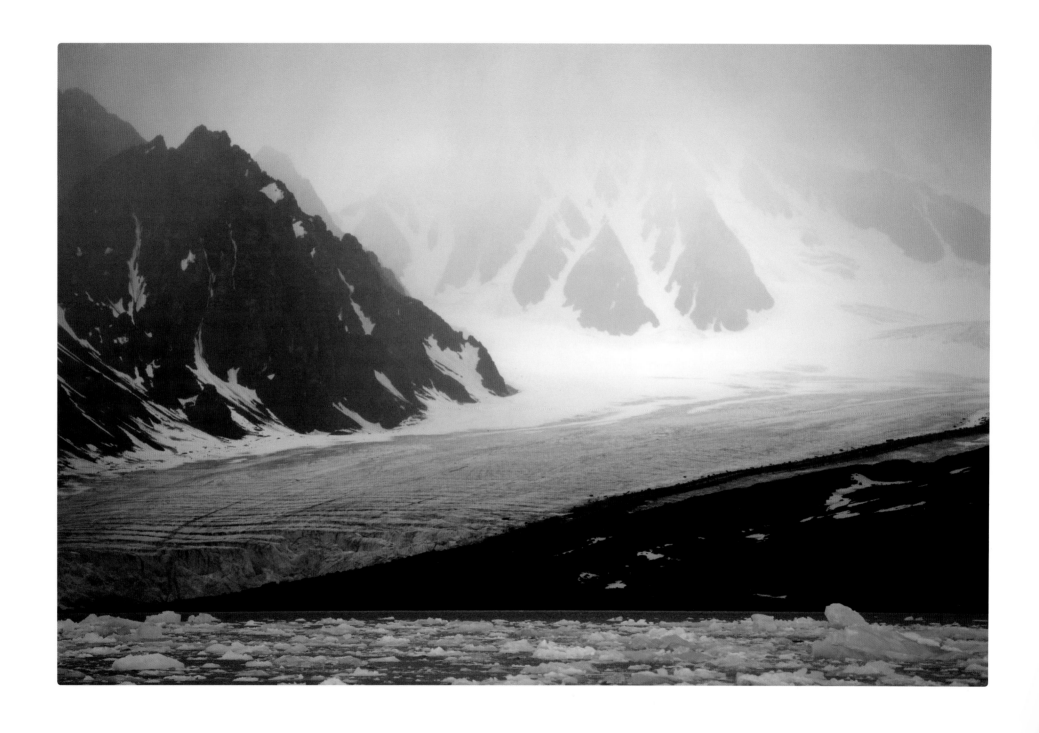

Svalbard, Norway

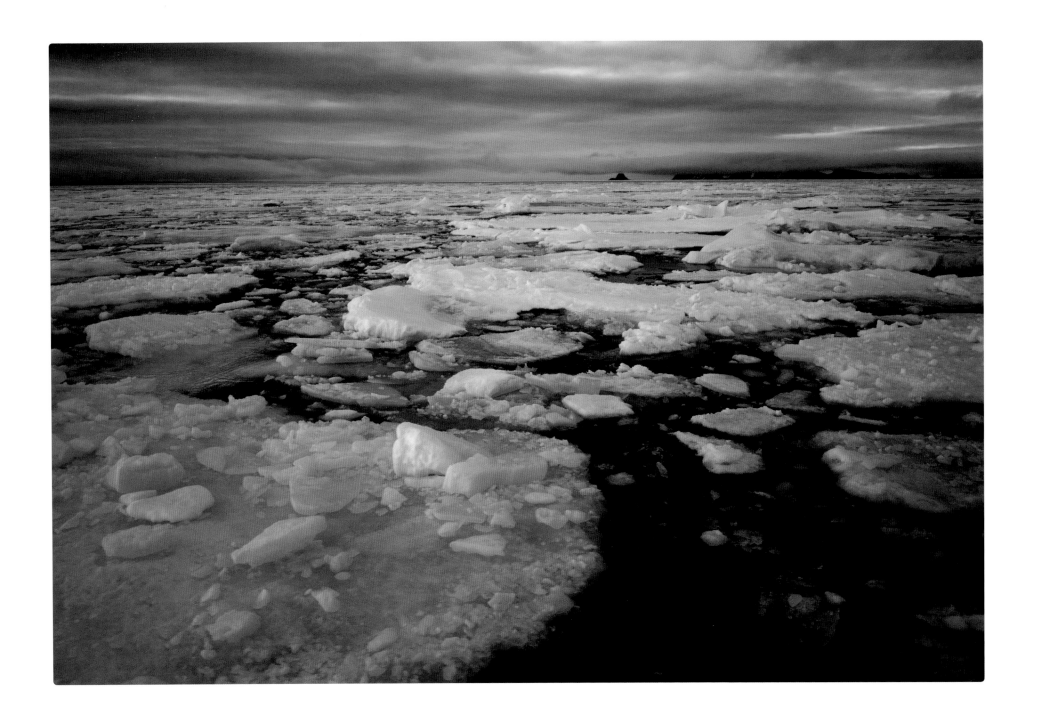

Svalbard, Norway

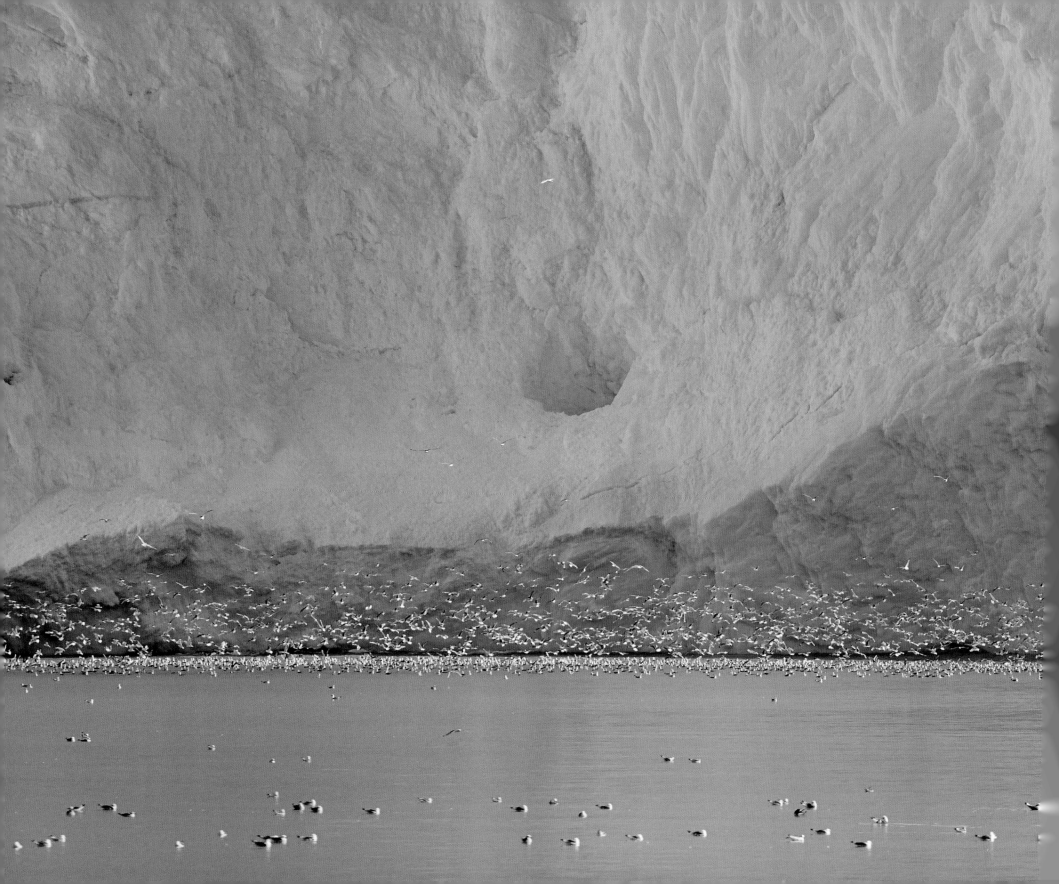

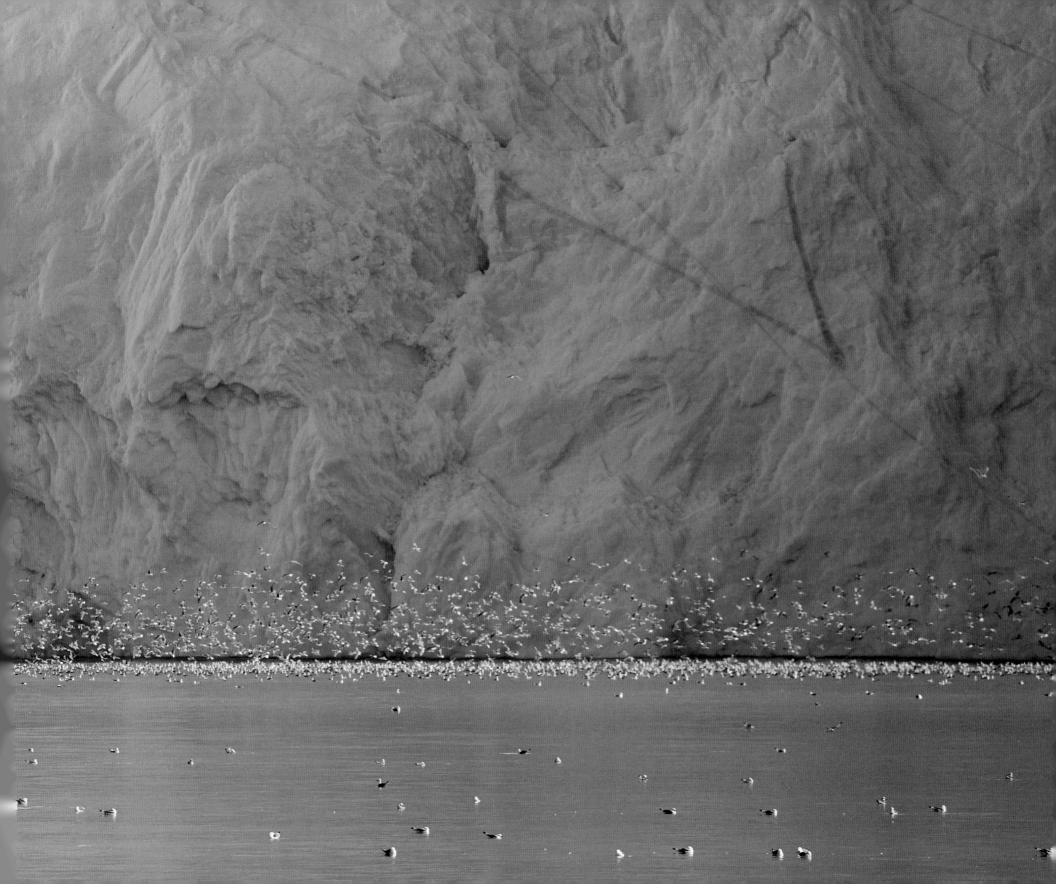

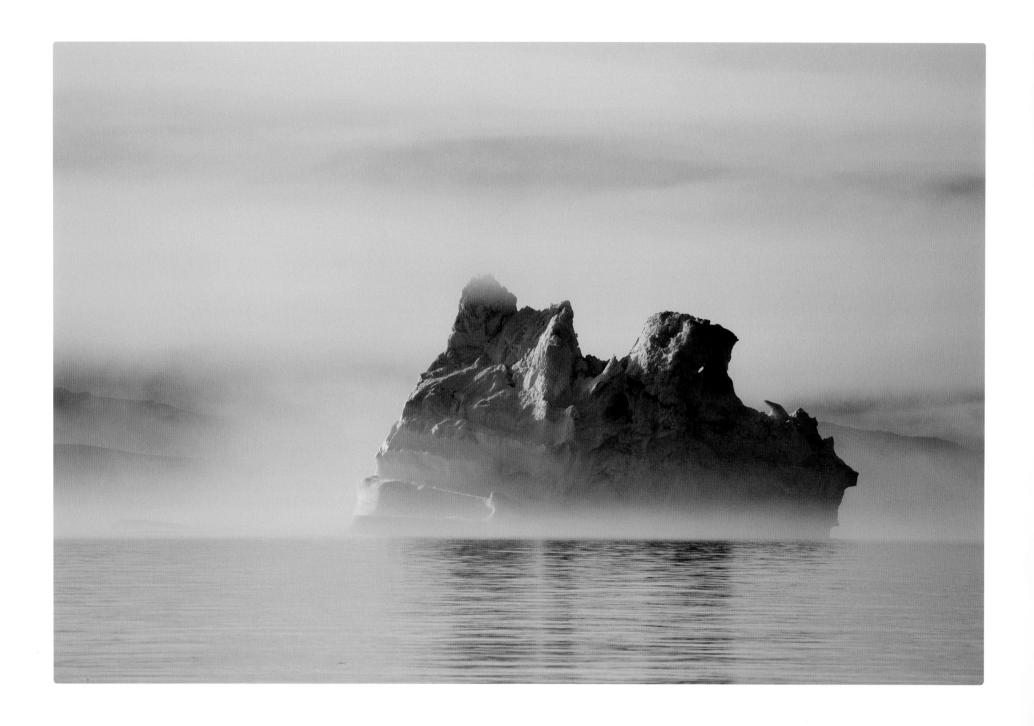

Greenland

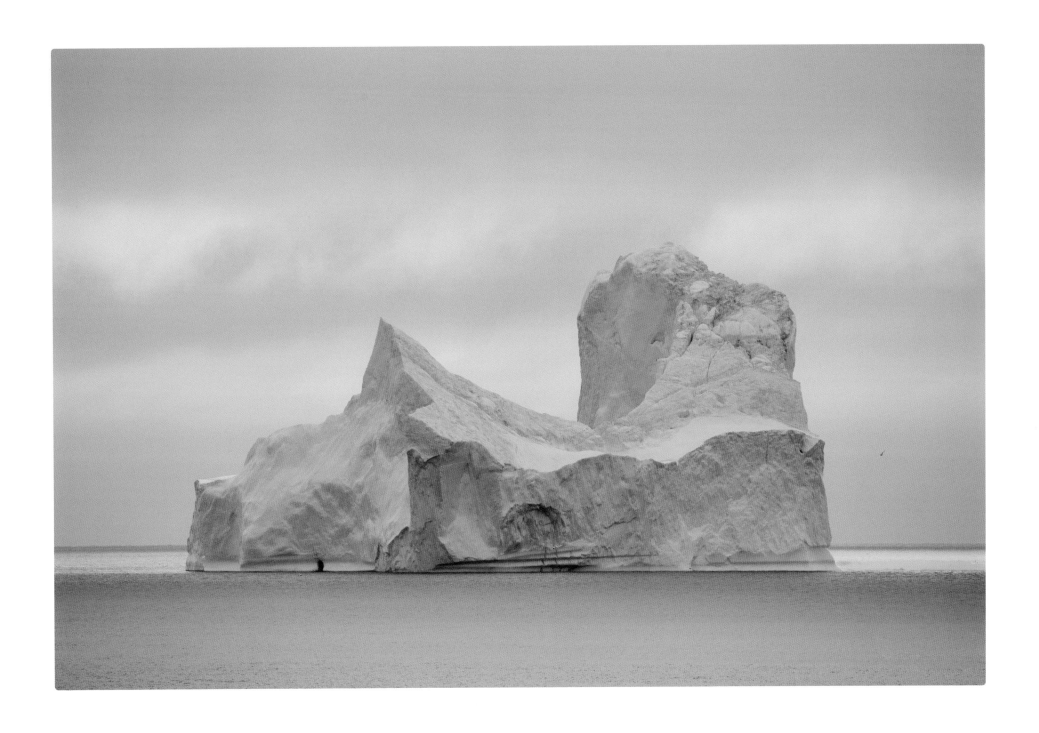

Greenland

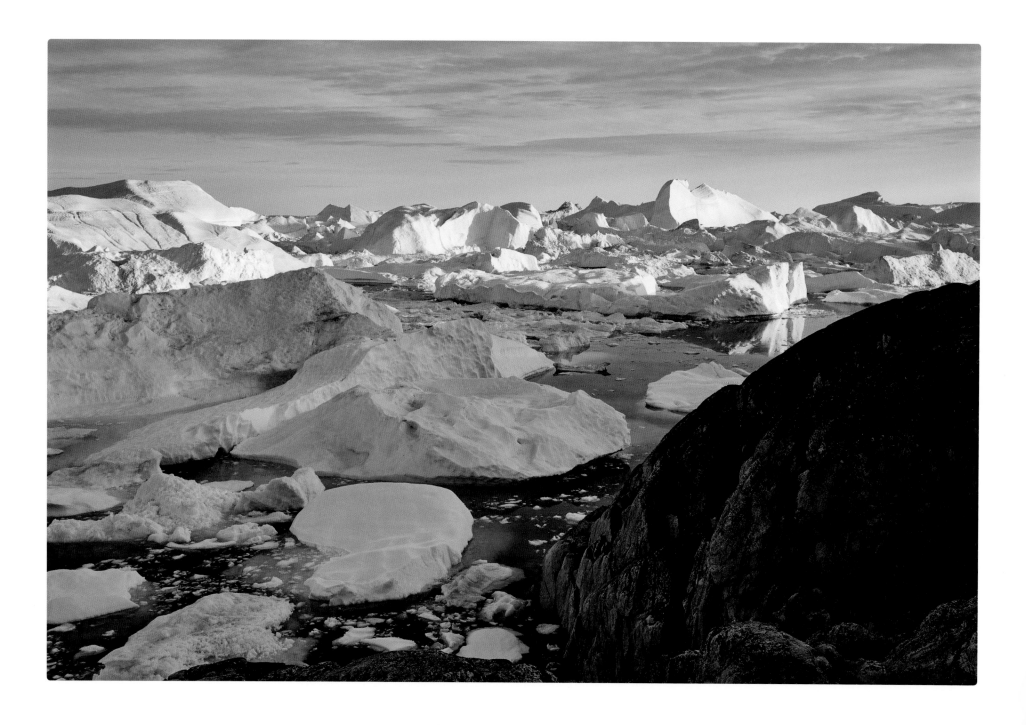

Greenland

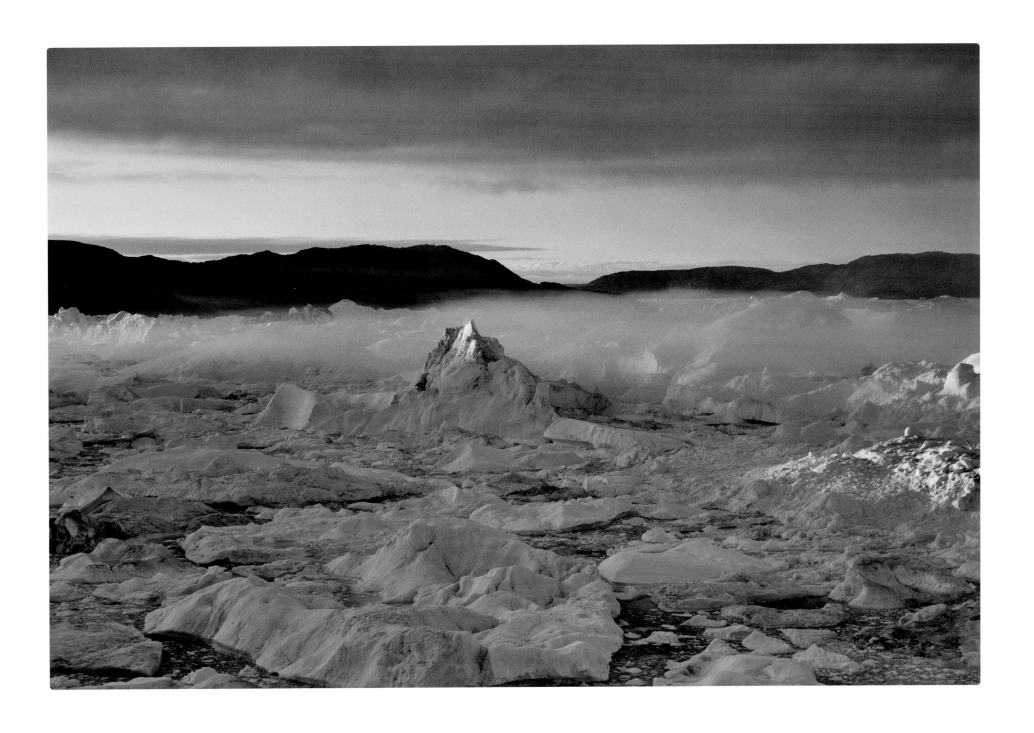

Greenland

Witching hour reimagined. At the beginning of August, at the point where the Ilulissat Icefjord meets the sea, the sun briefly disappears at midnight, only to return and rise again one or two hours later. The last sunrays reach for the peaks of countless icebergs which are still blocking the water's outflow into the sea. Over time, the icebergs melt until at last they are low enough to allow for an exit. To my mind, this is one of the most beautiful places in the world. How long will it last, though? The speed at which the Arctic is melting has increased steadily over the course of the past few years, beating even the bleakest forecasts.

Geisterstunde einmal anders. Hier, Anfang August am Ausgang des Ilulissat-Eisfjords ins Meer, verabschiedet sich die Sonne gegen Mitternacht nur kurz, um ein, zwei Stunden später wieder aufzugehen. Letzte Sonnenstrahlen erreichen gerade noch die Spitzen der unzähligen Eisberge, die den Abfluss ins Meer verstopfen. So lange, bis sie flach genug geworden sind, den Ausgang des Fjords zu überwinden. Für mich ist dies einer der schönsten Orte der Welt. Noch, aber wie lange noch? Das Tempo der Eisschmelze in der Arktis hat in den letzten Jahren dramatisch und weit stärker als erwartet zugenommen.

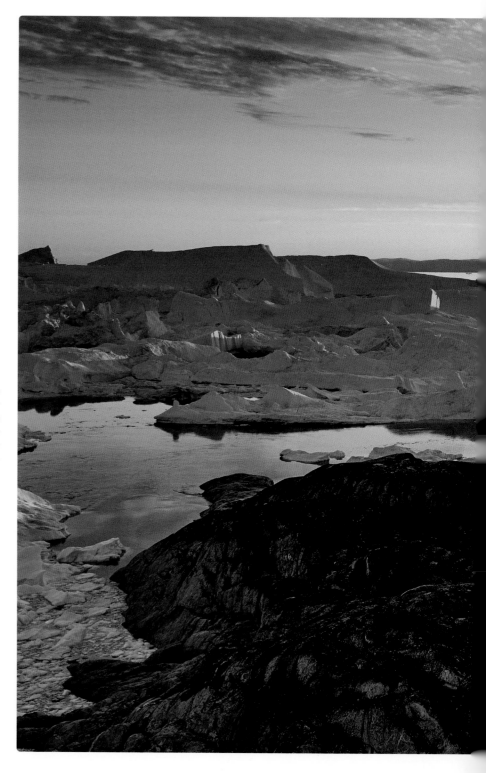

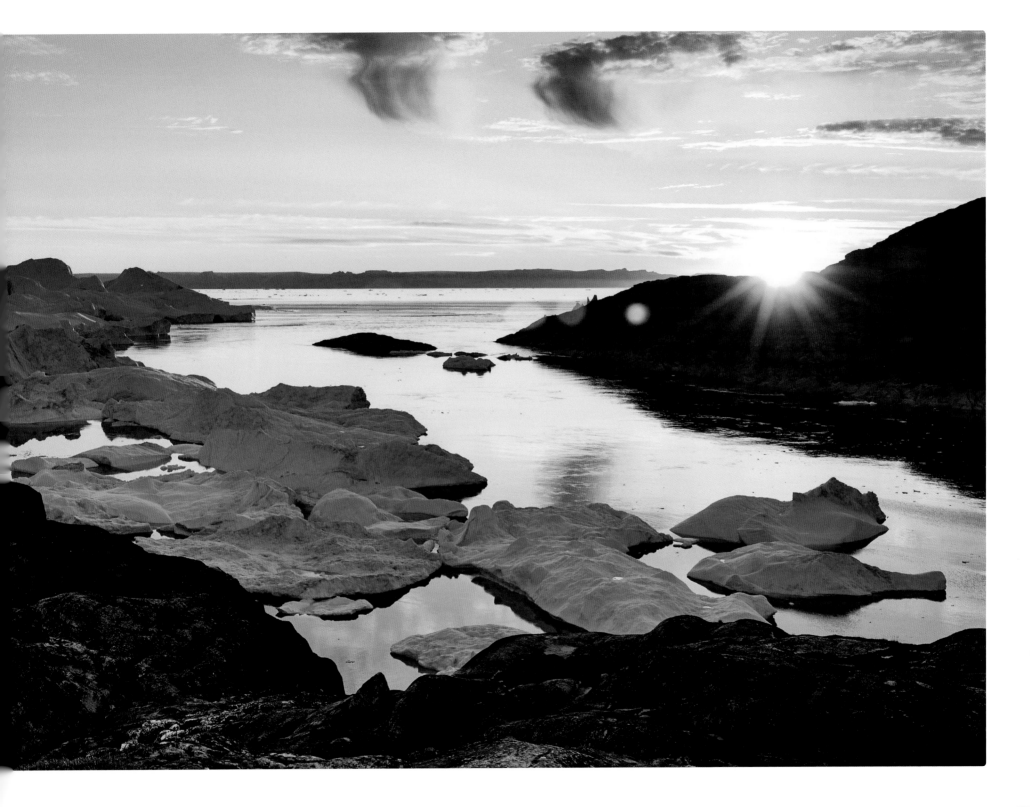

Greenland

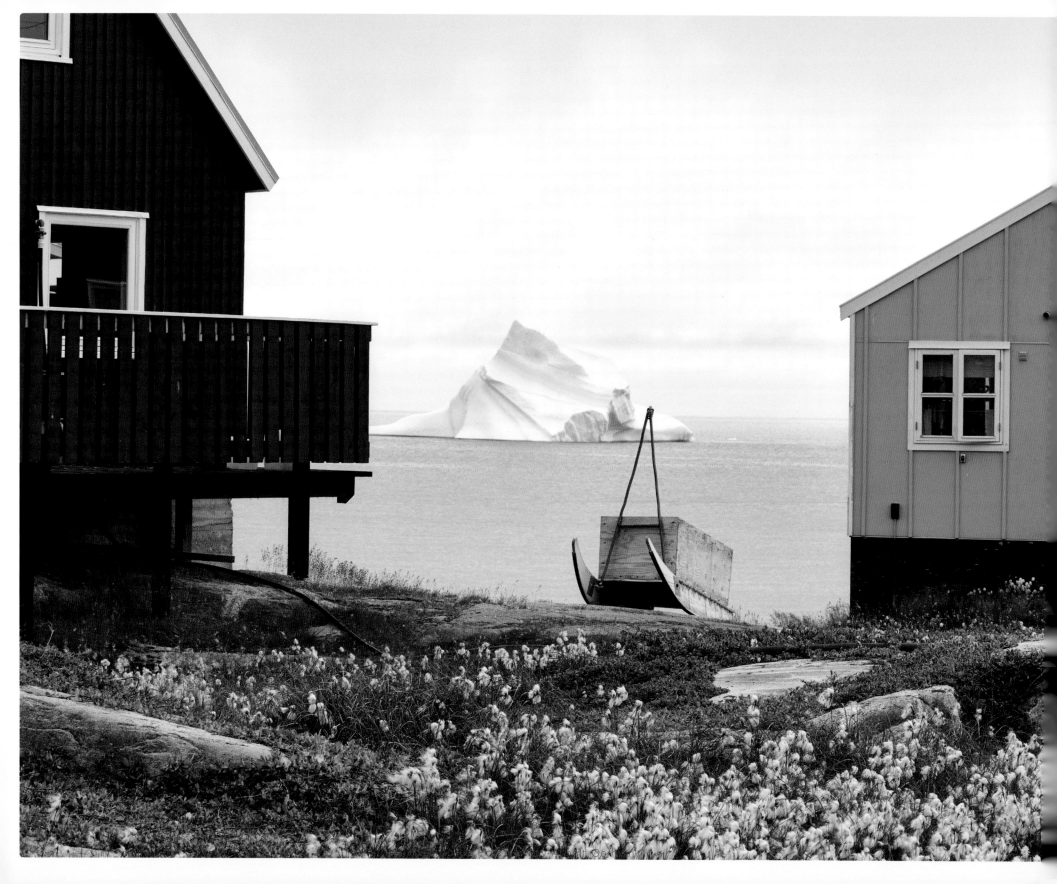

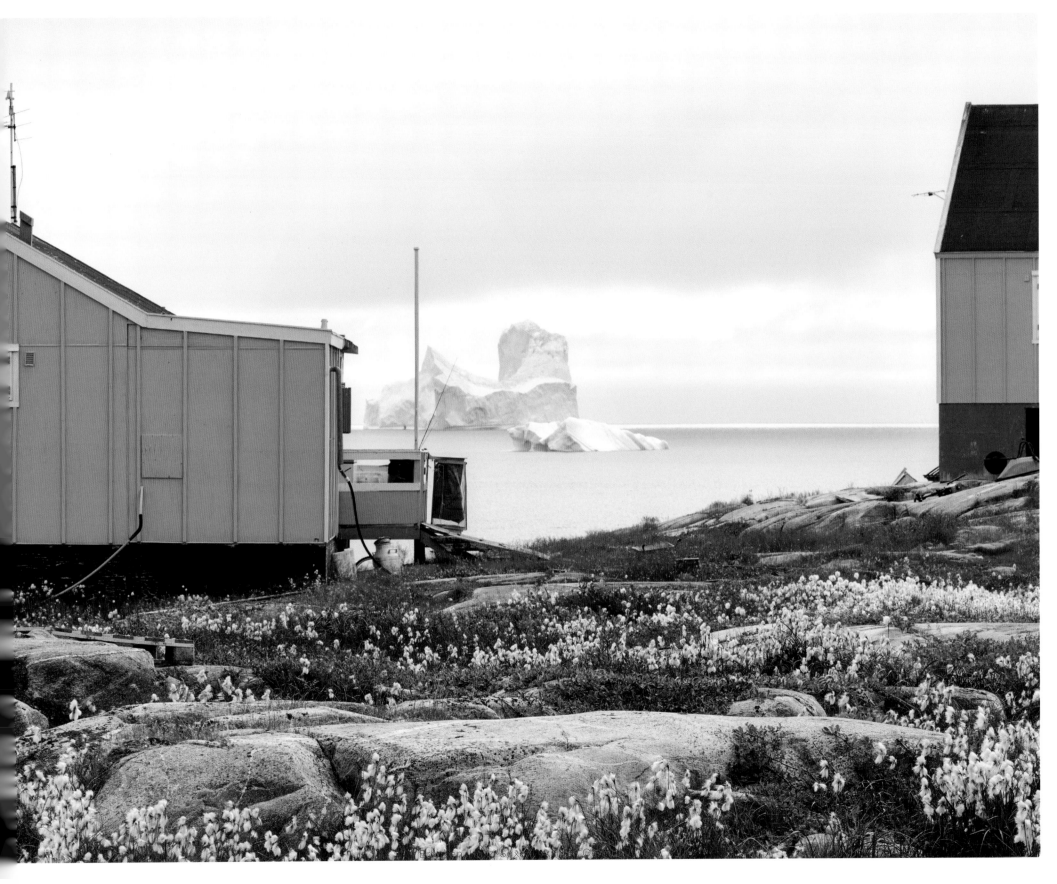

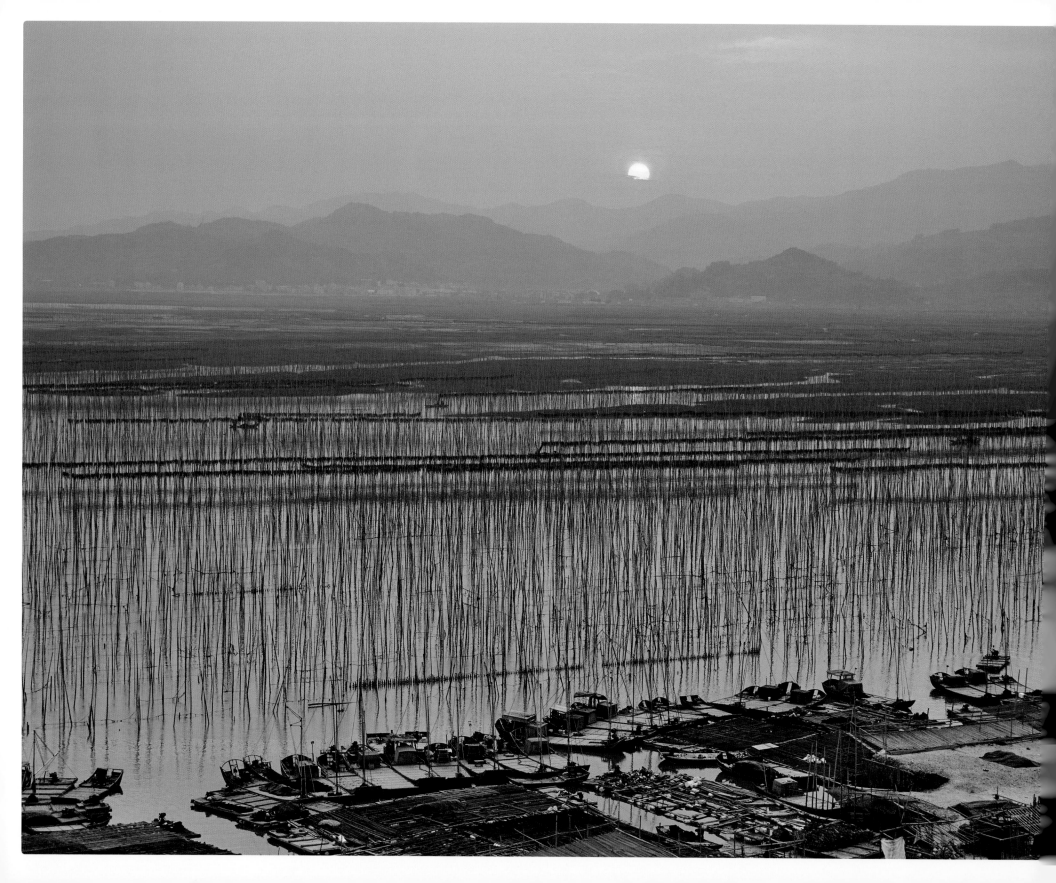

AQUACULTURE

AQUAKULTUR

Farming underwater. That is the most succinct way to sum up what is happening here in the bays of the South China Sea, in the Chinese province of Fujian. The shallow bays look like tidal flats and are covered in small bamboo sticks on which seaweed and kelp are being grown. Nearby, almost anything else edible that can possibly grow there is being farmed too: oysters, cockles, snails, mudskippers, and carp, to name but a few. The small traditional aquaculture farms have long since become large industrial operations. Hundreds of thousands, maybe millions of people have found a well-paid place of employment here. During high season, many workers stay in floating accommodation on the sea—right above the office, so to speak.

In times of excessive overfishing of the seas, aquaculture is playing an increasingly important role in providing fish and seafood to satisfy market demands. By now it is an extremely lucrative industry. In China, about two thirds of all fish and seafood consumed come from aquacultures—this makes it the country with the largest aquaculture industry in the world.

The picturesque beauty of the bamboo sticks emerging from the water, the patterns and structures, the floating houses' bright colors—here, natural landscape and artificial elements merge and make it all too easy to forget that aquaculture often causes devastating ecological issues. Why should farming in the water be any different to farming on land?

Landwirtschaft im Wasser. So lässt sich am treffendsten beschreiben, was hier in den Buchten des Südchinesischen Meeres in der Provinz Fujian seit vielen Generationen praktiziert wird. Die flachen, wattähnlichen Buchten sind mit einem Wald aus Bambusstäben gespickt, an denen Seegras und Tang herangezogen werden. Daneben wird so ziemlich alles kultiviert, was machbar und genießbar ist: Austern, Herzmuscheln, Schnecken, Schlammspringer und Karpfen sind nur ein paar Beispiele dafür. Mittlerweile sind aus den kleinen traditionellen Wasserfarmen längst Anlagen industriellen Ausmaßes hervorgegangen, die Hunderttausenden, wenn nicht gar Millionen Menschen einen gut bezahlten Arbeitsplatz bieten. Praktischerweise leben viele der Arbeiter zumindest saisonal in schwimmenden Siedlungen quasi direkt „über" ihrer Arbeit.

In Zeiten der zunehmenden Überfischung der Meere übernimmt die Aquakultur mehr und mehr die Versorgung mit Fisch und Meeresfrüchten und ist längst ein Multimilliarden-Dollar-Markt. Schon jetzt stammen etwa zwei Drittel aller „erwirtschafteten" Fische und Meeresfrüchte in China aus Zuchtanlagen. Das Land ist mit Abstand der größte Produzent weltweit.

Die pittoreske Schönheit der Bambuswälder auf dem Wasser, die grafischen Muster und die Buntheit der schwimmenden Häuschen, die schwimmende Verschmelzung natürlicher und kultivierter „Landschaft" macht es dem Betrachter leicht, nicht an die mit Aquakultur immer verbundenen ökologischen Probleme zu denken. Warum sollte Landwirtschaft auf dem Wasser anders sein als Landwirtschaft an Land?

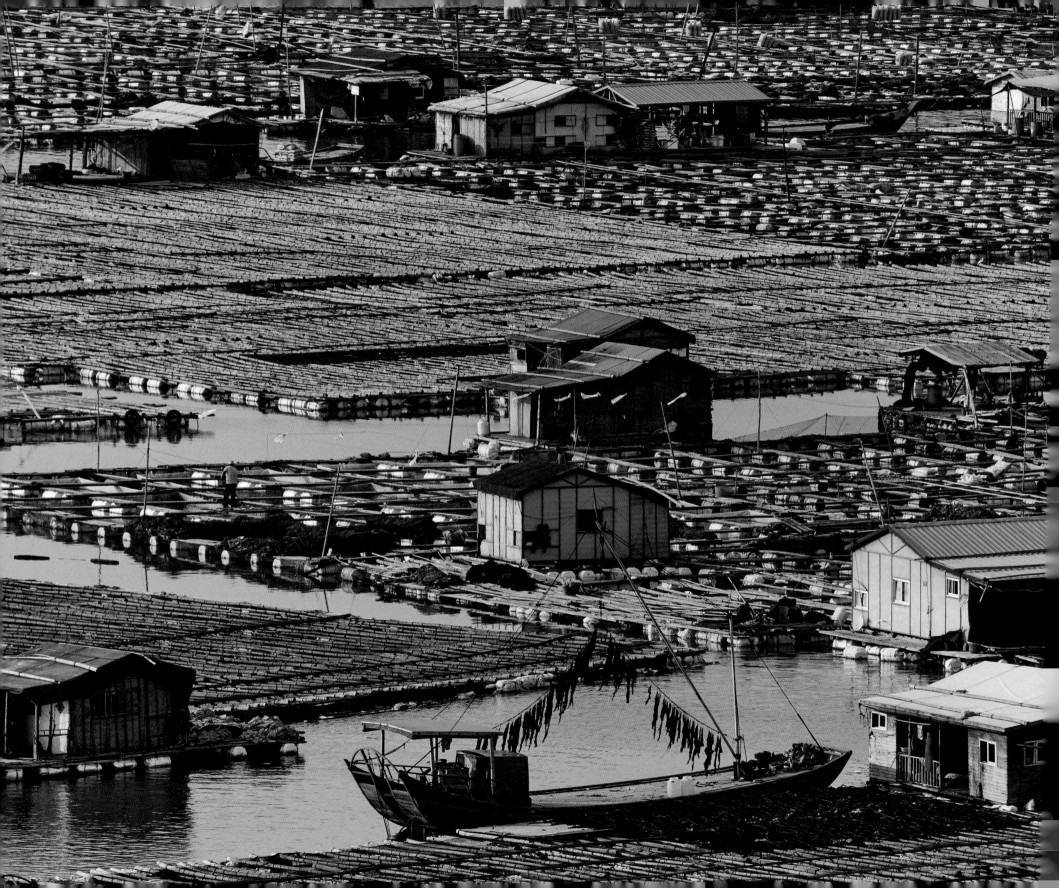

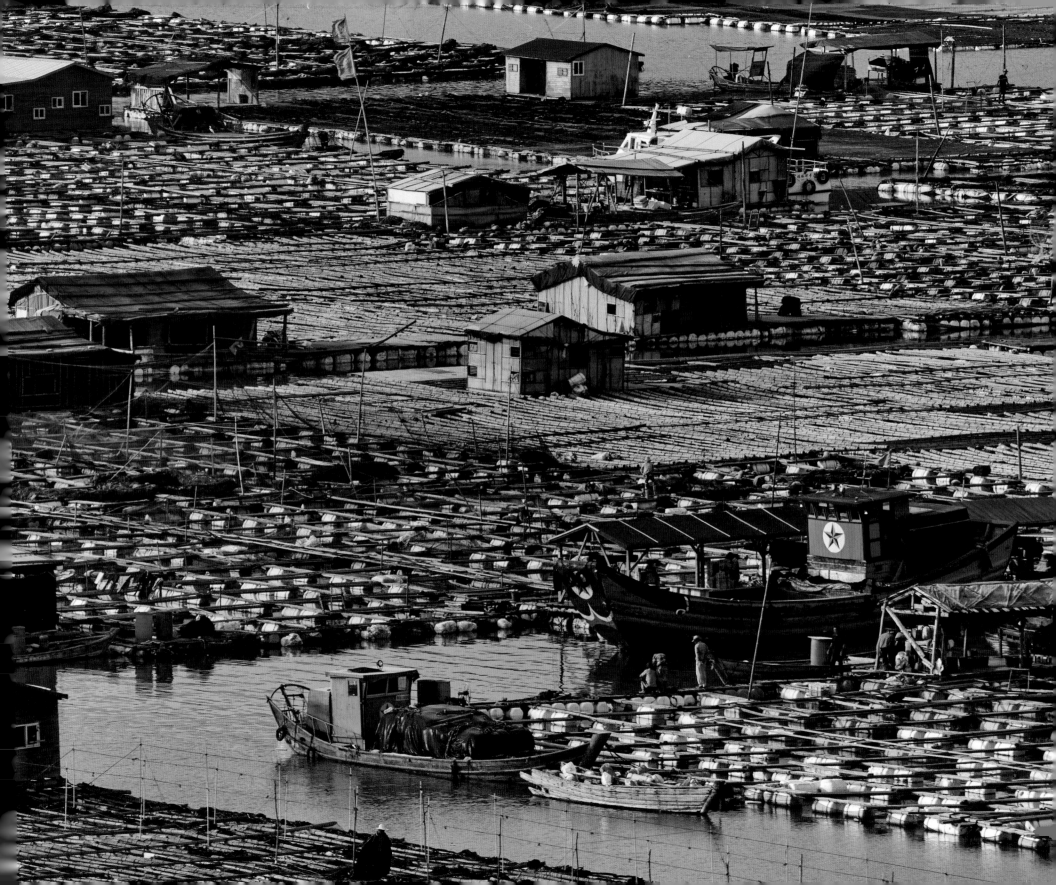

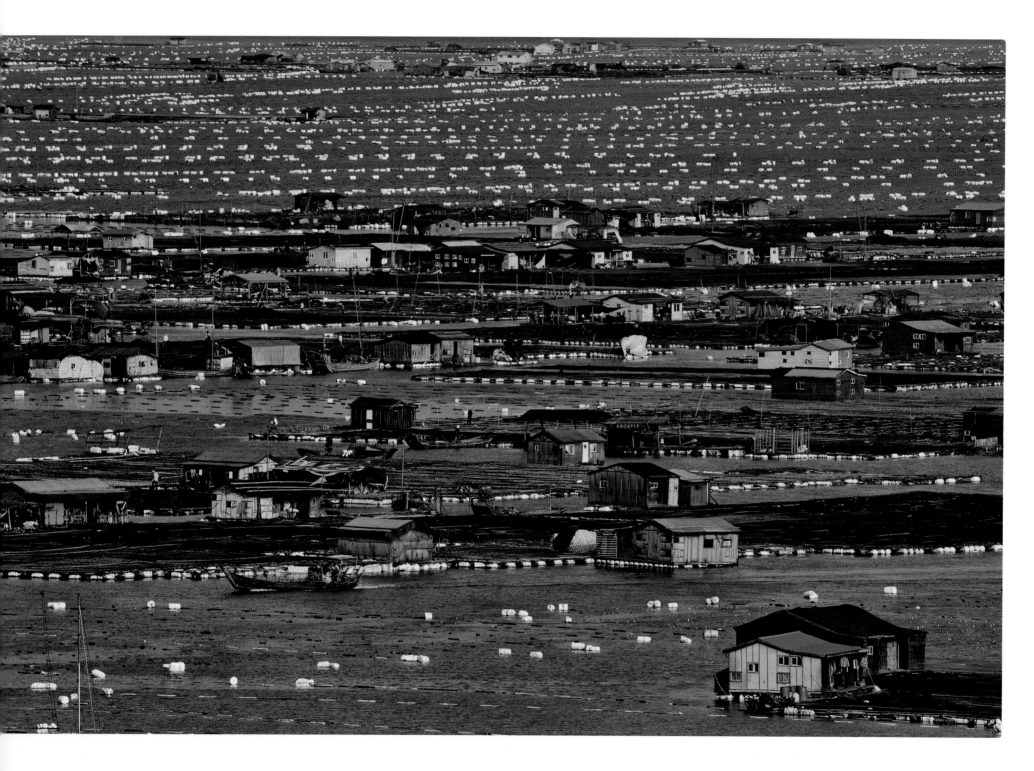

Xiapu, China

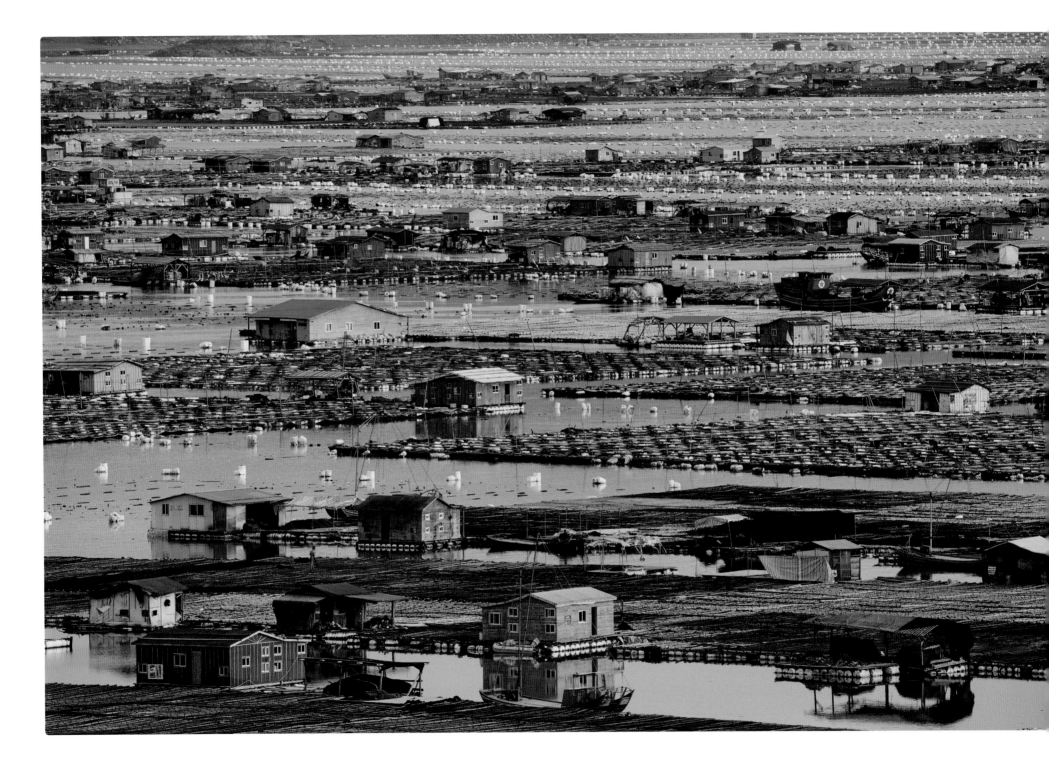

Xiapu, China

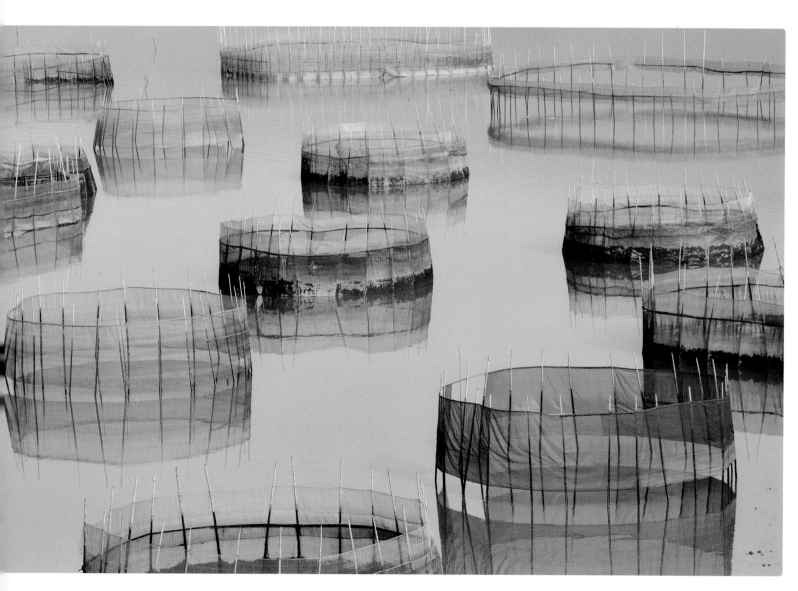

All just for show. These round nets are a relic of days gone by. The biggest challenge in realizing this photograph was the fact that a paid actor working for the many Chinese photographers kept paddling back and forth between the nets. It was difficult to capture a moment in which no person was entering the picture before the sun stood too high and the water levels fell too low. Photographing a staged situation was out of the question. In China, many iconic scenes are now just portrayed by actors and no longer happen in this form in everyday life.

Alles nur Show. Ein Relikt aus vergangenen Tagen sind diese Rundnetze. Die größte Herausforderung, um dieses Bild machen zu können, war die Tatsache, dass ein bezahlter Statist für die vielen anwesenden chinesischen Fotografen permanent dazwischen umhergerudert ist. Es galt, einen Moment ohne Mensch zu erwischen, bevor die Sonne zu hoch und der Wasserstand zu niedrig war. Denn so ein „Staging" wollte ich auf keinen Fall fotografieren. Viele bekannte ikonische Bilder aus China sind mittlerweile reine Inszenierung und kommen so nicht mehr vor.

Xiapu, China

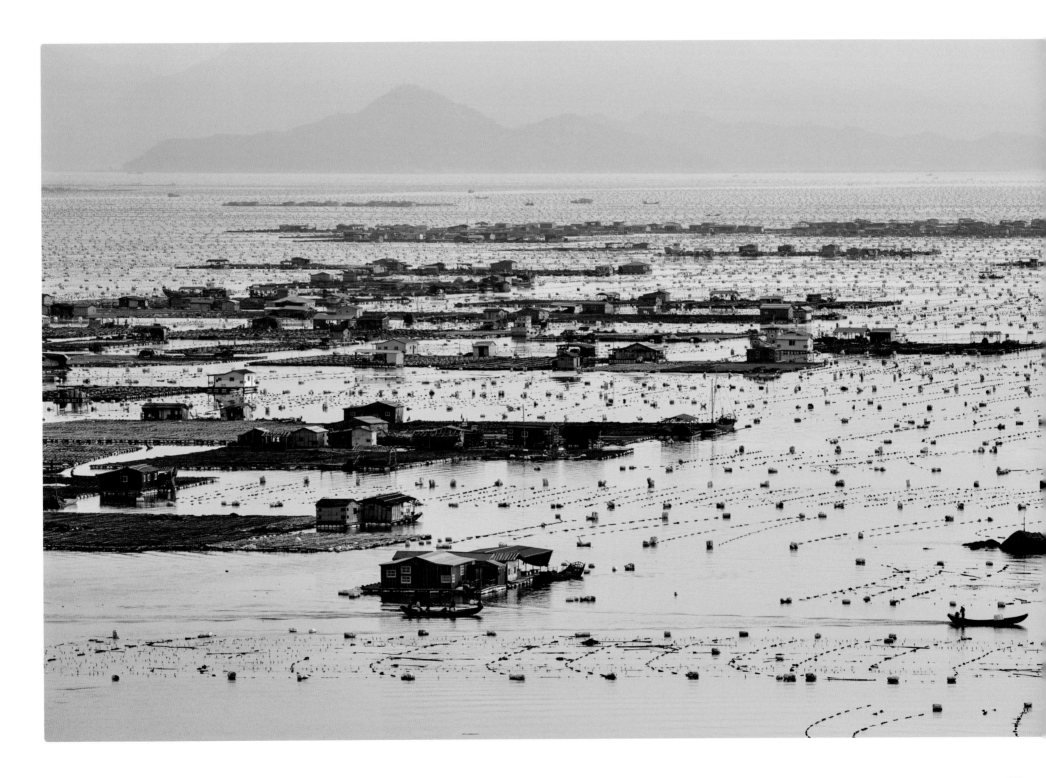

Xiapu, China

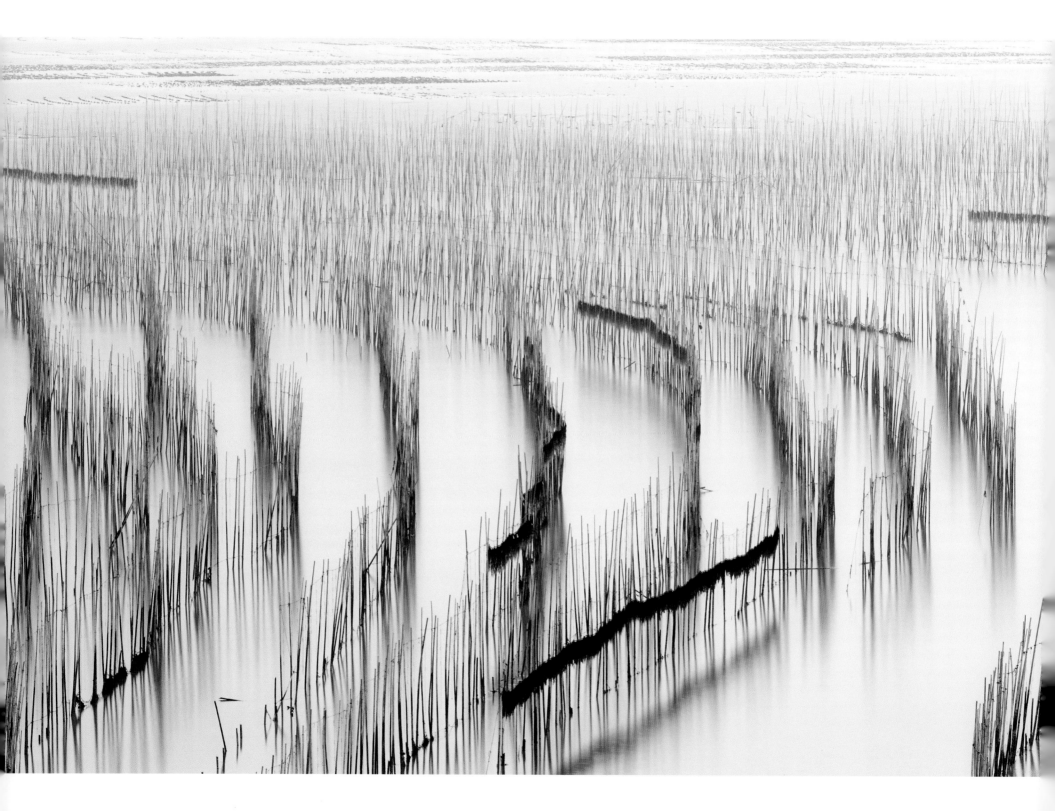

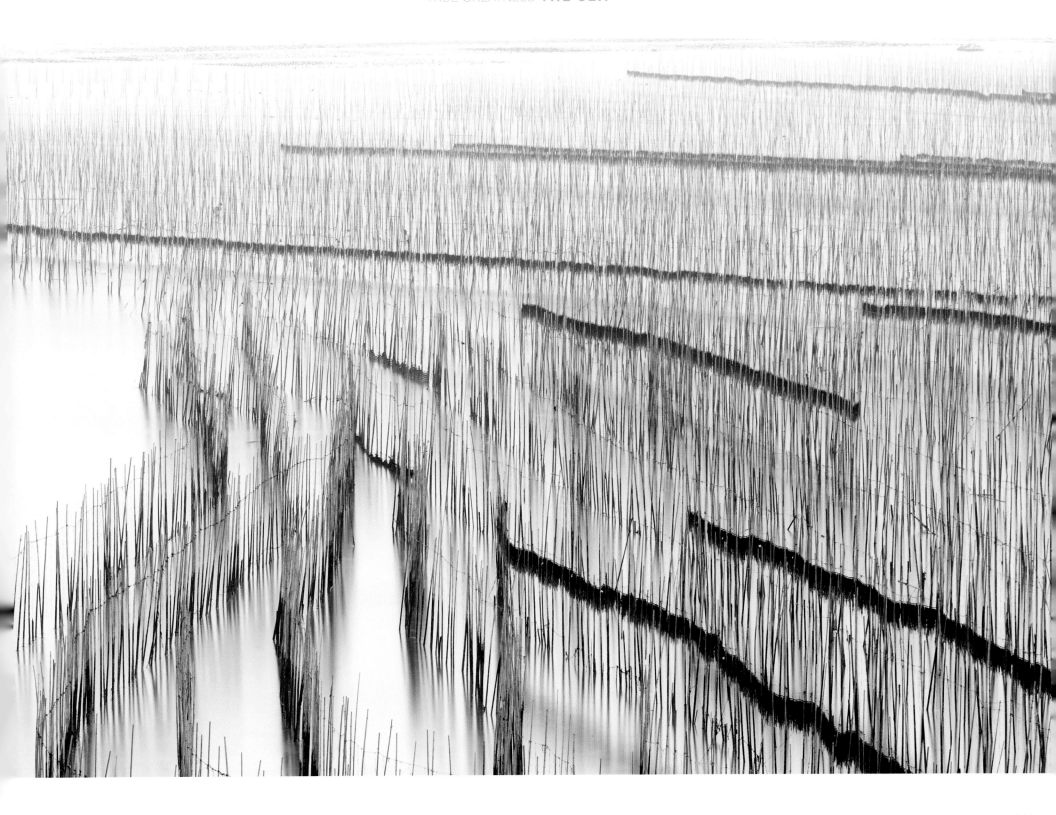

Xiapu, China

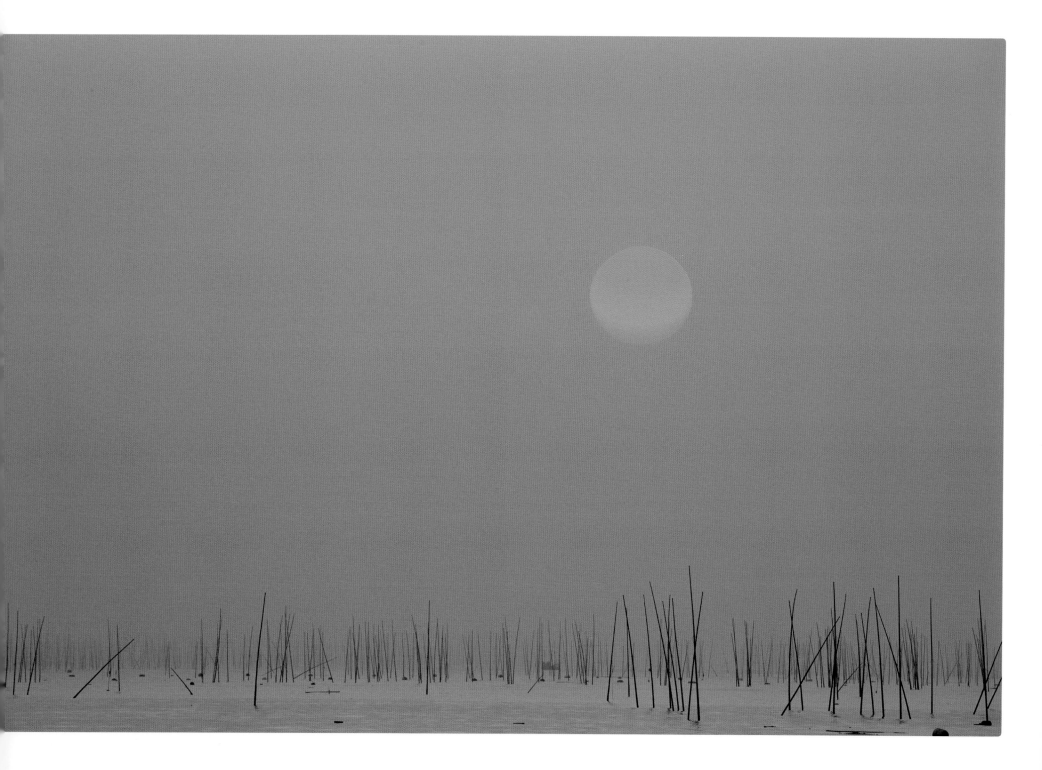

Xiapu, China

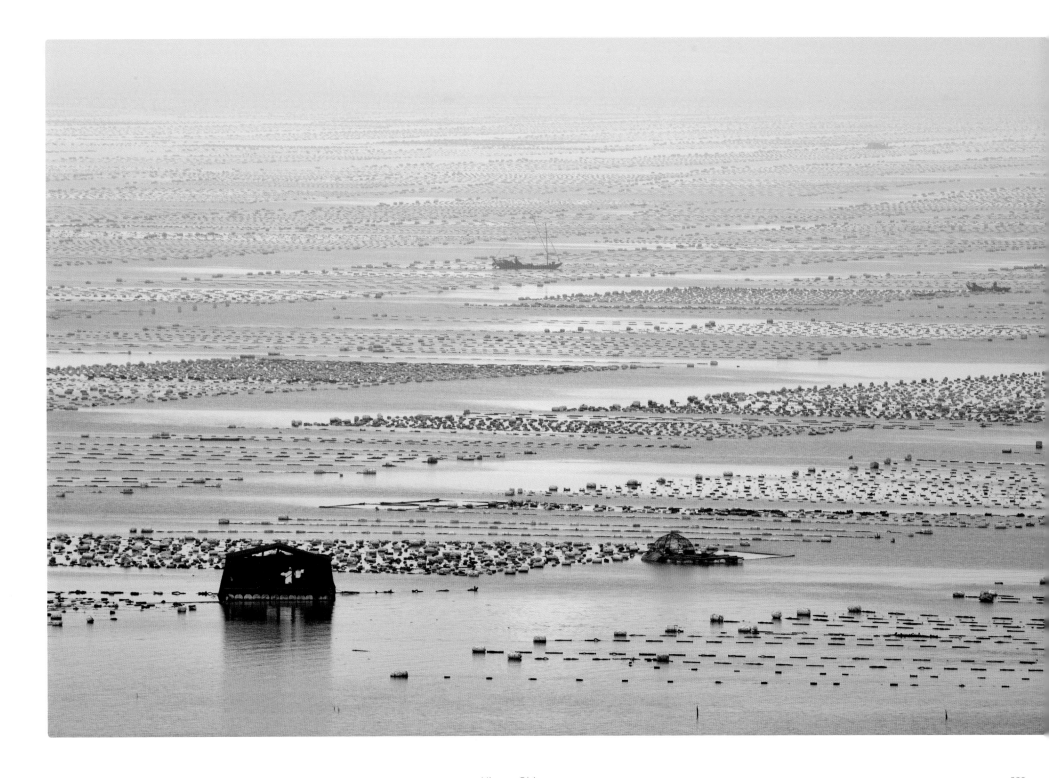

Xiapu, China

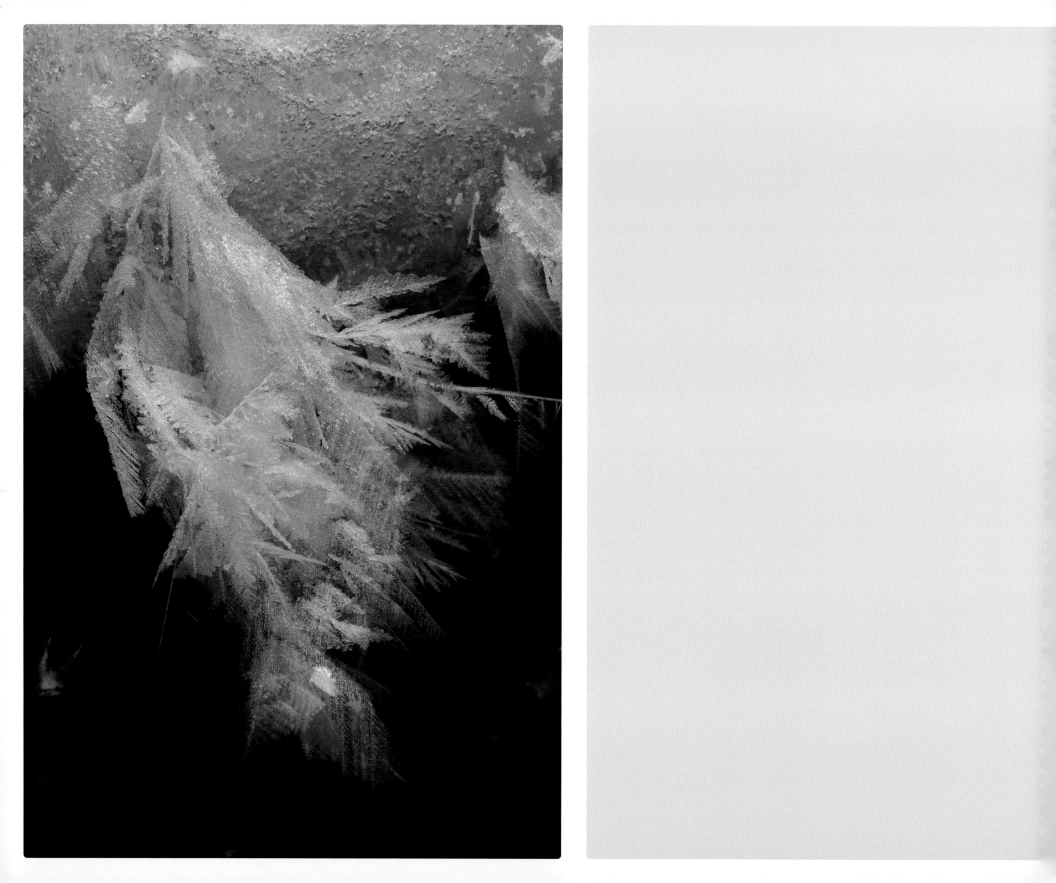

SEASONAL SNOW AND ICE

SAISONAL SCHNEE UND EIS

Permafrost can only be found in the polar regions; in all other areas of the world, water only becomes ice or snow following a seasonal cycle: when winter arrives and temperatures fall. At that point, nature takes a break. Large parts of the northern hemisphere follow this cycle; in the southern hemisphere, little land is to be found in the corresponding southern latitudes. Seasonal cycles dependent on the latitudes aside, there is another, vertical factor that has an impact on temperature: altitude. Sometimes, a sped-up micro version of the seasons happens in only one day. At night, water freezes and rain falls as snow. The next morning, the sun rises and it all melts away again.

Im Gegensatz zum sogenannten „Ewigen Eis" der Polarregionen geschieht die Verwandlung flüssigen Wassers in Schnee und Eis auch im Zyklus der Jahreszeiten, wenn der Winter kommt und die Temperaturen fallen. Dann legt die Natur eine Pause ein. Viele Prozesse des Lebens verlangsamen sich oder kommen ganz zum Stillstand. Weite Teile der Nordhalbkugel sind davon geprägt; im Gegensatz zur südlichen Hälfte, wo nur wenig Landfläche in den entsprechenden Breitengraden zu finden ist. Neben dieser vom Breitengrad abhängigen Form der Jahreszeiten gibt es auch eine vertikale Variante in Abhängigkeit von der Höhe. Jahreszeiten im Zeitraffer auf Tageslänge gebracht. Nachts gefriert das Wasser, Niederschlag fällt als Schnee, nur um am nächsten Morgen mit der aufgehenden Sonne wieder zu schmelzen.

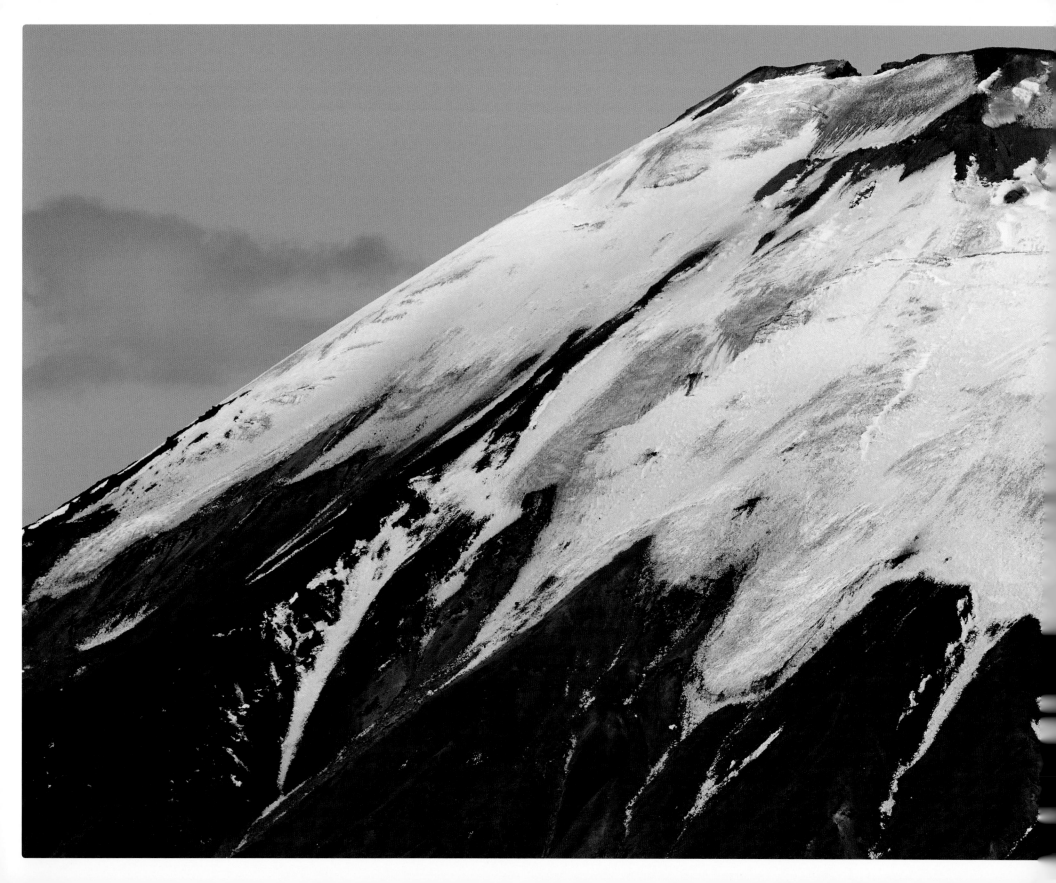

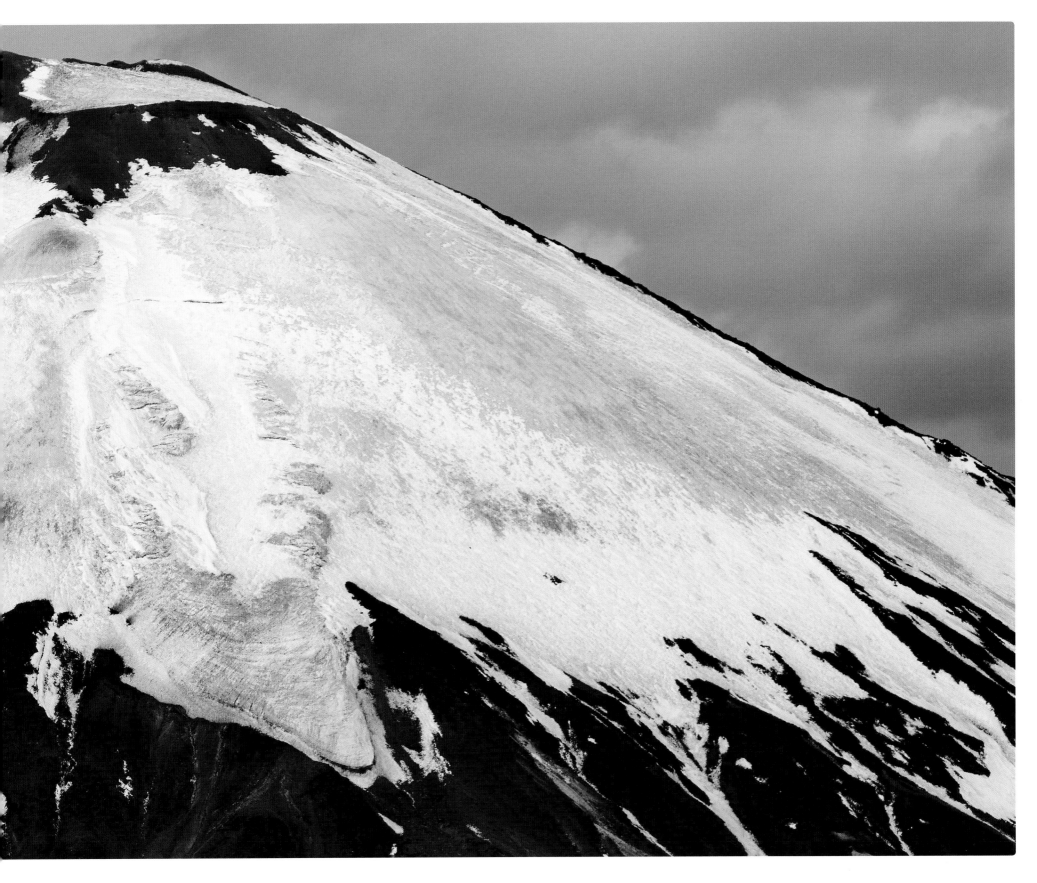

The Brocken, Harz, Germany

The Brocken, Harz, Germany

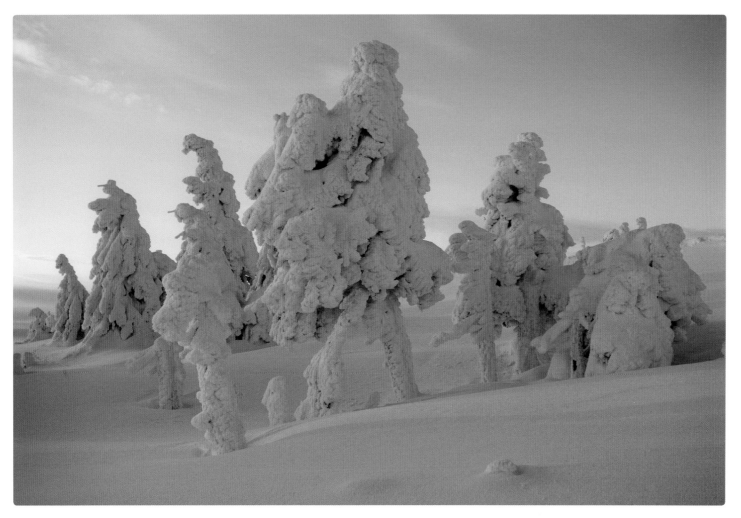

Baroque queen with ladies-in-waiting. Who needs Lapland or another Arctic tundra region when you could just visit the Brocken? At more than 3700 feet, it is the tallest mountain in Germany's Harz mountain range, and it is the only obstacle that stands between the cold air coming from the Arctic and moving towards the south. This produces a microclimate comparable to that found at Mount Washington in the north-east of the United States, with freezing temperatures and strong winds in winter. And thus, the wind-swept Swiss mountain pines at the summit are dressed up in a baroque costume with wigs and hooped skirts made of icy snow.

At temperatures below -4 degrees, it is a dignified but not exactly heart-warming spectacle—the air is perfect clear and the scenery is bathed in the rising sun's warm light. We rarely see it under these conditions. Usually, the weather is foggy and a biting wind blows.

(The traces are animal tracks, possibly left by a fox.)

Barocke Königin mit Hofdamen. Wer braucht schon Lappland oder eine andere arktische Tundra, wenn ma den Brocken hat? Der mit gut 1000 Meter höchste Berg Harz ist weit und breit die einzig nennenswerte Erhebur die sich den Luftmassen aus der Arktis auf ihrem Weg gen Süden in den Weg stellt. Ähnlich wie beim Mount Washington im Nordosten der USA führt das zu einem extremen Mikroklima mit ziemlich eisigen Temperaturer und starken Winden im Winter. Die windgebeugten Krüppelkiefern auf dem Gipfel erhalten so nach starker Schneefällen ein barockes Kostüm mit Perücken und Reifröcken aus vereistem Schnee.

Bei -20 Grad ein würdevoller, aber kaum erwärmender Anblick, auch wenn bei klarer Luft die Figuren von der gerade aufgegangenen Sonne in warmes Licht getauc werden. Das kommt leider nur selten vor. Meistens ist e nebelig oder es bläst ein rauer Wind.

(Die Spuren sind Tierspuren, wahrscheinlich von einem Fuchs.)

The Brocken, Harz, Germany

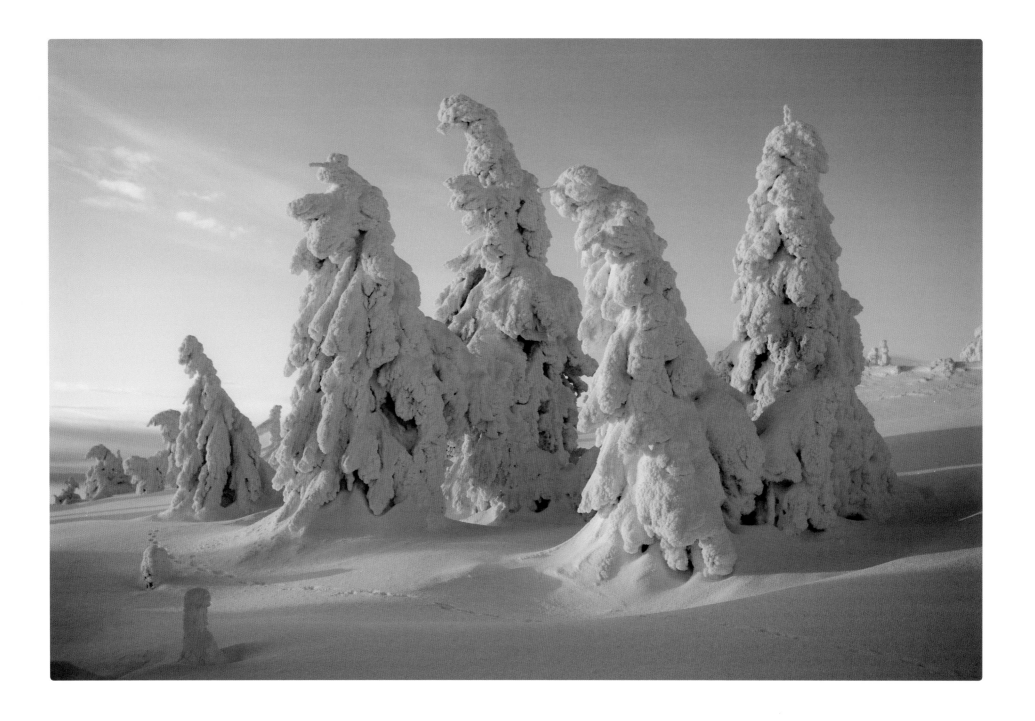

The Brocken, Harz, Germany

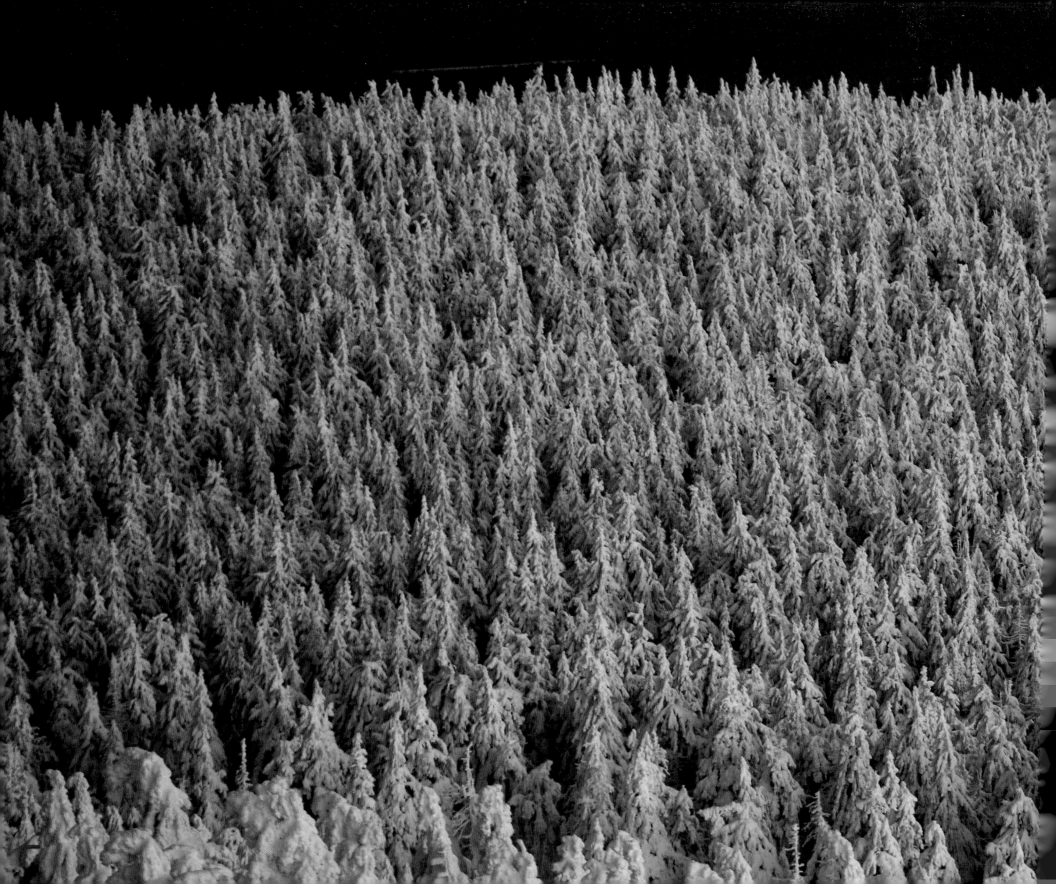

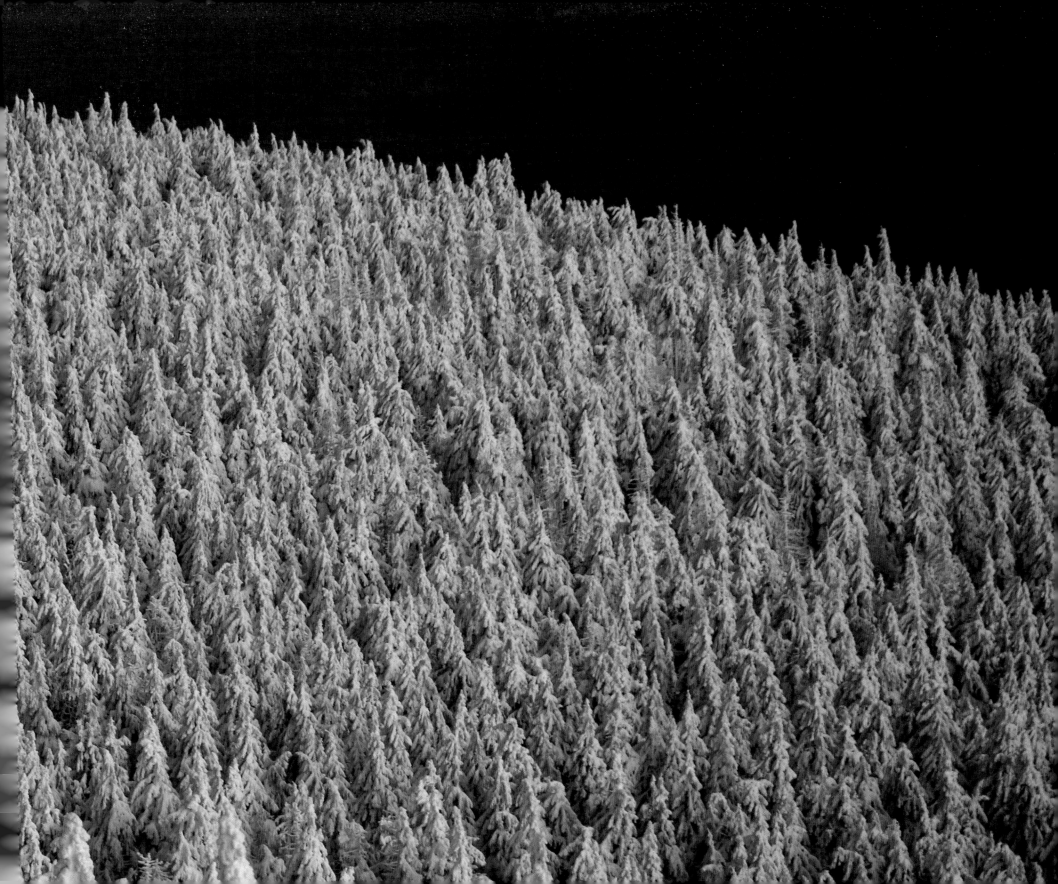

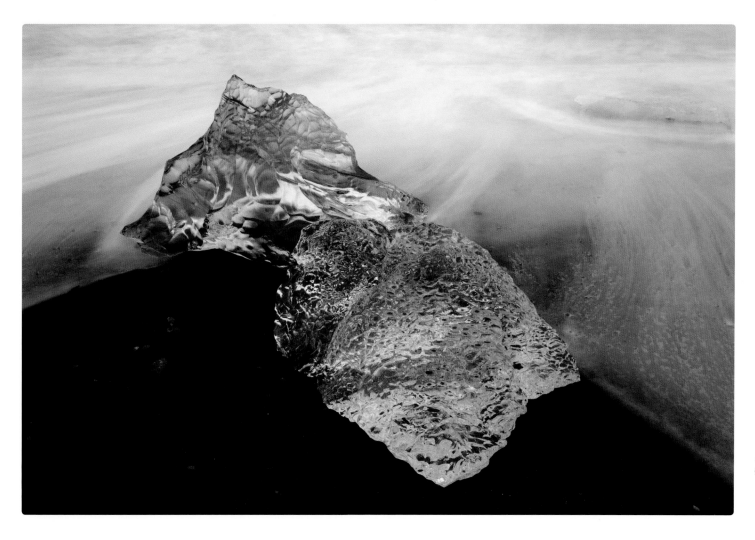

A tight squeeze. The entrance to the ice cave at the Vatnajökull Glacier does not give away what lies behind it. The opening that lead to the next chamber was less than 20 inches high, but several dozen feet long. The only way to traverse it is by crawling on your belly. Let's get this over with ...

Es wird eng. Der Eingang zur Eishöhle am Vatnajökull-Gletscher ließ noch nicht erahnen, was danach folgte. Der Durchgang zur nächsten Kammer war keine 50 cm hoch und viele Meter lang. Ein Durchkommen war nur auf dem Bauch robbend möglich. Augen zu und durch ... und durch ... und durch ...

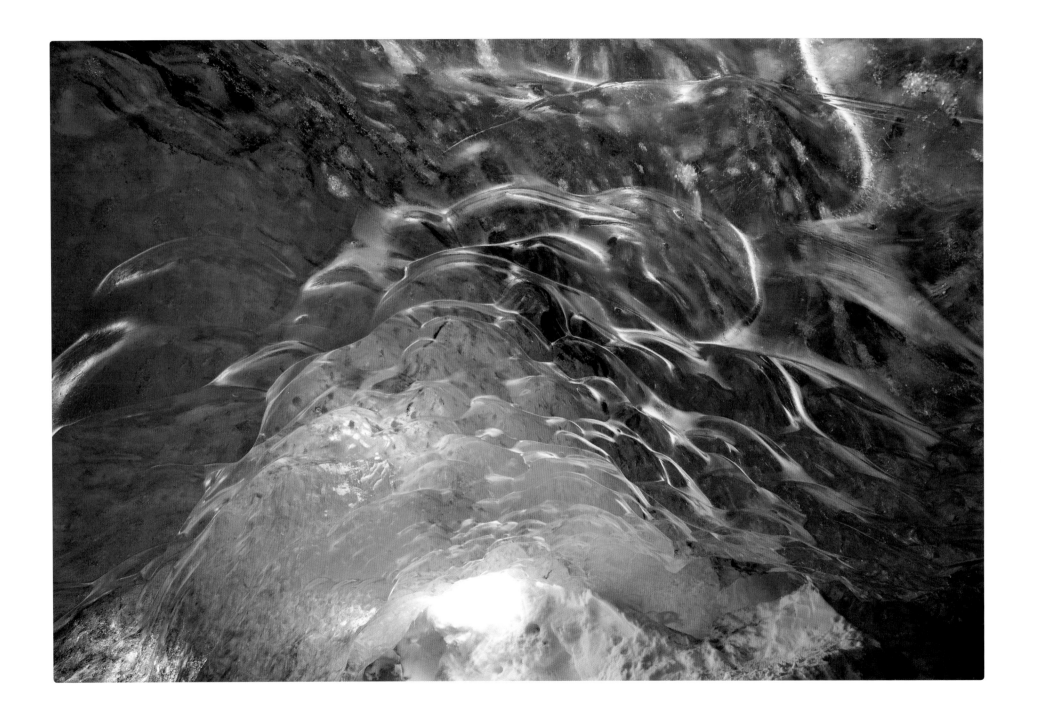

Iceland

Inked. Black lava, snow, and wind. And there we have it: an ink drawing which is, in fact, a photograph. It is both abstract and real. Black-and-white multicolor. Painting and photography reconciled. It is astonishing how little it takes to sum up and define a landscape.

Hingetuscht. Schwarze Lava, Schnee und Wind: Fertig ist die Tuschezeichnung, die ein Foto ist. Ebenso abstrakt wie real. Schwarzweiße Farbigkeit. Bildende Kunst und Fotografie versöhnt. Erstaunlich, wie wenig es braucht, um eine Landschaft zu definieren.

Iceland

Iceland

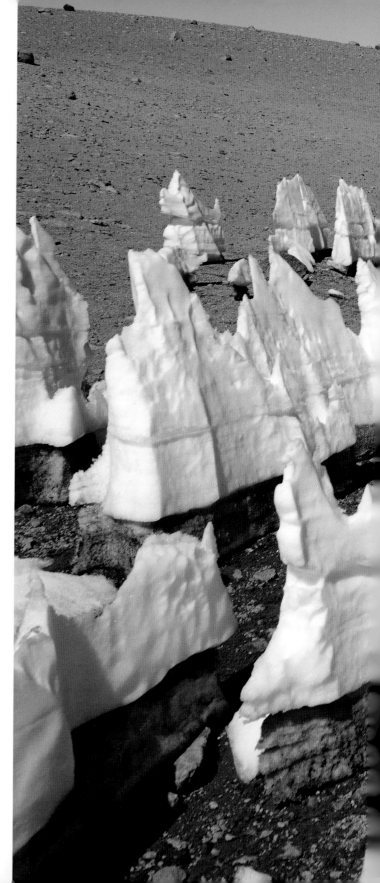

Only the penitent ... Penitentes, or nieves penitents refer to snow formations which were shaped by irregular melting due to strong sunshine and low humidity. Therefore, they are only found in tropical and subtropical high-altitude mountains such as here in the Andes, and usually only at altitudes of 13,000 feet and higher. This photograph was taken at 16,400 feet. The term penitentes comes from the Spanish conquistadors who saw the ice formations and were reminded of people doing penance, dressed in white and walking with bowed heads in an Easter procession.

As an aside, on Pluto there may be penitentes made of methane and measuring up to 1000 feet.

Tuet Buße. Büßereis oder Zackenfirn entsteht durch ungleichmäßiges Abschmelzen bei starker direkter Sonnen-einstrahlung und geringer Luftfeuchtigkeit. Es ist deshalb nur in den tropischen und subtropischen Hochgebirgsregionen wie hier in den Anden und in der Regel erst ab Höhen von 4000 Metern zu finden. Dieses Bild ist in genau 5000 Meter Höhe entstanden. Der Begriff Büßereis kommt wohl von spanischen Konquistadoren, die das Eis an weiß gekleidete und in gebückter Haltung prozessierende Bußgänger in der Osterwoche erinnerte.

Übrigens: Wahrscheinlich gibt es auf dem Pluto Büßereis aus Methan von bis zu 300 Meter Höhe.

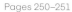

Pages 250–251

Frozen Air. Frost and rime form from chilled water droplets; they are the product of deposition from water vapour in the air (for example in fog) to ice. This process requires high humidity of at least 90 percent and temperatures of about 17 degrees Fahrenheit or lower.

Gefrorene Luft. Raureif, Reif und Raueis bilden sich aus unterkühlten Wassertropfen durch Resublimation aus in der Luft enthaltenem Wasserdampf, wie er in Nebel vorkommt. Es bedarf hierzu einer hohen relativen Luftfeuchtigkeit von mindestens 90 Prozent und einer Lufttemperatur von unter -8 Grad.

Penitentes, Atacama, Chile

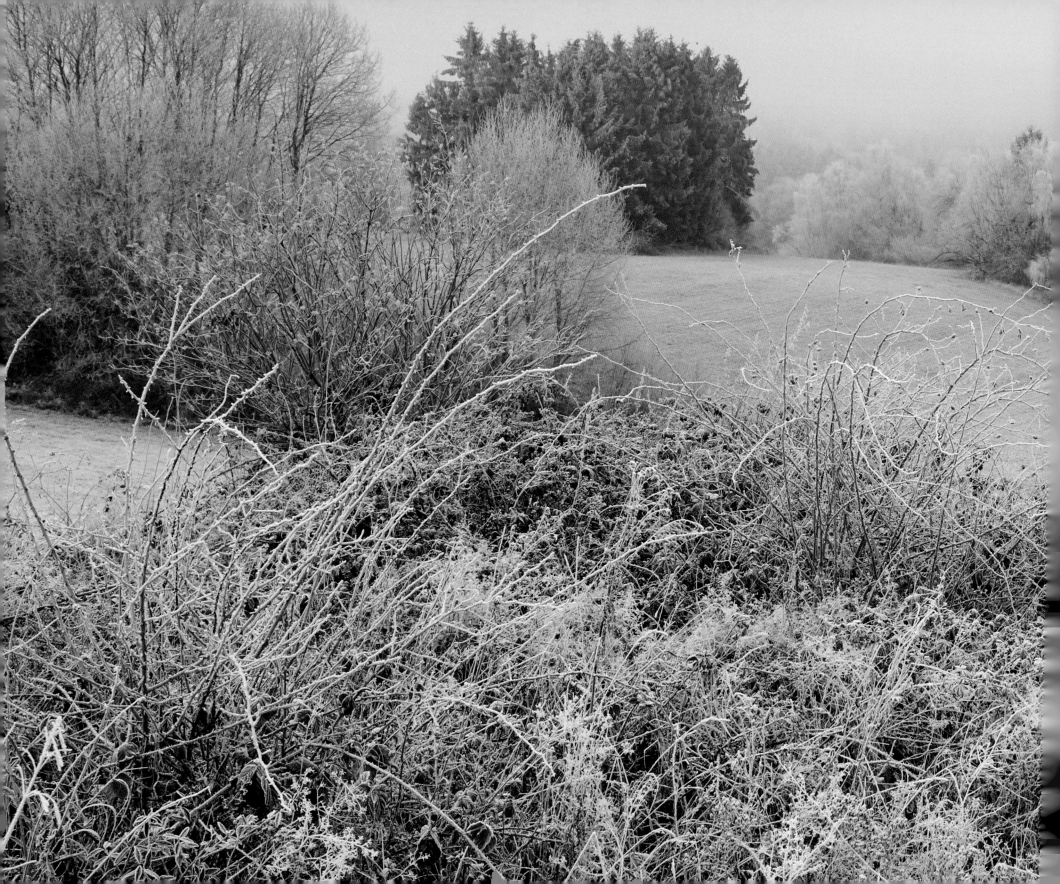

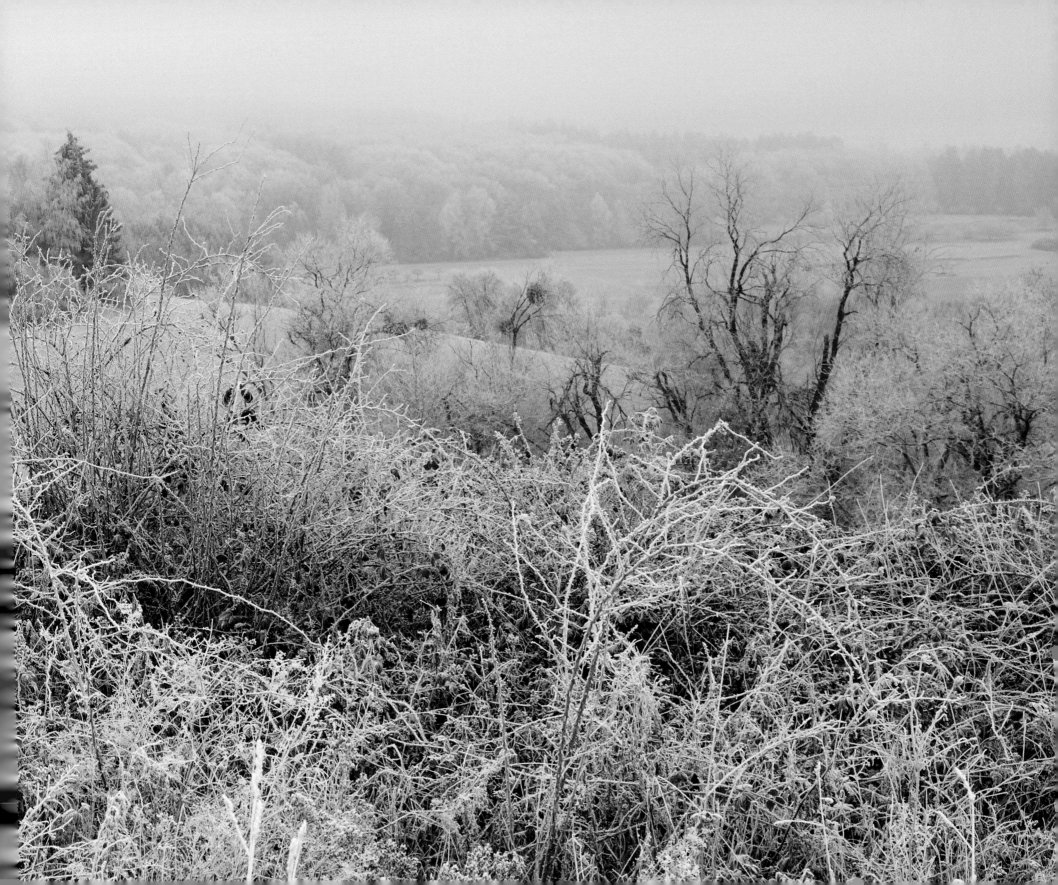

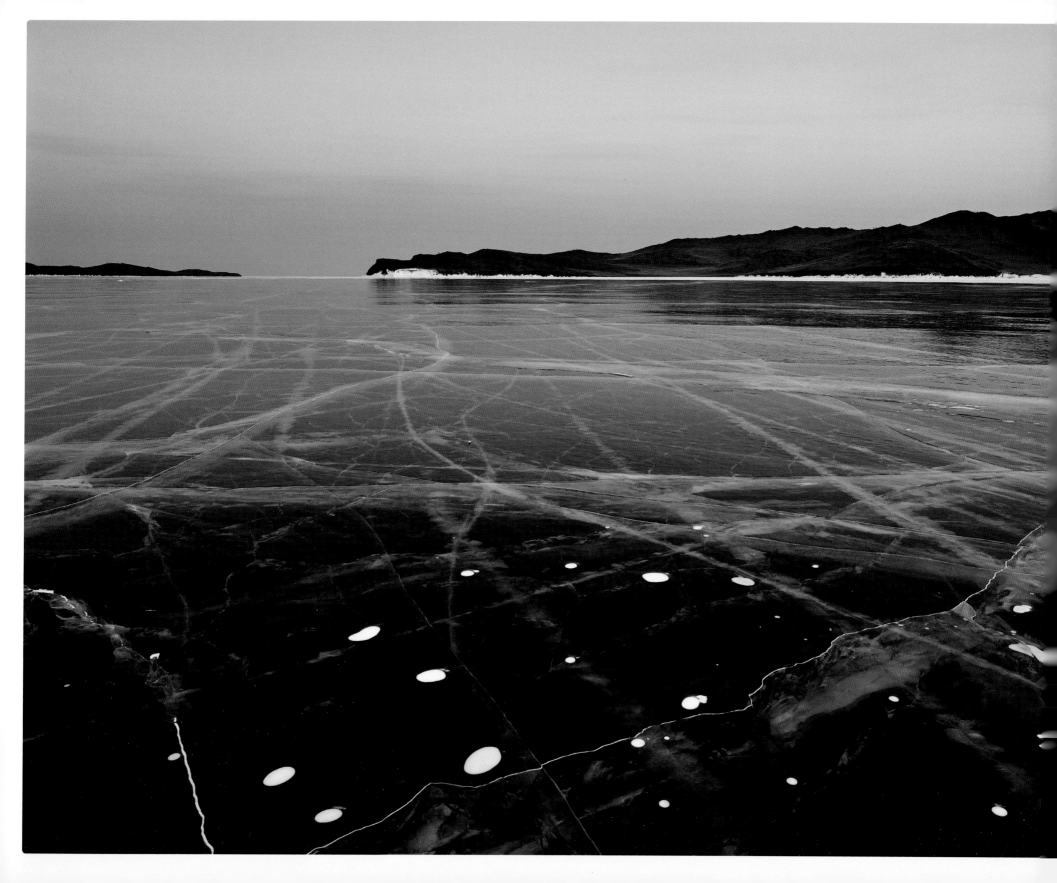

ANYTHING BUT SNOW

BLOSS KEIN SCHNEE

Baikal roughly translates as "rich sea". The lake is as big as a sea, at least in terms of volume. At almost 400 miles of length and 43 miles of width, it does not break any international records in terms of surface area. It makes up for it with a maximum depth of more than 5300 feet and an average depth of 2500 feet. Its enormous volume is equal to all of North America's five Great Lakes put together. About 20 percent of the world's liquid fresh water is found here, in this immense lake. Almost all types of subaquatic plants found here are endemic. The lake is home to the Baikal seal which is the only type of seal that lives in fresh water. Unfortunately, they rarely show themselves in winter. The Russian winter fairy tale is still just as enchanting though. It is a dreamy landscape made of ice—with no snow in sight. Luckily, this area, which is popular with photographers, rarely sees snow. Lake Baikal has several climate zones and here, roughly in the middle, we find a semi-arid climate. On the rare occasions when snow does fall, the frequent winds will swiftly sweep it off the ice.

Due to its immense size, variations in temperature can create strong tensions within the ice and result in dangerous cracks and dislocation, similar to what we see with tectonic movements. Even here in Siberia, temperatures are rising. Surveys have found that water temperatures have already risen by two degrees which has had far-reaching effects. Still, winter temperatures here may fall to below -60 degrees. With just a little bit of wind, even -20 degrees may feel like -60. The sensation is difficult to put into words—you have to experience it for yourself.

Baikal heißt so viel wie „reiches Meer". Ein See so groß wie ein Meer, zumindest nach dem Volumen. Seine 640 Kilometer Länge und 70 Kilometer Breite sind zwar keine Spitzenwerte im globalen Vergleich. Das macht er aber durch seine extreme Tiefe von über 1630 Meter bei durchschnittlich gut 770 Meter locker mehr als wett. Sein Volumen ist so groß, dass das Wasser der fünf Großen Seen Nordamerikas hineinpassen würde. Etwa 20 Prozent des globalen nicht gefrorenen Süßwassers konzentrieren sich hier in diesem See der Superlative. Die Unterwasserfauna ist so gut wie komplett endemisch. Hier lebt die legendäre Baikalrobbe, die einzige Robbenart, die ausschließlich im Süßwasser vorkommt. Leider ist sie im Winter nur mit extremem Glück zu sehen. Aber das tut dem russischen Wintermärchen keinen Abbruch. Ein Traum in Eis, nicht in Schnee. Der fällt in dem für Fotografen interessanten Gebiet eher selten, was ein großes Glück ist. Der riesige Baikalsee hat mehrere Klimazonen und hier – ungefähr in der Mitte – herrscht ein sehr trockenes Steppenklima. Und wenn doch einmal Schnee fällt, besteht die berechtigte Hoffnung, dass der oft blasende Wind ihn sofort wieder vom Eis fegt.

Durch seine schiere Größe entstehen bei Temperaturschwankungen gewaltige Spannungen im Eis und es kommt regelmäßig zu gefährlichen Spalten und Verwerfungen, ähnlich wie bei Kontinentalplatten. Auch hier in Sibirien wird es wärmer. Man hat festgestellt, dass die Wassertemperatur sich bereits um zwei Grad erhöht hat, was gewaltige Konsequenzen nach sich zieht. Trotzdem kann das Thermometer hier im Winter auch mal auf 50 Grad unter null fallen. Aber auch, wenn es nur -30 Grad sind – mit etwas Wind werden es auch so gefühlte -50. Man kann es nicht beschreiben. Man muss es einmal erlebt haben!

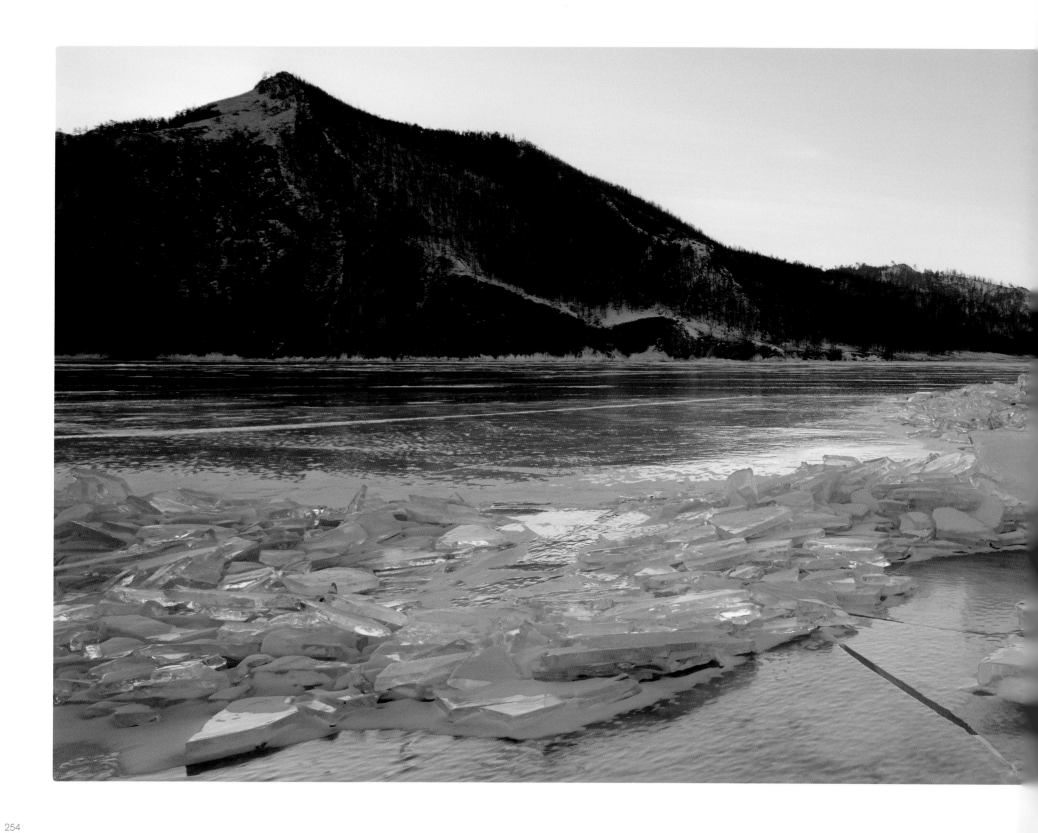

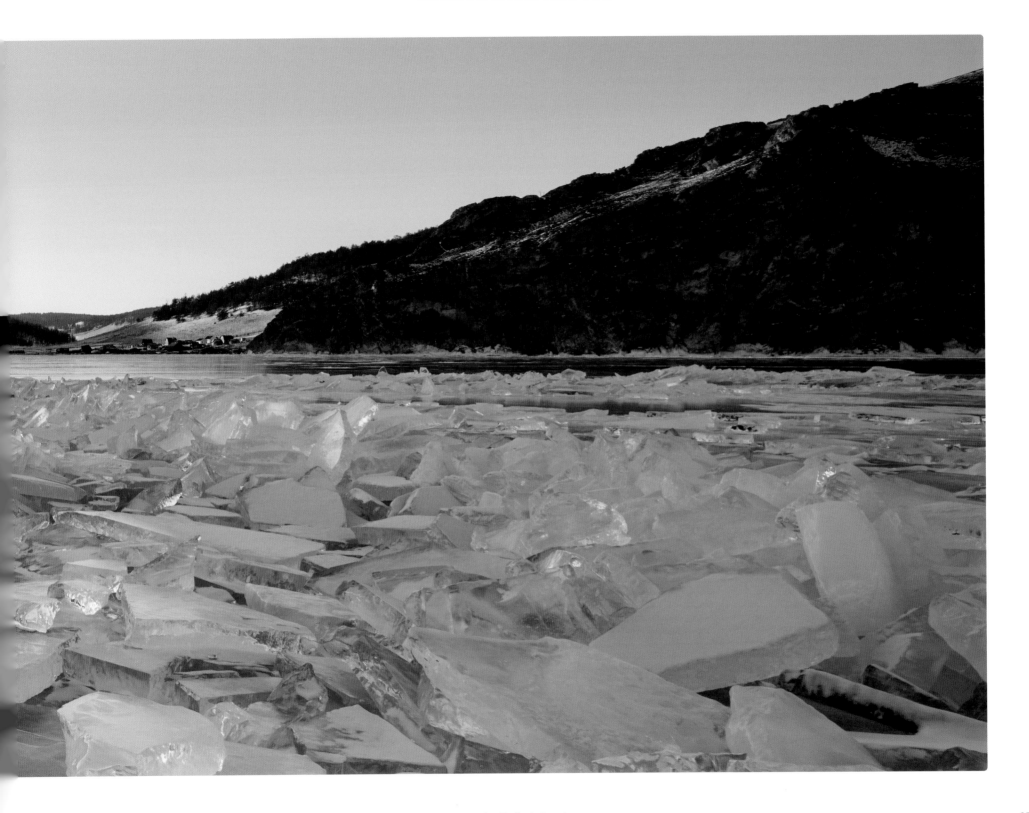

Lake Baikal, Russia

Lake Baikal, Russia

Lake Baikal, Russia

Lake Baikal, Russia

Lake Baikal, Russia

Fire and ice. The last sunrays illuminate the falling snow in a red hue but do not reach the cracks in the ice.

Feuer und Eis. Die letzten Sonnenstrahlen lassen den wehenden Schnee rötlich leuchten, während die Risse im Eis unbeleuchtet bleiben.

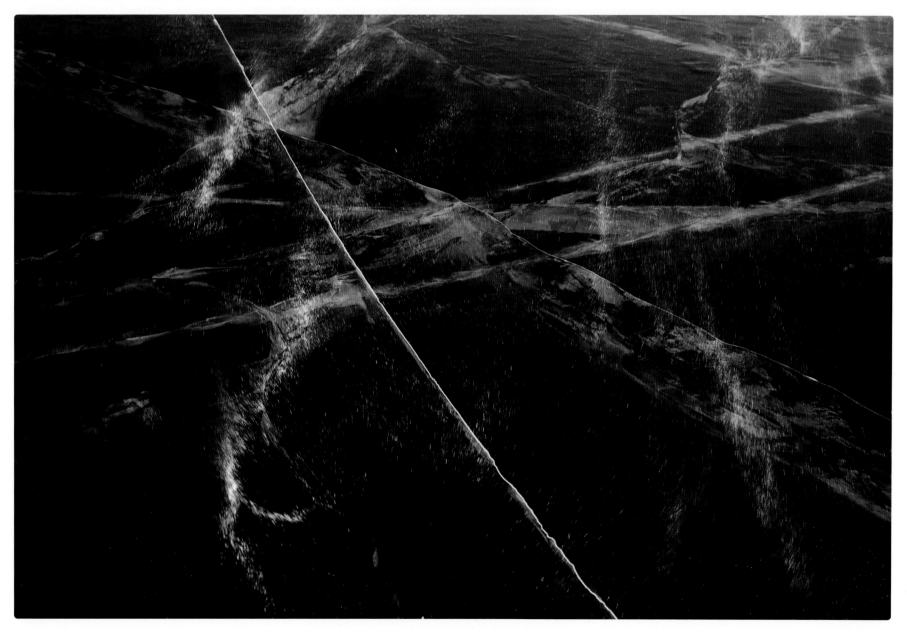

Lake Baikal, Russia

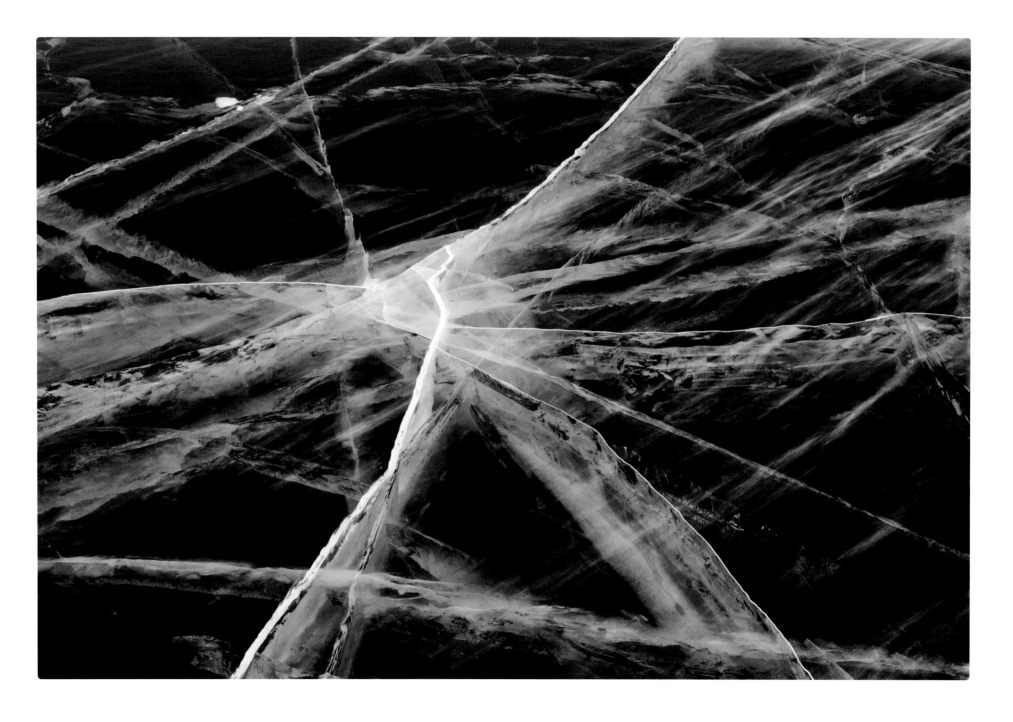

Lake Baikal, Russia

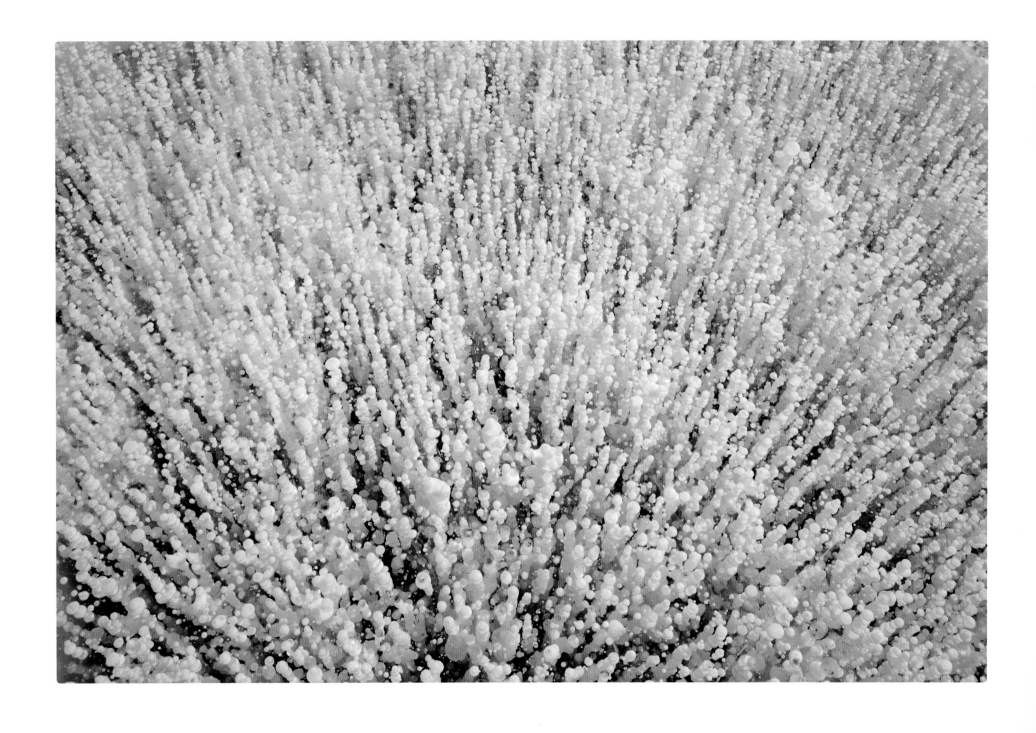

Lake Baikal, Russia

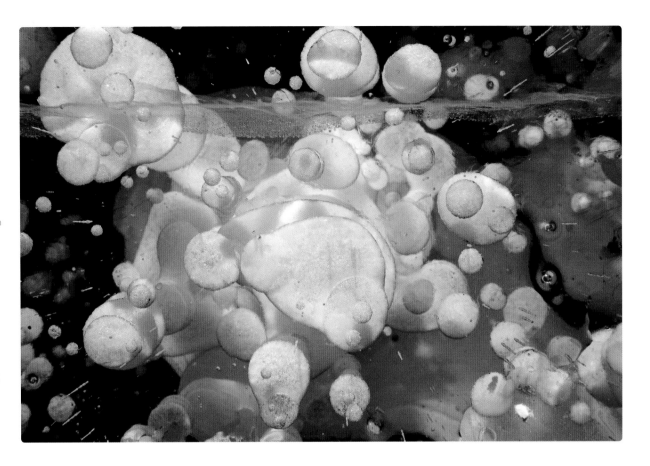

Vodka on the Rocks. In some places in this lake, gaseous hydrates such as methane hydrate or nitrogen hydrate emerge from the ground, rise, and are frozen in place.

Vodka on the rocks. What to do when the weather is foggy and a journey of several hundred miles appears to have been in vain? Easy—you buy eight bottles of cheap and one bottle of good vodka; then you carefully pour the contents of the eight cheap bottles onto the ice, covering a radius of about 10 to 20 square feet. At this point, if everything is prepared and you are ready to start shooting, you will have just about enough time to take one good photograph. After a few minutes, the vodka has evaporated and the ice is cloudy again. Now you can drink the good vodka to celebrate. On a side note, hot or cold water will not have the same effect. At any rate, it is easier to buy a few bottles of vodka than to bring a sufficient amount of hot water to the lake—and the shop assistant did not seem the least bit surprised by this bulk purchase.

Vodka on the Rocks. An einigen Stellen im See lösen sich Gashydrate wie Methan- oder Stickstoffhydrat aus dem Untergrund, steigen auf und frieren ein.

Was macht man aber, wenn das Eis trüb ist und Hunderte Kilometer Fahrt umsonst zu sein scheinen? Ganz einfach. Man besorgt sich acht Flaschen billigen und eine Flasche guten Wodka und verteilt den Inhalt der acht Flaschen vorsichtig auf dem Eis – immerhin etwa zwei bis drei Quadratmeter. Dann hat man gerade genug Zeit – vorausgesetzt, alles ist vorbereitet –, um ein brauchbares Bild zu machen. Nach wenigen Minuten nämlich ist der Wodka verdunstet und das Eis wieder eingetrübt. Anschließend trinkt man vom guten Wodka auf den Erfolg. Übrigens: Weder kaltes noch heißes Wasser haben dieselbe Wirkung. Außerdem ist es viel einfacher, ein paar Flaschen Wodka zu kaufen, als heißes Wasser in ausreichender Menge aufs Eis zu bringen – die Verkäuferin fand es auch überhaupt nicht seltsam.

Lake Baikal, Russia

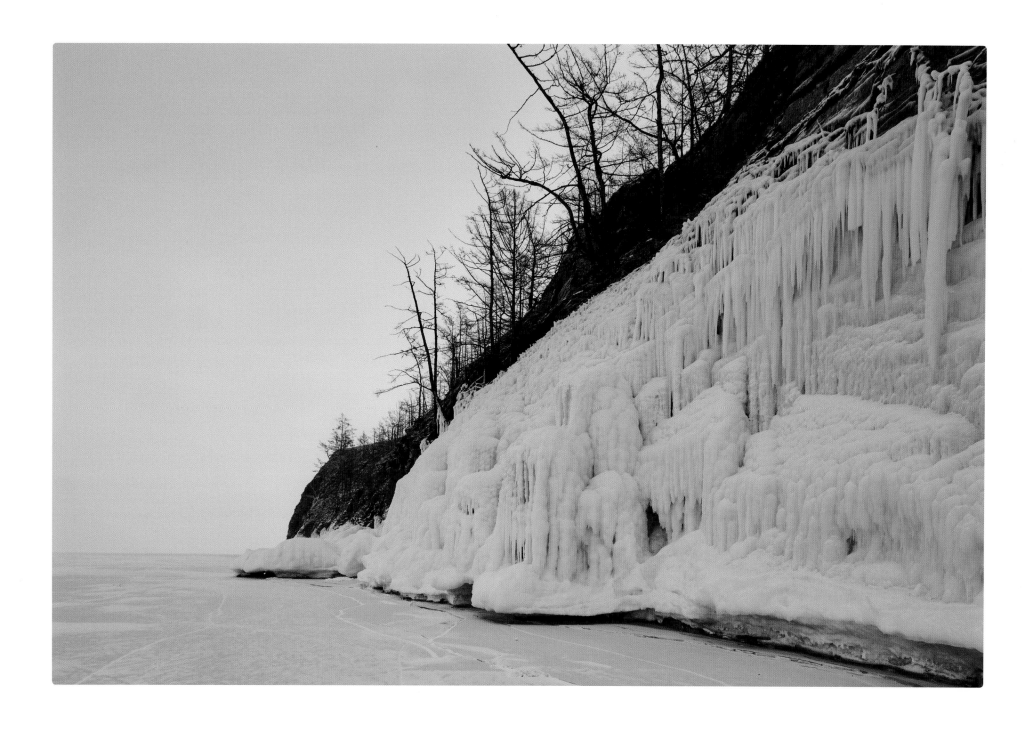

Lake Baikal, Russia

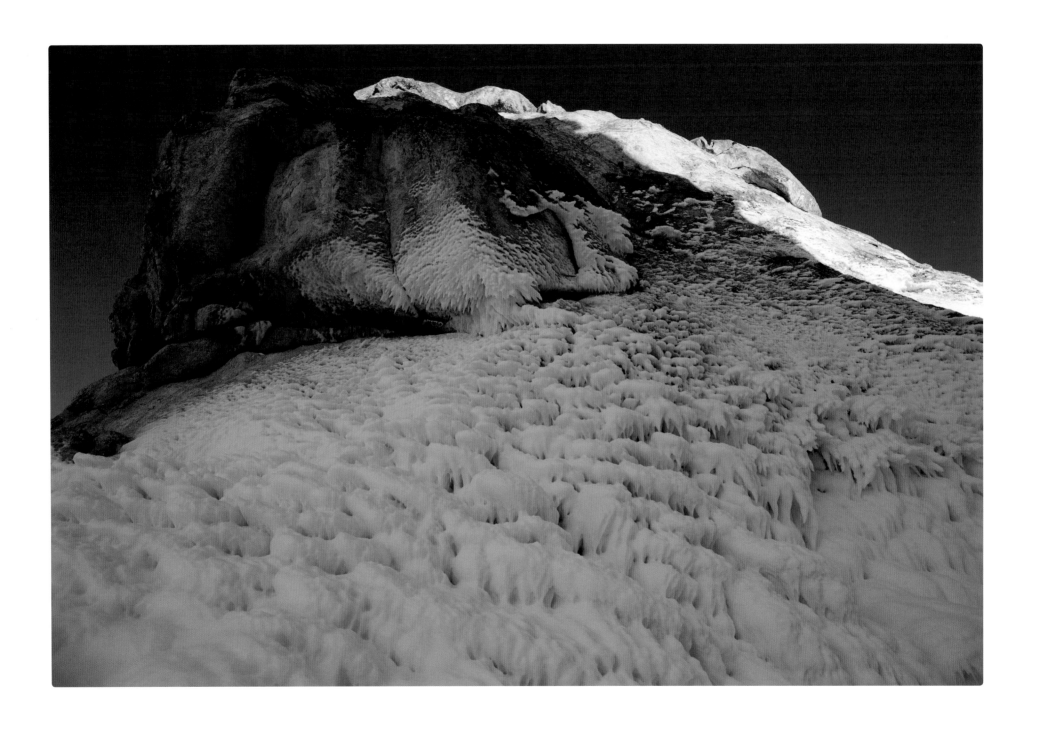

Lake Baikal, Russia

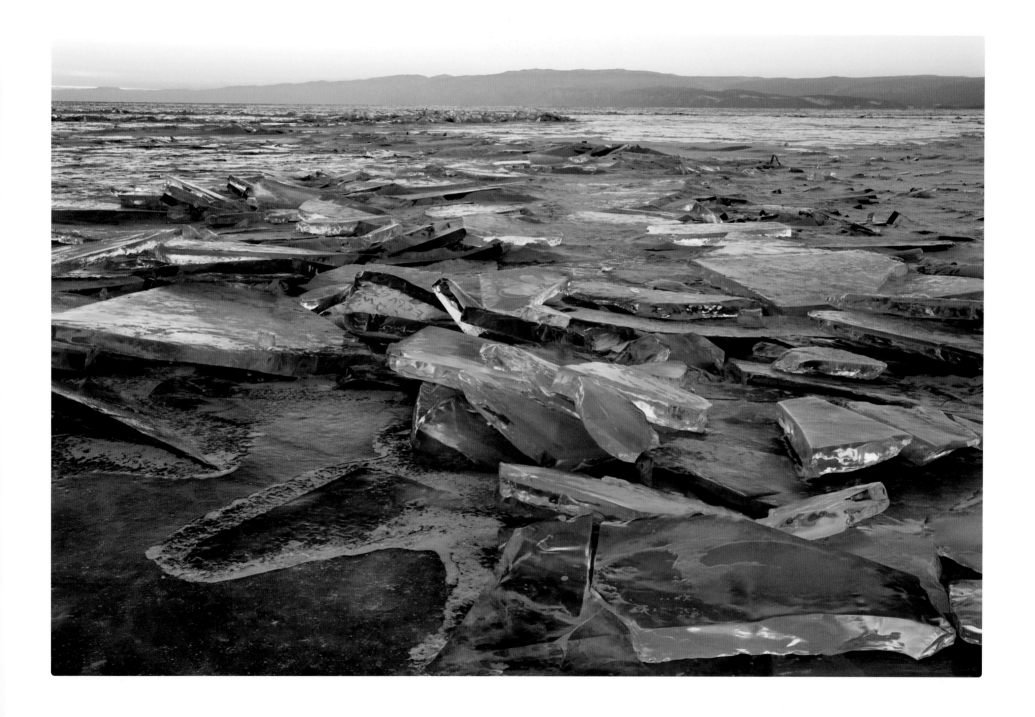

Lake Baikal, Russia

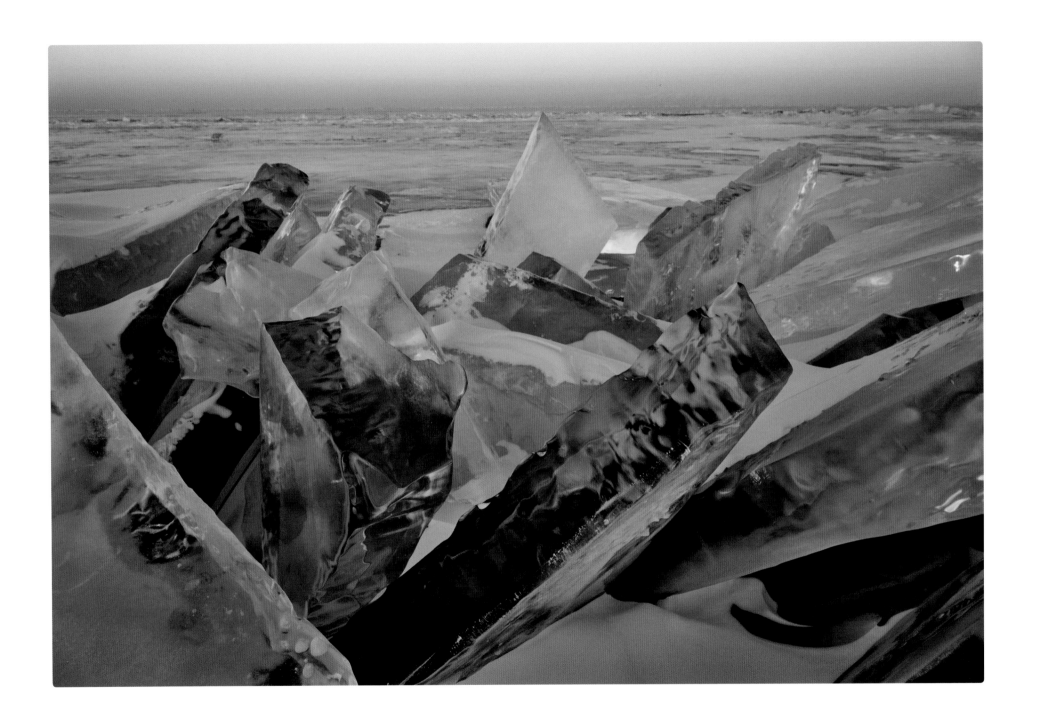

Lake Baikal, Russia

Lake Baikal, Russia

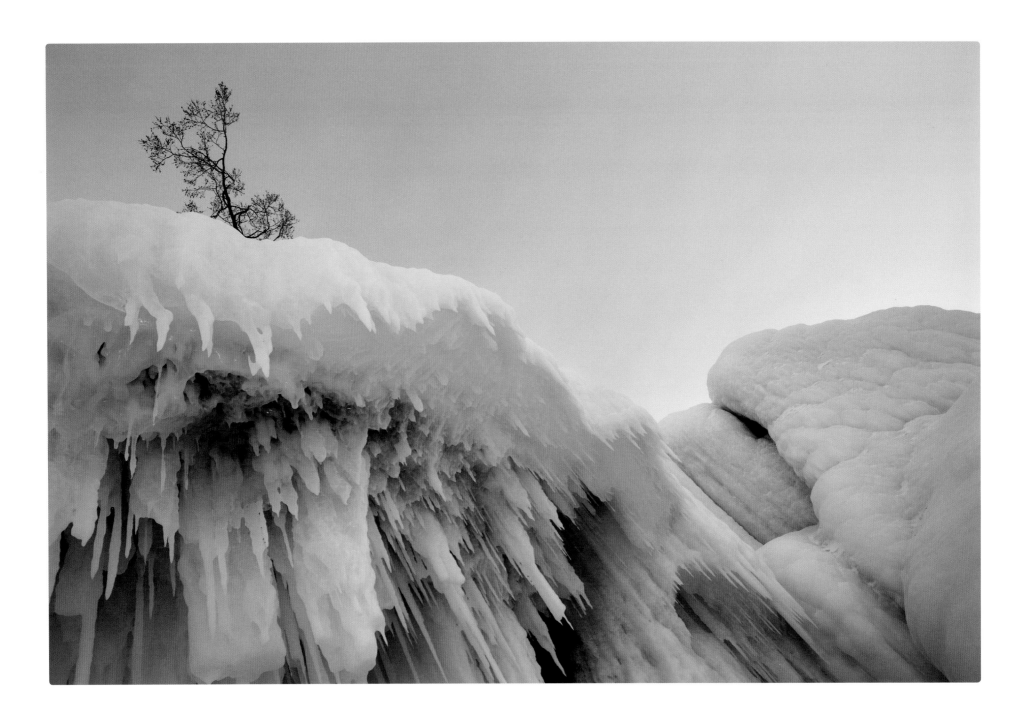

Lake Baikal, Russia

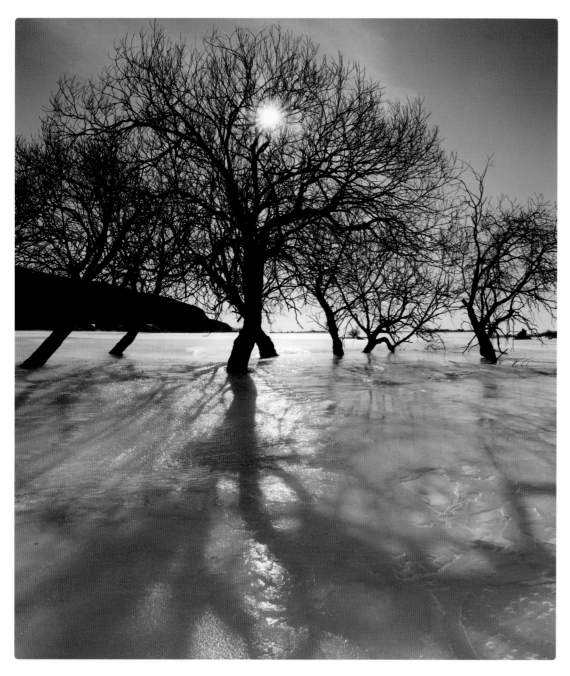

Trapped. At the point where Reka Bugul'deyka enters Lake Baikal, these trees are patiently waiting for warmer weather.

Gefangen. Kurz vor der Mündung des Flüsschens Bugul'deyka in den Baikalsee warten diese Bäume geduldig auf wärmere Zeiten.

A real iceberg. Strong katabatic winds blow across the lake's surface and produce waves of up to 13 feet. Those, combined with the spray, create fanciful ice sculptures which often look like waterfalls.

Ein echter Eisberg. Starke Fallwinde, die über den See fegen, lassen Wellen bis zu vier Meter Höhe entstehen. In Kombination mit der Gischt entstehen so fantastische Eisskulpturen, die oft Wasserfällen sehr ähnlich sehen, aber keine sind.

Lake Baikal, Russia

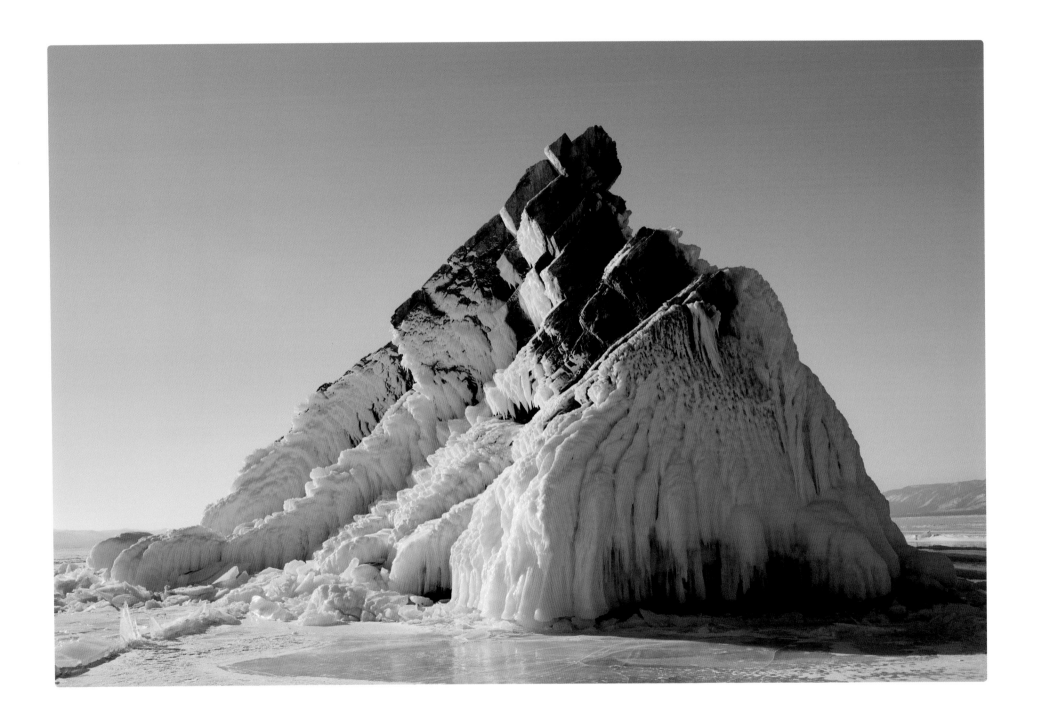

Lake Baikal, Russia

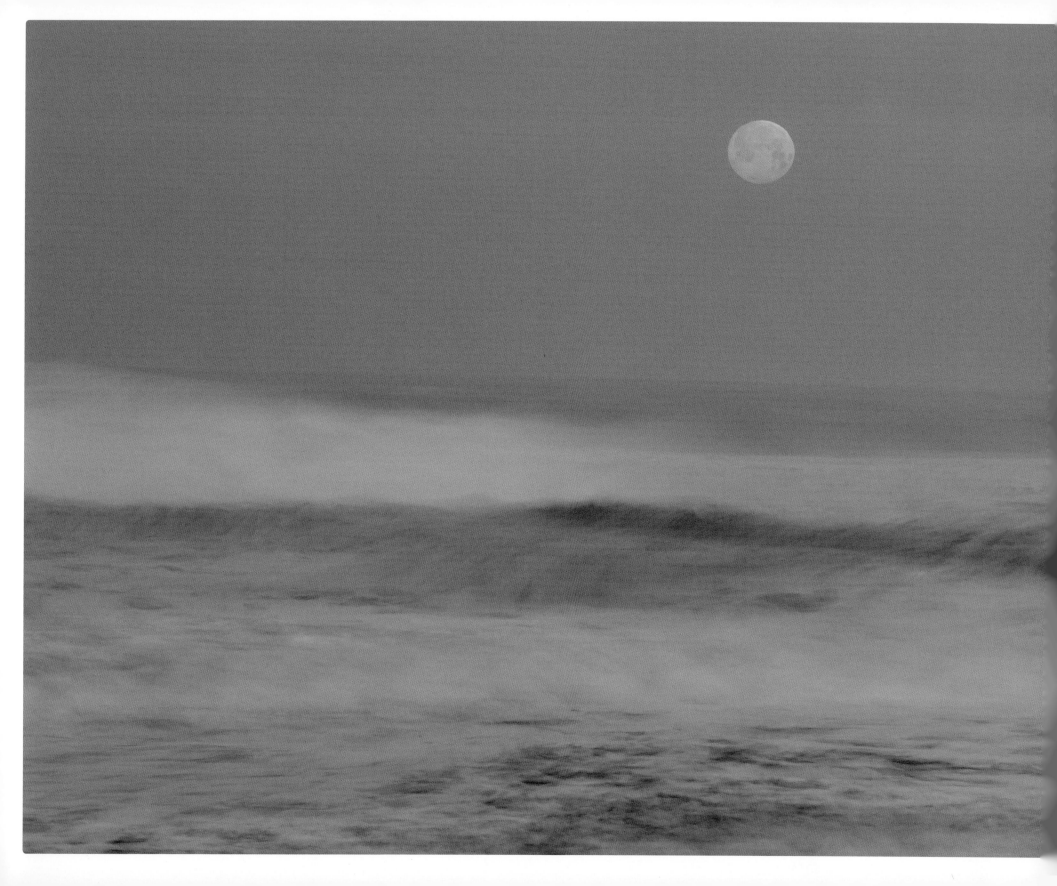

MOODS IMAGES OF WATER

STIMMUNGEN **WASSERBILDER**

Taking photographs of water is almost impossible. A still image can only ever be an approximation of what we experience. We only rarely see a body of water with a perfectly still, unmoving, smooth surface—usually we see water in movement. It is only when water is moving that we perceive it as water. Our eye is unable to stop the movement, to break it down and sharpen the image—and it is just as incapable of doing the opposite, of smudging and blending stillness into motion. This means that no photograph, be it a still showing frozen motion with a shutter speed of 1/4000 of a second, or a long exposure image, can ever depict water in exactly the same way we experience it. Even unmoving water only appears as water to us if it reflects its surroundings and the light. No matter how hard I try, any translation of water into photography can only be an approximation of visual experience. There are few other topics in nature photography that invite experimentation as much as water does.

Wasser zu fotografieren ist eigentlich unmöglich oder wenigstens immer nur eine Annäherung an das, was wir als Wasser wahrnehmen. Wenn es sich nicht gerade um eine völlig unbewegliche, glatte Wasseroberfläche handelt, sehen wir Wasser immer in Bewegung. Erst dann wird es in unserer Wahrnehmung zu Wasser. Unser Auge kann weder die Bewegung anhalten noch zeitlich besonders fein auflösen oder – das Gegenteil davon – Bewegung verwischen. Das heißt, kein einziges Foto – ob mit eingefrorener Bewegung einer 4000stel-Sekunde oder einer Langzeitbelichtung – bildet Wasser so ab, wie wir es eigentlich wahrnehmen. Aber selbst das unbewegte Wasser wird erst durch äußere Einflüsse wie Spiegelungen und Reflexionen in unserem Sehen zu Wasser. Egal wie sehr ich mich also anstrenge, jede fotografische Übersetzung ist immer nur eine Annäherung an unsere visuelle Erfahrung. Kaum ein Sujet der Landschaftsfotografie reizt gerade deswegen so zum Experimentieren, wie es das Wasser tut.

Plitvice, Croatia

Soča, Slovenia

Soča, Slovenia

Soča, Slovenia

Portugal

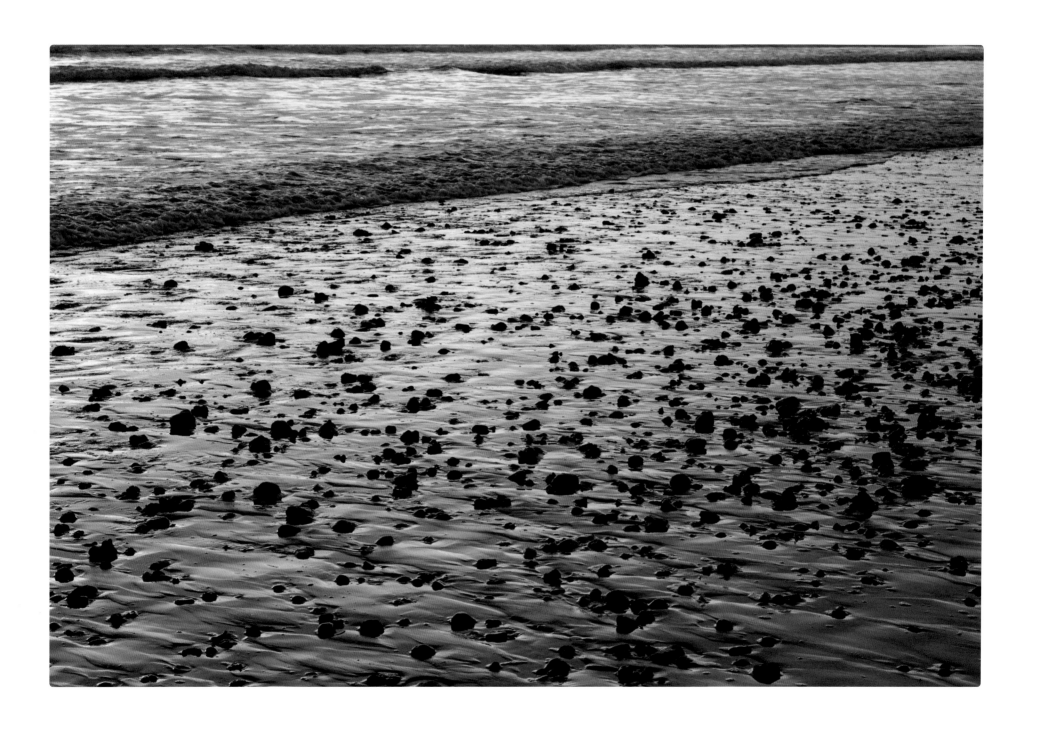

Spain

Portugal

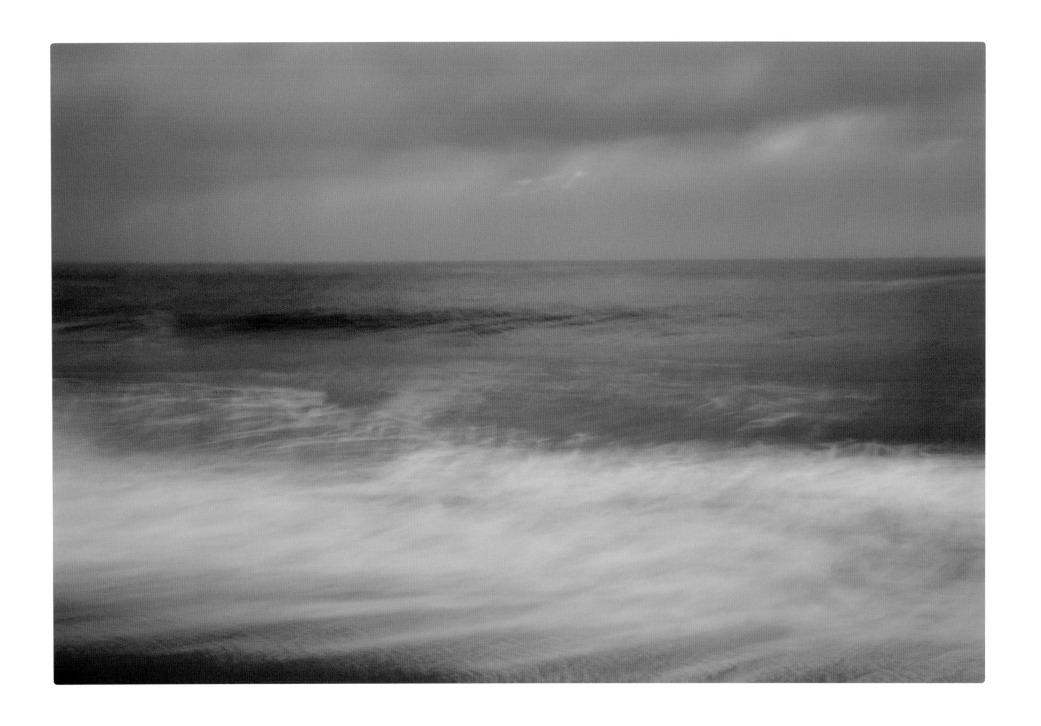

Portugal

CONCEPT, IMAGES, WORDS AND DESIGN

Rudi Sebastian, born in 1960 in Rüssingen, in the Rhineland-Palatinate state of Germany, dedicated himself to photography after many years working primarily in the advertising industry. His main interest is nature photography with a focus on water and vegetation. Sebastian's work has won numerous awards at major international competitions. His art prints, offered in very small limited editions, have collectors from Azerbaijan to Australia.
He lives with his wife in Wiesbaden, Germany.

Rudi Sebastian, geboren 1960 in Rüssingen in der Pfalz, hat sich – nach vielen Jahren in der Werbebranche – ganz der Fotografie verschrieben. Sein Hauptinteresse gilt der Naturfotografie mit den Schwerpunkten Wasser und Vegetation. Seine Arbeiten wurden mehrfach bei großen internationalen Wettbewerben ausgezeichnet. Seine in sehr kleinen limitierten Editionen angebotenen Kunstdrucke besitzen Sammler von Aserbaidschan bis Australien.
Er lebt mit seiner Frau in Wiesbaden, Deutschland.

Photo: Ingo Arndt

PROLOGUE

Axel Weiß, born in 1961, has been working as a journalist, editor, and moderator with a focus on environment, nature, and science, since studying biology and geography in Tübingen, Germany. He currently works for the German television station, SWR, and lives in Mainz.

Axel Weiß, geboren 1961, arbeitet seit dem Studium von Biologie und Geografie in Tübingen medienübergreifend als Autor, Redakteur und Moderator mit Schwerpunkt Umwelt, Natur und Wissenschaft. Er ist Redakteur beim Südwestrundfunk und lebt in Mainz.

All images: 2, Disco Island, Greenland; 4, Crater Lake, Oregon; 7, Iceland; 8, Tatio Geysir, Chile; 10–11, Iceland; 14 - 15, Tatio geysir, Chile; 16–17, Allgäu, Germany; 20, La Réunion, France; 21, Sevilla, Spain; 22–23, Tre Cime, Italy; 24, Soča, Slovenia; 26–27, The Li River, China; 30, 31, Rhine near Rastatt, Germany; 32–35, The Havel River, Germany; 36, Verzasca, Switzerland; 38–47, Soča, Slovenia; 48, The River Maggia, Switzerland; 49–53, Verzasca, Switzerland; 54–55, California; 56–57, Verdon, France; 58–61, The Li River, China; 62, Kerala, India; 63, Canal du Midi, France; 64, 66–75, Rio Tinto, Spain; 76–81, Rio Celeste, Costa Rica; 82–83, Lac Blanc, France; 84–85, Ammersee, Germany; 89, Lake Tahoe, California; 90, Lake Karer, Italy; 91, Lake Bohinj, Slovenia; 92, 93, Berlin area, Germany; 94, 95, Pond near Rio Tinto, Spain; 96–97, Mono Lake, California; 98, Salar de Surir, Chile; 100–101, Laguna Miscanti, Chile; 102, Salar de Atacama, Chile; 103, Aguas Calientes, Chile; 104, Laguna Verde, Bolivia; 105, Salar de Maricunga, Chile; 106–107, Aerial view on Salar de Atacama, Chile; 108, 109, Laguna Colorada, Bolivia; 110, 111, Laguna Verde, Chile; 112, 112–113, Salar de Uyuni, Bolivia; 114–115, Lake Nakuru, Kenya; 116, Lake Bogoria, Kenya; 117, Lake Nakuru, Kenya; 118, 120–129, Owens Lake, California; 134, 136–147, Lençois Maranhenses, Brazil; 150, Nazaré, Portugal; 152–153, Iceland; 156, 158–173, Bahamas; 174, 176–187, Bay of Cádiz, Spain; 188 - 189, Paranaiba, Brazil; 190 - 191, Long Island, Bahamas; 192, English channel, Great Britain; 193, Mexico; 194, Lofoten, Norway; 195, Iceland; 196 - 199, Nazaré, Portugal; 200, 201, Northern Ireland, Great Britain; 202–203, Long Island Bahamas; 204, 206–211, Svalbard, Norway; 212–213, Eqi glacier, Greenland; 214–219, Greenland; 220–221, Disco Island, Greenland; 222, 223–233, Xiapu, China; 234, Lake Baikal, Russia; 236–237, Vulcano Parinacote, Chile; 238–241, The Brocken, Germany; 242–243, Harz, Germany; 244 - 247, Iceland; 248–249, Altiplano, Chile; 250–251, Hesse, Germany; 252, 253–271, Lake Baikal, Russia; 272–273, Nazaré, Spain; 274–275, Lago di Misurina, Italy; 276, Plitvice, Croatia; 277–279, Soča, Slovenia; 280, Nazaré, Portugal; 281, Spain; 282–285, Nazaré, Portugal; 286–287, Lofoten, Norway.

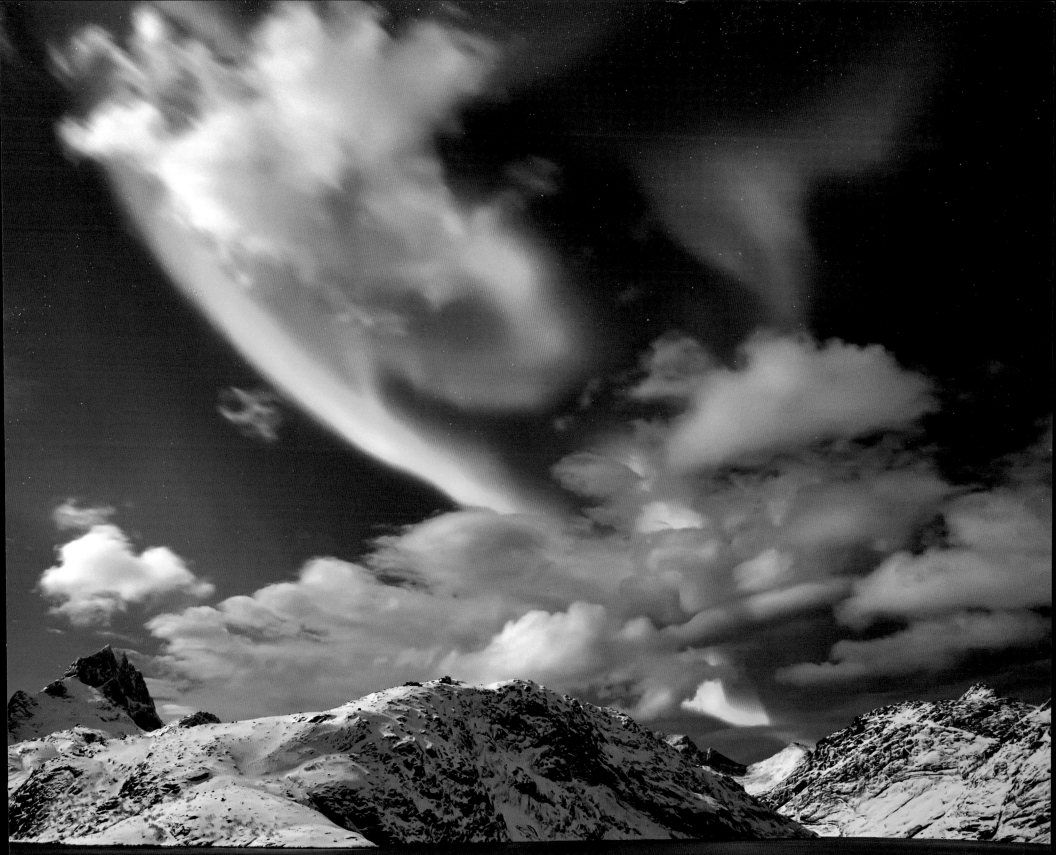

Imprint

© 2019 teNeues Media GmbH & Co. KG, Kempen
© 2019 Rudi Sebastian. All rights reserved.

Prologue by Axel Weiß
Translations by Judith Kahl
Copyediting by Roman Korn
Proofreading by Christian Wolf
Design by Rudi Sebastian
Editorial coordination by Roman Korn
Production by Nele Jansen
Color separation by Robert Kuhlendahl

ISBN 978-3-96171-221-2 (English cover)
ISBN 978-3-96171-216-8 (German cover)

Printed in the Czech Republic, Tesinska Tiskarna AG

Published by teNeues Publishing Group

teNeues Media GmbH & Co. KG
Am Selder 37, 47906 Kempen, Germany
Phone: +49-(0)2152-916-0
Fax: +49-(0)2152-916-111
e-mail: books@teneues.com

Press department: Andrea Rehn
Phone: +49-(0)2152-916-202
e-mail: arehn@teneues.com

Munich Office
Pilotystraße 4, 80538 Munich, Germany
Phone: +49-(0)89-443-8889-62
e-mail: bkellner@teneues.com

Berlin Office
Mommsenstraße 43, 10629 Berlin, Germany
e-mail: ajasper@teneues.com

teNeues Publishing Company
350 7th Avenue, Suite 301, New York, NY 10001, USA
Phone: +1-212-627-9090
Fax: +1-212-627-9511

teNeues Publishing UK Ltd.
12 Ferndene Road, London SE24 0AQ, UK
Phone: +44-(0)20-3542-8997

teNeues France S.A.R.L.
39, rue des Billets, 18250 Henrichemont, France
Phone: +33-(0)2-4826-9348
Fax: +33-(0)1-7072-3482

www.teneues.com

teNeues Publishing Group
Kempen
Berlin
London
Munich
New York
Paris

teNeues